P9-CFC-781

The
DECORATION
of
HOUSES

The
DECORATION
of
HOUSES

ALEXANDRA
STODDARD

WILLIAM MORROW AND COMPANY, INC.

New York

Copyright © 1997 by Alexandra Stoddard

Illustrations copyright © 1997 by Stephen Freeburg

All rights reserved. No part of this book may be reproduced or
utilized in any form or by any means, electronic or mechanical,
including photocopying, recording, or by any information storage
or retrieval system, without permission in writing from the
Publisher. Inquiries should be addressed to Permissions Depart-
ment, William Morrow and Company, Inc., 1350 Avenue of the
Americas, New York, N.Y. 10019.

It is the policy of William Morrow and Company, Inc., and its
imprints and affiliates, recognizing the importance of preserving
what has been written, to print the books we publish on acid-
free paper, and we exert our best efforts to that end.

Library of Congress Cataloging-in-Publication Data

Stoddard, Alexandra.
 The decoration of houses / Alexandra Stoddard.
 p. cm.
 Includes index.
 ISBN 0-688-14959-6
 1. Interior decoration. I. Title.
NK2110.S762 1997
747—dc21 97-1772
 CIP

Printed in the United States of America

First Edition

1 2 3 4 5 6 7 8 9 10

BOOK DESIGN BY MARYSARAH QUINN AND MARK GAROFALO

Contents

The

DECORATION

of

HOUSES

Foreword

Love of beauty is taste . . .
the creation of beauty is art.
—RALPH WALDO EMERSON

EDITH, ELSIE, AND ELEANOR: THREE DOYENNES OF INTERIOR DESIGN

One hundred years ago, the mother of American interior design, Edith Wharton, wrote the seminal book, *The Decoration of Houses.* Her friend, architect Ogden Codman, Jr., collaborated on technical aspects of the text. The book immediately changed people's thinking about how a room should be put together and became a revolutionary bible for professional designers and architects, both here and abroad.

Before Edith Wharton began writing novels, she traveled extensively throughout Europe, absorbing the beauty and studying the classical proportions and symmetry of grand houses and châteaux. This studied exposure to the best models led to her belief that interior decoration is a branch of architecture. Ever since reading Edith Wharton's novels as a teenager, I've been fascinated by her life and style. But it wasn't until I began to study interior design that I realized how knowledgeable she was about proportion, scale, and the elusive elements that create a beautiful, harmonious house.

One hundred years ago, there were no professional interior decorators. Unquestionably, Edith Wharton was the single most influential person in establishing interior decoration as a profession and an extension of architecture. Until she expressed her views, only antique dealers, upholsterers, and architects were considered knowledgeable in the

business of house furnishing. Edith Wharton, with her gifted aesthetic eye and boundless energy, decorated her own houses, and never received money for her artistic contributions to others' houses. She obviously preferred her career as novelist, remaining an amateur decorator with unequaled classical taste and style, as reflected in her novels.

At the time of publication of *The Decoration of Houses* in 1897, Elsie de Wolfe, an aspiring actress who needed to earn her own living, said, "I can't paint, I can't write, I can't sing. But I can decorate and run a house, and light it, and heat it, and have it like a living thing." Taking her cue from Edith Wharton, she completely redecorated the interior of her New York brownstone home, Irving House, turning the heavy, dark, airless atmosphere into light, white, uncluttered, mirrored splendor. Though Elsie de Wolfe never made any reference to the Wharton-Codman book, she recalled the classical instruction of the text and constantly solicited Ogden Codman's expertise. When she renovated Irving House (one of her dwellings), it quickly became a celebrated showplace for her brilliant talent and an example of how light, bright, and delightful an ordinary house could become when transformed by her magic wand.

Within a few years following the turn of the century, Elsie de Wolfe officially launched her career as the first card-carrying interior decorator. In 1913, she published *The House in Good Taste,* written with journalist turned interior decorator Ruby Ross Wood, who, after the excitement of publication, decided to turn her own energies toward becoming a decorator. (In 1935, Wood hired Billy Baldwin, a gifted young designer from Baltimore, to be her assistant. His work is now legendary.) Eleven years after publication of de Wolfe's book, Eleanor McMillen Brown opened her design firm in New York, and Sister Parish followed suit with her own company in Far Hills, New Jersey. In London, Sybil Colefax and Syrie Maugham were also making their way in the interior decorating field, providing additional professionalism and competition. Times were not always propitious. Thirteen years after Mrs. Brown founded her business, flamboyant Elsie de Wolfe declared bankruptcy of her New York decorating firm.

In 1978, Classical America reissued Edith Wharton's *The Decoration of Houses*. In the foreword of the new facsimile edition, Eleanor McMillen Brown is expressly credited as the chief exponent of the Wharton-Codman classical tradition of design as a branch of architec-

ture. In 1924, it was noted, she founded McMillen, Inc., a firm committed to classical principles and understated, quiet beauty.

Two years out of design school, when John F. Kennedy was president, I started as a designer at McMillen, Inc., and stayed with the firm for more than thirteen years. During my tenure there, Mrs. Brown was my teacher, mentor, and close friend, as well as my link to the knowledge and attitude of Edith Wharton's design precepts. We adapted these precepts to contemporary living, as I continue to do in today's vastly changed world.

In the course of her long, successful career, Mrs. Brown meticulously trained hundreds of designers in the Edith Wharton tradition with her own thoughtful embellishments, and they, in turn, shared their knowledge and skill with thousands of clients. Mrs. Brown's confident vision, her point of view, her exacting taste, never wavered throughout radical fashion swings and fluctuations in the often garish moods of the booming twenties, the Depression-laden thirties, the upheavals of World War II, and the good days following. Her legacy is kept alive as a gem burning in all who were blessed to know firsthand her principles and disciplines. She carried the Wharton torch for over half a century and added flame to it.

A century ago, the Wharton-Codman book showed us how to reconsider the Victorian penchant for gloom and heaviness and turn toward earlier European standards of simplicity, clarity, and elegance, creating the height of charm in living beautifully in well-ordered, traditional houses. One hundred years later, attitudes about decorating houses have changed radically. While the fundamental aspects of decorating are timeless—beauty in form, scale, and proportion, the inherent integrity and soul of handmade furniture, the use of organic materials and brilliantly clean, fresh colors, the nobility of uplifting art, and the rejuvenescence of nature—we have become more aware of the importance of our house as a space centered in love, where we reveal our intimate selves. No longer are our houses mere vain showcases, but rather the mirror of who we are and how we live. So while respecting the taste of the past, today we're taking a more down-to-earth, less formal, less costly approach to the decoration of houses.

Edith, Elsie, and Eleanor (who never encouraged first name familiarity) were the three players in the formative stages of interior decoration, all New York–based, and all with different background, talents, and

ambitions. These women were resolute pioneers—gifted, determined, energetic, imaginative, elegant, and gracious. We owe a special debt to them for bringing us to a fresh perspective of the vital significance of our private dwellings, reminding us of the centrality of our house, and of our own sense of well-being and happiness at home.

HOME AS A REFUGE

All of us live in our own individual worlds, trying to find ways to express our unique inner spirit and longings. Our house is a refuge, a safe, serene haven from a hectic world. We're spending more time ritualizing our daily lives in all the rooms of our houses rather than reserving some spaces solely for guests. We enjoy the shaping of mood and feelings created through the elements that make up our spaces. Through the materials we use, through space, scale, proportion, and color, and through the furniture and objects we select to use as well as enjoy, we animate the things around us and bring greater depth and meaning to our everyday existence. When we succeed, our house becomes a real and seamless extension of who we are, evolving with us as we grow to a higher aesthetic dimension.

In thirty-six years of decorating houses, I've deepened my understanding and appreciation of just how much you all care about how you live at home. You want your house to reflect your personality, speaking for and about you, even when you're not there. Your house is your presentation to the world, exposing your taste, lifestyle, and passions for things that are meaningful to you.

What are some of the seismic changes that have taken place in these past one hundred years? Are you at the point where you're able to set up rooms that are practical for daily living but also suitable for family, friends, and other company without inordinate effort and expense? Is your house arranged so that it functions graciously and conveniently when you have no one helping you on a daily basis?

AN ERA OF SELF-SUFFICIENCY

*O*ver the past ten decades, people have developed an increasing degree of self-sufficiency in the home. They've discovered that rather than being a chore, using their own hands and tools brings joy. Because of this, they have become more skilled, more confident, more involved in and content with the decoration of their houses. Most of the population today live without regular employed help. They've taught themselves how to manage the daily operations of their household, and they do an excellent job. Whether they're finding an interest in interior house painting or carpentry work, they've figured out where they can apply their own talents and labor in the rooms where they live, and can share their handiwork and efforts with loved ones who enjoy spending time in their home.

Just as the Shakers were expected to find many different outlets for their hands in order to be useful, each individual, in a unique way, is carving out a unique lifestyle by making significant personal, hands-on contributions to the practical necessities as well as to the aesthetic appearance of the rooms they occupy. No longer can anyone afford to turn these essential details of living over to others without paying an emotional as well as financial price. *The Decoration of Houses*, written a century later for today, is offered as a guide to designing the interior of your house so it becomes a reflection of you in all aspects of your life. If you are already an accomplished residential interior decorator, this book, I hope, may serve as a reminder of who you are, where you came from, your cultural exposure, and what kind of aesthetic environment is most suitable for your living requirements for beauty, design, and comfort.

A LIFE'S WORK

*I*f you want to participate personally in the decoration of the space where you live, and you're willing to put your hands to work, join an exciting adventure that may change your life's direction and your outlook. Now, at century's close and at the dawning of a new millennium, one thing is known for certain: No matter what happens politically or economically, no matter how fashion trends change, if

your house isn't your haven, your sanctuary, your personal retreat, you risk never finding contentment in your daily life. Whether you live modestly in a one-room studio apartment or in a large house, you must claim the space, give it your voice, your point of view, embrace it as yours, infuse it with your love and care.

The Decoration of Houses will guide you through the decisions you'll have to make in order to transform whatever space you have into hallowed walls, where you shelter and bare your soul, where you make an unspoken, aesthetic statement to all who enter and live there. Knowing how to approach space, how to hone it to function for your needs, how to decorate it so it resonates with grace and beauty, is the essence of interior design. Learning these basic classical skills so you can be your own decorator (if you are not already) is extremely rewarding because you will feel daily satisfactions in all the spaces. If daily living can be elevated into an art, *The Decoration of Houses* may be the book to teach, guide, encourage, and empathize with you as you go forward to make your house the most important place in your life.

Throughout your life, continue to travel, to wonder, exploring different ways people live and decorate their houses. Study regularly. Your passion for the home should intensify as you mature. You spend your entire life being influenced by your home. You will grow to understand it as your emotional, physical, and spiritual center. To the hundreds of teachers, architects, artists, designers, and craftsmen we pay sincere tribute, those blessed ones in our memory who have educated us, helped us hone our skills, trained our eye to see, allowing us perhaps to pass on some wisdom, taste, style, and knowledge. Interior decorators are not gifted with magical powers, but they try to create style and beauty in whatever space they touch. Edith Wharton presciently wrote in the original *Decoration of Houses,* "The decorator is . . . not to explain illusions, but to produce them." If you are blessed with a love of houses, if spaces somehow speak to you, you are loving yourself and dignifying your own life when you work to make your house not only the place where you present your prized possessions and entertain, but also an extension of your soul. The more love and attention you shower on your house, the more colors that dance and shimmer there in the sunlight, the greater the joy of living.

For such an epiphany we must sincerely prepare ourselves to set out on the journey.

A Philosophy for Your Home

When I go into my garden with a spade, and dig a bed,
I feel such an exhilaration and health . . .

—RALPH WALDO EMERSON

THE GARDEN AS TEACHER

When thinking about the decoration of your house, bear in mind that a philosophy for your home can encompass beaches, woods, mountains, and, most of all, gardens. The integration of nature with our interior environment as well as our inner world is the keystone of philosophies for wise living throughout history. Visualize yourself as a gardener, and your rooms as your gardens. Let gardens in bloom be your metaphor for the decoration of your house. Acquire as a point of view freshness, light, energy, color, and natural beauty.

Be open to this new vision for your own home life. Intuitively you know that light shines from within you. Developing a philosophy for your home will become an adventure on your winding path. In nature there are no harsh edges. Your basic principles will guide you as you continue to create living spaces. Be receptive to the invisible world of the spirit as well as to the visible material world. If the summer solstice intensifies your vibrational field, energizing you as you are exposed to more light, then shouldn't you create a more colorful, vital, cheerful living environment to celebrate life beautifully at home? The decoration of your house is simply a preparation for doing just that. When your living spaces feel irresistible, with fresh colors, a feeling of fresh air and fresh water, you and all those who enter in will be refreshed and vitalized.

Personal involvement with your home is the most important aspect of your project. Always remember that the outer reflects the inner. All the objects you possess are symbols and speak of your truth, character, and nature. You have or will acquire the inner wisdom to communicate your unique sense of beauty and your reverence for life. (The Japanese character for intuition is "original ability.") By deepening your appreciation for everything authentic, organic, and true, a new way of seeing and feeling will emerge. You can continue to investigate and evaluate the effects of light and color on your own behavior and energy. You will increase your understanding of the larger picture, one of integrity, because you're not separate: you and I or you and your surroundings. We're connected and inseparable, one.

BECOMING AWARE

When you seek a flow where your spaces are alive with the universal elements, you will become more aware, more conscious of and resistant to potentially toxic elements, both in building materials and in the vibrations and radiations in the air of the spaces you occupy.

Because life today is largely servantless, the evolving style for living at home and its priorities must be honed to be convenient and functional as well as beautiful so you don't become exhausted. Just as a garden changes from season to season, becoming larger and more abundant, your rooms can be thought of as gardens in bloom. All the walls that enclose you are your canvases to paint. You can express in your rooms the experience of nature on a sunny spring day. To refresh your color palette, you can let Henri Matisse's joy of life in Arcadian settings get you started. One of my favorite Matisse paintings is a still life of a woman resting her head on a lilac table. Reality and perception are not identical, and Matisse's clear, saturated palette demonstrates this as he intensifies color relationships in his expressive combinations of tints, energy, and life. Matisse's innovative, strong pastels, typical of the Fauvist style that he initiated, are an exciting and appropriate medium for his imaginative perceptions of nature and the world around him. His work enhances the sense of blessing one feels being at home.

In time, as you study nature and its expression in art, you sense with

greater clarity the overall wholeness of life, acquiring an improved quality of perception. You sense things intuitively—envisioning the connections between harmonizing opposites. Your house takes on an aura, becoming an image of yourself. No matter how experienced you are, wherever you are on your path, you can improve the decoration of your house by trusting your innate knowledge about how certain things make you feel. Through your daily life, you have astonishing insights about your own passions, and by being brave and paying attention, your confidence in your intuition increases.

The Power of Color and Symbol

Just as all the objects in your house are symbols, the colors you choose are also powerfully symbolic. Physiologically you are affected by color, a biological fact built into the central nervous system. Every culture has its own symbols and everyone has been conditioned to accept certain cultural norms. Eventually you must be wary of artificial influences and undaunted by flashy trends, barker forecasts, and phony fashion, finding your *own* colors and sticking with them. One of the most enjoyable houses might possess smiling lacquered colorful rooms with a delightful twinkle. Rooms that wink back at you exude surprising joy. By arranging your symbols in an effortless flow of light and color, you can live the life you envision, and do what you wish to do at home, buoyed by the quality of energy your self-expression will create.

Space is actually malleable and should be living and healthy, never monotonous or rigid, causing you to feel pent-up, fenced-in, trapped. Bringing the garden inside can be a heavenly transformation, inducing a magical uplift in mood. The garden should be unpretentious, generously exhilarating with its dappling light, vines, flower blossoms, trees, and the smell of gardenia, lulling us into another world. The fragrance can be an extravagant gesture of tenderness and sensual delight. The glow of your inside garden arouses you to action, spurs you to honor each moment, as you watch the hummingbird drinking from a honeysuckle.

You are an interior decorator, and you have acquired your own phi-

losophy for the decoration of your house. Be increasingly a practitioner of intuitive decorating. Begin where you are. Feel your way. Concentrate on the room where you spend most of your time. Live each day in affirmation of your love of life, beauty, and home. Your taste and style will continue to evolve. Your lifestyle will go through transformations.

If you want to work at home, you need not have a sterile look as though you were in a midtown urban office. A home office can be gracefully incorporated into the beauty of your house. You can have in one room the computer, fax, and copying machine sitting on eighteenth-century antiques or on some other lovingly burnished surface. The beauty of the furniture will draw the eye away from the cold inanimate machines. By having full-spectrum light bulbs in your rooms you can work, read, or engage in conversation comfortably.

"A TOUCH OF YELLOW"

*R*emember Eleanor McMillen Brown's wisdom: "Every room needs a touch of yellow." This was the favorite color of Socrates and Confucius because yellow stimulates, inspires, and is emblematic of the sun. Every day, seek fresh ways to bring nature's vibrancy into the rooms where you live. A few pieces of polished brass and silver brighten the house; you'll feel a glow inside from participating in the intimate, sensual experience of living in a home you keep vibrant on a daily basis without tedious schedules or cold formality. A silver pitcher can be used for ice water at the table, a shining brass box can cheer up a desk, the reflections twinkling, sparkling, and rebounding all the surrounding colors. When you water the garden, the spray creates a rainbow and your heart leaps. This is the spontaneous delight you can bring into your rooms. Your philosophy for your home will bring you incomparable joy.

Fifteen Defining Principles of Interior Design

We can't take any credit for our talents.
It is how we use them that counts.
—MADELEINE L'ENGLE

No matter what your philosophy, personal style, budget, or size of your house, certain canons will help guide you. Let these fifteen defining principles of interior design light your way on your path so you will make successful decisions and be drawn to positive taste and true beauty. Whether you're considering a move, a renovation, some redecorating, or even the purchase of 310-thread-count sheets, use these fundamental signposts to help you to know what is right for you. Casually asking someone unfamiliar with the whole picture is usually a mistake. By the time you have decided to make a change, you have an idea what to do because you know what will be functional, convenient, and aesthetically pleasing in your daily life.

If you are working alone without professional help, the fifteen principles will save you from confusion, indecision, and costly mistakes. If you are making decisions with a spouse or love, work through these principles together. And if you are an architect, interior designer, master upholsterer, or faux finish artist, use them to help your clients know what is best for their unique needs and taste, not yours. Consider these principles every day, and let them assist you in remaining focused and sincere. They will become alive and meaningful to you as you pour heart, soul, and hands into the ongoing decoration of your house so it is always a loving home for you, your family, and your friends.

Simplicity, Appropriateness, Beauty

1. Simplicity: The world has become so complex, yet our lives remain ephemeral, too brief to spoil our homes with outside confusion. Simplify everything. Go straight to the core of things. If you want a bed, begin with a good mattress. Don't seek embellishments; look at shape, scale, and proportion. When you keep your life and the decoration of your house simple, you reduce stress and have more leisure time to enjoy your home and family.

2. Appropriateness: We know our own circumstances better than anyone else. We understand what it takes to give us inner peace and contentment. Whenever we overreach, pretend, overspend, or lose touch with reality, we make inappropriate decisions and get off our path. If you have two toddlers, it might be most appropriate for a few years to use the dining room as a garden playroom, having a picket fence as wainscoting and a floor painted in green-and-white diagonal squares (instead of stained dark-brown) to create a playful atmosphere. You can set up some card tables with colorful, cheerful cloths for Thanksgiving dinner and everyone will feel relaxed and happy. The red burlap curtains purchased for a first apartment are economically appropriate at the time. Only you know how you will feel, so be sure everything is suited to your particular circumstances and conditions, and your decisions will fit your life. With limited resources, make appropriate choices that enrich your personal style.

3. Beauty: Just as you look for inner beauty in people, seek beauty in all things, even in the smallest details of the decoration of your house. There is no excuse for ugliness in manmade objects, and accepting them into your home will create an unhealthy atmosphere. Beauty is

your anchor, an angel guiding you in every decision you make. Choose quiet beauty. Don't make half your house beautiful and the other half less so, particularly where there are children who are influenced by daily exposure to this environment. A kitchen table can be inexpensive and still beautiful. Beauty connects us to the divine, pointing us to pure light.

Symmetry, Balance, Harmony

4. Symmetry: Biologically, we are programmed to feel comfortable with configurations whose opposite sides are in exact correspondence. Appreciate the Greek concept of *summetros,* meaning "of like measure," in the decoration of your house. We appreciate "everything in pairs." The pair may be broken up—one chair here and another one there— but the eye is still pleased by the repetition.

The more symmetrical the room, the more freedom you have to arrange your possessions in the most comfortable way, rearranging things as your needs evolve or the spirit moves you. Rather than building a closet in a corner of a room, for example, build a pair of narrower ones on each side of the wall so the storage unit doesn't spoil the living space by creating a disturbing lack of symmetry. If there is a center window, construct a window seat with its front edge aligned to the front edge of the closets.

5. Balance: Balance leads to both physical and emotional stability. With balance, you achieve both poise and equipoise. Do your best as you go along; seek excellence but don't fall victim to perfectionist traits; in turmoil, take the middle path; and hurry never. Balance allows an effortless flow of energy, as a pendulum swings freely back and forth under the influence of gravity. Balance may be your ultimate freedom. In the decoration of your house, a balanced arrangement of scale and proportion, mass and void, color contrasts and design sensibility adds long-lasting pleasure to the enjoyment of your space.

6. Harmony: When you repeat shapes in a room, harmony results. Harmonious proportions create a pleasing combination of elements that establishes a unified whole. While harmony in music is developed by a progression of chords that sound beautiful together, a harmonious household has melodious, happy sounds of laughter and joy that promote a feeling of ease, grace, love, and hospitality. Harmony delights the mind, heart, and soul and provides enjoyment and satisfaction, gladdening the spirit. Harmony tickles us lightly, making the skin tingle; when everything is just how it should be, grace enters in.

You can feel the harmony in objects and how artfully they are placed, and if one thing is "off," you know it. An antique shop displays a small cedar French provincial table in the window that causes you to press your nose against the glass during a nighttime stroll. The gutsy bold scallop-carved apron is obviously carved by a craftsman who loved life. The charm captivates you, but when you see this table the next day and take it out into the street to view it in full sunlight, you feel a tinge of disappointment. The cedar wood, though beautifully grained, is too red for your taste and will not fit harmoniously with your softer, warmer, more mellow fruitwoods. Harmony is the subtle undergirding of all beauty and grace.

To live with harmony in your possessions, repetition in shape, proportion, colors, and wood tones helps a great deal. The test that never fails is this: If you love everything about a single object, it will be compatible with your other revered possessions of artistic merit. Trust your eye. The lump in your throat can be your intuition.

Time, Energy, Money

7. Time: You always have time for the things you find important in life if you know how to say no to things that upset your focus. When something deserves priority, it takes precedence. Valuing the order of significance will greatly affect the course of events. How you choose to spend your time says a lot about you. If you sleep and work two thirds of your life, what you do with the remaining third is who you are.

People often complain they don't have time, but in reality time is all we have. Time is indeed relative. When you are painting a room, hours go by without notice because you give yourself the uninterrupted space to do the work. If you try to squeeze too much into too little time, you become anxious and stressed and risk losing your health. By putting a high value on your time, you will find each moment of the day intensified as you pursue your passions and accomplish your goals.

8. Energy: Your capacity for work and vigorous activity, your ability to be active, makes all the difference in your life. Whenever you feel a lack of strength and vigor, you obtain a greater appreciation for your usual vim and energy. What can you do to increase your vitality? Whenever you are free to do what you wish to do, to act according to your beliefs and follow the desires of your heart, you gain energy.

When you create, you express yourself and your energy increases. Those who are blessed with reasonably good health are capable of maintaining and increasing their creative, productive capacities. But even the most energetic have limits and can push themselves only so hard before their bodies complain. Your vitality allows you to act positively and do the things that fulfill and sustain you. The more positive energy you exert, so long as you remain Zen and don't stress and strain, the more abundant your energy will become. When you use your energy to improve the quality of your daily life at home, there will be a constant flow and radiation of your spirit.

9. Money: Time is not money. Money is a commodity, whereas time is priceless. Lost money may be retrieved, but lost time is gone forever. Money can surely be useful when it frees up your time, allowing you to pursue your passions and interests, but someone with monetary wealth can be spiritually impoverished, deprived of natural richness and strength.

Money does not buy happiness or guarantee that when the house is decorated, real living and loving will follow. People who have too many houses and too many possessions may be unable to devote the time and energy it takes to create a warm, loving atmosphere. Do not get caught up in shallow materialism. A plush carpet may be noticeably expensive, but is it attractive? Is it *you*? A super-absorbent terry-cloth towel might be thinner and more modest looking than a thick, lush one that is actually less absorbent. Remember, more is not necessarily better.

If you can afford fine possessions, it is always worthwhile to invest in quality. All the cheap tacky things you may buy to save money inevitably end up in a garbage dump after circulating around garage sales for years. Buy the best you can afford, and feel blessed that your treasures will be passed on to future generations of family, friends, and grateful buyers as profound symbols of the joyful continuity of life.

Within a period of fifty years, there are more than 300,000 hours to appreciate, experience, and become enlightened by the objects you love. And through time, more people will come upon these treasured objects and feel refreshed and illuminated as you have been.

There is a synergy among time, energy, and money that is pertinent in the decoration of houses. The more time, energy, and love you put into your house, whether you paint your bedroom yourself or install new cabinets, the less the strain on your budget. And the rewards you receive from doing a job yourself are immeasurable.

Luxury, Elegance, Refinement

10. Luxury: Luxuries are not mere inessential extravagances; they often provide stunning pleasure and comfort and, in a sense, become necessary in sumptuous living. American Impressionist Mary Cassatt was provided, in the late nineteenth century, with a horse and carriage by her wealthy brother Alexander, a luxury that gave her poignant uplift during her life in Paris. Luxuries can, even if only momentarily, make your surroundings more generous and meaningful. The frills, the icing

on the cake, the flowers that capture your attention, the roaring fire, the pure heavenly feeling of life's blessings are immediate and can be continuously uplifting. Consider the example of an elderly lady on a limited budget who used walking as her exercise to save bus fares so she could afford to go to the ballet. Luxury means keenly appreciating some of life's finest things despite some sacrifice, whether it be one piece of chocolate a day, having tea served in pretty china, or enjoying fresh flowers in the house.

There is a saying "Never economize on luxury." Let this be your reminder to have little luxuries every day, because without them life may become routine and banal. When you allow some luxuries in your life, the necessities seem to take care of themselves. Even one luxury at a time, it's good to know, can suffice.

11. Elegance: There's no need to give up elegance, grace, and polish. The dignity of your style and the tasteful way you present yourself can inspire you as well as others. The simplest meal can be elegant when served attractively with care and aesthetic sensitivity. Whenever something is tasteful in manner, form, and style, delicate and lovingly selected, it takes on an air that pleases the senses in subtle ways. A household that believes in elegance as a center point gives joy to all, elevating daily life to an adventure filled with dignity and exquisite perception of life's wonders.

12. Refinement: Throughout our lives we can refine our skills and character. We are all capable of improvement, and even the most subtle distinctions make a telling difference. You will grow in fineness as an expression of your developing taste and aesthetic appreciation. The process is mysteriously cumulative: The more you see, sense, and explore, the more refined your creative expression becomes. Because of its gentle nature, refinement often goes unnoticed among those in a hurry; but when elegance and refinement are combined, a dinner napkin can be a significant symbol that speaks of the quality of the evening.

If someone is said to have refined taste, that is high praise, and the converse of "rough around the edges." When you are refined, you are whole, and everything builds toward a purer state. Real refinement is not snobbish; it is refreshing. This subtle quality has long been a tradition in Japanese art; they call it *shibui*.

Interest, Knowledge, Experience

13. Interest: Whenever you are interested in something, you awaken mentally, often becoming passionate. You are always at an advantage when you become involved, aroused, and concerned. A lifelong love of gardening, art, architecture, and design assure there won't be dull moments. The more interested you are in a subject, chances are the more you will learn and the more fun you'll have. How can you find your passion? All you have to consider is what feels right, to be that true person you are. Your interest in your house will bring it to life and keep its energy at enthusiastic levels. All the things you're truly interested in, your collections, music, art, and books, will give joy to everyone who comes into your home. Everyone wants to know, to a surprising degree, what your interests are because they sense the energy engendered by your passion.

14. Knowledge: Knowledge is power. Once you learn about a subject, you can be discerning and decisive. Awareness, familiarity, and understanding inform you; with this practical knowledge you gain skills. Far better to know how to do something and then have the freedom to decide whether you're going to do it yourself or hire someone else to do it for you. You'll have far more control when you are knowledgeable about the process, what goes into accomplishing something, than when you merely act out of ignorance.

You'll be less likely to demand that the custom-color Thai silk fabric for your living room curtains be delivered *now* when you understand that the fabric is handwoven in Bangkok. A mother's bare feet move the shuttles as she weaves, her children playing with the yarn under the loom. All fifty yards you've ordered must be handwoven, fractions of an inch at a time; hours are required to create even just a few inches. You know that many thousands of silkworms are being sacrificed for your curtains, and that when the material finally does arrive it will look spectacular. When you understand how a textile is woven, you understand why it is expensive as well as why it takes so long to produce.

Acquiring information through listening and observing is invaluable in the decoration of your house. When you've been on the job site wearing a hard hat at eight o'clock in the morning, watching walls

being demolished and cement floors being jackhammered in preparation for marble installation, when you have hung around masons, carpenters, plasterers, tile setters, painters, plumbers, and electricians, you get a feel for the workmanship involved and you grow in respect for the craft or trade. If you spend time, one on one, with skilled craftsmen, caring tradesmen as well as artists, you further gain in knowledge and appreciation. Whether you observe a mason placing a several-hundred-pound stone, whistling *and* smiling as he lifts the enormous granite slab that is to become a bench, or listen to a cabinetmaker who builds traditional American and English-style furniture talk about his cherry and ash dovetail joints, the impromptu lesson is a privilege.

It is a true gift to know how something is made. Watch master craftspeople skillfully execute their chosen work, learned from past generations and continuously improved upon with a sense of humility. There are people here on earth who have extraordinary powers, and through your knowledge of their skills, you get to know many of them and become a richer person.

I recommend carrying a tote bag everywhere you go. Books, notebooks, measuring tape, swatches, and paint samples need to be handy once you are committed to increasing your knowledge and skills in the decoration of your house. You'll be astonished at how enthusiastic you can become when making a new discovery, no matter how modest. The more you know, the more your understanding adds pleasure to each day.

15. Experience: You apprehend an object, thought, or emotion through your senses and mind. Through actively participating, practicing, and sticking with something, you gain skill. Whenever you begin something new, with no prior experience, you are bound to be self-conscious and lack confidence. Your work may at first be undistinguished and devoid of any personal style. You feel awkward, even frustrated, because you care but don't know how to achieve professional results. But after you do certain things over and over, whether it's chopping wood, arranging flowers, having friends for dinner, or organizing objects on a table, you begin to experience the glorious, effortless glow and flow, and you're able to do things joyfully and with ease. Inexperience is transformed into talent, even gifts.

Experience reduces anxiousness and limits mistakes. You may remember how nervous you were when your husband's parents were

coming to your home for dinner for the first time. So nervous, you mixed the egg yolks rather than the whites with the sugar for the lemon mousse three times. By the time they arrived you were a complete wreck and forgot to put the roast beef in the oven.

Eventually you calm down and allow yourself time to learn, study, and have hands-on experience. If you've been arranging flowers since the age of four or five, winning a mother–daughter Garden Club award at age six, influenced perhaps by your mother or grandmother, chances are you'll arrange two thousand bouquets over the years. When flower arranging becomes second nature to you, you may want to create your own bouquets for family weddings, funerals, and other events. As soon as you have a cut flower in your hand, you have an intuitive sense of what container to use and how the flowers should look. Achieving this flow and instinct, where you and the task are one, takes time and practice. It cannot be forced or faked. If there is a substitute for experience, I don't know it.

When you focus on your love of beauty, dedication to elegance, and positive taste, you can channel your energy to improving the quality of the decoration of your house. Experience leads to skill and knowledge. When it is combined with interest, your appreciation for life builds dramatically and benefits you at home as well as everyone who can learn from you. Others can become inspired and illuminated by your passion and their exposure to your work and teaching.

Everyone carries a torch, a flame that illuminates their path. Let your experiences add up to positive taste and, if you're fortunate, your light will spread and touch the lives of many. Through your commitment to these fifteen defining principles of interior design you have the potential power to bring hope and comfort and perhaps even grace to generations that follow. Everyone learns by example. Let your teaching be the accumulation of your hands-on experience; let your artistic work speak for you on its own. The decoration of your house is a true monument to your life.

Simplicity
Appropriateness
Beauty
▲

Symmetry
Balance
Harmony
▲

Time
Energy
Money
▲

Luxury
Elegance
Refinement
▲

Interest
Knowledge
Experience
▲

These fifteen defining principles can have powerful meaning when you attach them to your home, where you make intimate, authentic connections between the seen and unseen, the mind and heart, and where you live with more clarity and appreciation.

The Decoration of Houses is a guide on this path so you can approach your house with information and optimism. When you care about the details that affect the texture and fabric of your everyday life, you will be cultivating your own garden. As Matisse taught us through his example of using clear, clean vivid colors, you find what is meaningful to you, what elevates your spirit is the potential blessing of your home. Your home holds a life's work, a life's living, and a life's loving. When you appreciate your unique house and the blessings it holds, in all its moment-to-moment detail, you can know, firsthand, that you are living. You don't need to explain or have anyone clarify the meaning you derive from your home. You are on your path to transforming matter into a soulful, safe haven.

Salute yourself and celebrate yourself as you continue on your way

in the decoration of your house. Remember, there will be many rooms in your life. In these personalized spaces, you will have extraordinary moments of bliss. You will find meaning and pleasure in the process of sanding a wall as well as celebrating with a drink in front of a warm fire. The music you hear out of doors and the sound of music from within can be spirited and loving. And, when you find you are grieving over the illness or loss of a loved one, the decoration of your house will send you loving karma so you feel supported, sustained, and loved. Through every chapter of your life, home will be the very center of your existence. If you are fortunate, younger ones will become attached to the environment you've worked so lovingly to create. They will come and enjoy time in this spirited place, and there will be lively continuity. Ultimately, wherever you live, wherever you go, you will not live in an apartment, a house, or a cottage, but you will live in a *home*, because this sacred space is all you'll ever need to feel blessed in life.

Who Are You?

Never worry. Use all your energy
and thoughts to solve real problems.
There are enough of those in
decorating.

—ELEANOR MCMILLEN BROWN

What's Your Style?

Trend is not destiny.
—RENÉ DUBOS

THE JOURNEY TO FIND YOUR PERSONAL TASTE

*Y*ou'll have to be patient as you go through the process of estab-
lishing your personal style. Americans want results fast, and pre-
liminary efforts are often frustrating. But if you are sincere about the
decoration of houses, for your own contentment or for the pleasure of
family, friends, and clients, you must realize that there are necessary pre-
liminary steps leading to satisfying results.

If you try to jump-start aesthetic enlightenment without respecting
the process of acquiring knowledge and taste, you will end up with tin-
sel and disappointment. You may determine how rooms will look, but
what is essential for you to know is what you love, so the spaces where
you live will *feel* right. Consequently, you must take certain steps to
reach your desired goal. You can't appreciate the section on color and
paint, for example, before progressing through preceding chapters. Each
part becomes an important piece of the unity of the whole. In my opin-
ion, developed over more than thirty-six years, each chapter, each step
is necessary to achieve a synergistic sum of the parts and to create
greater integrity. Any rushing into decisions now will be premature and
cost you time, energy, and money.

My goal is for you to get on your *own* style path. It's an exciting jour-
ney, and you will know more about yourself and how you feel in space

than ever before. You may have to give items away if you find they are not *you*. People have confessed to me that they were so out of touch with their own style that ultimately they began decorating their houses from scratch in order to make it theirs. Don't be afraid if you feel this is your situation.

I assure you that your time and effort will be well spent because you will decorate your house so it meets your individual requirements, and you will become more aware of space, scale, proportions, and architectural elements—as well as elevate your taste. Eleanor McMillen Brown said, "Taste is relative and is the sum total of the intellectual and emotional experiences of the individual. Taste, in order to be positive and vital, must be exercised and developed. Taste is changeable and is influenced by environment. A highly cultivated taste, a taste that is knowledgeable and eclectic, is likely to be exciting and provocative, a personal taste at its highest level."

Your house will be eclectic as a result of your life experiences. You will select elements from a variety of sources and styles, adding meaning and feeling to the texture of your home life. The nuances that make slight degrees of difference add up to make a powerfully significant difference to the mood and spirit of your rooms.

COURAGE TO EXPERIMENT

In the 1870s, Englishman Charles Locke Eastlake's little book *Hints on Household Taste* made a big impression in the United States, reforming household taste on a grand scale. Russell Lynes, one of America's foremost arbiters of taste in the decorative arts and author of *The Tastemakers,* published in 1954, wrote in response to Eastlake's book, "Out with the curliaries, out with the fringe, out with the fancy veneers and machine-carved furbelows and fruit-carved mantels! Down with the Damask draperies, the glittering chandeliers, the parqueted ceilings! But above all, down with the pretense! Down with the aesthetic quackery! And up, of course, with honesty! Up with sincerity!"

Edith Wharton said that if reform in house decoration was not absolutely necessary, it was at least desirable and can originate only with those willing to experiment with change. Anything you try that is new

will be original, and an expression of your style and fresh taste. Only through experimentation with the different elements, form, and scale of a room can you put your own interpretation on classic styles and make them yours.

LEARNING ABOUT YOURSELF

*Y*ou are now my client. I am going to ask you the same questions I ask my clients when they hire me to help them decorate their houses. We are in partnership, working together to create a living, evolving series of rooms that provide you with all your practical necessities as well as express your personal style for living. As we go on this journey together, a few words of warning. This is a soul-searching, soul-baring adventure. There will be awakenings as well as heartbreaks. As you open up to the interior design of the real inner you, your rooms will become more alive, more vital, more *you*. Nothing is more personally expressive than revealing your passions and secret loves.

In order for you to get the most out of this book, before you read any further, I suggest you buy a notebook to jot down ideas and thoughts that pop into your consciousness as you read. I use eight-by-ten-inch spiral books with four sections of grid-lined paper, each a different pastel tint—blue, green, yellow, and pink. You may prefer a looseleaf binder with white lined or unlined paper. Think this through because your notebook will be one of your first style clues. Does it matter what kind of book you write in? Do you like the French grid pattern or plain or lined sheets of paper?

Before you attack any area of your house or apartment, first sit back, put your feet up, open your notebook, and read on. Answer each question with a declarative statement in your notebook. In due course, you will see how the statements will be part of a mosaic created from the kaleidoscope of that volume. Your notebook and the decoration of your house will be experimental, and filled with your exclusive energy and personal aesthetic.

Do you consider yourself to be generally organized? Are you a systems person? What kind of pen or pencil are you using to record your thoughts, roller ball, felt tip, or a fountain pen? Perhaps you prefer a glass

full of sharpened colored pencils. Who knows when the spirit will move you to do a sketch? I prefer that you take notes by hand rather than on a computer. Computer-aided design (CAD) may be a miracle in speed, but we should always remember the pleasure in the process of finding, developing, and honing our personal style. The hand-held tools, the pencil, the pen, the pair of scissors, the pot of glue, the paint brush, the hammer, the nails, the screw driver and screws are all important elements in the creative process that make up the decoration of our house.

Think of me as a house doctor who has made thousands of house calls and has been in sick rooms in urgent need of a cure. As I ask you questions about yourself, remember that no one will ever know the answers but you. Our relationship is entirely confidential; I'm here anonymously as a guide, but also as a sounding board, a seasoned listener, receptive to all your thoughts and ideas. I know how much you care. We all do, it's just that some of us are less inhibited than others when it comes to expressing ourselves and being pleased with the results. Only when you reveal your innermost longings and fantasies is it possible to take an ordinary room and charge it with your spirit. But first you must really want to express your original, unique, fresh point of view. Style cannot be faked.

Some of my questions may seem farfetched or irrelevant to the decoration of houses, but I urge you to take each one to heart. They will help you to open yourself to new, fresh views and insights, giving you confidence in your style. To document any style transitions you may have, write the date in your notebook of impressions and musings. Everything is connected: You may discover that your passion for chartreuse began with your love for eating ripe avocados. Colors can become more than a hue; they can smell, taste, and carry strong emotions that are rooted in pleasant memories. I want you to think in self-expressive, creative ways.

STAY POSITIVE

As you dream, wonder, and explore, focus on what you like, not on what you dislike. I had a wealthy client more than thirty years ago who could only tell me everything she hated. When I

inquired what she liked, she invariably answered, "I don't know." I told her, "Unless you know what you like ahead of time, it will be too late when you see something executed in your home. Tell me what you love and I'll know you more authentically than if you list your dislikes."

How would you describe your favorite, ideal, decorative style? Do you consider yourself a formal person or do you lean on the more casual side? Do you enjoy both extremes, depending on the situation? Tell me about your wardrobe. What kind of clothes do you like to wear? Do you have different wardrobes for work and when you're free? Are you athletic? What are some of the sports you like to engage in? What are the clothes you wear when participating in these activities? Do you shop for yourself, or does someone else buy your clothes? Do you enjoy shopping? Describe what sorts of things you like to select personally and what you'd prefer not to have to bother with. Be very descriptive.

When you travel, where do you like to go? Do you like to return to the same places or do you prefer exploring new territories? Do you travel alone or with others? What kinds of things do you enjoy doing when you're on vacation? Do you enjoy cities more than rural areas? What do you do when you're in a city? Do you go to museums? The theater? Are you willing to experiment with different types of cuisine?

How much have you traveled in the past? Where have you been? What are some of the most vivid memories you have of places you've enjoyed? Using a stream of consciousness, list a dozen or more different scenes that made a big impression on you. Tell why. Was it the landscape? The people? The company you were with? In what ways have these experiences changed you?

What are some of the earliest things you can remember of your childhood? Where were you born? Can you remember your bedroom as a young child? What were the colors? How many places have you lived since you were born? How many different houses? Can you remember how each one looked as well as how it felt? What are some of your favorite houses where you lived or visited? Why are you attracted to certain ones? What are the attributes that make them appealing? Describe the spaces.

What are your interests outside of your work? What do you do in your free time? How much time do you spend alone? Are you interested in gardening? Do you have a garden? What are your favorite trees? Do you grow your own vegetables? What do you grow? Do you enjoy

cooking? What are some of your specialties? How often do you cook? Is it relaxing for you when you give yourself enough time?

What is your favorite season of the year? Why? What are some of the activities you do this choice time of the year? Do you enjoy repeating rituals based on the time of the year? Are you sentimental about birthdays or anniversaries?

How aware are you of your senses? Do you consider yourself contemplative? Do you spend time meditating? Do you feel you are anxious or relaxed by nature? Do you have to work at slowing down or unwinding?

What do you consider your gifts and talents? Can you sing? Do you play a musical instrument? Do you enjoy dancing? Do you feel agile? How often do you dance? Do you paint or draw for pleasure? What kinds of artistic things do you like to do? How much time do you spend reading? Do you write poetry or prose? Do you weave textiles or hook rugs? What are some of the things you enjoy doing with your hands? Do you consider yourself a patient person?

Who are some of your favorite artists? What is your favorite period in history? Do you identify with an earlier time and a different place? If so, why?

Do you enjoy going to concerts? What about the opera? Do you enjoy the theater? What about the ballet? Who are some of your favorite performers?

What are some of the achievements you're most proud of, since you were little? Have you saved your trophies, your ribbons from swim meets? How sentimental are you? Are you a romantic? Do you consider yourself a sensualist?

Have you ever studied the decorative arts? When you go to museums, do you spend time examining room interiors, period furniture styles, and old textiles and rugs, as well as china, crystal, glass, pottery, and objects d'art? Do you ever go to auctions, antique shows, country fairs, or craft shows? What objects are you most drawn to? Has it always been this way, or has your taste changed as you've been exposed to more refinement and quality? The great English scholar Dr. Samuel Johnson reminds us, "Knowledge is of two kinds: we know a subject ourselves, or we know where we can find information upon it."

ASSESSING YOUR CURRENT SITUATION

*T*hink about your current house or apartment. Does your space reflect *your* interests? Do you like the colors? What is the style of furniture? Describe the objects you have in your home. How good is your visual recall? Shut your eyes and pretend you're in the middle of your living room, and, in a calm state of awareness, try to describe all the things you have in this space, including furniture, lamps, objects, and art. This is an excellent exercise to see how visual you are, and how attuned you are to your surroundings. If you're able to recall more than eighty percent of your possessions, then you are extremely aware.

All rooms and the objects in them give off energy. What is the karma, the life force of the rooms you like to spend time in? The Chinese word for energy is ch'i, and I believe ch'i is the essence, the most important feature of a space. The more energy you put into a room, the more vitality the space generates. It is the energy that gives a house its voice.

What are some of your favorite objects in your house? What do you like about the furniture you have? Do you tend to like a lot of objects in a room, or do you prefer more open space?

What are some of your favorite textiles? Do you like patterns more than solids, or do you enjoy a variety? What kinds of materials do you like? Describe how you like a fabric to feel in your hand. Do you see any correlation between the materials you wear and the ones you have in your house? Would you describe your tastes as being on the opulent side of the spectrum or more down-to-earth? How does this play out in the fabrics you have for your sofas, chairs, and curtains?

Do you prefer rooms with lots of curves, or do you like straight lines? Some people enjoy rounded edges on furniture while others would rather have sharp, crisp, right angles. What do you prefer?

What kinds of fabrics predominate in your house? What are the general color schemes? Do you see a thread of continuity from room to room or is each space a separate entity with a discrete personality, mood, and color scheme?

How attached are you to your house or apartment? How long have you lived there? Do you feel there are some problem areas that need practical solutions? Are there some awkward spaces that need to be resolved? Does your house function reasonably well for your needs?

How much time are you willing to spend working on your place? Do you enjoy doing home improvements? What are some of the things you like to do? Are you quite accomplished in certain areas? Don't be modest. Have you ever made a piece of furniture? Only when you do a job yourself, whether you paint a room, refinish a table, or build bookcases, do you truly appreciate all the work that goes into the process.

Do you feel comfortable with the scale of where you live or do you feel cramped? What rooms do you sit in every day? Do you spend time in your living room or is it off limits unless you have company? Do you enjoy the way it is decorated? Is it comfortable for your needs? Does it have bookcases? A fireplace? How often do you light a fire?

What kind of music do you listen to when you're relaxing, reading? Do you have a favorite chair or spot you look forward to returning to when you're not at home? Is the upholstered furniture in your room comfortable? Is there a large, cushioned ottoman for you to put your feet up on? If you were to make some changes in the way this room feels, would you make it more or less formal? What kinds of spaces make you feel most comforted and relaxed? How much clutter do you feel comfortable with in your spaces? Do you like to save things, or do you regularly give things away or throw them out? How neat are you? Does a messy space make you feel ill at ease?

How flexible are you about your surroundings? Do you enjoy having your rooms serve multiple purposes so that furniture can be rearranged to accommodate different situations?

How much light do you like in your rooms? Does the weather alter your mood? Do you feel you have enough artificial lighting? How many windows do you open in your house? Do you use screens? How often do you use air conditioning? Do you have any paddle fans in the ceiling?

Do you have an attractive bathroom? Do you take baths or showers or both? Do you have a Jacuzzi? How much time do you spend in your bathroom?

Do you have a large enough closet to house your clothes? Is it arranged conveniently for your lifestyle? Where do you store your suitcases, linens, and other belongings?

Do you exercise regularly? Where? Is the space aesthetically appealing or set up to resemble a gym? What equipment do you use? Do you listen to music or watch television when you work out?

Are there live plants and trees in your house? Who waters them? How regularly do you have flowering plants or cut flowers in your home? Do you have a budget for indoor flowers?

Without saying anything negative about the decoration of your house or feelings it provokes, jot down a few areas you feel need improving. Don't worry about the money or logistics at this point. Concentrate only on how you feel about your surroundings.

Use your answers to these questions to declare authoritatively what speaks to you, so you can see a style profile of who you are, and where you are on your path toward the decoration of your house as a true expression of your total personality. You will see what areas you want to work on so your surroundings resonate with your taste and aesthetic vocabulary.

Creating Your Personal Style Everyone has a particular style, even if there is no name for it. A few years ago a journalist inquired about my style. After hesitating a moment, I answered, "Sunny, happy, a garden theme and mood." I didn't decide to become an interior designer because I grew up with a great fondness for furniture. I found far greater joy lying on my back in the hayloft of our barn, or bent down, on my knees, gardening, or doing somersaults down a hill, or climbing a tree than I ever did sitting up rigidly in my chair at the dining room table, being reprimanded for leaning back, or sitting on my bed, putting a dent in the otherwise perfectly smoothed out bedspread. Once when I chose to lie on the floor on my tummy in front of the fire, blissfully comfortable, I was told to get up off the floor.

I was drawn to interior design because I felt sorry for people living in dreary, airless rooms. If our spaces are an outer reflection of our inner spirit, what could be more important than to concentrate vital energy toward infusing our spaces with our own style and sensibility? Thomas Jefferson, the great philosopher and architect, wasn't happy with Monticello after it was built because he didn't feel it reflected his soul; he had it torn down and rebuilt. The clothes you wear, the books you read, the company you keep, your manners and habits, where you travel, your thoughts, disposition, and temperament all work together to create your personal style.

Describe your style as the voice you want vibrating in your spaces. Avoid labels. While they are quick and easy, a shorthand code, don't let

your style be characterized by a conventional stereotype because it will be an oversimplified conception. Personal style, as with personality, is always complex, subtle, and original. If you say you are a minimalist or a traditionalist, or that your style is contemporary or modern, you may be seeking to define your style through such a label, but this will never suffice. Rather than limit your aesthetic development, remain open to influences from around the world. You may never travel to Provence, but your experience with French flavor may lead to an affinity for the French provincial style.

Style setters are all original spirits. Your personality is different from anyone else's, and this uniqueness is what will mark your environment with charm and distinction. Your sense of humor, your interests and passions, are the ingredients that will bring all the elements of your home into a cohesive, coordinated, interesting whole. The key to learning more about how to translate your inner feelings into the tangible things you want around you is to be yourself. Admit you know a certain amount about many things, and that in some areas you may need to learn more. You may know a lot about porcelain, but very little about fabrics. You may have a passion for oriental rugs but not know the difference between a chair rail and cornice molding.

When I came to New York City in 1959 to study interior design, I was a teenager, eager to learn. I went to an auction at Parke-Bernet (now Sotheby's) one Saturday afternoon, and I found it an excellent place to increase my knowledge about antiques. The catalog gave a detailed description of the different period styles, so I could look at each antique and study the written information at the same time. I became more and more familiar with the vocabulary and, in time, I absorbed enough to get excited about old furniture and objects.

I tell all my clients to let their heart lead the way to further learning. In those early days of my discovering what kinds of furniture styles I was innately drawn to, I began to realize there were similar elements that overlapped from one piece to another. Within a few months I had auction fever, and I'd saved up enough money to bid on a small oil painting of a boat with a yellow sail. The fresh green water reminded me of a Claude Monet I'd seen as a child. I'd never heard of Theodore Robertson, an English Impressionist, but nervous and trembling I raised my hand and became the proud owner of the painting for thirty-five dollars. Just as I remember my first awakening to color in Mother's

beautiful garden, I will never forget this day. I carried this small and precious treasure out of the gallery onto Madison Avenue and Seventy-sixth Street, with the feeling that I was now an art collector. I found, over time, that the more I exposed myself to art in all its mediums, the more I discovered objects I admired and desired. Auctions are a great place to learn about what you like and, in the process, increase your knowledge about the decorative arts.

RESPECT YOUR ORIGINAL SELF

*B*ecoming personally involved with all the elements that make up the whole of your rooms pays big dividends in happiness. When you see something in a magazine that appeals to you, cut it out. Start to collect pictures of details you like, color combinations, chairs, light fixtures, table settings. Originality comes from seeing things you're attracted to and, by using your imagination, putting your own twist to them, making everything your own. Nothing is as meaningful as the things you re-create in your own fashion so they become yours, even though the object itself has been around a long time. By putting your mark on the way you arrange flowers or set a table or place objects on a table, you are giving off your energy, adding karma, positive ch'i, and flair. Be who you are. Never pretend you relate to something you don't, no matter what pressures exist to do so. This simple advice will bring you powerful results, as well as greatly increase your enjoyment in the process.

Try not to copy someone else's style. I have a client whose daughter tried to duplicate her mother's taste in her own home, but in the end it felt wrong because it was too fancy and luxurious for a young, newly married woman. Don't make the mistake of believing that someone else's style is superior to your own. Fifty percent of the people you know are not emotionally attached to their house because it isn't an expression of who they are. Absorb all the ideas and information you can from your observations, but choose and use things in new ways that speak to you and for you. Always think how you can put a signature twist on something. Take an ordinary object and make it yours by changing it around to best suit you. A water pitcher can become a

flower container, an old-fashioned wicker baby carriage can become a planter, or, if you miss your garden in the winter, bring the idea of a trellis inside through faux finishing or by applying one-inch-wide lattice strips to your walls and transform an ordinary space into a garden.

You can pay attention to fashion trends, what's new and available, but be careful not to allow what others say is "in style" to influence your taste in nonauthentic ways. Every few months, in clothes as well as home furnishings, there are new lines, new colors, new looks, all created and marketed to convince you to abandon the old and buy the new. In reality, you should be acquiring possessions you love and want to grow old with, that are enjoyed by family and friends, that will become immortal as they are passed on to future generations.

When I was young and had no money, I was extremely insecure about my taste and vulnerable to wanting the approval of others. My mistake was to pretend, to be formal and old-fashioned. Every year I seemed to grow younger in style, shedding rigid decorations in favor of young, fresh rooms. I feel even younger now, so perhaps my style is coming into full flower.

Style evolves gradually. No one is born with great style, but some people have the determination, energy, and enthusiasm to hone and refine their personal taste continuously throughout the course of their lifetime. We have all fallen off our "style path" at one or more times in our lives. Elsie de Wolfe loved leopard print in any incarnation, and many people shared her passion, but I am horrified when I recall that I had leopard design carpeting laid down in our apartment on Sixty-fifth Street off Madison Avenue. I used to watch my daughter crawl around on tones of brown, beige, and gold when she could have been enjoying garden shades of fresh greens, yellows, pinks, lavenders, and blues. The pale mint-glazed walls of the living room and the bedroom's seafoam-green chintz strewn with white daisies were a luminous burst after we'd been in a hall that was a dark tunnel, not a light-drenched garden on an August afternoon.

We burst at the seams after the birth of my younger daughter and moved two blocks south and one block west to a spacious, open apartment, filled with natural light pouring in from ample, generous windows. The leopard carpeting—a momentary aberration in the evolution of my own taste and style—was left behind, and we painted our entire apartment brilliant white, including our kitchen, pantry, and breakfast

room, where we rough-plastered the walls and then whitewashed them, ideas encouraged by trips to Provence and the Greek island of Mykonos.

My experience with the leopard print illustrates the importance of self-knowledge. I never liked it, but I felt my room should have a "look." Never let yourself be persuaded into a certain look, thinking you'll grow to like it. Follow your eye and heart and don't get talked into anything. Everyone is insecure to a degree about their personal tastes, but you need to get beyond this insecurity so that your rooms will be authentically you. With this integrity, you can experiment as your tastes and style evolve.

THE EVOLUTION OF YOUR PERSONAL STYLE

*D*on't be afraid of anything. Trust and respect your eye. In the decoration of your house, nothing is permanent. Old ways that were once satisfactory don't always represent you well in your present life. Your style will evolve naturally. Just as an artist sketches self-portraits to find new ways of expression, you will continuously seek ways to express the many different facets of your personality in your home. Think of your rooms as canvases to "paint" to express your point of view in a variety of ways.

There is no decorating style that is just the right fit for you. Years ago, Bloomingdale's had model rooms where people would look at each one as though it were a package they could take home. "I'll take the blue bedroom." Style, when it is real, requires many varied elements that give it a special chic, nuance, and charm. The job of an interior decorator, designer, or architect is to help you draw out your own style, not make you feel as if you have hired someone to give it to you. You select a professional based on an affinity you feel for their work and a trust that they will understand your interests and desires. Only when you've arrived at a stage in your life when you understand how much of yourself you have to put into anything that has integrity will you take the necessary steps to learn about your own evolving style. You will become your own interior decorator.

Style is a painting of who you are, set in the framework of your whole life, and it is an alive, exciting energy. You can't go anywhere, do anything, without self-expression. You don't develop great style overnight. It is more of a flowering of form, texture, color, and scale. Style is evolutionary because you're born with certain talents and flair, and then you're able to nurture your interests and hone your skills over a lifetime. There will be some backward moves and some motions forward, but complete consistency in style would be as awful as stagnant water. Style moves as water does, and there are calm periods and times of pounding surf.

When you buy a blazer and trousers, you usually try them on for size as well as look in the mirror to judge the proportions, color, and style. You become the model, moving around to see if you feel comfortable wearing the clothes. You can usually tell immediately if you feel good in a new article of clothing. But over many years, the huge puffy sleeves seem dated and you go to the tailor to get them reduced. You know you want to replace the modest plastic buttons on the blue linen blazer with brass buttons. Times change, and what was once new now needs alterations. Men's ties tend to get wider to a point, and then become more narrow. The bell-bottom trousers evolve to become stretch leggings. Nothing is ever static in life, not the clothes you wear or the decorations in your home.

How you decorate, dress, engage your senses, celebrate events, and spend leisure time are all interconnected. Always keep in mind that you are bigger than your studio apartment or your ugly house. You can make the best of what you have when you observe and find the connections. You can find your personal style in one area of your life and translate that into other parts until the whole is the essence of your true nature. There may be clues about your design tastes in the clothes you select, and these will help you decorate your space. The scale, form, color, texture, and pattern of the clothes you wear can inform you of the tailoring that would be most appropriate for your upholstered furniture.

Style is in part developed by how you employ and enjoy your five senses. Perhaps when you were young, you had no taste for lobster, caviar, and oysters. But as you grew older, you acquired a taste for such delicacies. This appreciation of the finer things is definitely an acquired taste. If you can learn to enjoy pâté, Brie, and cognac filtering through

your nose and taste buds, is there a similar educational experience that can take place visually, where you look and really see, and you're able to open up, absorb the atmosphere, and gradually understand the nuances of shape, form, texture, color, light, and proportion? The answer is yes. And just as certain people are allergic to shellfish or pork or can't drink coffee, it is perfectly possible to have an aversion to certain styles of decorating. Let your notebook guide you as you open up to all the inspiration around you.

Beware of perfectionist tendencies. When you seek perfection in every detail, you tend to lose the energy that makes a space alive. Some of the most "perfect" rooms are also among the dullest. There is no such thing as a perfect style because we are human, made up of yin and yang energies—light and dark, spicy and bland, colorful and subtle, happy and sad. Your rooms should be human, not perfect.

The essential ingredients of your unique spirit will find ways of making themselves known to you through tangible, physical, visual cues. All we truffle lovers remember that pigs and well-trained dogs sniff for this fungus that lies two inches underground. While the pig instinctively likes truffles, the dog has to be trained to associate a favorite taste with the scent of truffle oil. And truffles aren't much to look at in their dirty, knuckled state, but they are perfectly divine to those of us who are enamored of their taste. Let your tastes be revealed naturally.

Take the image of the truffle with you in your decorating. Pigs like truffles and so do I. Princesses may like leopard material on everything, including their table settings and curtains, but I'd rather be in a baby's brightly colored nursery. Some may think your style is for the birds (or your taste for the pigs), but if *you* are not enthusiastic about the decoration of your spaces, then they will lack the essential energy that is you and will lack vitality and be sluggish. Once you speak from your center when designing your house, the energy will be infectious to all who enter.

Before you can understand the joys you will experience from identifying your style voice, you have to accept human nature. Whether you are more or less unconventional than your peers, you are unique. Your style may make heads turn, and cause snickering and whispering behind your back. No one gets one hundred percent of the votes in every election. All you can do is be true to yourself, and nourish your individuality. The happiest people are the ones who are opinionated about

things in their lives, breaking free from the constraints of the collective opinions of others, having no urge to criticize or control anyone else's style. Variety and originality are what make you interesting to yourself and others. Each of you has to find meaning in the things you choose to possess, and in the atmosphere you create as the backdrop of your life's drama.

TRUST YOUR INTUITION

*I*f you're too intimidated to express your personal verve in the privacy of your own home, where will you ever be able to do it? Where will you find contentment, if not in your home? If you have a sunny disposition and love color, why would you ever consider living in dreary, dark surroundings? If you have a sense of humor, are full of energy, and are considered a live wire, wouldn't you want to have some symbols of your spirit around, even things as simple and inexpensive as a ceramic dish of penny candy in all the pastel colors you love? I collect mouth-watering, delicious porcelain made by Lady Anne Gordon in the shapes and colors of fruit, vegetables, and flowers. I sometimes whimsically place a real pear next to the porcelain one, or a real lemon on a green-leaf dish with one of her half lemons. "Oh, it's real," someone comments, catching a glimpse of the impromptu still life. One of Eleanor McMillen Brown's signature centerpieces in her legendary round dining room, at the center of her round Jeffersonian dining table, was a compote containing several fresh, plump, bright yellow lemons. What could be more lovely?

Can you learn from other style leaders to help straighten out some of the curves in your path? You can learn an enormous amount from observing how other people place ornaments on a table, or how they put together a flower bouquet, or how they coordinate a tweed blazer, shirt, tie, and silk scarf. You notice little subtleties, nuances, and take it all in. For years I never knew what to do with my ever-expanding silk scarf collection. I draped these colorful, patterned treasures over my shoulders as though I felt a draft, making me feel older than I was. One day I was having lunch with a friend who looked striking. I couldn't take my eyes off her. I noticed she had tied her large silk scarf in a bow

around her neck. Voilà, that's it. It had style, was fresh and snappy. The noted photographer Horst always places objects over the edge of a surface to create tension, something he obviously observed in the great nineteenth-century French artist Henri Fantin-Latour's still lifes. You stay alert to something that is harmonious and study why it is.

Whenever you observe something appealing that catches your eye and delights you, make a note of it in your book. Continue to cut out pictures from magazines of anything that you enjoy. Disregard brand names or other labels. What's important is that you're open and receptive to the attachment. Enjoy the mystery. In time, all these fragments, snippets, bits and pieces will come together. When you are free to select things you are drawn to—not what is popular or valuable, or what will impress others—you'll be amazed how much personal style is ready to be put into cohesive schemes in your rooms for your personal satisfaction.

Let your mind relax. Base your opinions on how responsive you are to something, and how it makes you feel. When you go to a museum, select some postcards by artists whose paintings mean something to you. You can find out what your decorating style is from selecting art you like. If you select a Rembrandt with a lot of Van Dyck brown, the room you would imagine creating for your beloved painting would be different in mood from one that held a Claude Monet picture of a garden. Notice the shape of the vase or the stem of a glass. Observe everything with fresh eyes so you're able to eliminate decorating ideas that are more appropriate for someone else, or for another time or place. The pendulum will continue to swing; you'll educate yourself about an endless variety of things. You'll learn that the deepest blue lapis lazuli comes from a single mine in Afghanistan. But you don't love it because it is rare, but because you are astonished that something so colorful and beautiful comes from the earth. And you grow to love verdigris, the French word for the green of Greece, the patina of copper that has been oxidized, introduced by the ancient Greeks. When you select your hall lantern, you want a tint of this pale green as a finish.

An ordinary dwelling can turn from dreary and dumpy to distinguished when you relate to it, and crisply manifest your point of view room by room. Stick by your convictions and continue to foster your interest in cultivating your taste by becoming more knowledgeable. Grow in confidence and faith in your intuition to know what to do in

any situation because you are clear headed about what you want. By understanding how beautiful life can be when you bring all these essential elements together in a personal pleasing style, you will be amazed at how things begin to click into place.

There are too many vagaries in developing your style to attempt to follow any formula for acquiring it. But whenever you're ripe, open, and juicy, you can seize the nettle quite easily. For now, as your interior designer, I give you my assurance that you will, eventually, without any hand–holding, be able to envision and enliven the decoration of your house so it is a haven where you live and love and have your being. By identifying all the wondrous things you love, you build on a mysterious intuitive sense, knowing what's really you and what's not. When you do this in all aspects of your life, you turn experiences into building blocks, and harmony results because of the way you mold the clay, put letters into words, or assemble an orchestra. Every event becomes important because you create your style and your style represents you, now and eternally.

CHAPTER 2

Budget and Priorities

We spend our incomes for paint and paper,
for a hundred trifles, I know not what, and
not for the things of a man. Our expense is
almost all for conformity.

—RALPH WALDO EMERSON

SIMPLICITY, APPROPRIATENESS, AND BEAUTY

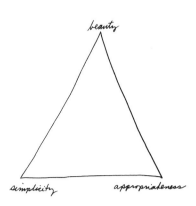

A house that deeply reflects the personal style of its inhabitants is a work of art within reach of us all. Whether you are in a large house, a one-room studio, a loft, a condominium, a stately mansion, a cottage, or a bungalow, you can transform your space into a place that houses your soul without spending an uncomfortable amount of money.

Throughout my career, I've adhered to a philosophy triangle of simplicity, appropriateness, and beauty (SAB), a beam of light on my path that has kept me grounded in my design work and my personal lifestyle. Draw this triangle in your notebook, labeling the bottom left *simplicity,* the bottom right *appropriateness,* and as the apex, *beauty.* Whenever you reduce the complexities to these three plain, direct forms of expression, you realize how straightforward so many of your decorating decisions

really are in terms of your budget and priorities. Where do you start with decorating when you have a limited budget? What's the most important element in a room?

Simplicity: Keep things simple in your approach to decorating your house for an atmosphere that is both sincere and attractive. When you select purchases for your home, ask yourself a few basic questions. Will these items add to the joy of living? Do they have a soul? Are they well crafted? Is the material good quality? Can I envision these things living with me for a lifetime? Do they have a timeless charm, a classic shape and form? Be wary of current decorating trends that encourage you to buy objects or make changes that are not truly you and that you'll tire of within months. Also keep in mind that you can respect the authenticity and integrity of a culture's art while recognizing that it does not fit your aesthetic. For example, if you appreciate the artistry and precision of modern art, but would rather not live with it around the clock, you should continue to admire it in books and at museums. If something isn't you, don't bring it into your home.

Appropriateness: The answer to many decorating questions depends on whether it is appropriate or not. Do you need to hire an architect or interior decorator? Should you try to do the planning yourself? What do you need more, a new floor or new cabinets? Does an oriental-style coffee table need ornamentation, or is the design complete in its plain execution? Should a towel or sheet be monogrammed or embroidered? Do you have young children or are you planning to have children in the future? Do your pets shed? Will something require special maintenance through the years that may make it inappropriate in your life? Should you move to a smaller house now that the children are married and have their own houses?

Your circumstances change over time. It may be appropriate for you to splurge on an exquisite baby pillow sham for your daughter's crib, but you could never afford to buy a set of king-sized sheets of the same quality and pattern. Even if you could afford it, chances are it wouldn't be appropriate given other items that have priority, such as curtains for the dining room. You may find a beautiful glass-topped coffee table for your living room, but because you have young children, you postpone purchasing it for safety reasons. What seems to be right at the time,

weighing everything, is what's appropriate. Let this principle guide you. While the children are young it may be appropriate to turn the dining room into a playroom. You never have to tell anyone your financial situation or your reasons for making your decisions. When you act appropriately, taking all relevant factors into consideration, you are unlikely to make foolish, costly mistakes or be misguided in your thinking. When something feels appropriate to you, it is for all the right reasons.

You may dream of a grand house, a far cry from your current relatively cramped space, but with three children you need a certain reserve of cash for operating expenses, so a downpayment on a new house is out of the question. You generally know when something is right for you, but often you lose sight of reality. No matter how beautiful something is, unless you can afford to buy it without excessive stress and strain, it is probably not an appropriate purchase. Many people confront this situation when they fall in love with a piece of furniture or a painting, or are eager to renovate an area of their space. If you're nervous about the financial consequences of a purchase or renovation, chances are you should wait until you feel comfortable spending the money. If you have young children, you may want to avoid buying carpeting for their rooms so they have a hard surface to build castles on, and you have a floor that's easy to scrub. When determining what's appropriate for you, use common sense and trust your judgment. One of the great joys of decorating is the hundreds of inexpensive, easy, relatively quick ways to spruce up a room. Whether you repaint the kitchen cabinets cherry red, stencil flowers on the bureau in the bedroom, or spatter the nursery floor with blue, white, and yellow, when you add color and creativity you feel better about where you are, even if ideally you want to make major changes. It's appropriate to live each chapter of your life fully, not wanting everything at once, but looking forward to what the future will bring.

Beauty: The ancient philosopher Clatonius believed that "the soul that beholds beauty becomes beautiful." Huston Smith, the spiritual scholar, believes that "a mean or despicable art is out of the question," and that "art teaches us to behave decently toward one another." If you believe, as he does, that art is as important as anything, that art is a spiritual reality, you should continuously try to bathe your eyes in great beauty. On any budget, you should focus on transcendent beauty. You

may want a few items that lean on the obscene side as a fun representation of pop culture. I love Day-Glo, especially the harsh, neon chartreuse, and to keep me smiling I have a Frisbee and a laundry sack this color, but I don't paint my living room walls with it.

There is far too much manmade ugliness in this world. Everything you do in the decoration of your house should be as uplifting and illuminating as you have the wit and strength to carry off. A client told me years ago, "I don't want to have any dark, disinherited corners in my house." If all areas of your life can be made more attractive, your spirit will never be broken by a dark, rainy day. You cannot underestimate the importance of beauty. Beauty, in most cases, outweighs even considerations of convenience or practicality because it gives you emotional comfort. You may find the most logical piece of furniture to house your unsightly television and stereo components, but if it is not pleasing to the eye, it is a waste of your precious funds even if the dimensions are perfect and the price is right. This is how you accumulate "junk" over time—cheap, tacky finds that fall apart and end up in the attic, garage, or basement, eventually making their way to yard sales, thrift stores, or the junkyard.

While everyone loves a bargain, when you make a purchase in the name of saving money you must focus on whether you want the object in your house. Ask yourself: Do I find it aesthetically pleasing? Nothing is a good bargain if your only reason for buying it is its cheap price. If you can avoid buying bric-a-brac and meaningless, shoddy, throw-away items in the name of a great bargain, over a lifetime you will save a great deal of money and space. This goes for ugly toys, gadgets, and all gimmicks.

Examine every single item in your house, including the pink Elvis Presley mug you got as a joke gift. Weed out everything that doesn't please you and never will. Take it to a local charity or thrift shop, or have a yard sale. Get back to basics. In order to live a beautiful life you have to revere beauty. It is a wise investment to surround yourself, family, and friends with artistic expressions of what you find beautiful. When you don't try to stretch your dollar too thin, in time you'll build an aesthetic background for your life that represents your taste. All your essential needs can be met in tasteful ways.

If you continue to use the simplicity, appropriateness, and beauty triangle as a reference point when determining your decorating budget

and priorities, it will serve as a beam of light on your path. You may move many times in your life, and you may discover that what's successful in one place doesn't necessarily mean it works well somewhere else. However, if your selections are simple, appropriate, and beautiful, chances are you will find a place for them wherever life takes you. And it is this continuity—where you're able to set up a pleasing house no matter where you are or for how long—that helps you sort out your budget and priorities. If you are passionate about literature, you will always need four walls with plenty of shelf space, books, and light. If you are a gourmet cook, your kitchen will be the center point of your house or apartment, so this is where most of your decorating effort will go. If you spend hours a day writing or painting, you will always want to make sure you have a space of your own that is conducive to these activities. SAB will help you make the best of every situation, no matter where you are.

TIME, ENERGY, AND MONEY

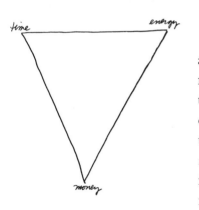

*W*hat are the basic resources you bring to your house? The answer is threefold: time, energy, and money (TEM). In your notebook, next to your SAB triangle, draw an upside-down triangle; on the top left write *time,* the top right *energy,* and at the bottom *money.* Think of time and energy as the forces pushing down expenses: The more of yourself you are willing to put into your house, the less the process will cost. You will need money to decorate your house, but it should be considered a tool to help you accomplish some of the projects you want to work on personally. Money ultimately is not going to be the pivotal factor in the way you feel about your house. You must set a realistic budget not only for money, but also for the time and energy you'll be able and willing to put into the decoration, improvement, and maintenance of your house.

Do you rent or own? Do you plan to stay in your house for an indef-

inite period? Your answers will in part determine to what degree you want to invest your time, energy, and money in decorating. If you rent, you probably will want to stick to purely cosmetic improvements that don't require digging into the skin of the spaces. A warning to renters: Your landlord might regard your improvements as horrendous alterations, and demand that you dismantle or reverse them. If you want to put a new kitchen floor down, be sure to obtain written permission. A fresh color change is one thing, but cutting tiles into the kitchen floor is something else.

There are many quick fixes for people who rent spaces, for those who don't intend to be in their present house for long, and for those on a limited budget. You may have a passion for hand-painted tiles and dream of lining the wall surrounding your bathtub with them, but because you rent, it's better to paint your bathroom a bright color and buy some colorful towels instead. The money you save on the tiles could be spent on some great colorful dinner plates. If you own, consider everything involved in structural changes. Clients have been driven to the verge of insanity by the inevitable plaster dust and other mess that builds up in their personal spaces. There is no such thing as neat construction, so you should expect your home to temporarily turn into a war zone.

You should not be discouraged if you're on a limited budget. There is always something you can do to improve your space and make it more your own with minimal cost to your pocketbook. For example, simple paint touch-ups can brighten a room immensely, and require only a small can of paint and a brush. You can also use colorful plates as wall decorations or patterned sheets as bed hangings or curtains. Rather than hanging a cornice molding, you can stencil a decorative detail directly on the wall under the ceiling for an attractive look, adding color and pattern in a way that is quick, easy, inexpensive, and appropriate. You should never feel trapped in the way your home looks. Throughout this book you will find ideas to inspire you to make little improvements that delight you.

CREATING A MASTER PLAN: THE DIFFERENT STAGES OF LIFE

*A*re you newly married and saving to put a down payment on a house? Or have you just bought your first house? Perhaps you have recently graduated from college and are living in your first apartment. Or maybe your last child has left the nest and you're in the process of reclaiming space. Your budget and priorities depend a great deal on where you stand in life's journey, and they will change as you enter different stages. There are roughly four phases in the decoration of your house, beginning with your first home and, as the years go by, ending where finally you are permanently settled. You may move through these years staying long periods of time in one house, or you may move every few years because of career demands, curiosity, or a search for a more ideal place for you and your family's growing needs. But whether you live in a single house for your entire adult life or move around frequently, you will, at different points in your life, advance through roughly four stages or phases. What phase are you in?

Phase 1: Efficiency and Economy The first phase usually involves primarily a large amount of self-help, your doing everything you can to save money. You learn the virtues of the electric drill, you master the fine art of sandpapering, and you clean your brushes with care. You are artisans working to master your own place, experimenting with different designs and colors, and doing a lot of improvising with furniture.

Phase 2: Defining Your Style Here you begin to acquire possessions of refinement that help you define your style. You're settling in, taking quality more seriously. During this phase I recommend saving as much money as possible on any structural alterations you make to your house, and instead spending available resources on quality furniture you love because these pieces will move with you. Purchase quality upholstery, a painting, and objects and lamps that speak of your spirit.

Phase 3: Refining Your Style Once you've settled in, feeling comfortable that you have fulfilled all the essential elements of dec-

orating your home, and are satisfied with the results, you become an avid collector, enjoying looking around for things that may not be functional but seem to "have your name" on them. You acquire art, more antiques and porcelain, and you continuously upgrade your lamps, table linens, and flower containers.

Phase 4: Fine Tuning and Enjoyment Now it's time to add those items that you've always wanted but never felt were a priority, such as a collection of porcelain vegetables and fruit, a set of botanical watercolors, several sets of fine new sheets with hand embroidery, or early edition leatherbound books. Having solidly established your personal style, you have everything you need and more. You may occasionally upgrade your furniture, but for the most part you find pleasure in objects that make you happy, rather than spending money on a chair or sofa the way you did in phases one and two.

HIRING A PROFESSIONAL

*D*uring these four phases you may wonder when you will need to hire a contractor, builder, architect, carpenter, or interior designer. Few people can afford to buy choice land and build their dream house designed by a talented architect. The rest have to muddle through, living in a house built for someone else, and with ingenuity and focused effort, make it theirs. No two situations are the same. Where does self-help end and the need for a professional begin as you pursue your dreams?

When you are self-contained, not needing the assistance of specialists, how you manage your finances, as long as you pay your bills, is your business. But when you enter into a relationship with someone you hire to help you with specific aspects of your home improvements, several issues need to be considered for such a venture to go smoothly. I speak from personal experience on both sides of the fence. In my business, I provide my design knowledge and skills as well as hire architects, landscape designers, engineers, builders, and contractors to complete a specific job for clients. In my private life, I hired specialists, including an architect, a contractor, painters, plumbers, electricians, tile setters, car-

penters, and floor and lighting experts when we renovated a cottage in Connecticut that was in need of major structural work.

The relationship between the client and the hired professional can be tricky, but it doesn't have to be if both parties take precautions before going ahead with a project. The foremost cause of tension between the client and the skilled professional is cost. Professionals usually have a payment structure that is not negotiable. In all my years as a professional interior designer, I have always appreciated the clients who respect my payment terms, never losing sight of the fact that we are engaged in a contract as well as an art project. When you build, restore, or add on to your house, in every case meet with the professionals to discuss the work that needs to be done, then agree on a fair price, and pay on time. If you decide to hire a professional for a specific project, whether it involves installing bookcases, tearing down walls, or something more complicated such as adding a room, it is crucial to set firm payment terms, and it is equally important to stick by those terms unless you feel the services rendered are below par.

DEALING WITH DIFFICULTIES

Problems also commonly arise when a certain project is not completed by the estimated date. I frequently run into this problem in my profession because projects generally take longer than originally planned. What I have learned time and time again is that it is impossible to predict precisely how long it will take to perform a task that requires skill and expertise. And extra time results in additional expense because labor costs money. The individuals you hire to help you are artists who truly care about the quality of their work. They are not inclined to rush themselves and compromise their work to meet a deadline. This is simply not their nature.

Recently I hired a carpenter to install a trellis I had designed in the entrance hall of clients in Virginia. The project turned out to be more complicated than we originally had predicted, mainly because we discovered after starting the project that each piece of wood had to be individually measured and placed due to the measurements of the room. But it was far more important to be precise than to do a

mediocre rush job. The delay frustrated the client, who was planning a party, and tempers began to flare. The atmosphere turned sour temporarily, but as soon as the project was complete, the client was so in awe of the work that he forgot his bitterness, replacing it with excitement and satisfaction.

Similar problems arise when clients order custom-made furniture or rugs and become furious when the delivery truck does not arrive with their goods on the precise date given by the maker. But because this is frequently the case, it is best to allow a few weeks or more of flexibility. Generally it takes up to twelve weeks to have custom furniture made, but it may take longer depending on fabric availability or other factors. If you are ordering a custom-handmade rug from a foreign country, be prepared to wait even longer. I had a client who had to wait three painful months for her living room rug to arrive from India, but when it did, she was ecstatic and forgot all about the delay. As a rule, don't plan to hold a party the day after your new furniture is scheduled to be delivered or the week after your new kitchen is predicted to be ready, or else you'll be setting yourself up for a letdown. Time estimates are exactly that, estimates. When working with artisans, it is wise to be flexible about deadlines. You never know what obstacles may arise. The wife of the workman building your bookcases may go into labor, taking him away from the project for a few days, or a blizzard may put construction at a standstill for at least a week.

ASKING FOR ESTIMATES

If you are serious about making structural changes in your home or other alterations that require a professional, it is wise to ask for a detailed estimate. This way, not only do you know how much you are paying for labor and how much of the cost is for materials, but you can also plan a timetable for making alterations according to your budget. If you are redoing your lighting, have the estimate include rooms you probably won't do anything about right away, but plan to eventually. Ask a lot of questions. Is the estimate based on the whole job or can it be divided into parts? If you do the work piecemeal, will it cost more or the same? Will a house painter work on several rooms at once,

moving around freely, painting all the trim first, and saving time bringing in supplies?

Don't always take the lowest estimate, because it could be a red flag for a mediocre job or con artist. You may discover that the final payment is twice the estimate because you need new wiring in the attic in order to put the circuit breaker in the basement. You have young children, and naturally you are terrified by the thought of a fire. Who wants to risk a fire? On the other hand, don't assume someone is trying to rip you off if the price seems a little high. Realize there are subtle differences in result that often connect to differences in cost. Quality workmanship is done by people who make their labor one of skill and devotion. High end, in the end, usually pays.

A floor company based in New York lays floors all over the world, and after working with them for over three decades, I can safely say this company does the finest work. To the wonderful people at the William J. Erbe Company, floors are their life. They lay, stain, and paint wooden floors that you could call floor art, and walking on them is a heavenly experience. These floors have been worked on with such meticulous care, they sing. And their high cost reflects the brilliant workmanship. In many cases, people who went for the lowest bid sometimes seek Erbe's help to bail them out of a lousy job. They learned their lesson the hard way.

If you're on the fence about whether to do a project yourself or to hire someone, ask for an estimate because often this will answer the question for you. It is appropriate to ask a professional for a ballpark price, based on time, experience, and materials. It is inappropriate, however, to ask for a detailed estimate if you have no intention of going forward with the work, because extensive estimates take painstaking care to write up, and there is usually no charge for this service since the worker hopes to get the job. One of my assistants recently married and moved into her new husband's rented carriage house. She couldn't stand the orange and black carpeting, and decided that one of her first decorating priorities would be to tear up the carpet and repair the wooden floorboards that lay underneath. But she knew she didn't want to sand and finish the floors herself. When she got a reasonable estimate, she was glad to pay to have the floors done professionally, grateful she didn't have to hurt her back doing the job herself with the help of her husband. What is reasonable and how can you know it's fair? Research

the cost of similar jobs done in your area. Talk to as many people as possible in relevant fields of expertise. The more information you gather, the more control you will feel in deciding what is fair and what is excessive.

Save your own energies for something that interests you. If ripping up an old ugly carpet and finishing the wood floor beneath seems like torture to you, it's worth it to you to pay someone else to do it for a reasonable price. If a project doesn't fit your temperament, it's better to have it done by someone who has the skills to do a good job. Surely there's enough to do in your home so you won't feel guilty hiring a professional. I've had clients who work side by side with the people they hire, painting walls while a paid professional lays a tile floor or installs an island in their kitchen.

Often, you won't have the tools or equipment that make a project enjoyable, and you don't want to invest in expensive tools or machinery you'll rarely use. These are all options to weigh in deciding whether to do a project yourself or to hire a professional. Before you hire a professional to do work in your house, be sure you have the following:

1) Fee arrangement
2) Time schedules for starting, reaching midpoint, and finishing
3) Workers' insurance coverage for work
4) Signed letter of agreement contract
5) Compatible personalities

CONSULTATIONS

*O*nce you've evaluated your personal style and are able to articulate it to an architect or interior designer, it could be well worth the money to pay for a consultation. If you were having open heart surgery, you'd research who currently is the best, most trusted doctor to operate on you. You don't go bargain hunting when it comes to your heart, and you shouldn't when it comes to your home. Interior designers are paid for their style, talent, color sense, ability to create illusion, and above all their technical skill. They have to be able to give sound, solid, wise advice to their clients, as a fiduciary to serve the clients' needs, being careful not to impose their lifestyle on their clients. While

they're able to envision the way a space will look and feel after it has been appropriately decorated, they should also concern themselves with the changing needs of the client.

If you need a little help to get you off to a good start, or to bail you out of continuing in the wrong direction, research who's out there by studying decorators' work in magazines, and exploring decorator showhouses and exhibitions. A talented designer can help you answer all kinds of questions in a few hours that could take years of trial and error to answer yourself. Designers are knowledgeable about what materials are available and what are not, they have access to "To the Trade Only" showrooms, where they buy wholesale and sell to their clients retail, and they can help you to formulate a basic decorating direction so a master plan can evolve gracefully over the phases of a rich, full life. The fee you pay for a top professional will be an investment, with dividends that will last a lifetime. The question is whether you need this help or can figure things out on your own.

When you ask an architect with a great eye and a taste for elegant refinement to come to your house to help you right the wrongs and add architectural details, he will make a full set of drawings for your contractor. If you live in an old house and want to build a generic white picket fence around the front and sides, a common sight in New England villages, you may find that such an undertaking is more serious an endeavor than you had thought. The cement foundation needs to be deep enough to ensure the fence will survive any hurricanes or tornadoes, even if the trees don't.

An interior designer, however, is a masterful trompe l'oeil artist who can help you create illusions of moldings when there aren't any, make you feel that your space is more expansive than it really is, turn an awkward nook into a sanctuary, bring more light into your rooms without installing new windows, and bring your favorite places into your home.

When you hire a designer, you can tell him or her that you're willing to do as much as possible yourself, within reason. The professional can then get you started by helping you decide what colors you want to paint the walls, where you should place your art, what flooring you should use, what window treatments would work well in your space, and how you might be able to install mirrors to expand your space visually, as well as giving other expert advice.

DO-IT-YOURSELF—THE SATISFACTIONS
AND THE SAVINGS

*T*hink of your house as a laboratory where you experiment in a variety of different disciplines, honing your skills. You may have a job where you sit at a desk all day. Being able to rest your mind, put on work clothes, and improve your immediate surroundings is a wonderful, healthy way to release stress, avoid anxiety, and find pleasure—all benefits of do-it-yourself beyond the money factor. If you went to a monastery to try to find the meaning of life, you'd spend half your time sitting still in meditation and the other half doing physical labor. As an interior designer I figured out early on that we can know what we want out of life by creating uplifting environments for ourselves and our families. The first sign of figuring things out after years in a monastery would be to go home.

The more you do yourself in the first two phases of development in the decoration of houses, the richer your rewards. Developing skills and experimenting with your talents in your home will bring you lasting happiness because as you do this, you infuse your home with energy from the center of your being, expressing your true personality. If you're a quilter, the pattern as well as the colors are a reflection of your artistic sense. When someone tells me they can't cook, I assume they don't want to cook. The *Joy of Cooking* spells out the steps for us; anybody can learn how to be an adequate cook and improve with practice. The same holds true when you approach your house. You want to live in your rooms as comfortably as possible, and you want them to reflect your aesthetic. Where do you begin? How do you approach this daunting task? How much do you have to spend to transform your space into a personal haven?

A good first step is to write down all the different things you'd be willing to do yourself. A few years ago, as an experiment to see if I could get up on a ladder and stay there without falling, I decided to paint the walls and ceiling of our bedroom and our bedroom hall in our New York City apartment. I even bought a battery-operated digital stopwatch that attached to my waist to time how long the project would take me. Every time I rested or went to make tea, I stopped the clock. Once I started this project, no one and nothing could stop me. After logging sixty-five hours, I finished. I was exhausted, with a pulled right shoulder,

but above all I was thrilled and proud. I admit I didn't time my chief plasterer, taper, ladder holder, hammerer (of loose pins in the door hardware), and brass polisher, my husband. He did ask me kindly to be a little more careful with the paint that I periodically splashed on the piano hinges of the shutters. My occasional carelessness led him to spend much time removing paint with a single-edged razor blade and steel wool. He estimated his hours of labor totaled thirty-five. Together we spent one hundred hours on the project. Imagine how much it would have cost us to hire someone to do the job! What do you estimate it would cost to hire someone to scrape, tape cracks, spackle, sand, and brush paint your bedroom or any other room in your house?

During this experiment, I didn't tell anyone I was doing this work myself. People would have discouraged me, told me I was too busy, or tried to convince me that "You could be putting your time to far better use." I didn't want to hear one negative comment, so I bolted our front door, put on my mask so I wouldn't inhale any toxic dust, donned my safety glasses, tuned the radio to some fun, fast music, and away I went, into a project I loved thoroughly. I would get up early and do my writing first, and then, "owning the day," I would be free to paint. My experience turned into one of the most rewarding tasks I've accomplished in years. Anything that's worthwhile is going to require total dedication.

Don't underestimate yourself. Unless you are all thumbs, you can do a large portion of household improvements. For all of you who have never tried to paint, refinish, or build, you'll be amazed how capable you are. The more you learn the steps you have to take to accomplish your desired goals, the more confidence as well as expertise you'll gain.

BE REALISTIC

There's just so much anyone can do, and it's important not to take on too many house interior projects at once, or else the tasks will become more overwhelming than satisfying, and it may take years to complete any one project. Also keep in mind how long you plan to stay in a particular space to determine what kinds of changes make sense.

If you love to paint, this is where to put your energy. Maybe you like to work with wood so your natural bent is to plane, shave, carve, sand, stain, and finish. Perhaps you have a passion for colorful Portuguese tiles and want to concentrate your time and energy on installing a row of them on your kitchen wall. In any case, through your hard work and devotion, you will be able to positively influence the feeling of your space.

Of course no one becomes an expert painter, carpenter, or tile setter overnight. One of the advantages of renting is that you can experiment on any awful wall or floor space, full of cracks and water damage, so that by the time you move into your own home, or a place where you plan to live indefinitely, you'll be adequately skilled. If your goal is to repaint your walls or cabinets, you may want to practice your brush technique on the underside of a table or the inside of a cabinet door until you're comfortable. If your project involves shaving and sanding wood for self-installed paneling or flooring, be sure to experiment on a piece of wood that you won't need so you know how much pressure to apply and when to stop. You can end up doing more harm than good otherwise. People have ruined their wood floors by jumping the gun with an electric floor sander. Remember always to get the landlord's permission for any changes, including paint color. If you live in a beige apartment and the landlord refuses to let you paint it sunshine yellow with white trim, be willing to do so anyway and repaint it beige when you move. Get permission either way.

What are the simplest, most cost-effective changes that will make your place more livable and pleasurable, and you happier? When you want to repaint a room, are you willing to spend hours doing preparatory work such as sanding the surface until it's glass smooth before brush painting, or are you more interested in expediency, opting for a can of paint and a roller? As a general rule, the more shortcuts you take, especially in painting, the less permanent your work will be. For example, I could have gone the roller route when I painted my bedroom, skipping over any preparation work and merely painting over any damaged areas, and the entire job would have taken a fraction of the sixty-five hours I spent. But chances are the damage would start to show through within the year. If I were renting, however, then it would have made the most sense just to add a few coats of paint on top of the existing layer, using a roller.

Patience is key in do-it-yourself projects. Inevitably you will be learning as you go along, so don't be too hard on yourself. Also, a small project may unexpectedly turn into a huge undertaking. This happened when I was preparing my bedroom walls for the new paint job and found a huge section of rotted plaster that had to be repaired. I've heard similar stories about people redoing the drab tile work in their bathroom with a more colorful style, confronting horror as they remove the original tiles from the shower walls only to discover they need a new wall. When you decide to take over a home improvement project yourself, remember to be patient and open-minded, and always have a sense of humor.

Before you embark on this lifelong passionate love affair with the decoration of houses, you have to understand that the magic wand is in your hands right now. Working around your house is essential to the pleasure you'll gain from the time you spend there. You'll get far greater psychological benefits than just the money you save. I've sanded floors and stained them after a full day at the office, and the exhilaration you feel when you soak your stiff muscles in a hot tub before going to sleep is soul satisfying. My mother's example of the capabilities of a woman to do physical labor is a blessing because I feel comfortable nailing into concrete, and from observation and personal involvement, I've learned that the satisfaction is in the process as well as in the result. By being involved, you learn what you most love to do. I'd rather build a stone wall than thread a bobbin, and many of the traditional things women did in pioneer days are things we could return to with relish.

TAKING CLASSES

Before I had children, I spent Saturday mornings going to the legendary decorative artist Isabel O'Neil's classes in New York City, learning how to do a variety of faux finishes, including glazing and gilding. We were sent off to buy a new, raw wood frame, bench, chair, or mirror and were told to make it look antique. We softened the hard edges with X-Acto knives, sanded, and then distressed our new wood object; within weeks, we were skilled in the fine art of faking antique French furniture.

Studying interior design teaches you how things work and how they're put together in the decoration of houses. The more involved you become in all facets of your house, the more content you'll be. Often this requires more than mere practice, so you may want to sign up for classes that teach specific skills if you're determined to do certain things by yourself. In addition to taking classes, you can watch the increasing number of television programs on home improvements, read books and articles on the subject, watch demonstrations in hardware stores, and rent how-to videos.

BUILDING OVER TIME

*T*he assorted accumulation over time of your things creates the decor that speaks for you, your style, taste, and sense of aesthetics. You may have mildewed walls, crumbling plaster, and threadbare silk (this is often referred to as "shabby genteel"), but as long as the totality of elements speaks of you, the look has style and charm. Often the most lavishly decorated rooms say nothing about their inhabitants, speaking instead of the professional designer's taste and budget rather than the client.

Many people in our society consider themselves uncreative. When they rent or buy a house, they accept it quite literally, not being able to visualize how the spaces could be transformed into something more attractive and closer to their hearts. Many of you will not want to do the physical work in your house but want to gain ideas so you'll know how to create a master plan and be intelligent about whom to hire and what to expect. Interior designers subscribe to the principle of placing the best interest of their clients first, and believe that when working together with them as partners, they can create a positive aesthetic effect. The contentment of clients ten years later is a far more telling evaluation of whether you were successful in turning their house into a home than an eight-page spread of their house in a glossy magazine.

Always aim for the ideal as you decorate your house, even if it means waiting years to acquire pieces that you love and want to spend a lifetime with, then pass on to others to enjoy. None of us wants to sit on the floor for too long, but it's better than rushing to buy an inexpen-

sive sofa that will only last two years anyway. You may be eager to buy a set of affordable reproduction dining room chairs, but the ones you like are twice as expensive. Far better to buy four of your favorite design now and four next year, using inexpensive folding chairs in the meantime, than to settle for a set of chunky, awkward chairs. You, your family, and friends will be enjoying not only the comfort, but the style and proportion of your chairs for thousands of hours. Stay in touch with the manufacturer. If the style will be discontinued, perhaps you can buy them on sale.

Whenever you buy any *thing,* such as a piece of furniture, think about its life span. Just as the permanence of the results increases with the amount of time spent on a job, cost and quality in most cases go hand in hand when your purchase involves furniture. Advocate quality over thrift in just about every circumstance; it's better to go without than to go shoddy. When you spend more for quality, it is an investment that will inevitably work in your favor in the long run.

Often the first question a client asks is "How much does it cost to decorate an average living room?" There is no one answer for this question because every person is different, and some care more about the way their rooms make them feel than others. Some people love the outdoors, gardens, cars, boats, and horses, but their living room looks as though it were a dated photograph from the fifties. Nothing is new, fresh, or alive. The room was decorated once, and they don't see any reason to change a thing. Nothing is worn out, because they rarely use the room. It is a still life, a reflection pond. No living in the living room, no swimming in the pool.

The first question I always ask a client is "How much do you want to spend on decorating this year?" The reason I qualify my question with "this year" is twofold. First, until you know the price of fine quality possessions, whether new or old, you can't set an accurate budget. The cost of certain objects is likely to help you determine how much you want to spend at a given time. You may find you want to save for a couple of years before making any major purchases. You have to know the facts. Secondly, I don't approve of rushing around, gobbling up furniture, art, and objects just to fill a room. In the same way that overeating takes the joy away from a dining experience, obsessive purchasing to fill a room is absolutely the wrong way to go about decorating your house. When you do this, you are robbing yourself of the satisfaction

that comes with gradually infusing your home with your spirit, taking care and paying close attention every step of the way. The finest rooms evolve over time.

A journalist came to me in the late sixties and asked me to help decorate her Madison Avenue apartment. I took one look at the client's space, and immediately asked the same initial question about her budget for that year. I was told eight thousand dollars. I looked around the client's rooms, all full of stuff but containing little pleasing to the eye or indicative of her personality. There were no architectural elements such as cornice moldings to mask the flimsiness of the wallboards, and the baseboard was a scant two inches high. It was so obvious she was a workaholic who spent very little time at home.

I didn't have the nerve to suggest she start over, though my instinct told me that her apartment needed a major overhaul in order to make it truly hers, and this would require a larger budget. I suggested the client splurge on one great armoire or an oil painting or a fabulous pair of antique end tables and some fine porcelain lamps, advising her not to try to do too much with the budget. I believed it was better to find one grand piece the client loved, and this piece would become a focal point and delight the eye. That day I made an excursion up Madison Avenue to Parke-Bernet (now Sotheby's) auction house at Seventy-sixth Street. I took the elevator up to the selling room floor and strolled around to see what was being auctioned the following Saturday. When I reported back to my client about my findings, her face immediately lit up. I told her I'd seen some beautiful furniture on preview and could take her to see it right away. She explained how she had always worked seven days a week and had never taken the time to look for pretty things. As a result, her apartment was boring. She was eager to start acquiring nice things that she wanted to live with.

When I brought her to see the furniture, she danced around the floor, touching the wood pieces as though she'd never seen so many things she loved. Because it was an estate sale, the pieces coordinated attractively, even though they were randomly placed around a huge room. That Saturday she and I attended the sale together, and bid on and purchased a French provincial armoire for her living room that remains her most treasured possession. She claims that if the armoire were the only piece of furniture in the entire apartment, she'd still be delighted with her home.

There will be many rooms in your life, and you should never rush to fill them up. As you mature and learn more about the world, as you travel and see great beauty, and as you learn more about yourself, your tastes will become more attuned to quality. Be patient, because this discernment is a result of your exposure and is developed over time. As long as you're tenacious about the decoration of your house and are willing to set goals and have a plan, you can achieve your individual sense of luxury. Just as you don't buy all your clothes and shoes in one year, you'll never be able to afford or rationalize purchasing fine furniture and objects in clumps.

I've helped families assemble collections by budgeting, buying one quality piece of furniture or art a year. When young people come to me for advice on their first house or apartment, I help them understand the wisdom of building their possessions over time. Only then will a space develop authentically, reflecting a more tutored, experienced eye, and be a true home. If you fill up entire spaces at once with new purchases, even if you can afford this extravagance, your house will be a series of frozen rooms that do not relate to you. Some people tend to take a business approach to their homes, wanting everything to run like clockwork, where all the parts fit together by design and tick away. But a home should not be run or decorated the same way a business is so everything fits a pattern and works efficiently. You should become emotionally attached to your French provincial side table, your Shaker chair, or your beautiful old quilt hanging on your wall as a work of art. And positive feelings extend from that attachment to something you love. Your taste evolves in attunement with these core pieces you're drawn to, and they're important clues to your personal style. Your home reflects who you become over time, all the diverse pieces working together to form a multifaceted whole.

It is better to wait and save for a piece of furniture rather than buying something that lacks your style or is less than attractive, using lack of money as an excuse for your purchase. Better to eat from your lap or sit on cushions on the floor than to have an ugly machine-made table and chairs you don't like. One great coffee table with brightly colored Thai silk pillows around it, placed on a shiny wood floor, where you serve take-out Chinese food in red-lacquered bowls using colored lacquered chopsticks and huge white damask napkins you bought at a thrift shop is chic, even if the rest of the apartment is empty. If you can't

buy a good coffee table and chairs to put around it, buy the table and bring in folding chairs for people who are too old to sit on the floor. If you meditate every day and do a great many projects on the floor, you have found the comfort of not always being seated in a chair.

In the past, no one invited guests over until their house was "finished." Many people still behave this way. Don't be embarrassed to decorate your rooms slowly for fear people will think you're struggling financially. If you're young, energetic, and low on cash, you'll be spared the temptation to lose sight of your personal style. The more realistic you are about yourself, the greater the chances are you can live quite comfortably on any budget. Snobs pay through the nose because they're out to impress people. If you avoid this trap, seeking only satisfaction for yourself and loved ones, your home will reflect this authenticity of spirit and will be a magnetic force drawing others in.

YOUR PRIVATE SANCTUARY IS ALWAYS WITHIN YOUR REACH

What are your priorities? Where can you bring other worlds into your daily life? Where in your home are you able to create a sense of the infinite? Think of your house as your private sanctuary in this vast universe, and do whatever you can with your gifts, talents, interests, taste, imagination, and resources to make it a bright star. I wouldn't have spent my whole life focusing on the decoration of houses if I didn't have a burning desire to help you improve the quality of your daily life at home and find more fulfillment and joy in this essential quest. To feel happy in your surroundings, to feel an inner glow in your private retreat, is all you need to know about life's joys. As Edith Wharton needed the right schemes for emotional contentment, you do, too. This opportunity is yours, now. It's never a question of how much money you have, but always a question of how well you utilize what you have.

Your home should be a beautiful frame for the life and spirit within it. Working fireplaces, dimmed lights in the evenings, candles shimmering, flowers, music, and stimulating conversation by charismatic people make living culture. In such a setting, life seems to be lived without

strain, and an unpretentious life can be well ordered, comfortable, and useful, without the usual hoopla. The hype that surrounds anyone's life is the least satisfying. When you grow more unassuming, you come to your senses. You enjoy the company of children, delight in a private banquet, and, when you're really blessed, your house becomes your best friend. It's alive, and when you are home, you are invisibly supported and sustained by loving arms, embracing your essence, caressing your soul, maturing your spirit.

PART TWO

The Background of Your Home

If your work of art is good, if it is true, it will find its echo and make its place.

—GUSTAVE FLAUBERT

Space

*You have to live in a house and know its circulation
in order to furnish it decently.*
—KARL LAGERFELD

REDEFINING SPACE

Space isn't only defined by its physical dimensions, but also by
its potential and what you do with it. Virtually nothing is
impossible in any given space. Dream freely and without fear because
you can make even a ten-by-ten-foot boxy room feel spacious.

First figure out how your spaces are to be used. What rooms will be
bedrooms? Is your dining room going to be a library? Perhaps you don't
have any choice because you live in a studio apartment, a common real-
ity today due to high living costs and shrinking space. Even if one room
is your bedroom, living room, dining room, and office, remember you
can only be in one room at a time, and this space, no matter how hum-
ble, is yours to mold, to transform into your heart's desire.

FEELING COMFORTABLE IN
YOUR SPACE

The space you inhabit evolves as you progress through the dif-
ferent stages of your life. Any decoration of houses that doesn't
consider the constantly changing dynamics of the people who live there

will erase the present by existing in the past. Space should always be alive, breathing vigor and positive energy. You have to learn to create and recreate illusions in the space you occupy in order to make the most of what you have, seizing every opportunity to personalize each living space with a breath of your own fresh air, adding to your enjoyment as well as prosperity. Just as it is important for you to feel good in your own body, you need to feel at complete ease and comfortable in the skin of your space. Ultimately, you need to view your space as an extension of your body, so that it continuously reflects who you are.

Some people may be so frustrated with their space that they're tempted to put a match to it. To a visitor, your house may be absolutely beautiful. But regardless of the compliments you receive, you may not feel you fit into any area of your own house. Maybe your rooms are filled with inherited furniture you've never liked. One man told me he felt awkward at home because his wife and an interior decorator friend decorated the place head to toe and he felt as if he had been robbed of his space.

Many people like their houses, but feel a need to rework the spaces so they flow more comfortably for their current needs. For years, clients looked for land on a beach in Florida where they could build a house to replace their current dwelling they'd decided was too awkward and did not sufficiently fulfill their needs. There were far too many small rooms, and the layout was all wrong. When they couldn't find a desirable piece of land, they decided to rework their existing spaces, area by area, putting the house's shell back together with more symmetry and grace. Rather than having the living room in the front of the house, they located it in the back so it opens to a view of the garden and lawn rather than the driveway. The interior space became more open, giving the environment a lighter, more airy atmosphere. The entire character of the house changed to be more compatible with the personalities of the owners.

When Eleanor McMillen Brown moved into her Sutton Place duplex in Manhattan in 1928, she decided the dining room just wouldn't do. It was a small square box with one window overlooking an air shaft. Undaunted by this horror, she drew the square on a piece of paper, and then drew, freehand, curves in the four corners. "Ah," she exclaimed, "niches for sculpture." And her small dining room, now round with a decorative marble floor and a round table, became a leg-

Mrs. Brown's square room made round with three niches and a folding screen to hide the kitchen door.

endary space where hundreds of young designers were invited to break bread with the giants of taste and design. The sculptures she placed in her four niches, all well lit, and the chandelier beaming over the table drew your eye to the center of the room, taking it away from the window. To cheer it up, however, she hung beet-red silk taffeta curtains, contrasting with the yellow lemons she displayed in a bowl at the center of the table.

Look around your house. How do your different spaces make you feel? What was your first impression of your space? Were you intimidated and overwhelmed or were you excited about the potential? What do you most like about your space now? What do you least enjoy about where you live? What is the general mood of your space? Do you feel good energy when you enter these rooms? Is it productive, focused energy or nervous energy? What makes you feel comfortable in one space, and ill at ease in another? Are there places where you can retreat to feel serene and calm, tranquil and content?

Compare the feelings you would have when you are alone in a waiting room at a doctor's office to being alone in a room that is filled with color, texture, comfort, and love. When you are alone in a space that has been decorated to delight your senses, you don't feel lonely, but connected to others, and the walls are not barriers but comforting protectors. Walls can be arms embracing a space that has been created in loving ways.

The design of your space must function well for your purposes, and be appropriate to the activities you wish to carry out in each area of your house. Your space should be arranged and used as individually as you plan your diet because you will be nourished or malnourished to the degree you care about or ignore the importance of your space. Claiming your space takes time, you cannot accelerate the process by filling it with new purchases overnight.

WORKING WITH SPACE
RATHER THAN FIGHTING IT

One client is excessively literal, always focusing on tangible details instead of vision and imagination. When I visit her house in Birmingham, Alabama, she has her notebook filled with questions, waiting for answers so she can solve the room's problems. She loves her garden and the combination of physical exertion and solitude she finds there, breathing fresh air and delighting in the wonder of all that grows, and she always wants to get her spaces "done" so she can go back into her garden where she really lives. But even Alabama has winters, so automatically she faced three months of dis-ease in her house. I suggested we talk in her garden—with her notebook left inside. This made her uneasy, but she was a good sport, agreeing to have a chat in her garden without paper and pen.

I asked this client to dream of turning her entire house into a garden. She had been fighting her interior space all along, rather than planting it. She needed to make her interior spaces fertile, capable of initiating, sustaining, and supporting growth. Sitting among the azaleas, oleanders, geraniums, pansies, and tulips, shaded by pink apple and cherry blossoms, with no notes, we envisioned together how to transform her interior spaces. She awakened fully to this changed perspective, where she could seamlessly bring her love of gardening into all her spaces. In the winter, when she'd dream of spring, she could tend her house plants in her solarium.

Her living room became the garden room, and the family room now has an old French round table and Windsor chairs in front of the bay window, so she and her family can overlook the garden for breakfast, lunch, tea, games, and poring over seed catalogues. To improve her dining room, she brought the garden inside by installing a complete decorative trellis with one-inch lattice strips on the green walls, creating trompe l'oeil details around the doors and cornice with decorative pilasters and overdoors made of trellises to fool the eye into thinking the doors were arched. She grouped two dozen floral botanical watercolors on large wall spaces, surrounded by trellises. By redirecting her energy so her garden could energize her spaces inside, she felt a sense of abundance.

Confronting Empty Space

*B*egin with a blank canvas. Claude Monet's garden at Giverny went beyond the limits of his palette. He taught about the limitlessness of space and, nearly blind, painted huge canvases of water and lilies where there was no need for a horizon, only pure depths of space and color. Your rooms, too, can expand beyond their walls, and you can stretch the edge of your envelope of space by thinking unconventionally, connecting to your intuitive level of awareness.

Professionally, I've studied more than six thousand empty rooms, perhaps equivalent to a doctor examining a patient with nothing on but a paper gown. When you strip a space naked and stare at its core, studying it from all angles, you begin to understand the more subtle characteristics and nuances that contribute to a harmonious interior environment, such as a space's dimensions and the influence of natural light.

When a raw space feels good, there are elements working together to interact harmoniously. If the space is somehow unsettling, perhaps the room is too narrow, and the ceiling too high, or there is very little natural light entering the room. The challenge in such cases is to manipulate elements to achieve the desired feeling of comfort and invigoration.

In my thirty-six years of studying space, only rarely have I met someone who isn't to some degree afraid or uneasy in an empty room. Most people are under the false impression that space is a void until it is filled up, and only then can the people who live there get on with the business of living. I've seen the most graceful, elegant spaces wrecked by ugly furniture and objects, beaten down by a random assemblage of things that have no sense of cohesiveness. Before you fill a room with tangible objects, contemplate the space. If you're planning to move to a new place and are house hunting, try to train your mind to visualize each space empty, even if it is completely furnished at the time. Empty space is an opportunity to have a fresh new beginning as well as to see clearly how to improve the fundamental health of your spaces, area by area.

The next five chapters will all deal with the designing of space, but first you have to undress, strip away the layers, and get to the bare bones. For now, think of nothing but pure space, and work with what you

have, connecting your spaces, however humble, with your present life, and your goals and dreams for the direction you want your life to take.

Think of your raw space—your rooms without any furniture or other objects—as an *opportunity*. Once you feel what empty is, you will be full of ideas for how you can transform it to meet your needs and satisfy your dreams. Just as an artist sees a white canvas as an exciting chance to express himself freely, your empty space is yours to paint as personally as possible to achieve your short- and long-range goals for the direction you want your life to take.

Even in the worst-case scenarios in decorating—the windows are tiny and too high, there are no architectural elements, the ceiling is made of acoustical tile, the workmanship is flimsy, and the furnishings look like a stage set for a depressing play—I begin my job by envisioning the space without the confusion that fills it. Through this exercise, I have found that almost all space is salvageable and can be cured, no matter how great the problems seem at first glance.

Edith Wharton, as a child, was fond of the expression, "I'm going to 'make up' now." You might have to make believe an ugly dump is a dream house before you begin a decorating project. Clients did this when they found their dream house in New Jersey. Hundreds of people had traipsed through this ugly house for four and a half years before they discovered it, and not one family could envision living in the place. This house was a serious wreck, but the clients were young, energetic, and willing to do most of the work themselves. They saw beyond the damage and the multitude of problems. They recognized a solid bone structure and a charming view overlooking a lake. The house may have been in disrepair, but they knew that through their loving care it would have new life.

I had a client in Texas who insisted that she was incapable of visualizing empty spaces, and she was reluctant to literally empty out one of her rooms to experience it bare. I asked her to try shutting her eyes so she could dream of what felt right for all the areas in a room. She explained that she knew what she liked when she saw it, but she could never visualize what she wanted.

Starting with empty space, literal or envisioned, can be difficult if you allow yourself to be intimidated by it. Some people hire interior designers for their ability to envision a space and see its potential. Professionals see the potential of a space by using their trained eyes and

tapping into an acquired sixth sense that combines intuition and imagination, much the way novelists do when they create characters. If you're a doctor, you could jeopardize the life of a patient if you made a mistake. If you err as an architect, the building could fall down or the window could pop out. Thankfully, if you're an interior decorator, you can work through trial and error to see what works best for each area, each room, each space in your house during the changing seasons of the year, as well as during the new chapters in your life.

VISUALIZING EMPTY SPACE

This expression has become a keystone in my interior decorating philosophy: "space to breathe." Just as an artist is better off starting with a clean, fresh, white canvas rather than trying to paint over an old picture that didn't work out, by first taking time to examine your naked rooms rather than immediately dividing your energies and focusing on all the individual elements that will later inhabit them, you'll be creating space to breathe. Once you achieve this state of open-mindedness, you can proceed with a greater sense of ease and adventure.

Having your own space is the greatest freedom. Ever since I moved into my first apartment in 1959, I've had a great spiritual affinity for personal space. While many people see space within its purely physical dimensions, scale, and proportion, I view space as infinite. While thinking this way is not a mandate for the decoration of houses, you may find it liberating to do so.

How can you train your mind to envision and contemplate emptiness in your space? How can you be as objective as possible? Begin by ridding your mind of fashions, customs, and ghosts of tradition, your neighbors' styles, and your friends' tastes, and sit on the floor of your space. If your floor is rough or dirty, sit on a cushion or pillow. By sitting alone, without the aid of a friend or professional guide, and opening up to your space, you'll be able to experience the vibrations and energy of your surroundings. As you take deep breaths, inhaling through your nose, pausing for a few seconds, and blowing the air out of your mouth through your lungs, ask yourself *How do I feel?* Where are you

on your "space satisfaction" chart, from being content to dissatisfied with certain things? Generally do you feel positive, or are you more discouraged?

Do you want to feel more physical and mental freedom in your own room? Can you look at a wall or ceiling and sense a new vastness? When I perform this exercise, the physical space I inhabit becomes more ample, larger than reality dictates because of the connection I've made to the world beyond the four walls.

As you continue to take deep breaths, turn clockwise, slowly, until you've taken in the whole space visually. Do you feel safe in your space? Where do you feel most comfortable? What is your view? Sitting on the floor, what do you see out the windows? If your windows are too high, chances are you're not getting as much natural light as you would if the windows were lower. What is the shape of your space? Do you envision any steps you can take to move toward improving it?

All space can be manipulated, and in the area of personal space, you can climb to the top of the emotional mountain with whatever you have to work with. Think of Michelangelo's block of marble speaking to him, leading him to know what the sculpture would become. By backing off and taking an objective view of your most subjective spaces, you'll be able to help your rooms reflect you, and in this process, both you and your spaces will increase in vitality, spirit, and well-being.

When you dream at night, you don't take notes before the dream begins. Once you awaken, you might take a few notes to help you remember your visions. Use this time contemplating empty space to conjure up authentic visions, and then write them down. Once you're able to appreciate your space void of any objects, you can begin to understand what is askew and make defining changes. But you must empty a room in order to achieve a resolution that springs wholly from your understanding of what will make you feel good after you've made the change. You must draw a parallel between your interior, spiritual space and your house's interior space. To attune to one, you must visualize the other.

"Expanding" Space

*M*y awakening to life occurred in a flower garden where I felt the energy from the colorful blossoms, and I've never been content in any space that wasn't in tune with nature. As an interior designer, I've come to appreciate fine craftsmanship, but the natural world remains my teacher. A beautiful hand-carved table doesn't inspire as much awe in me as a towering redwood. And as much as I enjoy a room sprinkled with a flowery chintz material, I'd rather be outside in a garden.

Space to call your own is expensive, and very few people can afford the ideal amount of square footage. Though your apartment or house may be tiny, with creativity and imagination you can make it ample to fulfill your needs by expanding your sense of wonder, awe, and adventure so you do not feel closed in. Given your limited interior space, it is important to understand and use the potential connection between your rooms and nature's expanse. Ideally, you have large windows that more literally connect you to the outdoors. But if you don't have huge windows with beautiful expansive views (few do), you must create the illusion of nature in your space.

The relationship between man and nature is integral to balancing your space so that when you're indoors, you have the elements from the natural world in your rooms. First, try to pinpoint the atmosphere and spirit of your favorite places and identify why. Think of some of your favorite natural settings. When you're there, whether on a mountaintop or looking out at the ocean or in a garden, what are the elements that attract you? Then envision your favorite man-made spaces. When you are in harmony with a walled-in space, what are the elements that make you feel good?

Also contemplate the interior spaces you like the least. When you are in a bland, depressing room, what is it about the space that bothers you? Was there sufficient natural light? Were there too few sources of artificial light? What were the colors? Did you feel claustrophobic?

Paley Park on East Fifty-third Street between Madison and Fifth avenues demonstrates how elements from nature can open up a small, enclosed space. Somehow, in this tiny space, bordered by tall buildings on three sides and a bustling street on the fourth, the landscape architect created a feeling of expansiveness. If you sit under the tall trees in

front of the man-made waterfall and listen to the pounding energy that drowns out your voice, you feel your spirit is being lifted to the sky above in this miraculous haven, not suffocated by the city's congestion, crowds, and noise.

I decorated a beach house where the same landscape architect built huge decks cascading to the sea below, leaving all the ancient evergreens on the deck, as natural umbrellas to protect people from the heat of the sun. When you eat meals on this deck, shaded by a majestic tree, looking out to sea, you always feel the heavens caress you. In both cases, the architect was able to create the infinite expanse of nature within a limited space. I approach every interior design job with this goal in mind.

FENG SHUI:
THE ART OF PLACEMENT

*I*n order to design your rooms to best suit your emotional and physical needs, you have to understand the invisible as well as the visible elements of space. The ancient Chinese art of placement, feng shui (pronounced fung shway), can help you to understand the powerful effect your surroundings have on your well-being beyond furniture styles and color schemes. Feng shui literally means wind and water, but represents the natural world as a whole and its rhythms, fueled by the flow of ch'i, the vital energy that connects man to earth and beyond. The goal of feng shui is to achieve harmony and balance with nature within our personal environments by maximizing the flow of ch'i.

According to feng shui, the design of your interior space should echo nature, balancing the Chinese five elements that contain all matter and together create ch'i: earth, water, fire, metal, and wood, with earth being the central element. When all these elements combine in a space, as they do in nature, they create a greater whole that becomes the space's aura. Their interaction promotes a direct connection between your own breath of life and the spaces you occupy.

By adopting metaphysical understanding of space, you can manipulate your rooms to trap and pool beneficial ch'i, enlivening the atmosphere. For example, through the skillful use of mirrors, it is possible to

reflect continuously the flow of ch'i ignited by either a window to the outdoors or a bouquet of fresh flowers. If you use heavy window treatments, such as elaborate curtains over a large picture window, you would be blocking the natural flow of ch'i in your space, creating a harmful, stagnant atmosphere that hints of death. If you have a long, narrow, dark hall, place a mirror at the far end to bring the positive energy of sunlight back into the space. Mirrors in the dining room reflect the joy of celebrating with family and friends and the beauty of the table and food.

The front door to your house, the threshold between your public life and your private haven, should be freshly painted and should not stick. Keep the outside and inside door knobs freshly polished. The entrance hall should be well lit, uncluttered, and cheerful. There shouldn't be any burnt-out bulbs. If you hang a picture opposite the front door, have it be a scene from nature so that you're drawn into its expansive beauty as soon as you enter.

To prevent valuable energy from escaping up the flue of a fireplace when enjoying a fire, you can "cool down" the space by placing a plant on the floor near the hearth or a pair of cachepots on the mantel ledge with trailing ivy. Or you can place a mirror over the mantel, a practice commonly used by Edith Wharton. Because she lived in a grand house with high ceilings, she was also able to place a painting above the mirror, in this case called a trumeau. If you would prefer to hang a painting over the mantel rather than over a mirror, select a highly polished marble facing for the fireplace so it will reflect light and positive ch'i.

In the living room, decide where the desk and reading chair should be, and create seating arrangements around this prominent area. While guests can sit anywhere in a public room, the occupants must have the most commodious location for themselves. Always place the desk as far into the room as possible with the chair facing the door so your back is against the wall. The same holds true for a reading chair because you need to feel secure and private when you are occupied in desk work or reading.

The practice of feng shui is most important in the bedroom because this is where you rest, dream, and love. The placement of the bed is key to feeling safe and content. Never place a bed under a low slanting ceiling. If you must store things under your bed, be sure they are objects you love. You should never lie on top of items that may give off nega-

tive vibrations, such as tax files, while you sleep. Keep all electronic equipment to a minimum in the bedroom.

Think of feng shui as the art of subtlety where the smallest change can make a huge difference in your vibrancy. Use white to suggest purity. Edith Wharton liked to use translucent tied-back white gauze curtains in her bedroom to give the space a light, airy feeling. Toilets should not be visible from outside the bathroom.

Never before in world history has there been a greater need to provide emotional security, serenity and inner peace, ease and contentment in a complex age of mind-boggling change. Many feng shui masters feel that by adhering to some of the fundamental principles of the art of placement you will tap into a higher level of awareness that will enable you to live more intuitively. Every action has a consequence, and there's a fundamental need to counterbalance the excess emphasis on superfluous consumption and outer-directed living. Realizing this reduces complexity, creating more harmony.

Feng shui empowers you to increase positive energy so you can live more vitally and experience greater health, prosperity, success, and happiness. If mirrors deflect negative energy and bring in light, why not consider using more mirrors, both decoratively and architecturally? If a worn-out, dirty, upholstered chair sends you negative energy, remove it, clean it, or recover it but don't live with it as is because it will continue to drain your energy.

If you love meandering in nature and are charmed by its gentle curves, keep this in mind when you choose the shape of a chair or table. Let your response to man-made objects speak to you on a deeper level. Always be aware of a greater need for sunlight and warmth, especially in a era seemingly dominated by cold technology and machines. Technology must be in the home to serve, not intrude. When you are in your study reading, it is wise to keep the television screen out of sight. Drape some quilts on a wooden rack placed in front of the television so your sense of tranquility won't be disturbed by the blank screen's bleak omnipresence.

You have probably intuitively practiced feng shui in your home. If a space feels right to you, you are relaxed and comfortable when you are within its walls and feel a sense of inner peace there, then you are experiencing feng shui. Have you ever entered a room and immediately felt off-kilter, though you cannot identify the source of your uneasiness

right away? I find this the case when I am in an apartment where an assortment of objects has been randomly placed around the living room with no general scheme in mind. On one side of a sofa there may be a table with nothing on it but dust, whereas on the other side stands another table with a small lamp, a framed picture, and a piece of porcelain. The blatant imbalance impedes my concentration and ease, even if it is not identified by the occupant. If the same two tables each had a similar lamp, then I probably would not have noticed, and instead would have glided into the room feeling welcome.

Certain spaces produce subconscious stress. I feel uncomfortable in "perfect" modern residential spaces, where every detail is rigidly correct, yet cold and impersonal. All lines are straight as an arrow, and all angles sharp as a surgeon's scalpel. But just as a superhighway may get you from point A to point B in record time, you may arrive at your destination with frayed nerves. Expediency isn't appropriate in the home.

According to feng shui, if you opt to take the long route rather than focus on speed and destination, you will be rewarded with positive ch'i. A wood-burning fire might involve more effort than turning up the heat, but the energy from the flame can increase your ch'i and vitalize your spirit and sense of contentment. A car is much faster than walking, but you may risk missing a beautiful landscape. I like spaces that slow me down. I want to be charmed, as though meandering along a country road or in a garden. Curves and other imperfections help slow your pace, and you can be enchanted only when you slow down enough to confront your *self* in the space. In the practice of feng shui, as in nature, there are no straight lines. They are considered harmful, allowing positive energy to escape too quickly. If you live in an old house, appreciate the lack of straight lines. These acquired curves and bends give you time and space to enjoy the transition from one experience to another.

BALANCING YIN AND YANG IN A SPACE

The practice of feng shui also requires balancing the forces of female energy, yin, and male energy, yang, in your personal space. Every person is made up of yin and yang energies that comple-

ment each other, also called harmonizing opposites. Nature's rhythms are dictated by the balance of yin and yang where one exists only in relation to the other, such as night and day, cold and hot. Your goal is to achieve the right combination, or balance, of yin and yang within your enclosed space, understanding you have to rearrange things so the space makes you feel good.

Often women tell me how different their tastes are from their husbands' and they seek my advice on how to combine lacy Victorian white wicker with heavy, brown leather club chairs. This is a very specific, literal example of yin versus yang. Try to prevent the domination of either male or female energy in your space, respecting the importance of a harmonious atmosphere for you and your spouse. Perhaps the wicker chair in the bedroom can have a heavier scale so a man will feel comfortable sitting in it, or you can add an appropriately proportioned upholstered chair more suited to a male's body. Or fussy white wicker could be replaced with natural rattan or stained green, and the brown leather club chairs could be spring green leather.

When two people share space, the yin-yang energies must be democratically distributed for mutual enjoyment. Intelligent compromises always make sense. When there is this mutual understanding of the differing tastes, including those involving scale and proportion, the challenge is always to find ways to make these tensions complementary. Through compassion and understanding, opposites are drawn closer together. Never let furniture or taste interfere with your relationship; focus on how you can coordinate your respective styles. Whenever one taste dominates, you risk the other person feeling left out, as if he or she doesn't belong. Most often the spaces that have been well thought out by two people working together are the most cheerful and loving.

By practicing feng shui in your interior environment, you learn that Shangri-La is here, around you and also inside you. You create spaces that have a pulse, that are alive and breathing vital ch'i. When you energize your rooms with increased ch'i, all the people who enter these spaces will benefit. The practice of feng shui helps you never to allow your spaces to become stale or uninviting to others. To learn more about the ancient art of feng shui and its mysterious, timeless wisdom, I recommend reading a book or two on the subject so you have a greater understanding of how to increase the essential ch'i in your space.

SHAPE YOUR SPACES

*N*o one can afford to be limited physically and emotionally by the dimensions of a space. The glory of a space is in understanding its potential. Two lovers on a deserted island don't need a huge hut because the entire world is theirs—the sky, the water, the beach, the mountains. The *allness* is apparent everywhere. Two people tenderly entwined don't tend to complain the bed is too small. Whether you live in a mansion or a studio apartment, you can create a space that uplifts the human spirit and is welcoming to others. Even in grand houses, poor feng shui can make you feel confined and anxious. But if you use inspiration from nature, you can turn a one-room living space into a sanctuary, your private world, so that when you're there you feel you've truly come home. Some of the coldest houses with the least soul are the largest, so size and money are not issues. When you love your home and want to share it with others, the love is always felt and happiness is forthcoming.

A room that overlooks a seascape taps into infinity and the energy of water, wind, and timelessness. And when you're not able to look at water, your awareness that it is there, your ability to remember and carry with you accumulated memories enlarges your spirit and eliminates emotional barriers. You can find ways to improve your imagination and open up to an internal alchemy so your space becomes a personal harbor you dream about when you're not there, a place of inner peace.

You have all the space in the world. There's no need to feel constricted in any man-made space. Walls protect you, but they should not make you feel constrained and uncomfortable. There are infinite opportunities to transform your spaces into experiences that go beyond physical dimensions. But first you have to move beyond the physical matter in a space to recognize the invaluable living, breathing energy in the space itself. What you cannot see is what truly makes a house a home.

As you gaze at your spaces, ask yourself some questions. What attracts you? What evokes memories of happy times? What are your aspirations for your future path? What are the things that provide you with a sense of unity and emotional nourishment? Whatever you put in your space should be something you are attached to in order to give the space your unique life. Perhaps it's pictures of your family, quilts, flowers, or paintings or prints by favorite artists. Enveloping yourself in the objects

you've selected over the years brings you solace as warm memories of their provenance flicker in your mind. You remember the scenes, the vacations, the auctions, and the galleries, and you feel you're among friends and loved ones. The sense of continuity and nostalgia enlarge your spirit.

While I'm well aware that a lot of people want their house to make a statement about their wealth and power or presumed social status, these houses are not homes. When you have a library filled with treasured books, when your living room is alive with treasured possessions, you are experiencing the art of living, where everything connects to a mysterious whole, and your space is a visual autobiography of your own life and extends to those you love.

There is no single, correct way to think of or arrange space. You must uniquely customize it so it changes and evolves gradually, naturally. Your space helps you chart your course and steer your path. Spaces should charge you with an abundance of energy as well as soothe your spirits. Every space is a retreat, a haven, a dream as well as a reality. Your desire for tranquility, privacy, comfort, and beauty can be achieved through inspiration, light, and color. Whether you're in a small, one-room, rented apartment, share a college dorm room with a roommate, or live in a large house, spaces should speak of and to you. You will always exist in space, and what you surround yourself with will influence your health, work, success, leisure time, intimate relationships, and well-being as well as your sense of graciousness and hospitality. Claude Monet loved to share his garden with friends. After one visit, Edgar Degas commented, "Monet made only beautiful decorations."

Let the decoration of houses begin with a meditation on space, and the flow of loving energy you bring to each area will add up to a transformation of the whole spirit of your space. Bless all your spaces with your vital energy *before* you begin to fill them with tangible objects. The more vibrant your mind and imagination, the more radiant your spaces will become. It's time to get up, get going, take a few notes, and shape your spaces.

Scale and Proportion

*The elements of proportion and scale are
necessary before decoration is applied.*
—BILLY BALDWIN

DEFINING SCALE AND PROPORTION

Before filling your space with furniture and other objects, you must become familiar with the concepts of scale and proportion, the two defining principles behind designing an interior space. Scale and proportion are what bring a room and all of its elements—windows, furniture, fabric, window treatments—together to form a whole. If a room lacks proper scale and proportion, the atmosphere will be unsettling. But when these elements of design govern a space, they possess a subtle refinement that brings with it a charming cohesiveness. The goal of this chapter is for you to identify, appreciate, absorb, and create ideal scale and proportion in your rooms so you feel they are truly housing *you* in the most embracing way.

It's important to grasp the meanings of scale and proportion before using them as tools in the decoration of your house. Scale relates to the size of a room and of all the elements within a room. The scale of rooms and objects is only relative. If a room or object is larger than "average," then it has a large scale; if a room or object is smaller than "average," then it has a small scale. For example, the average size of a coffee table is approximately twenty by thirty by fifteen inches. Anything wider or deeper is considered large scale; anything smaller is small scale.

Classical architects and designers have always argued that large-scale

rooms should contain only large-scale objects, and small-scale rooms should contain only small-scale objects. I prefer to be more flexible. For instance, I find that in a small room, often a few large-scale pieces are more appropriate because they "enlarge" the space. Having a room full of small-scale objects may make you feel as if you're in a doll's house. In large-scale rooms, often it is wiser to set up three or four human-scale seating areas rather than trying to fill the room with large-scale furniture because it creates a more intimate, comfortable feeling. It is necessary, however, to adhere to one scale within a single room. A petite side table will be dwarfed by a large sofa or upholstered chair, and a collection of miniature porcelain objects or enamel boxes will be lost on a large coffee table.

The function of an object will in large part determine its scale—how big or small it should be. The proportions of an object, however, are determined by its shape, form, line, curves, and design details that give it distinction. Every object in a house, from a vase to an armoire to a door, has either graceful or awkward proportions depending on these factors, regardless of scale.

Proportion is a less technical concept than scale, pertaining to the overall form of an object rather than to its actual size. An object with good proportions has dimensions, lines, and curves that work together ideally to create a whole that is pleasing to the eye. A room with good proportions is neither too long for its width nor too high-ceilinged for the size of its floor. Often, deciding whether an object or room has good proportions needs an experienced eye. Edith Wharton warned her readers about the complexity of this elusive study: "The essence of great styles lay in proportion and the science of proportion is not to be acquired in a day." All eyes, however, appreciate good proportions even if only subconsciously. Whenever something is sublime, I believe it is universally recognized.

COMBINING HUMAN SCALE AND THE SCALE OF YOUR ROOMS

How to combine human scale with the scale of architecture is a primary consideration in the decoration of houses. Human

scale should guide you as you plan what to put in a room. If you are above average in size, you need above-average-scale furniture in order to feel comfortable, regardless of the scale and proportion of the space. If you are petite, you will naturally be drawn to smaller-scaled furniture so you won't feel dwarfed. Because large people enjoy overscaled furniture and objects, men tend to have bolder-scale possessions than women, though a tall, large-boned female would rarely select delicate dainty furniture because it would make her feel awkward. A female designer was asked to create a miniature exhibition at an auction house and she turned it down because she simply couldn't relate to tiny things; they made her feel gargantuan and clumsy.

When a house is lived in by a man and woman, it's necessary to strike a balance so the furniture and objects are in the average size range. One couple bought a small apartment, and while the husband was away on a series of business trips, the wife decorated the space with diminutive furniture. She is a little over five feet tall and small-boned. He, however, is well over six feet tall and heavyset. He felt like a bull in a china shop and regretted not taking the time to help with the furnishing of the apartment. But if you're in the house of a small single woman, the dimensions of the pieces she selects will invariably be smaller than average, just as a bachelor pad will undoubtedly have a larger scale to the furniture and objects.

If great care goes into selecting clothes that fit properly, why shouldn't the same thoughtful consideration go into choosing the scale of the objects you choose to decorate your house? Even something beautifully designed can be all wrong for you if it is not compatible with your appropriate scale. This object by itself can also throw all other items in a room out of scale, creating an unsettling feeling.

In decorating your house, try to stay within the average range in scale, making variations when they are conductive to your human scale. Public spaces, such as museums and city halls, are monumental in scale to accommodate crowds of people. In a house where people live, eat, bathe, sleep, relax, and love, the scale of the elements that make up the whole should represent the scale of the inhabitants. A house with tall parents and tall sons looks different from a house where the parents and children are shorter than average. Even though these scale differences may be slight, you do see differences from household to household.

Scale is also affected by the spirit of the space. The more formal and

refined the space, the more delicate the scale in most cases. The more casual the atmosphere, the bolder the scale. Once you establish a scale range, then you generally have to stick with it because if you go too far in either direction, you will throw off the balance of the space. It is far safer to have a comfortable human scale that accommodates most people. Extremes of scale are difficult to reconcile in most people's houses.

COMBINING SCALE AND PROPORTION

*P*roportion and scale go hand in hand. Once you understand that you want all your furnishings to be more or less on the same scale to create a harmonious whole, you can focus on the proportions of each object and their relationship to each other. All objects have both scale and proportion that influence their visual and emotional effect on us. Think of a chest of drawers: The piece of furniture itself has a bold or refined scale, and the individual drawers should be in proportion to the scale of the entire piece. The hardware, knobs, or latches in turn must suit the scale of the individual drawers. All of the individual elements of the chest of drawers suit a single scale and should be in proportion to each other. Just as individual objects need pleasing proportions within themselves to delight the eye, in a room, all objects should be in proportion to each other. For example, if the shapes of the backs of chairs are repeated in a room, you will experience greater harmony than if each chair is of a different design. Even upholstered furniture can have similar proportions so the repetition of shapes helps soothe the eye.

Scale and proportion and their interrelationship can be difficult concepts to grasp if you have never studied architecture or interior design, though for architects and interior designers these concepts must become second nature. A decorator also must always bear in mind the scale and proportion of the room's architecture while simultaneously considering the scale and proportion of the furnishings in order to ensure that all the elements of the room harmonize.

A room can contain furniture that is the wrong scale and in bad proportion. A table can have a lamp whose proportions look clumsy, but the same lamp can look attractive on a different table. You can have both

large and small tables in the same space, but for them to harmonize there must be some consistency in the scale of their design. If some tables have pencil-thin legs and others have bulbous, heavy, oak legs, the contrast will make them incompatible in scale and proportion. As elusive as these concepts may seem, they are the blueprint that brings the room scheme its integrity.

A room by itself has a certain scale and proportion, regardless of your human scale, and in some cases you will want the room's scale to dictate the appropriate scale of an object. In a university president's office, a grand twenty-by-twenty paneled room with a twenty-foot-high ceiling, a giant three-foot-tall blue-and-white Canton teapot adorned the top of a bookcase. If this teapot had been placed on a tea table in the same room, it would have looked ridiculous because of its exaggerated scale, hardly suitable for serving tea and much too heavy for a small table. But because the overscaled object rested in a spot where it had a prominent relationship to the room's grand architecture, it was appropriate in scale and proportion. Placed high in the room above shelves of art books, the giant teapot served its ornamental purpose well.

Walk around your house, stand in front of each table, including any round and oval tables, and evaluate the scale. Measure a table or two and jot down the dimensions in your notebook to become familiar with the relationship among length, width, and height. Now measure the thickness of the legs and the depth of the apron. Do you feel there is a good relationship between these few tables, one to another? Are they in proportion, one to another? Look at the objects you have placed on the tables. Is each object generally in the same scale? Are these items in proportion, one to another?

"THE GROUND RULES"

\mathcal{E}dith Wharton wrote in *The Decoration of Houses:* "The architect and decorator are often aware that they are regarded by their clients as the possessors of some strange craft like black magic or astrology." The backbone of interior decorating, however, is purely logical and thousands of years old, and that is a commonsense understanding of the classic scale and proportion that dictate order and symmetry.

Edith Wharton wrote, "Proportion is the good breeding of architecture. It is that something, indefinable to the unprofessional eye, which gives repose and distinction to a room . . . in its effects as intangible as that all-pervading essence which the ancients call the soul."

When John Barrington Bayley was president of Classical America, a nonprofit organization that promotes the classical tradition of the arts, he admitted taking a "decidedly partisan view: tradition lays down the ground rules, and they are an expression of what life is all about. One of civilization's tasks is to find rituals which give human existence significance. The rites of daily life are ritualized by *suitable* rooms. . . . These are the ground rules."

The most basic example of logical scale and proportion is the human body. Though people come in all shapes and sizes, a single body has a specific scale made up of symmetrical parts that are all in proportion to each other. It is this fundamental logic that we want reflected in our rooms for a comfortable atmosphere.

To achieve the goal of appropriate scale and proportion in your rooms, seek out spaces that have pleasing scale and proportion and study their elements. One advantage trained architects and interior designers have over nonprofessionals is the constant studying of the finest rooms. Study the Renaissance architecture of Andrea Palladio, who believed in the virtue of twenty-foot-square rooms, to teach yourself about the rules and effects of beautiful scale and proportion. The great houses of France, Italy, and England work so well because the scale and proportions are seamlessly married. Or seek inspiration from ancient Greek and Roman architecture, classical American and English eighteenth-century furniture, or the austere objects handmade in Shaker villages. My favorite room shape is an ample rectangle, where the width is approximately eight to ten percent less than the length. A room that is twenty-two feet long and eighteen feet wide is generously and gracefully wide in proportion to its length. Generally, the larger the room, the taller the ceiling. A nine-foot ceiling is a graceful height for most rooms.

Architects and decorators open up to forms, orders, and elements in spatial compositions, absorbing as much classical architecture as time and money allow. Through scale drawings, continuous study, and hands-on experience, they have developed great respect for the subtle charm created by proper scale and proportion of space and furniture. If you fail to take notice of the scale and proportion of a space, chances are the

designer of the space paid very close attention to these elements. It is when the scale and proportion are "off," following an illogical, awkward pattern, that you most often take note because you are instinctively uneasy, feeling that the structure is impermanent and unstable. The ceiling may be too high for the floor area of the room, making you feel alone among skyscrapers; the side tables may seem to be miniatures beside a large sofa and therefore too fragile to place anything on; the bulbous, brass table lamps may appear to be crushing the small tables underneath them.

No aspect of a room, whether in its dimensions or in its furniture, can be considered alone when you determine a decorating scheme for a room; each measurement and the design of every object work in relation to everything else.

ESTABLISHING THE SCALE OF YOUR SPACE

*Y*ou determine the scale of a room by studying the dimensions of its permanent elements. Measure the room's dimensions, including the ceiling height, and write them down in your notebook. Now study the size of the windows, the height of the doors, the width of any other openings, and the height of the baseboard, as well as how wide the floor boards are. How would you describe the room's scale? Is it bold, grand, and large? Or is it small, diminutive, and petite? Once you assess the room's size and scale, you can determine whether you want to scale down or scale up the architecture in the room, trying to stay in most cases in the middle or average range whenever possible.

Before you can draw a floor plan—a chart drawn to scale detailing where your furniture will be placed in a room—or choose and install any architectural elements, such as a cornice molding or overdoor, you need to establish what scale you feel comfortable living with. Once you set a scale true to yourself, you can design your space, choosing everything from architectural elements to furniture to decorative objects accordingly.

Everything should relate to the particular scale based on your physical size as well as your cultural and aesthetic preferences. If you want

to set a scale for your space, I suggest you start carrying a tape measure with you. I've carried a small six-foot spring tape measure in my purse for forty years and I'm astonished at how this simple habit has helped train my eye. Wherever I am, I can whisk out my tape and quickly check a dimension. This way I become more familiar with standard proportions, gaining a sense of the volume, projection, and impact of objects and how they work together to create harmony in a space. Just as every color has thousands of different shades, there is an equal number of distinctions in line, form, curves, and shapes that your eye will become more attuned to with experience.

No space needs to feel too cramped or confused. The details and the embellishments you judiciously add can compensate for any structural flaws or limitations in square feet. You can create a "larger" space by paying attention to the interrelationships among the room's permanent and movable elements so there is a flow that pleases the eye. A small room can have brilliant white walls, repeating the white in the curtains so the eye is drawn beyond the wall's physical constraints. Have all the furniture be consistent in design in a small room, and consider covering all the upholstered furniture in the same fabric.

As you work on your house, remember how important one sixteenth of an inch can be. If you have delicately decorated, hand-painted four-inch-square tiles in the bathroom, the tighter the joint (the space between the set tiles), the more refined they will look when set. But if this elegant, graceful tile is surrounded by one quarter inch of grout, it will be as unsettling as a dessert plate with a huge chip in it. If you install a pair of brass pulls on the bottom of your old windows in order to raise them more easily, you have to take into consideration the size of your fingers or you might pinch them when you shut the window. By sanding the end of a wooden counter, you can line it up exactly with the wall.

A good command of scale and proportion helps you bring your room interiors into a cohesive whole where you stop fighting boundaries, and you feel more comfort, intimacy, and luxury. Grace in space and matter is created by understanding complementary relationships, one shape to another. Everything should make a meaningful contribution, helping the overall scheme.

Before you create your personal master plan, you need to do more homework. The pioneer architect of institutional spaces, Louis Sullivan,

coined the phrase "form follows function." Scale and proportion are form. They should suit the intended function of the room. What style is most suitable for your life? What are the best shapes and structures for the objects in your life? Think of scale and proportion as the nucleus of space, the core of everything. Whether you have a sharp right angle or a rounded corner matters.

The scale and proportion of your possessions will fit better as the years inform you. Look for the clues and connections. The scale of your life, your self, your house, and your possessions are all one. As you move from house to house, and when you find yourself in transition, find comfort in the fact that your possessions are compatible with your spirit, and that their scale and proportion will fit in wherever your life takes you.

The only way someone can teach another person to develop personal style is to help them to see with more nuance. There are subtle differences, gradations that affect the whole. Just as large earrings can overpower a petite woman's face, oversized, elaborate hardware on a small-scale piece of furniture obstructs appreciation of its delicacy. Refinement is always in subtle detailing and understatement. Nothing should ever overpower or be overdone.

If you have one chair you feel comfortable sitting in, measure its height. Ideally, the chair and sofa seats should be the same height so everyone is democratically situated in the space. If you want to make someone feel awful, ask them to sit in a chair whose seat is two to four inches lower than yours. If a child doesn't have his or her own chair, add cushions to the sofa or chair seat to bring them up to your level. Children usually like to be at the same height as adults.

Start with one favorite piece of furniture. Have this object instruct you about your other selections, setting you on your course. If you have one end table, you will want another to be compatible in scale and proportion. Heights of desks, tables, and end tables usually vary from twenty-seven to thirty-one inches, and while you don't need exact pairs, there should be some continuity. You can have some higher desks and tables and some lower ones, but there should be a measure of evenness that suits your eye.

No piece of furniture or object exists in isolation. A pair of wing chairs or a camelback Chippendale sofa looks wonderful with a twenty-six-inch-high tea table, but a low-back modern sofa with this same

table would look awkward, out of proportion. A high table looks best against a solid wall, whereas a lower table is attractive floating in a room. Picture solid pieces against solid walls, and light pieces floating in space. Consider the yin and yang energies of dark and light, solid and open, and you'll be on your way. Next to a love seat skirted to the floor you can have a large but delicate tray on a narrow leg base. If you have a draped end table, the sofa can have wooden legs. If you have a pair of wing chairs with exposed legs, you can have a trunk or chest as a coffee table.

The scale and proportion of your possessions will determine how many things you will be able to fit in any given space. The larger the scale of your furniture and objects, the bolder the look. Always remember to consider the relationship of your furniture to your decorative objects. Massive rustic furniture doesn't want little bitty things on or around it.

Objects look different depending on where they are placed. By picturing your space as well as your objects from different angles, both sitting and standing, you will get a truer sense of the whole. The view as you enter a room should delight the eye, but you should be equally satisfied seated at your desk at the far end of the room, looking toward the entrance. Just as a work of art with good composition can be turned upside down and still have balance, you should be able to stand, sit, and lie down in a space and feel soothed by the proportions and harmonious scale. All slices of the layer cake should taste delicious.

SOLVING PROBLEMS OF SCALE

You may have inherited a huge sofa or sectional or other large piece of furniture that simply does not fit the scale of your place and is not in keeping with your other things. The white elephant throws off the room. How do you deal with the awkwardness? How can you minimize something that is noticeably bulky in relation to your other pieces? If the shoe doesn't fit, don't force it on your foot. An overpowering object that you don't like will be a continuously negative note in your space. Can it be cut down or reduced in height, depth, or width?

A few years ago a client moved from a large, architecturally grand

apartment to a modern, bland space with low ceilings. After installing cornice moldings and hanging hand-painted Chinese floral paper with a yellow ground, we discovered that the client's huge mirror hung two inches below the edge of the sideboard, forcing us to move the sideboard out into the space, rather than having it touch the wall. It looked awful. The first thing you saw when entering the room was this large piece of furniture, and the gap behind it with the mirror hanging down looked extremely awkward. We decided to wait until all the furniture had been placed before figuring out a solution.

We had several options. We could raise the mirror by hanging it over the cornice molding, but then this huge glass would appear to tilt over us into the room and make us feel uneasy. We could remove the cornice molding behind the mirror, but that is always a last resort because the break in architecture would disturb the eye. Besides, we needed the cornice to cap off the traditional wallpaper in a room full of antique furniture. Rather than attempting to cut down the old mercury mirror and risk shattering it, we chopped two inches from the legs of the sideboard, put them in a Ziploc bag, and stored them in one of the drawers behind a stack of napkins in case a future generation wants to reattach them.

Miraculously, in this small dining room, the reduced height of the serving piece proved to be a blessing. The diminished height difference between the dining room table and chairs and this large antique sideboard improved the proportions of this small-scale room where the pieces of furniture are in close proximity to one another. It's all a matter of perspective. If a sideboard is eight or ten feet away from a dining table and chairs, then a substantial height difference would look more harmonious. The eighteenth-century sideboard was obviously designed to be in a grander room.

If a sofa back is too high, consider placing it perpendicular to a wall, rather than going to the expense of having the back cut down, replacing the legs with round bun feet, and placing a piece of foam rubber under the cushion so the seat won't be as low. Repeating a fabric pattern also can minimize the size of a piece of furniture.

I was called into a house outside Philadelphia to help with the furniture arrangement, but for the first time in more than thirty years I felt I couldn't fix the problem. The couple clearly didn't like the house because they felt it was much too small for their energetic children. Out

of pure frustration over not knowing how to decorate their long, narrow living room, they bought one nine-foot-long taupe leather sofa and one gigantic blue leather chair. Other than a baby grand piano, a huge black television set, a pine coffee table, and lots of toys, there was nothing to work with. To make a bad situation turn to horror, a support column in the middle of the room cramped the space and robbed it of any feeling of openness or flow.

The owners informed me that the furniture was bought drastically reduced at a department store and claimed, "We hate this house and want to live in a bigger house soon, so this furniture is really for our next home." If the huge taupe sofa and blue chair had at least been covered in the same material, the look would have been less offensive to the eye. Because the room was so narrow, the sofa could only fit against the long wall, making you feel as though you were sitting in a narrow hall or waiting room. By slipcovering both the sofa and the chair in a French provincial small-geometric-patterned cotton, we integrated the furniture with the space as best we could.

Feng shui, the ancient art of placement discussed in the last chapter, will also help you to place everything favorably. If a sofa looks heavy sitting in the middle of a room, it will block energy. Unless a sofa is the right scale and proportion for the room, it should be placed against a wall. Furniture placed centrally in a room is viewed from all angles, so be sure that the back of a love seat, sofa, or chair placed in this way is soft looking, not too angular.

If the scale and proportion of your furniture is well integrated, you can continuously rearrange your things, moving your sofa, chairs, tables, and stools so the room accommodates your current needs and feels right. If something is graceful, it will look pleasing in different locations. Your arrangement of furniture may feel different to you depending on what time of year it is, so you should always feel free to rearrange your pieces into a setting more conducive to the season.

In the winter months, placing a table in front of the fireplace with additional chairs invites anyone who enters to enjoy the warmth and energy from the flames. It also provides a cozy place to enjoy a bowl of soup and salad. If you do this, be sure to keep your fire burning, because sitting near a black, empty hearth does not create a joyful atmosphere. On cold snowy evenings, you can eat supper in the private haven you've created around the fireplace in the living room.

In the spring and summer, you can create a seating area near the windows so you can enjoy the warming, natural light. Moving furniture around will give a room a different feeling and allow you to enjoy greater flexibility. Sometimes I suggest switching the end tables around so you see them both with a fresh eye.

Many people prefer to always have the same furniture arrangement, but every time you go to their house it feels fresh and alive because it's brimming with flowers. Vases whose top diameter is twice that of the bottom allow flowers to be held together at their base, but then fanned open at the top, exuberantly spreading their blossoms in all directions. Some people have a scale that is bold and handsome, and a plan where nothing is ever randomly placed. A pair of cachepots on the mantel filled with white azaleas is bold and classic. A pair of trees on either side of a bay window is striking. Order and symmetry as well as the fine art of placement play key roles in scale and proportion.

Think about people sitting in the chairs, on the sofa and love seat, and on a bench or ottoman. The way to group furniture should be based on people being able to have intimate conversations without straining to hear each other. In a large living room, there may be three or four different places where groups of people can sit comfortably and visit. Several seating areas also warm up a large room and make it feel cozier because it is arranged to fit the human scale, a much better alternative to overscaling furniture to fit a larger room.

EXCEPTIONS TO LOGICAL SCALE

*S*trict logic does not always apply in a proper scale in furnishings. There are other psychological factors at work here. An Asian couple who are my clients are both under five feet tall. In airplanes, their feet don't touch the floor. But these same clients enjoy large rooms filled with large-scale furnishings; they feel claustrophobic in small spaces. As Easterners in the West, they've adapted to the scale of Westerners. Their high, four-poster bed has to be accessed by a step stool. But this scale, though it does not logically conform to their physical size, provides emotional comfort for them.

Interior designers shouldn't be too quick to walk into a house, mea-

sure the rooms, and draw up a floor plan at a one-quarter-inch scale, room by room, without knowing what makes people feel comfortable in a space. I'm continuously surprised by the needs and wishes of clients, but by spending time with them and by observing their habits—how they walk around a space, where they sit, how they lounge—I understand their specific desires and help them accordingly. I always ask a lot of questions, to further learn about their preferences and taste.

The CEO of a large public company loves to lie down in his family's sun room because he spends most of his professional life sitting at a table in a board room. I placed a large tufted leather bench in the center of this room, with a sausage neck roll at each end so he could lie either way and have a foot rest. This shape on a floor plan looks completely out of proportion, but, in reality, because it floats on thin chrome legs and has no back or arms, it's light enough to suit the dimensions of the sun room and be proportionately compatible with the other furniture in the room.

All exceptions to scale require careful study and consideration. Anything extremely small in scale or very large and heavy will throw off the harmony of the space if it is out of proportion. If you want the eye to be drawn to one magnificent, large object, place it in the center of a wall, and have smaller-scale, but unified in proportion, pieces surrounding it. One wonderful, bold-scaled item in a room commands attention. Eleanor McMillen Brown's famous love affair with a red-lacquered Venetian secretary is a good example. This piece was dramatic and theatrical, covered with gold detail, and the red was electrifying. She kept the upper cabinet doors open, exposing the beautiful intricate details of the interior, so the piece appeared as though it were spreading its wings. Once this secretary was in place in her drawing room, the scale of the other furnishings appeared smaller. Because of the presence of the cabinet, they became more subtle in design and decoration, calmer and less ornate. This one piece transformed the space.

If you find an object or piece of furniture that you absolutely adore and feel a special connection to, the question of where to put it or whether it fits the scale of your home become secondary issues. You will always find a place for the things you can't live without.

Clients were bursting at the seams in their Chicago apartment. They were practically tripping over each other and all their possessions. Their grown children wanted them to save *everything,* and they felt as though

they were living in a warehouse. Their weakness was auctions. One Saturday afternoon they went to Sotheby's for an important estate sale. They couldn't sit together because it was so crowded. When the wife learned her husband had bought a large eighteenth-century farm table, she couldn't believe it. At first she thought he was crazy. "Hugh, it's beautiful, but we don't have a dining room. Where are we going to put it?" After many discussions, she regained her Zen. How ridiculous the scale of this table was, stuck against the wall of the library in their apartment, the only place they could mange to fit it. But it was a subtle push for them to find a fitting home for it. Within a year they'd bought an old farmhouse where they have shared many long, leisurely meals in the dining room around Hugh's beloved old farm table.

Scale and proportion are affected by color, form, texture, and design, as well as by adoration. When you love something, just as when you love someone, a bulge here and there or a less-than-ideal scale doesn't matter in comparison to the positive energy you feel in cherishing it. Try to establish some consistency and order in your personal scale, and then be open to interjecting into your life some drama or surprises in scale. If an object is important to you, there's a reason. Even if you fall in love with a "scale reach," something that doesn't really fit into your space, go for it.

Always remember who you are and, as you plan your space, don't get too caught up in conforming to the house's scale. One of the most expensive decorating mistakes people make is scaling furniture to specific rooms, using large-scale furniture in large rooms and scaled-down furniture for smaller rooms. Both extremes are inappropriate because they lock you into where certain furniture can be placed. This presents problems when you move into another house. White elephants are large and expensive, and a burden to have to store in a warehouse because they don't fit anywhere in your new house. It is best to buy furniture you like, that you will be able to put together in a variety of rooms in the years ahead.

Even if you hire an architect and interior designer to draw up your floor plan, pay close attention to the scale and proportion of your rooms. One of the highest-paid executives in America neglected to study the scale of his new bathroom design. The architect could have done anything in the space, but chose to place a five-and-a-half-foot bathtub along the end wall, neglecting to take into consideration that

his client is more than six and a half feet tall. A longer tub could easily have been placed along one of the two longer walls in this room.

Even after decades of decorating I made a scale mistake with a client in Texas. Together in New York City, my client and I went to a favorite antique shop and bought several tables and lamps for her library. This shop also sells new coffee tables in a classic Chinese design that are wrapped in linen or fine rattan before being custom lacquered. The tables could be ordered in several sizes and shapes, and we selected a thirty-six-inch square, the exact size I had scaled for a table on the floor plan. We picked a shrimp color and felt quite pleased with our selection. But after the table arrived, my client called to tell me the table was too big. I couldn't imagine what was wrong. Her floor plan showed that the table sat in front of a seven-foot-two-inch-long sofa, and had to accommodate two armchairs on either side. If anything, I thought, the table could have been larger.

For hours I studied the client's floor plan, a photograph of the table, the lacquer sample, and the fabric scheme. I simply could not figure out the problem. Finally, I spoke to my client's daughter, for whom I had also done design work. She explained to me that though her mother thought the table was gloriously beautiful, it was all out of proportion with the house and her possessions. It diminished the delicate, feminine objects that adorned the library, including a collection of fifty miniature Staffordshire cottages.

The rules of logical scale and proportion did not apply in this case. I'd overlooked the scale that had been established by her vast collection of small objects, so the Chinese-style table looked uncomfortably chunky even though its dimensions were the right proportion on the floor plan. We found a more delicate, lighter, thinner model and started from scratch.

One rule of decorating is that when you change one thing, you have to change everything. The shrimp lacquer of the original table would have looked vulgar on this more refined, slender-legged form, so we selected a tortoise-shell finish that had as much delicacy as an enamel Fabergé egg. I learned my lesson the hard way: Floors plans don't always give a complete picture of scale and proportion. The scale of the objects on the surrounding tables and bookcases will affect the overall picture in terms of pleasing your eye.

How to Accommodate Others in Your Spaces

The Museum of Modern Art in New York City had an exhibition in the seventies I will never forget. The exhibit featured furniture in giant sizes to awaken us to what a baby sees crawling around on the floor.

We're all unique in size, taste, and sensibilities. No one is really average. Many of us are married and have children, so our lives incorporate old and young people of different sizes and proportions. How can our rooms accommodate this scale range without sacrificing cohesiveness and harmony? Scale must relate to people and space, and, in most cases, you will be able to adequately satisfy both. But at some point you may be challenged, and I suggest that if you have to err on one side, create a human scale. Always keep in mind who will be spending the most time in these rooms, and plan accordingly. It doesn't seem appropriate to sit at a thirty-inch-high kitchen table with a chair that measures twenty-one inches from the top of the cushion to the floor if you have short legs and your feet won't touch the floor. I'd rather sit at an island on a high stool with a foot rest if it were my kitchen. Or I'd cut the legs of the table down to twenty-six inches and then cut the legs down on the chairs to a comfortable proportion.

Creating Symmetry Without Monotony

As you establish your preferences in furniture design, you will most likely discover a repetition in shape that naturally creates harmony. If your antique chairs all have oval backs, they'll look graceful from front, sides, and back. Be it an armless chair, an armchair, or a bergère with fabric-upholstered sides, as a group they will offer variety without confusion.

Don't be a perfectionist when it come to scale, because rooms that have the best energy exude subtle nuances that save them from being rigid and dull. The eye needs stimulation, and too much "matchy-matchy, blendy-blendy" lacks vibrancy. Having a table at both ends of a

sofa makes sense so there's a place to rest a book, teacup, or glass. If there's a lamp to one side of a bed, who wouldn't want to claim that space? We're drawn to soft, charming, cozy places. Symmetry is achieved by having two end tables, but they don't necessarily have to be a matched pair. Two different tables with similar scale will look in proportion and add interest and vitality.

When you are sitting in a sofa or chair, the table next to you should be a few inches lower than the arm of the furniture. Your eye is pleased when there is a graceful transition from where your arm rests to the table where you rest your drink. You want to feel at ease in a space; you feel awkward if you're nervous about spilling something.

Understanding the nature of relationships between objects begins with training your eye. Certain master designers can go up to a table, move one object two inches, and give the room an enhanced look. They understand the need for the eye to experience some tension between the objects in a room. They may place a book so that it hangs over the edge of a table, ever so slightly, catching the eye's attention. Your interest is captured by the tension, but it's not so extreme that you feel the object might fall off.

EXPANDING YOUR VISION AND REFINING YOUR SENSE OF SCALE AND PROPORTION

As you work on your personal spaces, you will become more acutely aware of their energy and how to maximize it, absorbing clues from all you experience. Remember that everything is connected, and your spaces are all an expression of you, integrated through your heart and mind, soul and body.

When you go to a museum, look for ways to refine your sense of size and form. When you look at a master painting, become enveloped in the space. Ask yourself: How tall is the ceiling, how wide are the windows, what is the diameter of that vase? Study all the details so you bring ideas and inspiration home. Through your enthusiasm you will absorb the teachings of scale and proportion great art can offer.

You can't touch the objects in museums, but the rest of the world

can be your laboratory. When you see a great floor design, measure the length and width of the pieces that make up the pattern. You never know when this information will come in handy. The height of a chair rail should relate to the height of a chair back so the chair back rests against the wood molding, not the wall. If you are in a hotel lobby and the chair you are sitting in is uncomfortable, risk public embarrassment by measuring the height of the arms—they are probably too high, not allowing your arms to relax. When you look at a teacup and saucer, examine the proportion of the saucer to the cup and handle. Notice the shape of a bottle, a glass, a sink and faucets. If something is too low or too high, too big or too small, or too anything, register it in your mind.

Some imbalances are so obvious, you smile in recognition, while others are more subtly disturbing. A table's pedestal base can be too bulbous for the three-quarter-inch marble top it supports. A vase lamp with a shade can take over a table, overpowering it visually. A few tiny objects placed on top of a large coffee table look lost. A delicate open armchair will look flimsy pulled up to a contemporary round drum table, solid and heavy in appearance. A gigantic hip-high terra-cotta pot for an indoor tree is attractive if a room's ceilings are high, but the same-sized container in a low-ceilinged room would dwarf the space.

If a bedroom is tiny, put fewer, well-selected pieces in it. The size of the bed will set the tone. I once decorated a small bedroom for a bachelor who wanted a queen-sized bed. Rather than having the room feel cramped by such a large bed, I suggested he have a dramatic four-poster bed that would draw the eye to the height of the center of the space rather than keeping everything low, with the only height being the headboard against a wall. He selected a bed with posts that look like tree trunks. By painting the woodwork white and the walls and ceilings atmosphere-blue, covering the bed in white sheets with a blue, green, and white coverlet and a companion crib quilt above the headboard, we made the bed appear to be floating in the sky, and the square space's scale seemed to enlarge to accommodate this spectacular bed. Not all small bedrooms are limited to a daybed. If you're going to have a large bed in a small room, rather than trying to hide it, be bold.

Remember that everything you bring together will have to go together. The scale of your dining room table must relate to the chairs,

and eventually you will select dinner plates in keeping with the spirit of the other objects in the room. When recently married clients selected a silver pattern for their home, they chose the most simple pattern in the largest scale. Their forks are actually meant as serving forks, but they love the elegance of their scale because it suits their large French country dining table. They also enjoy balloon glasses, so one scale complements the other.

The scale of your candlesticks should be related to your centerpiece. If you want to place a basket of tulips between delicate crystal candlesticks in the center of your table, use two pairs of candlesticks and place brightly colored candles in them to make them bolder. If your candlesticks are large, have three "centerpieces," one between them and one on either side.

Be on a quest to establish your personal scale. Study the interrelationships between items in a space. Measure the size and proportion of ideal spaces. Even if you never build your dream house, eventually you may move and you'll want to be prepared to find a good spatial fit in a new house. Some people like small, cozy, intimate spaces while others like vast, open, grand rooms.

Find a comfortable scale for your lifestyle and needs that will continuously please you. Think about space, scale, and proportion the way professionals do. If you are tall and like to cook, have one tall counter in your kitchen when you can chop and mix without having to bend over. Wander through your spaces and dream of the ideal.

In a New York kitchen, a client has a high counter where she loves to do projects. Though she mostly stands at this counter, she keeps nearby an antique English burl oval-top stool thirty-inches high so she can sit and talk on the telephone or wrap some packages. Every inch of space can work better for you when you connect its use to an appropriate and ideal scale and proportion for you.

Clients in a large apartment transformed a maid's tiny bathroom into a laundry room; so they no longer had to go down to the dreary basement to do the wash. By replacing a wood-framed, double-hung window with a modern single sheet of glass, painting the room a shiny white, and hanging a large "building block" pastel quilt on the wall, they turned this puny, awkward space into a little retreat. The washing machine and dryer fit side by side on the wall under the window, and a smaller-sized European ironing board hangs on the opposite wall,

handy but not taking up floor space when it isn't in use. By treating a small, utilitarian space with the same attention and care as a room others use, you will enjoy your time there far more than if you didn't work out the details well.

In a later chapter, your eye is going to discern whether you want a table with a pedestal base, a tripod, four legs, drums, or panels. The form you select has to conform to more than mechanical functionality; it has to appeal to you sensually, to represent your aspirations, and create feelings of luxury, elegance, and refinement.

I disagree with the architect Corbusier who believed houses are machines for living. I believe your house is an extension of your soul. Creating and decorating your house to exude your spirit is a lifelong undertaking. You are on your own journey, and your willingness to take the initiative to train your eye is an industrious, noble, rewarding challenge. Graceful moments are lived in graceful spaces, and it is up to you—and in your power—to create this atmosphere in your house.

To expand your vision, look for the same attributes in space and objects that you most like in people. Is something charming? Does it have a pleasant disposition? If a loved one has the patient and generous temperament of an angel, when you see a sweet, charming table, chair, or stool, you may think of that person. Your furniture and objects should never bore you; they should have an integrity and personality of their own. You should feel an awesome connection between your essence and the essential character of the things that live in your spaces. Hands-on touching and feeling of the workmanship will improve your skills and competence as you guide yourself toward more graceful forms, gentle curves, beauty in line. You will become more open to experiencing the energy and integrity of spaces and objects as well as their scale and proportion.

INTRODUCING YOURSELF TO ARCHITECTURE

As the boss of dozens of assistants and interns, my hardest task was to get them to open up and see. They tended to bury their heads in a notebook, madly taking notes but failing to see and absorb

the totality of space. When I was twenty, I went to work for Jane Christian, a decorator whose reputation as the toughest, most perfectionistic person in the interior design field soon hit home. Dressed in all black and hunched over an eighteenth-century secretary, she'd interrogate me about a job. "When do you mean you don't remember if bathroom number five's cornice molding is up?" she roared at me. "You were there to *see*. What were you doing there if you didn't see?" I had just been on my first visit to a twenty-two-room, Fifth Avenue triplex apartment overlooking Central Park, and had tripped over wood boards, paint cans, ladders, drop cloths, and armies of workmen. The thousands of details were a bit too much for a green assistant to comprehend. In art school we worked on one room at a time, but here I was thrown into the pit to be eaten alive. I went back to the job site on my lunch hour, and there was a painter priming the cornice molding in bathroom number five. From that day on, I noticed details and architectural complexities.

There's nothing as valuable as personal contact with artistic splendor. Just as sages from ages past become models of excellence for us, so majestic architecture can set high standards for us to aspire to. When you combine interest, knowledge, and experience in the decoration of your house, you can let great architecture guide you to realize a nobler ideal of living well that is within reach of all of us. Through bringing architectural elements into our interior spaces, we create a harmonious background and at the same time add classic style to our homes.

Decorators learn strategies to fool the eye, and in our own style, we become trompe l'oeil practitioners. But first we have to train our eye to see reality to be able to create illusions. Before we can cast a spell and add enchantment to our spaces, we have to be able to diagnose it and see what needs improving.

Architectural elements can enhance and dignify space, and no eye can be too well trained when working with the permanency of architecture. Before you begin the next chapter, go on an architecture hunt. Look for moldings you like, notice doorways, arches, columns, and pilasters. Study the way certain shapes work together. If you live in a town that has grand architecture, hunt it down. If you have access to the inside of great houses, use it. Your task is to try to emulate the most superior architecture in the world, and seeing and experiencing the finest of it is rudimentary. Designers regularly go on study programs in Europe. All the

book studying in the world will never be quite as powerful as being eye to eye with the buildings themselves. Go to the source.

The United States has fine architecture and many grand houses open to the public. Spend an entire week studying the architecture of Williamsburg, Virginia. Go to Monticello and the University of Virginia (rotunda and quadrangle) to experience the architectural genius of Thomas Jefferson. Go to Old Deerfield Village in Massachusetts where you can take guided tours of fine old houses open to the public.

Wildenstein and Company staircase

When Edith Wharton lived in New York City and Newport, Rhode Island, during the writing of *The Decoration of Houses,* she observed many fine examples of local architectural elements available to us today. I used to live just one block away from Wildenstein and Company, the art gallery whose building is featured in her book. Walking up the stairs of that building is a journey into the past. The main entrance features a grand staircase with a wrought-iron banister (a signature of Ogden Codman), generous treads and risers, and three semicircular curtails, in white marble, bull-nosed. *The Decoration of Houses* includes photographs of classical rooms in the fine old traditional New York clubs, including the Metropolitan Club, designed by McKim, Mead & White, a great architecture firm that built many of the houses Mrs. Brown decorated. This club, located on Fifth Avenue and Sixtieth Street, has mantels, mirrors used architecturally, an egg and dart molding trim, overdoors, and acanthus leaf carvings in the cornices, all worth studying.

Metropolitan Club mantel

Another fine example is the sitting room of the University Club, located on Fifty-fourth Street and Fifth Avenue, with its Palladian-arched French door windows, Corinthian columns, and an ornate ceiling with carving and clouds. Columns and niches add grandeur to the halls. Near this club, on Fifty-fourth Street, is a branch of the United States Trust Company, housed in an attractive old Georgian building.

Whenever possible, try to absorb the workmanship of the eighteenth century, when the machine age had not yet taken a grip on building and manufacturing. When a cabinetmaker works with hand tools,

craftsmanship and soul are one. Go to a Shaker village and feel the compelling power of restraint.

Wherever you travel to discover fine architectural examples, you will bring your knowledge to the decoration of your house. On guided tours, ask a lot of questions. Be sure to keep notes in your notebook about special architectural details. Take pictures of them so you can study their scale and proportion after you're home. To build your decorative arts library, buy books and postcards about the houses you visit.

Architectural Elements

*I like lots of air, order, personal objects
and beautiful architecture.*
—WILLIAM HODGINS

THE SPLENDOR OF CLASSICAL ARCHITECTURE

John Barrington Bayley, an expert on the decorative arts, laments that today we live in "nonarchitectural" rooms: "We have been on a starvation diet as to ornament for a good long time; now, with the demise of modern art, a strong reaction—the swing of the pendulum—for ornament is upon us." He refers to Edith Wharton and Ogden Codman, who wrote: "The attempt to remedy this deficiency [of architectural ornament] in some light degree has made it necessary to dwell at length upon the strictly architectural principles which controlled the work of the old decorators. The effects that they aimed at having been based mainly on the due adjustment of parts, it has been impossible to explain their methods without assuming their standpoint—that of *architectural proportion*—in contradistinction to the modern view of house decoration as *superficial application of ornament.*"

The ideal home has classical architectural proportions, but even if yours doesn't, you can take the parts or elements of a space and adjust them to create the illusion of architectural harmony. The eye demands order, symmetry, cohesiveness, scale, and proportion to achieve rhythm and harmony. Webster's dictionary says quite plainly that art is a skill acquired by experience. When all the parts are in concert, an artistic

Renaissance occurs. Through the process of the decoration of your house, you have the opportunity to experience a greater appreciation for classical art and architecture. You will be able to achieve a higher degree of artistic excellence through applying architectural elements to the interior of your house.

THE MAGIC OF TROMPE L'OEIL

*I*n 1897, the authors of *The Decoration of Houses* announced with a voice of authority that "there are but two ways of dealing with a room that is fundamentally ugly . . . one is to accept it, and the other is courageously to correct its ugliness. Half-way remedies are a waste of money and serve rather to call attention to the defects of the room than to conceal them."

Architecture is both an art and a science involving the designing and erecting of buildings. The style and method of design as well as the construction varies, but certain principles are classic and apply universally, regardless of time and space, location and money. For example, line is more important than substance because it creates the grace. Michelangelo put it best: "Design, which by another name is called drawing . . . is the fount and body of painting and sculpture and architecture and the root of all sciences." The lesson is that if we can please the eye with a line, we can manipulate the literal proportions of an awkward space.

Most people have a limited choice when it comes to the spaces where they live. Only few can afford to build their dream house. But Wharton and Codman showed foresight when they said, "When the rich man demands good architecture his neighbors will get it, too. . . . Every good molding, every carefully studied detail, exacted by those who can afford to indulge their taste, will in time find its way to the carpenter-built cottage." Everyone can emulate the finest architecture no matter what their house looks like.

Sometimes your circumstances require that you settle for awkward spaces that lack imagination, spirit, and energy because they were built quickly and haphazardly with little concern for order and symmetry. Or you live in cramped apartments with no view. Living in architecturally

proper houses of classical elegance is more the exception than the rule today. What can you do to rectify this, to bring classical architecture into your home, without spending a fortune on architects and reconstruction? Enter the magic of trompe l'oeil, the fine art of fooling the eye.

Whether you apply a cornice molding to give visual pleasure, dignity, and order to a bland space, install a carved mantel to soften the straight lines of a room and create a beautiful focal point, or raise a baseboard to seven inches to give a wall a feeling of substance, architectural elements can turn you into a trompe l'oeil artist, giving you the wizardry you will need to resurrect dull, unattractive spaces into classic, interesting backgrounds pleasing to the eye.

Someone once said, "I like metaphor in literature and trompe l'oeil in architecture." Obstacles can be overcome, boundaries expanded, beams disguised, and other awkward elements can be camouflaged using traditional architectural elements. Once we open to the world of trompe l'oeil, we can face the challenges of our spaces, overcome the horrors, never accepting what is insipid or ugly but setting a course to bring classical elegance into our spaces.

You don't want energy to be drained by awkward or dangerous elements that interfere with the overall integrity of a room, such as loose tiles in a bathroom, a crude fireplace, or a low beam, opening, or sharp-edged ledge. If cabinetry juts out, you could strike your face or hurt a shoulder. A cornice molding is meant to frame a room, to give it a cap. Applied several feet below the ceiling, it angles down a wall, causing a jarring, unsettling feeling. A closet built into a square room is unsettling unless balanced symmetrically with another closet, bookcase, or cabinet on the same elevation (wall). Some spaces are unwieldy because they have been put together awkwardly. A disjointed layout may prevent you from moving objects around, an inflexibility causing discomfort. This is energy going in the wrong direction. But it is up to you to seize the opportunity to right the wrongs, make whatever changes you can so you elevate your mood and sense of happiness during the time you spend in your rooms.

Trained in the school of architecturally-based interior design, I am accustomed to making major and minor improvements in preexisting space. I've knocked down walls, raised and lowered ceilings, moved doors and windows, built in and rearranged bathrooms, elevated floors, and transformed the visual perception of rooms by using mirrors archi-

tecturally. Generally, I like flexibility and change in a space, keeping permanency only in architectural elements that enhance the background appearance, adding detail and, more important, scale and proportion through trompe l'oeil. To secure harmony you unify all the elements or reject the ones that can't be unified. Unity gives you beauty as well as the sublime.

ACHIEVING ARCHITECTURAL CONTINUITY THROUGHOUT YOUR HOME

A salient goal in architecture and interior design is to achieve a structure where the exterior and interior echo each other. Interior architecture should be at best a continuation of the exterior. When this marriage occurs, the integrity of the house will shine through.

I disagree with the traditional classical architectural approach to space Edith Wharton and Ogden Codman espoused, that "every house should be decorated according to a carefully graduated scale of ornamentation culminating in the most important room of the house." Today, most private houses have a less rigid line drawn between public and private rooms. They are integrated into a seamless whole, reflecting the inhabitants throughout. You may live in an apartment with as few as one or two rooms, so the distinction between public and private space doesn't exist. Regardless of the number of your rooms, you want your guests to experience the warmth and intimacy of your love in every space, right down to the laundry room. When you are in a space that houses love, no matter what function it serves, you are uplifted by the harmony and spirit of place.

Architectural elements, the blend of science and art, are needed even in the spaces no one sees but you. You don't want to give your guests better treatment than you give yourself. Some of the greatest refinement in your house may be in your bedroom closet where the lines are lacquered smooth and the edges rounded and sensual, although no one ever spends time there but you.

Interior design and decoration for your home should begin with you and your family and the ninety-five percent of your time spent

without visitors. You build from there, room by room, space by space, bringing refinement and harmony through your use of architectural elements.

ARCHITECTURAL ELEMENTS WITHIN OUR REACH

*U*nlike architects, I conceive of houses from the inside out rather than the outside in. Many people have only the interior of their home to work with. Architecture should never impose limitations on the comfort or convenience of the residents. Often a space has never been touched by the hands of an artist or architect, and it is up to you to improve it yourself. Learning about architectural elements and how they are within your reach, even with limited resources, empowers you to confront bland, awkward spaces and transform them into graceful rooms with classical elegance. They are not a luxury of the wealthy; they're as near and accessible as your local lumberyard. As was pointed out in Wharton and Codman's *The Decoration of Houses,* all these elements can be purchased by the inch and foot and easily applied to a room that doesn't have character or classical detailing.

When you walk into a room, focus on the background details that are permanent fixtures. Look up to where the walls meet the ceiling. Is there any horizontal carving, or molding, that covers the sharpness of the ninety-degree angle? If your ceiling joins the wall without a cornice molding, you can inexpensively buy wood, cut it to fit, and nail or glue it up yourself. Use headless nails, called brads, and once the cornice is painted they will no longer show.

To relieve the flatness of the wall in your entrance hall, you can install a chair rail. The appropriate height depends on the room size and height of the ceiling, but on average it should range thirty to forty inches from the floor. At this level, a molding is comforting and satisfying to the eye. To serve its practical function of preventing the back of a chair from damaging a wall, it should never be higher than the chair. Classical architecture includes a chair rail in most rooms, with elaborate paneling installed beneath the molding to the baseboard. If you decide you want a chair rail, select one that is compatible with the cornice

molding in projection and design. Rather than purchasing expensive wood paneling, consider painting the chair rail and the space below it white and the space above the chair rail a tint to break the monotony. If you love striped wallpaper, the most elegant place to hang it is in the space above the chair rail in a room.

If you have a rubber baseboard in your kitchen or bathroom, you can replace it with a taller wooden one to uplift the space. By treating every area of the house with the sense of equal design aesthetic, every inch of your home becomes dignified.

Architectural elements not only enhance the beauty of your spaces, but they also make your house more valuable. Whatever your circumstances, the synthesis of architectural elements is a worthwhile investment if you plan to stay in a place for a while. Furthermore, your well-decorated house is there, unlike stocks and bonds, for you to enjoy every day.

Chair rail with striped wallpaper

MOLDINGS

Cove ceiling

*J*ust as important as the tailoring of a man's jacket is the art of dignifying a room with architectural moldings, including cornices, chair rails, ceiling ornaments, and baseboards, as well as paneling and other ornamentation on cabinets and doors. Our apartment building in New York City was constructed before World War II, when a crew of carpenters and plasterers was brought over from Italy to work on several similar buildings. I have a deep appreciation for the skilled workmanship in all the rooms, and enjoy the architectural elements that were installed when the building was constructed. The bedrooms all have curving cove ceilings, adding visual height.

Any molding, even a small one, can add dignity, grace, and beauty to a room. On our cove ceilings, there is no molding because the curve eliminates the right angle between wall and ceiling, leaving no proper place for a cornice. If we were to install one underneath the curve, it would appear to dangle down the wall. On the edge of the flat ceiling, however, there are two-inch plaster projections, adding interest.

General rules apply to the use of interior cornices. In a room where the ceiling and walls meet at a right angle, the molding is placed to connect the ceiling and the wall. Never have a dangling cornice molding, one that is installed several inches below the ceiling. If you have a picture molding hanging down your wall, remove it, fill in the holes with spackle, sand, and paint. In low-ceilinged rooms (low studded), a cornice molding must be correspondingly narrow so it will not be out of proportion. The grander the room, the more elaborate the cornice molding in scale and detail.

The handsome Knickerbocker Club at Fifth Avenue and Sixty-second Street in New York City has large-scale classical rooms with a variety of impressive architectural elements creating an expansiveness with the majestic sixteen-foot ceilings. The double-hung windows reach to the floor like French doors, and tower up so the top of the trim is only a foot and a half away from the bottom of an elaborate plaster cornice molding consisting of Greek fret, egg and dart, and, underneath, urns and swags. All the designs speak of elegance and culture. Master architect William Aldrich Delano was commissioned to do this Georgian-style gem in 1916; he also did the Colony Club and the Union Club—equally attractive inside and out.

Clients advancing in years decided to give up the large, grand Park Avenue apartment that had been their home for thirty-five years. When Sotheby's put it on the market, it was described as having "fine architectural elements." The building they were moving into, however, was modern, and the former owner had installed obtrusive moldings. Even the hollow-core flush doors (doors with a flat, plain surface, flush with the wall) had been glopped up with a series of raised plaster disks that made you feel seasick, so dizzying was their repetition. Our clients wanted us to create a mini-apartment that would feel wonderfully warm and homey. Their furniture, art, and objects were all of great quality, so our task was to strip away tasteless, gaudy ornamentation and put classic moldings in their proper place.

Luckily, we found a carpenter who was willing to bring his equipment from his shop and work on every room until he achieved the proper refinement. Our clients bought egg and dart—a classic—and

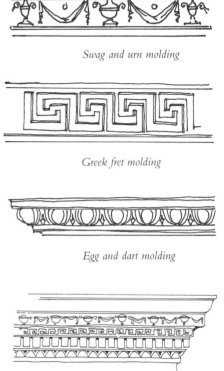

Swag and urn molding

Greek fret molding

Egg and dart molding

Greek fret, dentil, egg and dart beneath urns and swags

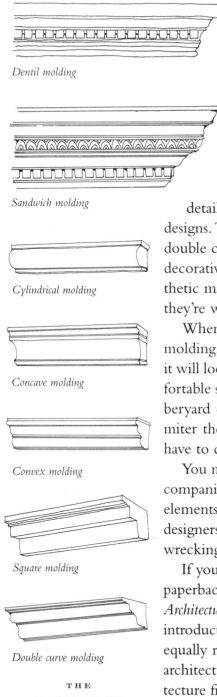

Dentil molding

Sandwich molding

Cylindrical molding

Concave molding

Convex molding

Square molding

Double curve molding

dentil (tooth-shaped) moldings from a timber merchant in London and brought them to New York. The same moldings are available here, but they loved the adventure of selecting and purchasing them in England, where there are so many stately homes to see and try to emulate. We installed acute-angled moldings with a sharp projection and an angle of less than ninety degrees on the top. Then, as if making a sandwich, we added the egg and dart and, under that, the dentil.

Installing moldings is the simplest way to add decorative details to a room. Moldings come in a wide variety of sizes and designs. They can be square or cylindrical, convex or concave, have a double curvature, a plain surface, or be richly carved. A great variety of decorative architectural elements is available in plaster, wood, and synthetic materials lighter than plaster. They also range widely in price, so they're within everybody's reach.

When you look at the cross section of a molding, called its profile, you can read how it will look on your wall. Once you feel comfortable selecting the right molding, the lumberyard can cut it to the proper length and

Cove molding

miter the corners (bevel them so that the pieces fit together); all you have to do is install them with glue or brads.

You might want to explore architectural wrecking barns, demolition companies that salvage architectural elements from old houses, to find elements you can bring home and install. Ask local architects, interior designers, or contractors, or look in the Yellow Pages for locations of wrecking barns near you.

If you are eager to learn more about moldings, I suggest buying the paperback *The American Vignola, A Guide to the Making of Classical Architecture* by William R. Ware (Dover Publications, Inc.). With an introduction written by John Barrington Bayley, along with others of equally respected company, *The American Vignola* is a technical study of architectural elements, including a review of the classic orders in architecture from the simplest, Doric, to Ionic and Corinthian and composite orders. This book will show you the difference between ovolo, cavetto, cyma recta and cyma reversa moldings and teach the vocabulary of the trade.

Whether you install a bold cornice molding to draw the eye upward, a chair rail with a deep projection and flat top surface of about three quarters inch (especially useful as visual balance to pictures that have deep frames), or replace a two-and-a-half-inch-high skimpy baseboard with a thick, curved molding, you will be adding a handsome architectural detail that gives the room substance. Baseboards can be built up in much the same way as cornice moldings and can have an equally profound effect on the room's structure.

Ovolo molding

Cyma recta molding

Cyma reversa molding

DECORATIVE FRIEZES

*P*erhaps your room longs for a decorative frieze, a horizontal decorative band applied just under the cornice molding. A frieze depicting any subject matter stenciled or painted freehand can enliven your space with a signature theme. It can be made of plaster or a resin, a substance used in plastic, to give the border relief (the projection of figures or forms from a flat background), or you can create a frieze by applying one row of ceramic tiles.

Moldings with decorative friezes

COLUMNS AND PILASTERS

*O*ther classical architectural elements that contribute depth, height, and ultimately a sense of permanence to a space are freestanding columns and pilasters, rectangular vertical members installed on walls to add detail. There are also illusionary columns, pilaster-like features (but rounded) that look like columns but are actually a wood, plaster, or marble design that projects into the room. When used appropriately, columns,

Column

Pilaster

Doric column

Ionic column

Corinthian column

pilasters, and illusionary columns create period style where there was none, and allude to monuments of Roman, Greek, and Tuscan orders.

The design of interior columns, including the capitals that crown them, are usually adapted from one of the orders of classical Greek architecture—Corinthian, Ionic, and Doric. A Corinthian column is defined by its slender fluted (vertically grooved) columns and ornate capital decorated with the carved acanthus leaves. An Ionic column is marked by a pair of opposing volutes, scroll-like ornaments, atop a fluted shaft. The simplest classical style is the Doric, with its heavy fluted columns capped with plain, saucer-shaped capitals. Doric is the only order without a base or plinth.

Columns and pilasters can be fluted or smooth. Most are made of plaster, wood, lacquered wood, or marble, though some consist of brick covered with a layer of plaster. Some pilasters have a simple horizontal architectural capital, even if greatly modified or stylized. For a more contemporary feeling you can have unadorned, unfluted columns with no capital or plinth.

When Elsie de Wolfe moved to Hollywood after fleeing France during World War II, she created an indoor garden with hunter green-and-white canvas striped curtains and white plaster columns styled to resemble tree trunks, complete with branches sprouting green leaves. While they departed from the classical orders, they recalled the columns of ancient Greece.

When a client decided to move into a modern, postwar building on East Sixty-fourth Street, she immediately set out to create architectural elements, room by room. In the drawing room, a grand space reserved for guests and celebrations, the entrance door was located at one end of a long rectangular room. She added pilasters and overdoors to create a

Smooth column

Fluted column

classical architectural background for her fine collection of eighteenth-century antiques and art objects. For symmetry, she asked me to place an identical false door and frame on the far end of the same elevation. On the other side of the wall of the ideal location for the false door, I discovered a closet for the guest room. By borrowing eight inches from the back of this rarely used storage space, we were able to create a real door and have a space where she could store her extra porcelain and decorative objects. We installed wooden shelves painted a soft green, and mirrored the back wall. Now she can easily change her ornaments at whim. If they were kept in a dark, inconvenient storage space, she wouldn't enjoy the variety as often.

In contrast to columns that serve a structural purpose, pilasters are almost always purely ornamental. You will often find them on either side of entrance doors to give a house's face dignity and elegance. A client's late eighteenth-century house in Massachusetts has fluted pilasters with beautiful carved Ionic capitals, marked by two opposed volutes (carved scrolls that wrap inward) flanking her entrance door. In another client's formal living room, two pilasters were painted chalk-white to contrast with the refreshingly clear-tinted lemon-yellow walls.

When renovating a New York client's West Side apartment, we turned to classical columns to enhance a room. We had taken three cramped rooms and knocked down two walls to achieve a large open space overlooking Central Park. The only drawback of the new expanse was a large, naked, structural steel column—a huge eyesore—located off-center near the east elevation where a wall had separated the dining and living rooms. Around this time I traveled to Charleston during the peak garden season and toured dozens of houses owned by friends for inspiration. When I developed the film of the photographs I took during the trip, I noticed classic fluted Doric columns on the front porch of an eighteenth-century house on the Battery. I immediately knew this architectural element would be a perfect solution to cover the structural column in the renovation site in New York. Of course, to satisfy the

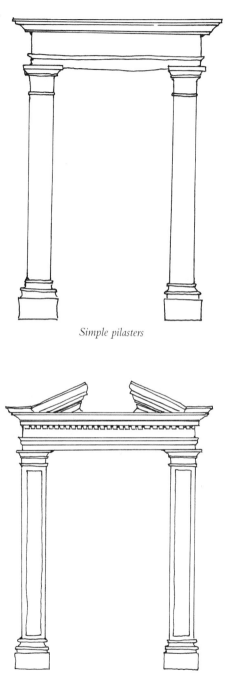

Simple pilasters

Ornate pilasters

need for symmetry in the space, we created a second column from scratch and placed it at an equal distance from the west elevation, in line with the existing column, adding elegance and grandeur to this plain, open space. If we hadn't needed to conceal the ugly square steel column, we might have ended up inventing this classical architectural reference simply to add interesting ornament to the space.

Often columns are installed to hide an unattractive, unavoidable structural support, but at other times they are used purely for interior design purposes. Elsie de Wolfe's dining room had an extremely ornamental off-white marble column that didn't reach the ceiling, but was solely an ornament, too high to support a statue. After she renovated her town house the year *The Decoration of Houses* was published, having hired architect Ogden Codman, the same fluted, marble column appeared in her new dining room. Its base and wood-carved Corinthian capital were painted white to coordinate with the new white woodwork, stained mahogany in its earlier incarnation.

A tiny apartment clients rented on East Sixty-fifth Street had a dining space in a small alcove in the living room off the kitchen. It was a small recess, a partly enclosed extension of the rectangular living space. To give the small space a feeling of distinction, we used two fluted columns forty-eight inches high, for two hand-painted porcelain cachepots filled with trailing English ivy. I sometimes use lacquered columns as pedestals for sculpture or for a porcelain cabbage that should stand out on its own.

Classical symmetry is a pleasing form of order and noble grandeur. When you can bring some of the ancient architectural elements such as pilasters and columns into your own private surroundings, you feel a continuity with the past that is part of your inheritance.

OVERDOORS

Triangular pediment overdoor

*J*ust as an antique door adds architectural detail to a space, so do overdoors, decorative elements set above a door frame. In the elevator hall of a client's apartment, I installed a bold white marble floor in twenty-four-inch squares with contrasting eight-inch-square Vermont verde green marble keystones that cut into the four corners of the white tiles, creating an octagonal stone. The floor, while beautiful and grand, made the two white paneled doors flanking the wide, elegant brass elevator door look too plain.

Broken pediment overdoor

John Stair, president of Sotheby's Restoration, came to the rescue with several classic pediments, the triangular detail that looks like a gable roof, first used in Greek temples, and often used to cap highboys. He also showed us broken pediments with a space, or void, at their apex, from old New England houses. We selected a broken pediment that added quality and elegance to the doors flanking the brass elevator door. The wooden design was installed above each of the doorframes and painted white to match the door and trim. The pair of mahogany doors opposite the elevator are two feet taller than the white doors on the opposite elevator elevation, so the overdoors became a unifying element to make the heights visually compatible.

Fan-shaped overdoor

When selecting an architectural detail for an overdoor, look at the face of houses you admire, and study photographs of eighteenth-century houses as well. You can then choose from hundreds of different designs, including semicircular or fan-shaped overdoors.

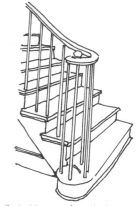

Elliptical overdoor

STAIRCASES

A staircase is a major architectural feature that can add considerable grace and elegance to a house. Always hold on to and rub the banister of a staircase because it unites you with all those souls who have climbed the stairs, and maintains the polished look of the wood. At the University of Virginia, the famous Jefferson double staircase always remains "waxed," thanks to the natural oils of all the hands that caress the banister.

Stair (riser, tread, nosing)

The design of a staircase is complex. The staircase's height, width, and

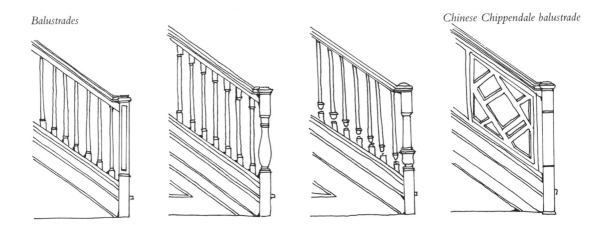

depth must be precisely connected and compatible with the space it occupies. The vertical measurement of each step must be compatible with the horizontal space where the foot rests. The deeper and wider the horizontal plane, the more graceful the staircase's appearance.

Ideally, you want a staircase that is both beautiful and safe. A client's New York duplex had stairs that were too steep, so we had to reconstruct the staircase. Her riser (the vertical part of a stair) was more than nine inches high. The steepness of indoor stairs can vary by several inches, but six inches is average and comfortable. A six-inch riser works well with a twelve-inch-deep tread, where your foot rests. Most people appreciate generous treads that not only are more graceful, but allow a foot to rest fully on the tread. But if you live in an eighteenth-century house with a staircase that has narrow treads, refrain from altering it, because this feature is an inherent part of that historical period. The tread of most steps has a projection called a nosing, a curved molding that overhangs the riser and overlaps the tread.

Today, safety codes dictate how close together the spindles (balusters) holding up the handrail of a staircase (banister) must be. Check the code before you fabricate a new balustrade, the staircase unit that includes both the banister and balusters.

The prominent post at the bottom of a staircase is called the starting newel. It is usually set on the first or second step, generally wider than the other steps. The newel adds substance and grace to the staircase and surrounding space. When the banister curves outward, or curls around, at its base to conform to widening, curving steps (a section called the curtail), the starting newel is referred to as an angular newel. Staircase landings also have newels.

If the mortgage has been paid on an old house, a small piece of ivory is inserted in the newel. You can select any decorative ornament to cap off the newel. A carved pineapple symbolizes welcome and hospitality. I've seen a rock-crystal ball, all kinds of carvings, and brass decorative ornaments placed on the newel to crown it with a sense of importance and prestige.

When one client hired me to design her apartment, she showed me dozens of pictures of architectural elements she wanted to incorporate into her apartment. Every picture included steps. To satisfy her passion for steps in an apartment all on one floor, we decided to create a series of three ledges leading from the living room floor to the windows overlooking Central Park so she could sit there to read, write, talk on the phone, or simply lie down and gaze outside. A two-foot-wide step became a ledge. On the opposite wall, leading to a newly raised dining room, we created three gracious steps with rounded, two-inch bull-nosed oak, curtailed in bold, satisfying curves. By raising the floor, we could see from the dining room through the living room to the park beyond. Raising the dining room floor also created a sense of intimacy in an area where walls or doors would have obstructed the view.

One of the most ordinary, boxy staircases became electrifying when we painted the banister shiny emerald-green and used as a runner a floral hooked rug woven with all my client's favorite flowers, trimmed in a rainbow ribbon design. If you have ordinary spindles, you can replace them with a more interesting design. Clients didn't want the traditional vertical, bulbous spindles so they had their architect and me create a classical Chinese Chippendale fretwork design, inspired by Thomas Jefferson, who used this architectural detail lavishly at Monticello and the University of Virginia.

Newels

MANTELS AND FIREPLACE FACINGS

*M*antels and fireplace facings are excellent opportunities for adding architectural elements to your home, often serving as focal points in a room. A mantel is a decorative frame that surrounds the fireplace and facing on the top and two sides. The facing is the protective frame that surrounds a fireplace opening, and is usually marble, brick, tile, or slate.

Garland mantel

Plain mantel

Mantels

On one architecture hunt I found a large wood panel beautifully carved with musical instruments, garlands, flowers, and fruit and bought it for a client to imbed in her plaster wall over her fireplace. In one apartment, the plain English pine mantel in the living room was extremely tall for the scale of my client's French antique furniture. I hunted down an old well-carved mantel from the South of France, had it cleaned and bleached, and installed it. The new look added considerable grace and charm to the room.

Clients who don't have a fireplace in their living room often ask me whether I believe in installing fake fireplaces. Though I have put in mantels for clients who insist, I believe a living room will only be enhanced by a fireplace if you can light a fire in it. Edith Wharton, too, was extremely firm about the dreariness of sitting in front of a black hole. I recommend a gas jet only if there is no way for you to have a working flue.

If you have a working fireplace, evaluate the scale and proportion of the opening and see if you can improve the appearance of the mantel. If you can afford an old wood, stone, or marble mantel, this architectural element will greatly enhance the room and the way you feel sitting next to a warm fire. The refinement will smile back at you as you gaze into the glow of the fire and at the beauty of the surrounding facing. But you don't have to spend a fortune on an original, antique mantel to achieve this pleasing effect. You can buy a reproduction in raw wood and paint it the same color as your trim, or stain it.

Usually old wood is more lovely stained because of the patina resulting from years of being waxed. A new wood mantel you stain will, in time, mellow and become more interesting and authentic looking. It isn't always easy to find an old mantel you like that will fit your existing fireplace opening, but if you're lucky, you can find one too big and have it cut down. An advantage of buying a reproduction is that it can be custom made for your desired style and proportions. If you don't have a mantel, just an opening, and want to wait before purchasing one, consider installing a simple ledge above the opening for displaying decorative objects.

Paneled mantel

Every room needs a focal point, and a striking mantel draws your eye into the room. Select a mantel in the decorating style you most love in furniture. Usually a mantel is well located in the center of a wall with solid walls on either side so there will be plenty of room for a furniture grouping. Facings must meet fire codes, but can still be attractive. Sometimes I use old blue-and-white tiles for facings. For a delicately carved fruitwood mantel in the dining room of one client we used hand-painted tiles, each one a different flower. In the living room of another client is a polished Vermont verde antique marble facing and hearth, adding warmth and beauty as it contrasts with the sensuous curves of an eighteenth-century carved fruitwood mantel.

MIRROR AS AN ARCHITECTURAL ELEMENT

The use of mirror as an architectural element in your house can profoundly alter the energy of a room. When a client moved into an apartment where another family had lived for more than a decade, she was leaving a sunny, light apartment on the eighth floor overlooking brownstones, where she had a double living room and an open, airy feeling. She felt the new apartment was dark and heavy, and asked me to figure out what she could do to brighten it up. Sitting on a sofa against the north wall looking at the fireplace, we realized the recessed walls on either side of the mantel ledge could be mirrored. There was already a chair rail above a paneled wainscoting, giving a mirror a plinth to rest on (mirror is heavy and should always be supported by a molding with a solid projection). The molding/mirror combination created the appearance that the mirror was architectural, rather than stuck there as an afterthought.

When mirror is used architecturally, it can transform the shape of a space visually and bring in light. The two large sheets of mirror on either side of the mantel created the impression that the two windows on the west wall were really four because they were reflected in the mirror of the adjacent south wall. What did this do to the light? It doubled it. What did this do to the view? My client can now sit on the left side of her sofa on the north side of her living room and see in the mir-

ror on the south elevation a church and a bell tower exactly one block north of her apartment.

On the opposite wall, were two corner pilasters that looked clumsy, so we mirrored them from the cornice to the chair rail, making them virtually disappear. You don't notice this detail when you walk into the room, but the effect is cheerful.

A client's entrance hall was awkwardly long for its narrow width, and because of its location in the middle of the apartment, it got no natural light. It was a gloomy, constricting space. By mirroring the north wall, we visually doubled the hall's width to create ideal proportions, as well as brought in light by reflecting sunlight from the windows in the rooms flanking the hall. The entire wall had a soffit beam hanging down from the ceiling. It was six inches high and projected four inches into the room. We decided to have the mirror installed under the soffit to rest on the top molding of the baseboard. Had there been no beam, the mirror would have continued up to meet the cornice molding.

A large expanse of space, such as this 25-foot-long entrance hall, requires more than one sheet of mirror. If a seam is unavoidable, try not to have one center seam, but instead create three breaks, a triptych. Otherwise your eye will be drawn to the center "crack" in the sheet of mirror. If you have horizontal breaks in the mirror, the separate pieces can all be the same size, but, depending on your space, you may want the center mirror to be larger than the two side pieces. The entrance hall we mirrored had two traditional raised-panel doors on the mirrored wall. It would have been a mistake to mirror them because the mirror on either side of the doors creates the illusion of more space and light. The doors are not symmetrically placed on the elevation, but they are more or less on opposite ends of the 25-foot-long by 9-foot-high wall space. All of the wall space is mirrored, and the center part of the wall has one 5-foot-wide mirror with two 2-foot-wide sheets on either side.

This entrance hall now doubles as a dining room, and a French farm table stands against the wall in the large center area. On the south wall, opposite the mirrored elevation, is a large colorful painting reflected in the mirror, giving the impression of two identical pictures.

A three-inch-wide wall space to the left of the bedroom hall doorway is mirrored also. The height of the door trim determined where the vertical break in the mirror should go, because the sheets don't come in

pieces sufficiently long to cover floor to beam. By aligning the upper rectangular pieces of mirror to fit exactly above the two doorways, and over the five mirror sections below, the effect is well ordered and symmetrical. Always line up a break with an architectural element such as a door trim. Just as you want to know where the seams in your carpeting will be, you should work out your own mirror plan so that the breaks are where they make the most architectural sense. Sketch the plan on grid paper in your notebook.

We could have installed a chair rail in the entrance hall to allow us to place the mirror sheets without a horizontal break over the doors, but we preferred an unbroken reflective expanse on the entire north elevation. That required sheets of glass too tall to fit in the elevator, so they had to be cut and seamed. Because there is a large, bold, colorful painting opposite this mirror, no one notices the seams in the mirror. You enter the apartment opposite the mirror and are greeted with a painting that you wouldn't immediately see if it weren't reflected in the mirror. Moreover, the painting or its reflection is visible even from the living room.

A client has an awkwardly narrow, long back hall leading to two offices. Mirror placed at the end of the hall on the side of a protruding bookcase throws the space back at you as you approach. In a tiny laundry room I boxed in a pipe to the left of the window. By mirroring the front, the long, narrow vertical box vanished, adding light and seeming to expand the small space.

In a client's bedroom, beneath the windows on the west wall, I had a ledge built across the entire wall, seventeen inches deep and thirty-one inches high. With a four-inch facia on the front edge and plywood underneath, the supporting angle irons are completely concealed, as though the ledge is floating. There are vertical beams at both ends so I mirrored the inside of each one to create an illusion of more space.

Between the two windows in the living room of her Sutton Place apartment, Eleanor McMillen Brown placed a large black-lacquered chest of drawers. By mirroring the entire space between the windows she fooled the eye into believing the windows were larger than they actually were. As you entered her round dining room through a pair of doors, the far wall was mirrored, giving the impression that the space was large, when in reality it was quite small.

In a New York City kitchen, mirrors on the back walls below the

cabinets bring in more light and give the perception that there is twice as much space as there really is. Placing mirror behind a counter is a great technique I often use to "double" the space. In a tiny bathroom I created a charming powder room by "tilting" the floor, wall, and ceiling. I framed a huge sheet of mirror on three sides, rested it on the counter behind the sink, and attached a block of wood behind the top of the mirror to make it tilt forward. This way you don't notice the mirror as a mirror, but instead experience an altered reality of the space. No surface is tilted except for that of the mirror, and it creates a fantasy in an otherwise unsatisfying space.

The backyard of our Connecticut cottage is tiny, but because it doubles as a summer living room, it's important for us to make the most out of it. To do so I had a mirror installed behind a white trellis, having been inspired by the use of mirror in gardens in France. When ivy is entwined in the trellis the mirror is so subtle that many people don't notice it's there. It vastly expands the space because all the flowers and furniture are reflected back into the mirror, including a red antique wheelbarrow filled with pots of pansies.

In a client's *hôtel particulier* in Paris, a French architect created a dressing room of mirrored doors, bringing light and space into an ordinary rectangle. The wooden Chinese Chippendale fretwork in front of each mirrored door keeps the eye from that crazy feeling of infinity when mirror reflects into mirror. The fretwork was installed on a piano hinge so it could be swung to one side, and the mirror could be wiped clean.

In a cramped closet, you can mirror the entire back wall to expand the space. You can place double hanging clothes rods on the left wall and a series of small cupboards with deeper drawers below them (with a six-inch strip of mirror to conceal the break between the two) on the right wall. If you have arched bookcases on one elevation, you can create arched, slightly recessed niches on the opposite wall directly across from the bookcases with beveled mirrors in the niches, creating the illusion of books on both walls.

For clients who collect antique crystal decanters, I mirrored the back wall of their display cabinets, "doubling" their collection. But, in order not to have the crystal appear too cold against the mirror, I wrapped the shelves with the same vibrant, grass-green Thai silk used on the sofa and

two chairs. In a kitchen pantry with old-fashioned, glass-fronted pine cabinets, I mirrored the back wall of each cabinet, reflecting light from a large window on the opposite wall.

Edith Wharton installed mirror in arched niches opposite the Palladian French doors in the loggia of the Mount, her house in Lenox, Massachusetts, for symmetry and light. When mirror is used architecturally, and used well, the result is wise and wonderful, but when it is inappropriately used, it comes across as looking cheap. For example, gold flecks in mirror are vulgar, and while I do use slightly antiqued mirror under certain circumstances, to be on the safe side, always select clear mirror. Throughout this book I will discuss a variety of ways to use mirror to enhance your spaces, bring in more light, highlight beauty, and conceal ugliness.

THE ARCHITECTURAL USE OF TILES

*T*iles can be used as an architectural element in the decoration of houses. Tiles have a feeling of weight, whereas mirror has more of a "lightness of being." Tiles are solid, while mirrors reflect something. They can be used on floors, walls, counters, and tabletops, and can add a great deal of interest to a room.

In a client's country kitchen, above the vertical line beaded board wainscoting, I installed one score, or row, of decorative two-inch-high by six-inch-long ceramic trim tiles in shades of blue hand-painted on white. Above this band of tiles I've hung some ceramic trompe l'oeil dishes. (One of my favorite things to collect is these plates or small bowls containing real-looking ceramic olives, cheese, eggs, or nuts.) The permanency of the ceramic tiles placed thirty-six inches high around the room makes a nice base for such a collection of whimsical, eye-fooling dishes.

In a kitchen where I installed hand-painted fruit, vegetable, and flower tiles behind a stove, I put an assortment of tiles in the back of each glass cabinet on the opposite wall, "emotionally" mirroring the space.

Mirror with tile frame

When I want a mirror to appear to be floating in space, I don't frame it. But when I want to define specific spaces, I use a frame. For example, in a bathroom where tiles dominate the wall space, I use trim tiles on four sides of a mirror opposite a window, giving the suggestion of an identical window. Buying tiles and installing them yourself is far less expensive and more architecturally pleasing than buying a decorative mirror.

CREATING THE ILLUSION OF WINDOWS

Windows play an important architectural role in the decoration of houses, connecting you to nature as well as establishing symmetry, balance, and harmony. But sometimes when a window is desired, the only option is to create the illusion of one. If you have a long, dark hall, you can do this by framing and mirroring one end, complete with wooden mullions, so it appears as though there were a real window. The deception is welcoming. In a house where there was a long bedroom hall, I created a faux arched Palladian window with wood mullions dividing the panes of glass and beveled mirror to create the illusion of light and openness. We tiled the console ledge, and by placing a spotlight over the ledge, enabled ivy plants to thrive.

LOUVERED SHUTTERS

Louvered shutters

Louvered shutters, hinged window covers or screens with fixed or movable horizontal slanted slats, can be used architecturally to improve the look of windows. Indoor louvered shutters, whether white, green, or stained, always echo the architecture of the exterior of a house and suggest a garden beyond, bringing nature inside by illusion. At the indoor swimming pool of the Colony Club, a women's club in New York where Elsie de Wolfe got her start as a decorator, louvered shutters make you feel there are gardens all around the pool when, in reality, the pool is deep underground. Louvered shutters have the feeling of permanency while giving a space a garden feeling, because they are usually used in sunny climates for cooling a room.

Louvered shutters come in a variety of sizes and thickness of slats. I find that one bifold panel hinged to another, and installed on the side of a window, is more elegant than two large panels, but it depends on the width of the window. The most elegant hinge to attach two panels is the piano hinge that screws onto the wood, so the brass or chrome strip completely conceals the thickness of the wood frame.

For the shutter slats to open and close, a vertical strip of wood with U-shaped pins connects the slats. These flimsy pins tend to pop out of the slats, making the shutter look disordered, since the slats with missing pins can't operate. Even thick plantation shutters have this flimsy connection, so examine your patience before you select shutters for a room. Our New York apartment has shutters in the living room, library, and bedrooms, giving a unified architectural feeling to the spaces, but I often regret their fragility.

Bifold shutters

Permanent slats are often used to frame exterior windows, especially when the slats and shutters are not intended to close. But the virtue of a shutter treatment with movable slats for the indoors is the light and privacy control. They have a far more solid architectural appearance than temporary-looking curtains. Having a multitude of wooden slats framing a window with light streaming through adds chiaroscuro, the Italian technique of using light and shade in pictorial representation that also applies to the art of creating pleasing illusions in interior space. Every time you can add a projection putting one line, contour, or outline on a slightly different plane from others, you are adding architectural complexity and enriching overall refinement.

If you choose to have louvered shutters on the inside, make sure that when they close they cover the entire window. Using a pair of bifold shutters on only the bottom portion of a window always looks flimsy. Just because you have them on the top doesn't mean you ever have to close them, but it is correct to hang them to frame the window properly.

Floor-to-ceiling-shuttered window

Indoor shutters are a practical as well as pleasing architectural element. If a window goes to the floor, solid shutters add architectural strength when they are of a large plantation scale and are made in one panel extending the entire height of the window. If you have a window that is too high, by shuttering the sides and adding a splayed window seat, you can turn an awkward feature into a cozy spot for contemplation. By paneling the space between the window and seat, you create a flow and the

eye is pleased. If you choose to install these shutters, you can still have window treatments such as curtains, valances, swags, and jabots.

Raised panels are an architectural element similar to shutters and are used in the same way. But, unlike louvered shutters, raised panels when closed for privacy do not allow any light to stream in. Panels can be beautiful, but when they're closed they give the impression that a storm is coming. For this reason, I prefer louvered shutters. I will, however, use raised panels for a pass-through between a kitchen and a breakfast room, and for any other area where the infiltration of sunlight is not a factor.

FAN WINDOWS

Fan window

*F*an windows can play a significant architectural role in houses. In a small backyard garden, clients installed an old fan window on their Colonial house and replaced the clear glass with mirror so that it would reflect the flowers, trellis, and ivy. They'd originally purchased this fan window to go over the front door, but later found an eighteenth-century door frame with a fan window with its original glass. They replaced their double-hung window in the attic with a huge old fan window, completely altering the look of their house. They intend to design a spa bathroom in this front space where the fan window is so high up they'll be able to see the ocean as they luxuriate in a raised tub and watch the boats coming and going, with no one looking in except the birds.

Often, in apartments, there are hinged transom windows, once used to bring in light and ventilation, above a door. Today they seem dated and are not architecturally pleasing. John Stair has designed a wooden fan window that gives a Palladianesque grace to an ordinary rectangular door, adding height and elegance. Looking up at the ceiling at the Knickerbocker Club one night, I noticed a similar fan design in the four corners, hiding the utilitarian air vents.

Window seats

WINDOW SEATS

*W*indow seats always add charm to a room with their human scale, and they are an especially inviting sight when adorned with colorful cushions and pillows. They can be used to sit on, to stack books and magazines, or as a sunny spot for flowering plants.

There is something wonderful about sitting with your back to the window, feeling the warmth of the sun as you take in the full sweep of the room. To recess a window seat without breaking into the wall, install floor-to-ceiling bookcases flanking the window, as I did in a client's New York apartment library. To hide the ugly heating and air-conditioning units underneath the window seat, we placed a trellis on the front of the window seat, flush with the edge of the bookcases on the right and left sides, allowing heat and cool air to enter the room through invisible vents. A hinged portion opens when cleaning or repair work is required.

Arched corner cabinet

Corner cabinets add architecture, style, and elegance to a room, not to mention a very functional feature. Building arched cabinets in two or four corners of a dining room or breakfast area can add great charm and ample storage space, and increase the value of your house. You can incorporate a carved shell motif on the back wall of the inside top area under the arch. The shelves can balloon out in three areas and display favorite bowls, vases, and decorative objects, lit to draw your eye to the delicate colors and workmanship. A groove or a small applied molding at the back of the shelf creates a ledge where you can rest a set of dessert dishes.

Building a cabinet or other corner niche at either or both ends of a bathroom tub can be a successful treatment. In a home in Texas we created a niche at the end of a tub and a separate water closet behind the niche for privacy. In a house I decorated in Paris there is a niche at the end of a bathtub with a dome painted in a cloud pattern. We placed a huge decorative vase on the marble ledge of the plaster niche, so when you're taking a bath you feel connected to the ancient Roman baths.

Domed corner niche

ARCHITECTURE AS A
LIFELONG COURSE

Any time you go on an adventure to see and study architecture, bring your notebook or a sketchbook and a camera. The more beauty you expose yourself to, the more you will educate your eye and refine your taste. Record your feelings as you go along, because the information you gather from these field trips is invaluable in the deco-

ration of houses. Edith Wharton's architectural education primarily consisted of the exploration of great houses and their gardens. She absorbed the atmosphere of these places, and in time developed a discerning eye. If your train your eye, then when you see something ugly, flimsy, or grotesque in your own house, you'll have the vision and courage to correct it by adding a classical element.

Dado molding

Your local lumberyard may rent videos demonstrating how to install moldings, put up doors, install windows, replace fireplace mantels, and use related spare parts, anything from a dowel and set of brackets for curtains to dado molding. You may want a ceiling ornament to draw attention to a hanging chandelier or lantern, or a pair of fruit and flower garland reliefs made of plaster, wood, or resin on either side of the mantel wall with a mirror or painting in between them over the fireplace.

Perhaps you want to replace a rotten balustrade, or just the supporting balusters. In any case, by knowing what you're looking for, you liberate yourself by seeing how easily your situation can be rectified. If your door frame is too narrow and plain, you can add an egg and dart or a dentil molding to the frame rather than replace it entirely. If you want the rich texture of raised paneling, you can install wainscoting between the chair rail and the baseboard.

An old raised-panel door installed horizontally as paneling on a wall under an opening between the kitchen and a breakfast room could add atmosphere where you have a counter and Windsor chairs. If you live in a recently built Colonial-style house and the doors are not the traditional simple four panels of the period—two on the top and two on the bottom—you can purchase new doors from the lumberyard and install them yourself.

A restaurant in an ordinary residential area of New York City created the atmosphere of a charming Normandy cottage through the use of old wood fragments. The owners installed a deep cornice and stained it to contrast against the white stucco walls. They sank an irregular antique door frame into the plaster of one wall, creating an illusion of space, a feeling of wonder and fantasy, and a charming warmth. The side of the staircase is filled in with one large eighteenth-century raised-panel door, set horizontally. Another antique door is installed the same

way in front of the bar. This restaurant is as cozy and delightful as a private dwelling.

When your house abounds in these classical details, with sublime references to the past, your rooms will echo the grace of harmony, dignity, and timeless beauty.

CHAPTER 6

Walls and Ceilings

*Walls give us the security of boundaries
as well as privacy and intimacy;
ceilings become the enclosure of our private heaven.*

THE PRESENCE OF WALLS

*W*all space is an essential aspect of interior design. By making the most of your walls, or your lack of walls, you'll be able to enjoy greater convenience and freedom of imagination in your planning.

Few people can afford the luxury of single-purpose spaces. More and more often you see people making traditionally single-use rooms serve a variety of purposes. Decorating such multifunction spaces requires extra thought and planning, but the process and end result can be surprisingly rewarding. When deciding how you're going to use a space, first you need to establish what its requirements are, keeping in mind how it must stay flexible to adapt to your evolving needs. You'll soon discover that there are many different ways to put a room to use once you prepare the background—the four walls—to take on the challenges of flexible furniture arrangements, storage needs, and decoration. You'll find that living rooms can also be bedrooms, bedrooms can also be dining rooms, and dining rooms can also be home offices. The key is in creating as pure, clean, and wholesome a backdrop as possible.

For an interior designer truly to be a house doctor, he or she must be willing to make minor or, if necessary, major structural changes that will be the spine of the decorating job. Usually this entails either widening an opening in a wall, putting up a wall, or tearing one down.

Sometimes these structural renovations are required to make awkward spaces more comfortable and convenient.

EXPANDING YOUR WALLS

*W*alls give spaces physical boundaries as well as privacy and intimacy. But walls can also be emotional barriers, blocking the energy flow of a space, causing a feeling of entrapment for you and others. Never allow this to happen. Don't have a wall unless it is structurally necessary or desired for privacy. View your walls as spaces to hang beautiful art or to hold books so they enrich you rather than confine you.

Think back to when you were very young and spending summer days playing outside. Picture running inside to get a glass of lemonade and how you immediately felt the abrupt darkness of the interior space relative to the outdoors. Does this drastic contrast exist in your house today? Chances are you have become so accustomed to living in the dark that you hardly notice. How can you design your walls so they become more expansive, more useful, and less of an emotional barrier? How can you extend your space, making the "bone structure" less constricting?

Study the walls of your rooms, including any openings. Become familiar with each of the four elevations (walls) and then join them into wholeness. How can you put this wall space to best use to satisfy your essential needs? What is the most comfortable way for this space to function practically as well as be aesthetically pleasing to your senses? Are there generous wall spaces for bookcases? Do you have sufficient wall space for art? Where will you want to sit and read? Where do you envision placing the bed and other furniture? What will be the focal point of the room? Where will it be located? What does the door, or doors, echo on the opposite wall? Are the openings where they make sense? Do they line up opposite a window so they bring in light and view?

Before discussing floor plans in the chapter entitled Furniture, where we will explore the art of furniture arrangement, examine your walls, room by room. Turning clockwise, north, east, south, west, look at each wall. Take notice of all the unavoidable elements taking up wall space. There could be a radiator in an awkward place, or an air conditioner

stuck in a window prohibiting you from seeing outside when seated and from washing the window. You could have a pipe in the corner, or worse, projecting into the room, preventing you from hiding it by boxing it in. There may be forced-air ducts crawling down your walls. You may have grillwork for a vent, wall sconces, or a jumble of wires stuck around applied moldings.

None of us inherits perfectly graceful walls. You can't cure the problems until you face this reality. If there is an ugly protruding surface-mounted duplex outlet on a wall, once you plug in a lamp the wire will protrude into the space. If you intend to place an armoire in front of it, there will be a gap between the back of the high piece and the wall. The best solution to this problem is to replace surface-mounted duplex outlets with recessed outlets.

Now is the time to be critical, clinically examining everything you see, think, and feel. You should not build a room around flaws or eyesores, covering up and hiding things that make you shudder. While few people meet their goals of ideal walls entirely, at least you can be on the path of having each wall, or elevation, in every room make sense so they create a cohesive background.

KNOCKING DOWN WALLS AND WIDENING OPENINGS

*I*n 1960, interior designer Dorothy Draper urged her class of eager students, "Don't design scared." Keep this in mind when you contemplate literally pushing away walls to open up space. Remember, walls should never be emotional barriers. Widening an opening so that you're able to sit in your study and see through your living room out to the garden creates a flowing space that may open up a new world to you. But you have to have the imagination, courage, and patience to see past the demolition. Think of yourself as an interior architect and ponder how you would redesign the inside structure of your house. You may want to knock down walls to achieve a more open, freer atmosphere and a more workable, flexible space. Or you may need to knock down a wall to open up a space for practical reasons.

When a client with young children moved into a sun-filled apart-

ment, she decided to turn a former maid's room next to the kitchen into an informal French provincial dining room. The only entrance into the new dining room was at the end of the adjacent galley kitchen, making it impossible to see between the rooms. My client wanted to be able to see her children while cooking and to be able to serve food without having to walk around the corner. The only solution was to knock down the wall between the kitchen and the new dining room. After creating an arch in the new opening and extending a counter, she could easily cook and keep an eye on her children, who would be sitting on high stools facing the kitchen. Rather than having two separate, inaccessible rooms, one open, flowing space was created which became the heart of the apartment. What a revelation it was for my client to be able to cook and interact with her children simultaneously.

Your exterior walls require much more major reconstruction if you choose to alter them in any way. But they, too, can be improved upon to "expand" the space without knocking out an entire wall. For example, adding a bay window to the family room, or installing French doors leading out onto a deck or patio could bring hundreds of hours of happiness to you and your family because of the greater light, sense of space, and view of the outdoors.

Removing unwanted interior walls, in most cases, is not a major expense. It may create what looks like a bomb site, causing tempers to flare when plaster clouds the air and gets in your lungs or you trip over rubble. Eventually, however, the dust settles after the dismantled wall is carted away, and you realize the lasting transformation is worth the temporary inconvenience.

But be certain to consult a builder or an architect before removing a wall, to ensure your house will remain structurally sound. Don't be discouraged if you open up a wall and find a pipe in one side. You can either leave the pipe in its original location, settling for a narrower opening, or get a plumber to relocate the pipe. When you reevaluate your walls, you will discover that some walls need more consideration than others, and each elevation needs to be individually thought through from the perspective of appearance as well as practicality.

If you fall in love with an antique doorframe and want it for your house, you can widen the entrance to accommodate the larger structure. Most openings are three feet wide, but older ones average forty-two inches. Even if the door butts up against the interior wall of the hall on

the right-hand side, you can open up six inches of wall to the left. But never assume anything. If you live in an old house and think that you can move the stone front steps to center them under the door, you may discover that they are cantilevered into the house. Because of the age of the wood support beams, you dare not risk moving the steps. But no one will notice this irregularity if you place huge terra-cotta pots filled with geraniums or ivy to camouflage the absence of symmetry.

If you rent your house, you probably won't be allowed to make structural changes unless you obtain permission from the owner, and you may not want to make the investment unless you plan to stay for several years. If you own your house, however, consider structural alterations to maximize your pleasure from your rooms. Keep in mind that the existing walls were put up at a different time for someone else's needs and taste. Confront your walls and study their usefulness to your living patterns. If you see a way to relocate, remove, or push open a portion of one wall, be your own architect and dare to make structural improvements.

If you feel you aren't in any position to wear an architect's hat, there are ways to create the illusion of openness and expansion without making structural changes such as knocking down walls or widening openings. Paint the wall white to bring in light. Hang a large painting, print, or photograph of a landscape or seascape with perspective so your eye is drawn into the scene. Use bold moldings, leading your eye to the architectural refinement, not the wall. Hang windowpane mirrors in line with existing windows on the opposite wall to expand the visual space, breaking up the solid structural, and often emotional, barrier.

CLOSING IN UNNECESSARY OPENINGS

Not all existing openings are desirable. If you're an art collector, for example, you'll want space to house your collection. If there are two entrances to a hall where only one is needed, you can extend the wall by closing in the space, stretching the usefulness and enjoyment of an adjoining room.

While some walls may inhibit the openness, light, and view of a space, a lack of walls may limit your ability to feel embraced and cozy in a

space, bookcases within reach. A room with too many openings is unsettling, far from intimate and inviting. A room with openings on all four elevations is not a private space but a public hall. Don't let preexisting openings intimidate you. Be opportunistic in exploring ways to literally extend your wall space; whether you want to close in an opening for more privacy or to provide space for art, books, or collections. Invariably you will find openings that you really don't need, where you could use the valuable wall space for storage, art, books, or a furniture grouping. For example, if you turn your dining room into a library, there is no longer a need for the swinging door from the adjacent kitchen.

Why have two doors bunched in a corner, one leading from the hall, and another from the kitchen, when one is all that is required? Remove the doorframe and door, close it with Sheetrock, tape the seams, spackle, and paint. Now you have new wall space in both rooms, providing a place for a standing desk or bookcases in the library, and a wine rack or even an additional counter in the kitchen.

If you have a bathroom with two doors, one leading to a study (formerly a powder room) and the other to your bedroom, close in the study entrance. Far better to have space for a double sink in the bathroom and a desk in the study than to have an occasional guest be able to invade the intimacy of your bedroom. As a general rule, if you keep a bathroom door locked, remove it and fill in the opening.

PUTTING UP WALLS

*I*f you want to make a one-bedroom apartment into a two-bedroom, or divide a large living room into two separate spaces, it is easy to put up a Sheetrock wall and add the cornice molding, baseboard, and door trim to match the other walls. Explore your options for putting up walls at houseware stores and lumberyards. Be sure to ask about acoustics to ensure privacy within each room; you may want some insulation to absorb sound. If a roommate watches television or talks on the telephone when you want to read or sleep, you'll be glad for the peace and quiet.

The walls of your rooms should be cohesive in woodwork, theme, and color with few exceptions. If there are odd moldings or other awk-

ward details, or if one wall is wallpapered and the others are painted, the room will have an unsettling feeling. Just as you instinctively respond to harmonious rhythms in music, so you seek sweet melodies in your spaces. Repetition creates harmony. Repeat shapes and have all four walls as unified as possible. You achieve balance with repeated details and logically placed masses and voids in your rooms.

Whenever possible, divide a space so both rooms have a window and heat source. If the space won't allow this, and one room will have no natural light, consider having a permanent solid wall go up six or seven feet and install glass above, or leave the top open for light and air.

MOVABLE WALLS OR SCREENS

Silk-covered screens

*B*efore installing a solid wall, consider the more flexible option of a movable wall. In Japan, it is a common practice to separate spaces by using movable walls, or screens, to create temporary rooms within a single space. The textile artist and environmental designer Jack Lenor Larsen created a Japanese house design in his New York City loft, using movable silk-covered screens throughout to give unity to his theme. In South Carolina, I used the Japanese concept of movable walls for a house on the water. I designed four 4-foot-square partitions of

Shoji screen

folding solid panels on ceiling and floor tracks to open and close the kitchen to the living-dining areas, where the water was in full view.

In another apartment I wanted to eliminate bulky doors clanking into each other in a narrow space between two opposite closets. I gained full access to the space by knocking down the walls on either side of the doors and installing a screen of white wooden slats on a ceiling track. If you have two children sharing one space, you can easily hang a ceiling curtain track, using two different but compatible fabrics, so each child will have his or her own favorite material and also a sense of privacy.

Movable walls, or screens, are also an attractive way to hide unsightly equipment or other objects that have accumulated and have no place else to go other than against a wall. Jack Lenor Larsen houses an extensive collection of books in Long House, the seventh-century-style, Shinto-inspired home in Long Island he designed in collaboration with architect Charles Forbery, who also worked with him on his Zen-style loft in Manhattan. "I find books visually distracting," he says. "Unlike my literary friends who live in chaos with paper all over the floor, stacks of books and stuff everywhere, I am always trying to create tranquility. Books, to me, are very stimulating so I don't want them in direct view. I organize my books, and whenever possible their related collections, behind a movable wall of screens."

Larsen's books are accessible when he wants them, but he's able to have his rooms "serene and open." Some may disagree with Larsen that books should be hidden; yet he is a genius with space solutions, his ways to "conceal and reveal." He created reversible screens in panels using double-faced fabrics he designed himself.

Screens are also immensely useful in studio apartments to shield the bed when friends come to visit. You can instantly convert a bedroom into a dining room or living room. You have several options if you decide to have one or more screens in your space. You may want the traditional Japanese shoji screen made of rice paper that allows light to penetrate it, or perhaps you'd prefer a more solid decorative fabric or painted wood screen.

THE WALLPAPER OPTION

When decorating a house, you may find yourself spending hours poring over books of wallpaper samples. But before deciding on a specific pattern, ask yourself whether you really want to wallpaper your walls. Keep in mind that all wallpaper is an imitation of nature or art and very repetitive, and though it can be very pretty and useful in creating illusions, it may be more of a hindrance to your decorating scheme than an enhancement. Walls should be reserved for art and books, and almost always a solid, painted background is preferable to a printed wallpaper that may draw the eye away from favorite things.

What do you do, however, when you have an accumulation of pretty pictures but are a long way from having enough objects of scale to carry the entire surface area? In a desire to dress naked walls, the natural temptation is to employ wallpaper as a solution, though this decision may be shortsighted.

The main reason I prefer painted walls to wallpaper is that you can instantly change the mood of a room by dipping a paint brush into a delicious, fresh color. Wallpaper is static, inflexible. Walls should allow for spontaneity and change, just as a garden is in a state of constant transformation. Wallpapered rooms lack freshness, seeming dated, stuck in the past, never evolving. And few people muster the time, energy, and money to freshen up a papered room every five years.

Many people are tempted to wallpaper a nursery or a little girl's bedroom, but it is wiser to put the money into art posters and paint over cork board so a child can display some of his or her own art in the room. Also, the ladybug-and-clover wallpaper in your ten-year-old daughter's bedroom will probably not suit her when she reaches high school age.

It can be argued that wallpaper is less expensive in the long run because it has a longer life span than paint. Wallpaper also hides imperfections and cracks in the wall that paint does not. But a solution to this problem, aside from wallpaper, is to put up a large wall hanging—a quilt or tapestry or other large art—that will cover major imperfections.

If walls are in bad condition, it is usually far more sensible to repair and paint the damaged areas than to use wallpaper as a cover-up. However, when walls are in really bad condition, canvas-back papers may be a less expensive solution to repairing the walls unless you do the

*Hand-painted Chinese
wallpaper panel*

Wallpaper above chair rail

repair work yourself. Canvas-back papers are practical bandaids for large cracks in old plaster walls, and provide a textured surface and color.

Some wallpapers are works of art and have a lovely effect on any wall they cover. Hand-painted Chinese wallpaper, used mostly in formal dining rooms where people gather for celebrations, is sumptuous and elegant. Originally these panels were called "India" papers because Britain's East India Company was the largest importer. In the glow of candlelight, silver, and crystal, there is nothing as richly beautiful as hand-painted Chinese wallpaper. These wallpapers come in forty-six-inch-wide panels in lengths ten to twelve feet high, and are sold in sets to cover the entire room's four walls. The scenes of blossoming trees and fantastic rocks with animals, birds, and insects are brilliantly colored in naturalistic detail. There was a time when this wallpaper was so popular that some people even built a room to fit the panels' dimensions. As early as 1787 President George Washington ordered a set for Mount Vernon.

Woodblock printing eventually brought down the prices of painted wallpaper in the latter part of the nineteenth century after the introduction of Japanese prints, but there is nothing as breathtakingly beautiful as the handmade originals. In a dining room with antique mahogany furniture, a lemon-yellow background is sumptuous. One client wanted a room with yellow panels of flowering trees cascading from cornice to baseboard, while another aspired to having oriental wallpaper in her dining room but couldn't afford the expense of covering the entire wall space, so she compromised by selecting short hand-painted panels of flowers designed to hang above a chair rail, achieving the same effect at half the cost. If you install a four-inch molding with a deep projection, there is a quality architectural base to support the paper. If you desire a dining room decorated in this extravagant way, have a breakfast room where you can eat your family meals. Few can stand this amount of richness as a daily diet.

If you do want wallpaper and can't afford hand-painted panels, select a quiet, small pattern or a wide stripe so any art you place on the walls won't clash with the paper. Large-scale designs don't work well with art and photographs, leaving mirrors and brackets with porcelain the only way to break up the pattern. But even these displays can look fussy. And any room without pictures, with the exception of a powder room or a formal dining room, will be a lifeless, rigid space.

With this warning, in the right room, wallpapers can be pretty, and a suitable alternative to expensive woodwork. For example, rather than going to the expense of having real trellises installed on the walls, some papers fool the eye and are extremely effective in creating an architectural garden mood. Guest rooms can be charming papered with small-scale geometric patterns or flowers. If you have a vacation house where you go infrequently, paper could be welcoming, though I prefer quilts or botanical prints, photographs, or paintings.

Unless you're properly trained, do not install wallpaper yourself. Because of the lengths from cornice or ceiling to baseboard, usually over eight feet, the risk of creasing is too great for inexperienced hands. Glue bubbles can cause stains on the seams that often don't show up for months, and if the paper is not glued evenly, the seams curl. Professional paperhangers are expensive. The more valuable the wallpaper the more they charge because of their responsibility for any potential damage.

PUTTING YOUR WALLS TO PRACTICAL USE: THE HOME OFFICE

*Y*ou are probably familiar with the term "floor space." Now it is important to make "wall space" part of your decorating vocabulary as well. When square footage is scarce, you should use your walls to full advantage. A client converted two maid's rooms in a city apartment into two home offices by hanging bookcases and installing storage cubicles on the wall above ledges used as work surfaces, or desks. A thirty-four-inch-deep oak ledge along the north wall curves around to continue along the east wall under a window.

The bookcases above the desk space are eight inches deep, hanging down from the ceiling seventy-six inches, fourteen inches above the thirty-inch-high ledge. On the south wall under the ledge nineteen inches deep are lateral files, taking up all the floor space, and above are fifteen-inch-deep storage shelves, seventeen inches above the ledge and set back four inches to leave a convenient surface for the fax and Xerox machines. Lined up with the front of the hanging bookcases and storage shelves is a brass strip of lighting.

The same open cupboards and bullnosed ledge were repeated in the second converted office, utilizing as much wall space as possible. To bring in more light, a mirror was hung on the south and east walls twenty-one inches high, behind a deep ledge where one can do paperwork or projects. Hanging on the east wall twenty-two inches above the ledge are ten-inch-deep shelves for reference books. On the north wall is a window with a bullnosed oak ledge. To the left of the window, to gain more storage space from the walls, is a twenty-inch-deep three-drawer file cabinet with an oak ledge on top, convenient for standing and doing work on the countertop and offering easy access to the square cubby storage cubes eleven inches wide by ten inches high

and eleven and a half inches deep above the file cabinet, ideal for stationery and office supplies.

In a section of cubbies is a series of red, orange, and green boxes the size of shoe boxes, creating a graphic Mondrian look, ideal for storing photographs, negatives, nostalgic letters, and postcards. By using a sturdy wooden folding ladder to reach the top shelves when necessary, and by making the most of the wall space, a husband and wife were able to meet all their working needs in these two small enclosed spaces.

This concept of a ledge where several people can sit and work in a relatively small area can be applied in any room, and works well in master bedrooms, children's rooms, kitchens, and living rooms. Installing a thirty-inch-high surface where you can easily pull up a chair and work on a project is the least expensive way to have lots of surface space without having to buy costly individual pieces of furniture that take up volume.

Lateral files

As long as you leave ample space for leg room under the ledge, you can install bookcases or shelves, or have file drawers on either side, creating convenient storage. On a window wall in a bedroom, displaying books, easel art, favorite objects, and flowers on a ledge is practical as well as convenient. On open shelves below you can store notebooks, books, and boxes of stationery.

These ledges can be cantilevered by sturdy, inexpensive angle-irons countersunk into the wall and plastered over. To conceal the support under the surface of the ledge, a semicircular molding can be applied, or a straight piece of wood from two to four inches thick, depending on the look you desire. If you never intend to pull up a chair and sit at this surface, you can have as deep a facia, or front ledge, as you wish, but if you do plan to sit there, keep in mind your height to be sure you have enough leg room.

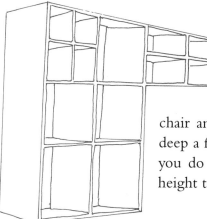

Cubbies

A crucial component of maximizing wall space is the installation of counters. An important design decision is how to treat the surface space of counters, that is, what material to use. You'll need ample horizontal surfaces in these rooms for practical reasons, and because of their visual prominence, making them attractive as well as useful is important.

Before installing any new horizontal surfaces in your bathroom, question the location of the toilet. If it is opposite the entrance to the room, you'll either have to keep the door shut or look at a necessary but essentially unattractive fixture. The view into a bathroom should be enticing. This may require relocating the toilet. By tucking it to the right or left of the entrance door, it is out of sight until you are in the space.

Next, place the bathtub, the fixture that takes up the most space. Once the toilet and tub are set, then you can think about the ideal spot for the sink and counter space. Aim for one elevation with a surface long enough for a sink with ample space on either side. Don't crowd in two sinks at the expense of generous counter space. Better to select a wide, oval sink with plenty of room left over for flowers, hand towels, and soaps.

Tiles surrounding sink

In bathrooms, I prefer glazed ceramic tile surfaces because not only are they beautiful and available in a variety of colors and designs, but they are very easy to clean. You can cover a plywood surface with any tiles you choose. One client covered her bathroom sink counter with British Library–green handmade French-glazed tiles. Now she can leave her bathroom door open and feast her eyes on the beautiful green tiles reflected in the mirror above, which doubles the visual space as well as the impact of the tiles.

Most bathrooms have a cabinet underneath the counter, but in a small bathroom, the cupboard doors may seem confining. In small spaces, I prefer ledges with open space below. One client chose an elegant pair of Lucite legs to support the sink ledge in her bathroom. They have the look of crystal, with brass tops and feet to add a light touch of grace. Consider hanging some prints on the wall underneath the sink to enjoy them from the bedroom or when taking a bath.

If you decide not to have under-sink cabinets and don't want the traditional medicine cabinet above, you'll need a place to keep bathroom items. Perhaps small shelves or cubbies could be installed on either side of the sink elevation, or you could store supplies in a free-standing cabinet against another wall.

If you have a small, high window in your bathroom, consider installing a ledge and covering it with four-inch-square tiles, repeating the same style on the front ledge, to give an awkward window some definition and beauty. You can even repeat these same tiles in several rows on the three walls above the tub for continuity. If the tiles are especially elaborate, use primarily white tiles to line your walls above the tub, interspersed randomly with the patterned tiles. If your tub doubles as your shower, tiles should continue to the height of the shower head or to the ceiling.

Next to glazed ceramic tiles, marble is my choice for sink counter material. Marble is usually more formal than glazed tiles, but in a classical, traditional house, it is elegant and appropriate.

Tiles surrounding tub

If you own your house and intend to live in it for a long time, invest in mirrored walls or large expanses of mirror in the bathroom because they make the space twice as commodious. But don't install mirror where it will have direct contact with water.

There are several options when choosing the ideal material for kitchen countertops. I have a special passion for butcher-block counters because not only are they practical for chopping but I find them

Butcher-block counter

organically beautiful, warming up a space that contains cold, inanimate appliances. In a New York City apartment kitchen a client's two-inch-thick butcher-block counters line up with the window trim of a huge picture window on the wall opposite the door into the room. To the left of the window is a square counter with a round copper bar sink, leaving enough space for a small, square, American pine farm table where the family can have breakfast. By installing an eight-inch-deep ledge underneath the kitchen window and covering it with two rows of tiles, the client can place flowering plants in the morning sunlight. The counters continue on the north, south, and west walls, with one area raised from thirty-six to forty-one inches high so the client can stand and work without leaning or sitting on a high stool. (If you are tall, you will want high counters in the bathroom and laundry area as well as in the kitchen.)

As a result of the attention given to the counter space in this kitchen, the family uses this light, bright space as a gathering place. Kept free of appliances and clutter, the counters are ready to be used by children decorating gingerbread cookies or by parents paying bills or wrapping birthday presents.

Butcher-block counters not treated with a protective polyurethane coat require regular sanding to keep the surface fresh. Though there are a wide variety of practical materials for kitchen countertops that are easier to maintain than untreated butcher block, I prefer the raw maple for two reasons. First, water eventually causes the polyurethane to peel off; second, the coating gives the wood an undesirable orange tint. Untreated wood also shows all the grease spots that attract insects, so once you rub out these spots with sandpaper, you know your counters are sanitary.

The easiest counters to care for are water and stain resistant, namely plastic laminates and pressed marble, though some hard marbles have these qualities as well. But there are really no maintenance-free materials. If someone puts a hot kettle on a wooden surface it can be sanded until the burn mark disappears, but if the same kettle is put on a pressed marble or plastic laminate counter, the surface will melt, making you replace the whole counter.

Organic, nonsynthetic materials tend to age well. Even if marble is cracked or glazed ceramic tiles are chipped, this is not necessarily unat-

tractive, but scratches in plastic might be. Finally, it is important to choose a material you love for your kitchen counters, because you will touch them more often than most surfaces in your home.

CABINETS

*W*hen choosing the right kitchen cabinets, first decide whether you want cabinet doors made of solid wood or glass, or if you want doors at all. You can incorporate all three options in a single kitchen.

The cabinets of most kitchens are best hidden behind solid doors because much of the storage is unattractive and not fit for display. Even if you have pretty dishes, if you tend to be messy, the inside of your cabinets may be unsettling to the eye. Often it is wiser to store kitchen items by convenience, not appearance, making solid cabinet doors very useful. One woman stores her children's books in a cabinet along with her nail polish

Wood cabinet doors *Glass cabinet doors*

and remover—not something to display, but obviously an arrangement that works for her. You may want to have a series of small square cubbies or shelves to display teapots or cups and saucers, or hold cookbooks.

Kitchens can be practical *and* sensual. It is possible to find a balance between the stowing away of utilitarian equipment and the displaying of favorite pottery, china, crystal, and glass. In some situations, for prac-

tical reasons, you may not want cabinets at all, but exposed shelves. In a laundry room, for example, wire shelves allow you to reach everything you need with minimal effort. You don't spend much time in this room, but come and go quickly throughout the day, making these shelves a great convenience. Don't worry if the space is cluttered, most laundry rooms are. Try hanging a large pastel-colored quilt on the opposite wall so the eye is drawn to its beauty. This touch makes spending time in this space more relaxing, pleasant, and efficient.

BOOKCASES

*B*ooks are enormously decorative as well as informative. Bookcases can turn a plain, dull room into a rich, interesting, colorful space. Over a lifetime you have a constantly growing inventory of books you're emotionally attached to and want around you. When you have a great deal of books you may decide to turn your dining room into a combined library and eating space to house part of your book collection.

Many books are large and heavy, so the shelves should be vertically supported every thirty-two to thirty-six inches to prevent the shaft from warping. Make all the shelves adjustable, resting on brass shelf pins inserted into round holes on both sides of the wooden frame. If you have bookcases on one elevation, whether floor to ceiling or above storage cabinets, repeat the exact design unit if you decide to add more. The width can vary but the style and height should be the same.

Because of their accumulation of books, clients asked me to hire a talented carpenter to repeat on the opposite wall the exact design of the bookcase on the east wall of their library, leaving just enough space for their sofa to be placed in the middle. Along the south wall are a high French provincial pine cabinet and an Edwardian standing desk topped with an enormous old dictionary. You feel the intimacy of being surrounded by books on three walls relieved only by windows, the antique high piece, the sofa, and the entrance to the room. This library houses more than three thousand books, categorized by general subject. My clients value being able to spot their favorite books, gaining emotional comfort, a handsome room, and a working library.

Exposed shelving

If you are a bibliophile and plan to continue to buy books throughout your life, I would advise installing stacks of open, ceiling-to-floor shelves rather than built-in cabinets with hinged doors. Let your books be decorative walls. Remember, you don't have to fill all your spaces with books overnight. I've heard about people buying "books by the yard" just to fill up shelf space. I find this dishonest. Everything evolves over time. You can put some books face up or face out, alternate sections with small paintings on easels, and place some of your favorite objects among the books. Books also can be opened on easels. I have a client who loves her library so much that she makes miniature bouquets of flowers to rest on some of her bookshelves where decorative bookends keep the books upright and together, freeing shelf space for her flowers. Narrow strip lights can be installed under each shelf to illuminate books, flowers, and treasures.

Books are alive and need to be accessible, not hidden behind closed doors. If you've been hiding books in the dark, remove the cabinet doors and let the shelves breathe new life. Most rooms are improved by the presence of books. One friend's favorite expression is "Where your focus is, that's where your energy goes." If yours is a book family, and your love of reading has enriched your lives, creating ample wall space for books will greatly enhance your home.

You will be blessed with a library in your house. Put books in a family room, have a book-filled study, have bookcases in the living room as well as in the bedrooms, and you will be rich. I prefer used paperback classics purchased at a flea market to lifeless art and useless decorations. Books are our continuing education. A house with many books is a house of many mansions.

A publisher has bookcases under the kitchen counter on an elevation facing the breakfast area, turning the heart of the home into a sunny place where the family can gather and read around the table. A client wanted cookbooks on the galley side of her kitchen and gardening books in her trellised, sunny breakfast room, so we installed glass shelves accessible from both sides and placed the books back to back. Another client's bookcases are built on the wall opposite the stair banister.

HOW MUCH CAN YOU TAKE IN?

*Y*ears ago clients asked me to build bookshelves on the wall of their bedroom opposite the windows. They kept adding books to these shelves until finally, after several years, all the space was full. Then, they began to place books horizontally on top of the vertically stacked books. One spring morning the wife woke up, stretched, and suddenly became awake to the chaos she and her husband had created with their most treasured things, books. She knew she would always have a cluttered corner where she could keep papers, books and notebooks, file cards, pens and ink, to be used when the spirit moved her. But the once pure, serene wall with one large painting on it was now a busy hodgepodge of random colors, sizes, and shapes that felt top-heavy and threatening.

A bedroom should be a sanctuary, a soothing retreat that induces calm and peacefulness. But hers was looking and feeling more as though it were a college dorm room. She pulled the sheets up high, shut her eyes, and had a Zen moment where she realized the entire wall of books had to go!

After breakfast she and her husband put on their jeans, threw open the window, emptied the entire contents of this vast storage unit, and dismantled it. The hall of their house looked awful for a few weeks, but they restored the bedroom to a calmer atmosphere with bookcases under the window elevation, relocating most of the books to the sitting room. Book lovers periodically have to face the teeming stacks of accumulation and reorganize.

One of Jack Lenor Larsen's trademark touches, in addition to screens, is his use of glass shelves because they are easy to clean, light, and structurally strong. If you buy used plate glass, he says, you can save money; simply have the edges ground and polished. "Books are light absorbing," he tells us, and glass gives off light, rather than taking it in. His modular book system consists of one-inch-thick shelves, with a depth varying between eight and fourteen inches, with vertical supports every thirty inches.

How you use your wall space depends on your temperament, your emotional response to visual things in your environment, and how you wish to use and experience your rooms. Jack Lenor Larsen enjoys placing one beautiful object in his space so he can focus his appreciation.

Others prefer more variety. "There is no absolute truth," says a legendary literary agent and book lover. Each person has to find their own truth.

We have to know how much we can comfortably take in without it becoming excessive. What is tolerable at one point in life can become irritating in another. There are parallels between life and decorating. The story of the client who lost her Zen calm in her bedroom illustrates that how much you want on your walls is very individual and varies. You must determine how much is too much or too little, and evaluate your walls regularly to be sure you are being supported, not discouraged, by them.

The rhythms of active and passive wall space must be continuously reevaluated as you welcome growth and change. Walls can cradle you, delight you, provide places for your treasures, and store your utilitarian things. They can support ledges, counters, and be a backdrop for furniture. The more wisely you use your walls, the more joy you will feel in your home.

CEILINGS

*I*n the grand houses Edith Wharton wrote about, ceilings were tall, vaulted, and elaborately ornamented with stucco. Some were carved of wood, and were as beautiful in their own right as Michelangelo's Sistine Chapel. One of my favorite ceilings is in a French château at Chantilly, a town north of Paris where I decorated a seventeenth-century stone house. Chantilly is known for its porcelain chinoiserie. During my visit there, I bought several hand-painted tea and coffee cups and spent hours exploring this charming château. The Louis XV chinoiserie detail in the colorful ceiling of this château is enchanting. The wall decoration and elaborately carved cornice moldings lead the eye to this delicate artwork. Everything was integrated harmoniously into a refined, sensuous, enticing whole.

Look up at all the beautiful ceilings wherever you travel, because in your home you may have to make do with less than grand ceilings. Ceilings today don't carry the same visual impact as the floors, yet they are a fundamental feature that contributes to the overall presentation and feel of a house.

One of the greatest differences between the decoration of houses one hundred years ago and now is that today there is an appalling disregard for the aesthetic dimension of a ceiling. While ceilings take up the same space as the floor, few people consider spending even a fraction of their decorating budget to make them beautiful.

Think of ceilings as the sky. Whether the roof of a house is flat, sloping, or curved, most interior ceilings are flat, mirroring the image of the floor in size and shape. If your ceiling isn't flat or symmetrical, consider correcting it. Feng shui practitioners believe that an angled ceiling dissipates energy. If you have a gable roof with exposed interior beams, the symmetry of one part answering to the other is visually pleasing. The slopes of the ceiling can be painted sky-blue in contrast with the wall color to give both wall and ceiling definition.

Although modern architecture does not emphasize ceilings, you can make them more fascinating by learning how to create illusions. If you have unavoidable structural elements as part of your ceiling, such as air-conditioning ducts or beams in awkward places, make them part of the room color scheme rather than trying to hide them, because that often draws more attention to the problem. It's forgivable for an old house to have some pipes running along a ceiling, whereas boxing them in would lower the height of the ceiling, making you feel crushed.

Ceilings in houses and apartments usually range from a squat eight feet high to an expansive twelve feet. Many New York apartments are prewar buildings with ceilings averaging nine feet six inches high; most newer buildings have lower ceilings. Ideally, the ceiling height should be in proportion to the size of the room. The larger the room, the higher the ceiling can be and still please the eye. Eleanor McMillen Brown's Southampton summer house, Four Fountains, was an amateur theater that she turned into a forty-foot-square living space with twenty-two-foot-tall ceilings.

Many large rooms with high ceilings in apartment buildings have been divided into smaller rooms, creating awkward proportions. Rooms feel most comfortable when they are squares or fat rectangles. A tall ceiling in a small space makes you feel as though you're in an elevator shaft.

There are several ways to bring a too-high ceiling "down" in a small room. Bold cornice moldings can be applied where the wall meets the ceiling to break up the height of the ceiling, or you can apply plaster

ceiling ornamentation that borders the ceiling rim—strong architectural detail that draws the eye down from the ceiling. Painting your ceiling a dark color also has the effect of bringing the ceiling down. Blue ceilings, however, because of their association with sky, will always make you feel as though you are looking up to infinity. Painting clouds on the ceiling evokes the ancient Chinese meaning of wisdom and heavenly blessings.

A galley kitchen had teak cabinets to the ceiling. By painting the high ceiling a faux wood grain to simulate the cabinets, we brought it down several feet visually, adding comfort in this tiny efficiency space. Chinese silver or gold-leaf rice paper installed in squares in a small formal room warms the ceiling so it shines like the sun to warm you emotionally.

There's nothing more effective in bringing a ceiling down than a shimmering crystal or brass chandelier or a lantern. In a small room in Venice on the Grand Canal with a fourteen-foot ceiling, a blue, pink, and white spun-cone chandelier from Murano became the sky, the sunset, and the spirit of place.

Some ceilings feel oppressively low, especially to tall people, to people accustomed to being outdoors, or to those living in older, classical architecture. Clients moved from a large, grand apartment to a small contemporary one. They felt oppressed by the eight-foot ceilings, having lived with ten-foot-six-inch ceilings for thirty-eight years in their duplex apartment. By painting all the ceilings a soft glaze of blues and white, an Impressionist cloud illusion, they felt lifted up, expansive, and cheered.

In the eighteenth century, small rooms with low ceilings were easier to heat. The same applies today. New England has severe winters, and heating bills are high enough. Small rooms with low ceilings in old houses have an exclusive charm and atmosphere. Built to accommodate the local climate, these small rooms make you feel cozy, not cramped. Even for tall people, these small rooms seem inviting when the colors are cheerful, there's good lighting, and the taste and style reflect the owner. By keeping the height of the furniture low, the ceiling appears higher.

There are several architectural elements that create vertical "orders" on the walls and help add height to a low-ceilinged space. Overdoors, or pilasters such as those Mrs. Brown used in her drawing room, bring

your eye upward. Just as a cornice molding can bring a high ceiling down visually because of its architectural projection, a substantial cornice molding can also draw the eye to the height of the room. Keep in mind the eye wants to be pleased. By adding attractive details that enhance the scale and proportion, you are satisfying the eye.

To literally gain height in a room, in some cases it is possible to cut out a ceiling, opening up your room to the roof height. This way you may also gain another window from the attic. The "great rooms" that now omit formal living rooms incorporate the idea of openness and light.

Look up at your ceilings. As each room has a different ceiling that affects the feeling of the space, a range of creative options is available to you if you decide your ceilings deserve or need decorative attention. In the chapters ahead I discuss lighting, texture, paint, paper, and fabric. All of these you can apply to your ceilings.

In a coat closet, for example, to bring a too-high ceiling down, I had the walls shirred in a blue-and-white small-scale print and tented the ceiling so the eye was delighted with the color and texture of the rich folds of fabric. In the center of the ceiling where the material gathered together, I hung a hand-painted lantern in blues and greens. If you have beautiful carving or plaster work, it can be articulated and enhanced.

If your ceiling is low, you'll learn how to make the space feel more expansive other than by installing architectural elements. Standing halogen saucer lamps flood the ceiling with light. If you have a dome, color and a decorative chandelier may be what you need. If you have a cathedral ceiling with exposed structural beams, you may want to color them in bright, fresh shades rather than use the traditional dark stains.

Walls and ceilings take on different moods throughout the day and at night as well as at different times of the year. Be aware of the wide range of creative options and have the courage to make changes so your walls and ceilings feel right for you. Walls should never be emotional barriers but opportunities to expand your soul, please your eye, and delight your spirit. Ceilings, in addition to protecting you from bad weather, should allow you to feel free and open, as the sky.

CHAPTER 7

Floors

*Floors are the fundamental terra firma
of your house and should be beautiful
as well as suitable for use.*

WHAT IS A FLOOR?

*F*loors are one third of the visual space of any room and usually one third of the decorating budget. The type of floor you choose should be determined by the room's function, taste, budget, and the amount of upkeep required. You must never lose sight of the reality that *floors are to be walked on.* Don't pick any material that you're determined to keep in pristine, unmarked condition because if you do, you'll end up on your knees instead of walking. When I am hired to decorate a room, after understanding the intended purpose of the space I determine the most appropriate floor material for the room's function and build from there.

TERRA FIRMA

*C*eilings and floors are intimately connected. One morning at a client's old house in New Hampshire, an electrician who was putting in some new wires lifted up several floorboards in a study, revealing the wooden ceiling of their dining room below. The modern, flat plaster ceilings were once wood, so the ceiling was, in fact, the

underside of wooden planks that made up the floor. When my client realized she was walking on her ceiling, she felt a wave of insecurity. As in nature, with heaven as your ceiling, you want to feel planted on terra firma, having a feeling of being grounded. It is the same indoors, where floors support and ground you. Think of them in an entirely new, pragmatic way. Floors give you stability not only physically, but emotionally as well.

I rang the bell of a client's apartment on the thirtieth floor of a New York skyscraper, and upon entering I shuddered. The floor was composed of eight-inch squares of thin veneer parquet tiles glued directly onto cement, and all were loose. I had a feeling of vertigo tinged with sadness. I couldn't think of anything but replacing the insecure tile flooring with a simple, beautiful, oak floor. A substantial wood floor is fundamental to everything that follows in decorating.

Think of your floor as the soil of your garden. Without embellishments and ornamentation, if it is rich and wholesome, it will be a proper background for new growth. Simplicity is always the heart of elegance. Whether you have a wood, tile, marble, brick, or cork floor, an organic material will be the most satisfying. If your floors require little maintenance and are easy to clean, you will feel better, because people walk on them, often with wet and muddy shoes. The surface shouldn't be too rough, since many people enjoy walking around barefoot or in socks.

One hundred years ago it was unthinkable not to have hardwood, French parquet, stone, marble, brick, or tile floors to enhance the architectural presence of each room. Thomas Jefferson specified every detail for the floors at Monticello and the University of Virginia, using pine and brick. Floors are architectural, and should feel permanent.

A client bought a house from the estate of a woman who died at one hundred four years old. When he peeled up the old, dusty rose carpeting in the living room, he discovered cement. Builders cut cost corners by covering the ugly, dead cement with carpeting rather than installing wood floors, but they should know better than to ignore the integrity of floors made from organic materials. The client agreed to have a carpenter install a white oak floor. The floorboards were bleached and set on the diagonal, giving the house an open, fresh look. An alternative would have been to use ash, a wood similar to oak in density but naturally lighter in color. When you know in advance you want bare wood floors, creating a design with the wood makes the floor rich enough to

carry the room without a rug. Other than small area rugs hand hooked and designed specifically for this client and placed near the entrance to rooms, we left the floors bare. Every house should be built with wooden floors. Whether they're then covered or left bare, the wood provides options as well as insulation.

TO RUG OR NOT TO RUG

A client who asked me to decorate her house in Paris announced, "We're having tile, stone, marble, and antique Versailles parquet on the downstairs floors, and upstairs I want all wall-to-wall carpeting." When I inquired why, she laughed and said, "Because I can't cope with the horror of trying to figure out what size, scale, pattern, and color of area rugs to select." Some room shapes dictate more than one rug, but selecting them need not be daunting. How large or small should a rug be? How does the furniture sit on it?

No matter how much you love rugs, don't rush to cover up the room's bone structure. It is premature to consider rugs until you have a solid, attractive floor. Only then should you decide whether you want a rug or not. This way you will be free to choose rugs as floor art, rather than as camouflage or as monotonous dust catchers. Remember, rugs will inevitably show signs of wear and tear. Don't put a rug down where people must take their shoes off before stepping on it. People will not feel welcome, and it's rude to place more importance on a floor covering than on the soul who is standing on it.

I'll discuss rugs and wall-to-wall carpeting in more detail in Chapter 13, but now I prefer that you envision the floor rather than what may cover it.

UNCOVERING ORIGINAL FLOORBOARDS

*I*f you have wall-to-wall carpeting hiding wood floors, rip up a corner piece and examine the wood. You may have to dig a bit

because, over time, people pile floor coverings over the original wood. In an old house, you may have to remove as many as seven layers of linoleum before you reveal the original pine planks that have been dormant for decades. Don't be discouraged if you first find plywood. Keep digging and you may be rewarded.

One client began by ripping out an artificial marble floor in the entrance hall that the previous owner had installed over a beautiful chevron-patterned (a zigzag design) wood floor. In the sixties, black-and-white marbleized vinyl tiles were popular, and the former owners had used them to elevate and enliven the entrance hall.

To apply vinyl over wood, a plywood base is attached to the original wood with hundreds of tiny headless nails called brads. In this case, to return to the original floor, thousands of brads had to be removed with pliers, and then all the nail holes had to be filled with wood putty. The process was tedious but well worth it. The nail holes still show slightly, but only on close inspection. Even with expensive parquet floors, the more the floor is sanded smooth with a fine grade of steel wool or sandpaper, the more the brads will show.

Another client moved into a house with a dining room floor covered with dusty blue-green wall-to-wall carpeting. When I lifted the carpet, I discovered a layer of one-inch-thick granite tiles the color of a dead mouse, as cold and depressing as can be. Determined workmen used screw drivers to pry loose these rough porous tiles, and they finally crumbled to reveal a hard oak floor with the potential to be beautiful again. It had been covered over because wood wasn't considered formal enough for dining.

A child's bedroom floor could be a putrid green linoleum with spatterware, but beneath it is a wood floor with integrity. In every house I decorate, I try to get to the bottom of these layers of artificiality. Many clients resist at first, but as they uncover the original wood, excitement and the mystery of what lies underneath replaces fear of the disruption of change. They soon appreciate the beauty and begin to understand the importance of having a solid, natural foundation, giving a sense of bonding with the earth.

THE INTEGRITY AND BEAUTY
OF WOOD FLOORS

One of my canons is the superiority of wood floors in most interior spaces. Wood floors give off life and energy that you unconsciously absorb. Wood also *gives,* having buoyancy and flexibility that tile, marble, brick, and cement floors don't, providing subtle yet significant physiological benefits. Wood floors are used in gymnasiums because they are easier on the knees and the back. Because of the organic integrity of all wood, from soft, knotty pine to hard, red oak, no synthetic floor covering will ever be as satisfying to the soul as wood.

Subconsciously we associate wood with trees, a walk in the woods, nature. An exposed wood floor in a room frees you to create as much drama and character as you wish. Clients who love rugs consulted me about what kind of rug to purchase for their huge entrance hall. There was a pink rug in the family room, a Portuguese floral needlepoint rug in the sitting room, a floral hooked rug in the elevator hall, and floral wall-to-wall carpeting in the bedroom hall, and all four of these rooms were accessed by this central room.

I just couldn't see a rug in this space. Because my clients love to garden and use garden colors and floral themes in all their decorations, I suggested we turn the entrance into a garden without rugs. I proposed installing white trellis work on the four green walls, bleaching the mahogany-colored oak floor, and creating a pattern of squares using Minwax oil stains in shades of green and natural. The idea of entering their New York City apartment through a garden was appealing. We had the William J. Erbe Company, master floor manufacturers, machine-scrape the oak floor to a smooth, even surface. The parquet had been sanded so many times over the years that the nails had begun to show, so first Erbe covered them with a stained putty. Once the floor was smooth, they vacuumed and bleached it twice to achieve the desired lightness. After letting the floor dry overnight, they taped out the design with quality masking tape, rolling the edges so no stain would ooze from one wood tile to the next.

There were seventeen squares north to south and ten east to west. Because of the uneven number, we worked out the pattern on grid paper to ensure that the colors would be evenly distributed (it is always

a good idea to work out floor patterns on grid paper before you apply any stain). We decided to create a grid pattern on the diagonal, choosing one corner to start one shade of green, then letting the pattern work its way down the squares. We stained one color at a time and let it dry overnight before moving on to the next color. After all the stains were dry, Erbe sealed the floor with a coat of shellac, and then, using Butcher's clear paste wax, polished it to a shine. When the project was complete, the clients were thrilled. They stood looking at the floor in awe, afraid to walk on it. I urged them to have a walk in their garden room. The natural wear on a floor adds to its intrinsic, organic charm, just as the grain of the wood enhances its appearance.

Versailles parquet

Bathrooms should have a marble or tile floor that can be easily cleaned, but wood is ideal for most other rooms, including kitchens, powder rooms, closets, children's rooms, and nurseries. In a small powder room off an elegant entrance hall in a Texas house, a client had antique Versailles parquet installed on the floor, turning the windowless, closetlike space into something grand but not too showy. It is hard to be pretentious with wood, and that's one of the reasons I like it so much. Rather than using cut crystal and gold faucet handles for effect, laying a handsome old floor had a more quiet elegance. Good taste is never obtrusive, but gently lures you into a deepening appreciation of the subtle grace of beauty.

THE ART OF LAYING WOOD FLOORS

I once watched in amazement as clients laid a red oak floor in the living room of their house in upstate New York. The original floor had rotted out, and they accepted the challenge of replacing it themselves. I remember seeing them on their hands and knees swinging their hammers, nails in teeth. They were passionate about every detail of the installation, including shaving the boards smooth and rubbing their hands softly on the surface to check if the edges were level.

The boards fit together in a tongue and groove fashion. All nails were hammered in at an angle until they were invisible. The couple sighed in satisfaction when the large wooden leveler, with its chartreuse bubble encased in a glass tube, indicated that they had achieved a level floor-

board. The earthy smell of wood, an aroma that today reminds me of being outside, playing among trees, should be made into a perfume.

If you decide to lay floors yourself, a job that requires patience and skill and may not be for everyone, first make sure you seal the bottom of the floorboards with a protectant to prevent warping. This is a good practice even with hardwoods. Wood expands and contracts naturally, so it is wise to seal both sides as a precaution against warping.

When a client bought the entire thirty-third floor of the tower of a landmark building in New York, William Erbe and I sat down and drew the floor space, creating a bold chevron design for oak boards left in their natural color. In the entrance hall of another apartment, the company created a star design using five different woods with brass inlay that set the tone for the elegance of the other rooms. In a large living room we installed rectangular bands in three areas to create the illusion of area rugs. Because the floorboards were set on the diagonal, the borders created a trompe l'oeil suggestion of rugs in a vast sea of wood.

Trompe l'oeil floor border

If you love wood, the floor is the second best place for it to be, after a tree growing in the forest. But because a tree or two was sacrificed for your room to be physically and spiritually grounded, there are things you will want to do to bring out the grain and enjoy the uniquely beautiful thumbprint of each floorboard. If you decide you want to put in a wood floor, the next step is to look at all your options, not only at what kind of wood to use, but also its age, how it was milled (sawed), whether you will want to stain or bleach it, and how the boards will be patterned in the fine art of floor laying. A craftsman's care and skill makes walking on wooden floors a deeply satisfying experience.

CHOOSING WOOD FOR YOUR FLOOR

Wood generally falls into two categories: soft and hard. Softwood comes from cone-bearing evergreen trees, known as conifers, and includes pine, one of the most popular woods for floors. Hardwood comes from deciduous trees that lose their foliage in the winter and bear nuts or fruit, such as oak, walnut, maple, ash, and mahogany.

Softwoods give off a more warm and cozy feeling than hardwoods. Hardwoods, though beautiful, have a much more heavy and serious feeling. One advantage of hardwoods is that they are much more resistant to scratches, denting, warping, and other signs of wear and tear.

Pine is preferred for its warm, light color and soft essence, as well as for its availability and reasonable cost. Heart pine comes from the center of the tree, giving it a relatively tight grain and strong quality. When

Knotty pine *Heart pine*

Thomas Jefferson designed Monticello and the University of Virginia, he specified that the boards for all of the wood floors be cut from the heart of pine trees within specified latitudes to ensure that the wood would be neither too burled nor too soft. To replace the original floor after the house was gutted by a fire in 1895, builders used antique heart pine from early nineteenth-century buildings in Virginia that had been torn down.

Knotty pine is cut from the outer part of a tree containing an abundance of knots. Recently I had an antique knotty-pine floor installed for clients using boards of varying widths set on the diagonal. The feeling this floor evoked was casual, yet elegant, and also energizing. Such an old material used in a modern way was refreshing. While some people may consider knotty pine to be inferior to heart pine, I find both exceedingly beautiful. Knotty pine, while it warps more easily because the grain is not as tight as heart pine, offers a natural pattern and texture that can add interest to any room. If you like the vigorous texture of knotty pine but would prefer to eliminate the round knots, buy approximately twenty percent more lumber than you need and cut the boards in varying lengths to avoid using any knots.

ANTIQUE FLOORBOARDS

*O*ld wood flooring has a patina and mellowness not found in new lumber. Not everyone can live in an old house, but it is possible to use the floorboards from an old house to add elegance and quiet grace to a new one. The boards are usually much wider than the lumber found today, and ecologically, recycling old floors feels right. If you desire a floor that matches the original wide-board floors you see in many historic houses, you can purchase antique floorboards from a dealer. The cost is high relative to new lumber, but if you research your options, you may be pleasantly surprised.

In a grand new Georgian red brick house in Jackson, Mississippi, the architect suggested installing antique heart-pine flooring, the most sought-after wood in the nineteenth century. The best of the lot was stamped for King George and sent to England. This wood is from old yellow longleaf pine trees that grew as tall as one hundred thirty feet, as large as eight feet in diameter, and as old as seven hundred years. In the seventeenth and eighteenth centuries, these trees covered much of the eastern seaboard of the United States and extended as far as eastern Texas. The timber that wasn't sent to England was cut and sent to the Northeast for industrial purposes. The only way to obtain the wood now is to tear down buildings made of heart pine, preferably those constructed in the 1800s. Antique timber is carefully hand chosen, milled, and recut to custom specifications in various widths and lengths, ranging from knotted to clear-edge-grain heartwood tongue and groove, recessed for a tight fit. The deliberate variety in size of the boards used in a single floor creates a subtle intrigue. Carefully chosen finishes preserve the natural integrity of the wood.

Antique pine flooring is warm in winter, cool in summer, and smooth and lustrous all year round. In a letter, the client said how much she loves the floors. "Walking barefoot on pine boards is as though I'm kissing the earth. Salvaging wood from some of the oldest trees in our nation fills one with nostalgia and warmth of the past and hope for the future." Her old timber came from a sugar mill built in the early 1900s in a small town in Texas. This client turns down the lights at night, turns up the music, throws open the French doors, and dances with her husband on their heart-pine floor.

WOOD FLOOR DESIGNS

Octagonal floorboards with cabochons

Wood floors can be laid in a wide variety of patterns and designs. The most common is a simple parallel layout. Other designs include chevron, checkerboard, octagonal boards with cabochons, and custom patterns. The floorboards usually run parallel to the length of the room. But this is not always desirable, and whenever possible, you should consider each room separately. Clients bought some antique heart-pine boards for a beach house. We knew we wanted the boards to make the living room look wider. To accomplish this we laid the boards parallel to the shorter length of the room, perpendicular to the longer walls. Few people would notice this subtle detail, but it plays a significant role in the overall effect of the space, and the cost was the same.

PARQUETRY

Herringbone parquetry

Years ago floorboards were often beveled (the edges were cut on a slant) to give floors more texture and architectural interest, resulting in indentations across the floor. Unfortunately, these spaces inevitably become clogged with dirt and dust, requiring hairpins to get the gunk out. As an alternative to beveled floors, Tony Victoria—a second-generation antique dealer whose father, Anthony P. Victoria, was a man of elegant taste and legendary flair—created a floor using old wide floorboards and inserted white ash in one-quarter-inch strips between the irregular boards. The contrast between the dark oak and the blond ash was striking, and the varying width of the oak boards alternating with ash bands of uniform width created subtle rhythm without being repetitive. This type of flooring, where strips of different woods are laid in a pattern, is known as parquet; the design of the pattern is called parquetry. Parquet floors can be laid in a variety of patterns, including herringbone and checkerboard. Parquetry can also be custom designed.

The equivalent of parquetry in furniture, where a master craftsman uses inlaid wood to create an intricate design, is called marquetry. Parquet floors and marquetry inlay are true works of art, but due to

their high cost, few people choose them today. For the patient crafts-
man, creating parquetry is indeed a labor of love.

STAINING AND BLEACHING

*D*on't worry if you are not pleased with the look of your wood
floors but cannot afford to redo them. By applying colored
stains or bleach, you can achieve almost any effect you desire. Few
people can afford parquet floors, but dark woods can be bleached and
light woods can be stained to create a parquetry-like design. Study
parquet floors in museums and in old houses. If you like the way they
make a room feel, you can create the illusion of parquetry with stain-
ing and bleaching. If you use your large entrance hall as a family din-
ing room as well as for entertaining, you won't want a rug because
you'll need flexibility in rearranging the furniture depending on your
needs. A rug would be tripped on and would never be the right size.
Instead, you may decide to create a more decorative floor with faux
parquetry.

Bleaching floorboards, often referred to as pickling (though real
pickling is rarely done anymore), not only lightens the color of the
wood, but also makes the wood more uniform in color. The process
involves sanding a floor smooth, and then applying the bleach with rags.
How light you want your floor will determine how many coats of
bleach should be applied. Once the bleach is dry, a white or off-white
stain is applied, followed by a protective finish of polyurethane or shel-
lac. But beware: Not all woods, such as maple and some old pine, can
be bleached. Before bleaching your floors, check with your local lum-
beryard to make sure you have a suitable type of wood.

Clients in Chicago had a floor with a chevron design created with
eighteen by two-and-a-quarter-inch boards. To create a more dramatic
effect, they decided to have the individual boards bleached and stained
in different shades. After scraping the entire floor and bleaching it to
remove the orange color of the wood, we used quality tape to mask all
the boards we didn't want stained, a process requiring true patience.
Then the stain was applied to the entire floor with a paint brush, always
going with the grain. Once it had dried, we removed the tape and

applied a coat of shellac. Finally, the whole surface was waxed and polished to a radiant vibrancy.

The secret to a faux parquetry floor is to adhere to the individual floorboards' size and shape so your stain fools the eye into perceiving a darker (or lighter) wood rather than a stained (or bleached) wood. If the existing wood pattern can be incorporated into your scheme, you can alternate color based on the separation of wood pieces, one board from another. If you only want to enhance a floor made of dull, narrow boards that you feel lack character, you can ignore the original pattern of the wood and create any pattern you wish with colored stains and geometric shapes. This effect is similar to folk art and is not for everyone, but it can be very pretty and inviting.

If you plan to transform a plain stained floor into a decorative patterned surface, measure the floor carefully with a tape measure. Draw the shape in your notebook, and sketch the direction of the floorboards. If they're squares of wood, measure the square size and indicate the direction of the grain. Chances are you haven't thought much about the direction of the grain, but you can study it carefully. Even if you're planning to put a rug on the floor, you may want to create a subtle pattern, difficult to detect but adding richness.

For an entrance hall in Virginia, clients selected three shades of fruitwood in honey tones to be applied in squares, set on the diagonal. They trimmed the floor with three different-width bands of brown, the outermost being the darkest, to frame the entire floor. The charming result beautifully complements the antique fruitwood furniture and old oriental rug that grace the room.

One woman had floor installers come to the drawing room of her New York town house on a dazzling sunny day to chalk out the streaks of light coming in through the French doors. She had them lighten the floor accordingly to create a simulated burst of sunshine that illuminated the room night and day, rain or shine.

Think of creating floor art. Paint stores, such as Janovic Plaza, Inc., sell Japan aniline stains (aniline is an oily benzene derivative used in dyes, resins, and varnishes) in dozens of colors suitable for floors. Rather than putting the color on walls or on furniture, consider creating a colorful floor. In a dining room of a Fifth Avenue apartment overlooking the reservoir, we stained the oak floor emerald-green. The oak grain made the floor look marbleized and luminescent.

In a little girl's room we stained the floor a spring-grass green with a hand-painted border of spring flowers in tints of yellow, pink, blue, peach, and white. A boy's room in Texas was stained a French blue checkerboard pattern of 12-inch squares alternating with bleached white. In an apartment dining room, boring 2¼-inch-wide floorboards were transformed by a dazzling pattern in two shades of blue with pickled white copied from a bold geometric quilt pattern. In a library, a client chose to alternate three shades of green on three different board widths, with one 2¼-inch board of pickled white between each green band to create a dramatic horizontal stripe pattern, widening the rooms' dimensions visually.

When considering floor colors, keep in mind that floors comprise one third of the space in a room. The darker their tone, the more light absorbing they will be. The lighter the shade, the more expansive the appearance. If you love lots of colors in your rooms, consider alternatives to traditional brown floors. If you have antique or reproduction furniture in dark woods, you'll want a floor toned deeply enough to comfortably complement your possessions. If you lighten and brighten a floor, you may want to color stain some of your dark-brown furniture, especially if it is not of particularly good quality. The same aniline stains you use for the floor are appropriate for furniture.

Off an entrance hall with a chevron-patterned floor, the builder must have thought the tenants would use wall-to-wall carpeting in the narrow hall that leads straight to one bedroom then goes off at an angle to another. The parallel two-inch boards whisk your energy away; rather than having the charm of a meandering path. Floorboards should always go from left to right as you enter a long, narrow hall to widen the space by optical illusion. The client wanted to soften this rigidity without the expense of replacing the wood floor or having to resort to carpeting.

The hall was tiny, and if it weren't for the shiny white walls and halogen ceiling lights, one would feel cramped in this space. Putting a runner down the center or a series of scatter rugs would further narrow the look and feel of the area. The client had tried bleaching the hall floors to match the color of the bedroom floors, adding some of George Wells's oval, hand-hooked whimsical rugs of flowers and animals. Though they were undoubtedly colorful and cheerful, they were too

cute. You felt as though you should play hopscotch as you traversed this skinny passageway.

Eventually the client realized that drawing the eye from the large entrance-hall floor into the minuscule adjoining hall would make it appear larger. To accomplish this, she created a smaller version of the entrance hall's chevron pattern, using bleach, stain, and courage as her primary tools. The way the horizontal design proceeds down and across the L-shaped floor, leading into her bedroom (which is out of sight when you enter the hall), is inviting. A mirror placed opposite the bedroom door enlarges the space.

As background, the main floors should be unobtrusive even in their individuality. All rules can be broken when appropriate, but you should try to create a fluid, harmonious, interconnected expanse of floor flowing from one room to the next so the transitions between rooms are not uncomfortably abrupt.

I usually prefer natural to fruitwood tones on wood floors in rooms with unpainted, stained wooden antiques. If a floor is too light, the darker furniture will look leggy. Floors with an especially dark stain have their drawback as well. Years ago a client stained his floors in dark mahogany tones, only to discover that every piece of lint and dust showed on its surface. The most practical is the middle path—not too light and not too dark.

SADDLES FOR SMOOTH TRANSITION

*S*addles are the architectural elements that divide one floor space from another, similar to pauses in musical compositions. Even if you have to plane down your bedroom door in order to have a wood saddle, it is worthwhile. Wood saddles at thresholds serve as speed bumps, causing us to pause and enjoy the experience of entering a different room. Saddles also conceal the raw edge of a strip of carpeting and keep the carpet from unraveling from constant wear. Saddles should be stained the same color as the floors they separate. If you have an apartment or house where the bedrooms are located on the same level as the public rooms, and you want to bleach the floors of your private rooms, stain the saddle that divides the two the darker of the two col-

Wood saddle

ors. If your living room floor is a honey tone, all the openings to it should have the same honey-colored wood saddle to frame the main space, separating it from the lighter color; otherwise the room will look unfinished.

THE AGING OF WOOD FLOORS

*A*ll wooden floors show signs of wear and tear in time. When wood floors become worn from years of use, they have more energy and karma, and are more loved. Lived-on floors have a patina as beautiful as that of an eighteenth-century antique. You don't have to distress your wood floor to obtain this antique effect; all you have to do is enjoy it and, over time, it will become more graceful and lovely than ever.

However, if you are a perfectionist, don't live in an old house. The original pine floors of eighteenth-century houses are all warped. They dip down where they're tucked under the baseboards and bow out in the center of the rooms. Placing a piece of furniture where it can rest on the floor evenly is not always easy. Some table legs need a little wood block placed underneath to steady the table. The cracks between old wide boards become home to accumulated dirt and grandchildren's Day-Glo beads. A client told me of the time she vacuumed her antique floorboards, determined to clear out all those generations of dirt, only to realize it was serving as insulation. Some people have tried to fill in the cracks with wood filler probably to avoid excessive heat loss, but part of the charm of having old pine floors is their imperfect, irregular character.

OTHER FLOOR MATERIALS

*I*t would be boring to have all the floors in your house the same. Even though I'm an advocate of wood floors, I believe that certain rooms lend themselves to brick, tile, marble, stone, or cork. Bathrooms aside, think about what floors you feel should be wood, and what color and pattern you want them to be. Then you should consider the alternatives to wood floors.

Cork I've been using cork for approximately twenty-five years with great success in hundreds of different installations, from children's playrooms to law firms, libraries, and banks. Cork is soft underfoot and sound absorbent. Because it is organic (cork is harvested from the outermost layer of the bark of woody plants), it will satisfy your passion for materials from the earth. Cork is available in squares, several rectangular shapes, and other patterns. You can use twelve-inch cork squares, alternating the direction of each square so it looks as subtle as a patchwork quilt of warm honey-brown tones. Cork never gets cold and provides insulation, so it is an excellent flooring for children's rooms. Cork flooring is coated on top with a thin layer of vinyl to make it easy to clean with soap and water. Because cork is lightweight, porous, and resilient, it is the easiest on your feet, knees, and back. This is why many shoes are made with cork soles. You feel as though you are floating as you walk on a cork floor.

I've used cork in kitchens, home offices, laundry rooms, children's rooms, and in places where people spend long hours standing. The tiles cost approximately the same as wood boards but are easy to lay. You don't have to put a layer of plywood underneath, but you can flash patch the surface with an adhesive to even it out so each square will be smoothly joined. My preference is to use squares in a simple pattern so the floor doesn't look contrived. Save several extra tiles so if one or two get damaged over time you can lift them up and replace them. You must use a specific glue sold with the tiles.

Of the hundreds of clients I've introduced to cork as an alternative to a wood floor, each one swears by it. Children love sitting on the kitchen floor and playing jacks because of the cozy surface, every bit as rich and warm as wood, but softer, more supple, and a cinch to clean. You never touch wax to this flooring; the sheen comes from the vinyl coating. All you need is soap and water. After twenty years or more of heavy wear and tear, you may need to replace some tiles, because the vinyl may start to peel off on some squares. The sun will bleach the tiles over time, but this creates the charming illusion of sunshine near the window. Although replacement tiles won't match the faded ones surrounding them, instead of looking mismatched and confused, the result will be a mellow patchwork conducive to comfort and ease.

Items dropped on a cork floor usually don't break because the cork

is soft. This softness also makes walking barefoot heavenly. You'll find you're less tired standing on a cork floor for hours. If you spend a lot of time ironing and doing laundry, it is ideal for your laundry room. Cork also warms up home offices where there are cold, noisy machines. If you want an organic flooring other than wood, and a material that has intrinsic beauty and is easy to install and maintain, look into cork.

Stone and Marble Floors Few homes today have beautifully designed stone or marble floors. In the public spaces of grand houses, where the owner wants a formal look, stone and marble floors are appropriate. In most other cases, I don't think the expense is warranted. The material is hard and cold, and the cost high. In some settings, however, marble and stone floors are breathtakingly beautiful.

Stone floor

Limestone, marble, and travertine are commonly used for flooring. Limestone is a sedimentary rock containing mostly calcium carbonate, and ranges in color from cream to beige to gray. Marble is metamorphic, crystallized limestone (though some limestone that can take a polish is also classified as marble), often streaked with dolomite, a sedimentary rock similar to limestone. Marble comes in a variety of colors, including earth tones as well as shades of green, red, and bluish gray. Often limestone or marble tiles are tumbled in a rolling drum with a chemical medium to produce aged or softened edges. Travertine is often quarried near natural springs and is characterized by a porous surface containing sand holes, voids, veins, and lines of separation, giving it an open texture when left unfilled. I recommend going to several tile stores to explore your options in stone flooring before making any decisions.

Marble floor

In a house of architectural significance and formality, a natural, unglazed, quarry-stone tile entrance hall can be exceedingly elegant and practical for those entering in from a rainstorm with wet shoes and jackets. Clients bought an apartment that had marbleized Contac paper applied to the entrance hall floor—a cheap trick to try to fool potential buyers. Nonetheless, the lightness of the floor was attractive, contrasting against the richly polished mahogany doors. We

Travertine floor

Keystone-patterned floor

laid white marble in twenty-inch squares on the diagonal, with eight-inch Vermont verde antique keystones cutting into the corners of the white squares, offering accents of rich green while keeping the floor light. This classic design is always appropriate when a traditional interior is the goal.

In the eighteenth-century house in Paris that I decorated, white stones were laid on the diagonal with black Belgian marble keystones in the entrance hall and dining room. How charming this floor looked with terra-cotta pots full of blue hydrangeas clustered on either side of the French doors leading out to the terrace overlooking the garden. Because there are no straight lines in an old house, the white stones had to be enlarged or reduced according to the house's spatial irregularities. But because the black keystones were precisely aligned, the variation in the white tiles didn't bother the eye in the least. In a client's Fifth Avenue duplex we reversed the color scheme, laying green marble in huge squares with white keystones.

Marble floors, because of their hard and highly polished look, always make a grand statement. If your lifestyle is characterized more by the outdoors and nature than by formal dinner parties, a classically patterned marble floor will seem incongruous underneath your hiking boots. Marble floors are definitely black tie. A stone floor with irregularly shaped hand-cut tiles has more integrity in a more relaxed country house. Most beige travertine looks ordinary but in rich blue shades this stone looks elegant in powder rooms and bathroom floors.

Ceramic Tile Floors The primary appeal of ceramic tile floors lies in their striking color and pattern. Ceramic tiles are composed of clay that is baked in an oven or kiln at extremely high temperatures and then glazed or left unglazed. I find that people in sunny, warm climates use more ceramic tiles than wood to add a degree of coolness.

Ceramic tiles can be used in all rooms with success, as they have a great deal of charm and decorative advantages. They are also easy to clean with water. However, tiles tend to break and chip, and the glaze and color can wear off over time.

Ceramic floor tiles create a relaxed feeling which reminds me of Provence, though they are made by artists the world over. They come in such a wide range of styles, it is hard not to want to put them on your floors. One of the grandest houses in Texas has chocolate-colored

octagonal tiles in the entrance hall. In the small coat closet of a client's apartment, just to amuse her family and guests as they reached for their raincoats, we laid brightly-colored glazed four-inch-square Mexican tiles in a geometric pattern. Because this surface isn't walked on, the tiles have held up well and continue to bring cheer to the apartment. Their playful charm is compelling.

Terra-cotta Tile Floors Terra-cotta, the most popular ceramic tile, is a hard-baked porous clay in different shades of red, orange, and yellow that is produced in many parts of the world, including Mexico, South America, Italy, France, Spain, and the United States. On floors, terra-cotta tiles offer earthiness and subtle refinement.

A few years ago, while renovating and decorating a beach house, I had the opportunity to plan the floors of several rooms. My clients love to cook, so they insisted on cork tiles for their kitchen; cork is the floor most conducive to hours of standing. For the dining room, they chose antique terra-cotta tiles laid in a rectangular pattern, leading up to the fireplace. Because the tiles are fireproof, we didn't need a separate hearth. The tiles varied in shades of orange, yellow, and red, and some showed flecks of leftover glaze, adding warmth to an expansive room with French doors leading to a view of the sea.

Terra-cotta tiles come in various shapes, sizes, and thicknesses that allow for much creativity in design. You may choose simple squares, rectangles, or a mixture of the two; hexagon-shaped tiles; a chevron pattern; or octagons with small white inlaid glazed tiles or keystones to complete the pattern. Terra-cotta tiles can also be made with carved design imprints. There are octagonal terra-cotta tiles in Claude Monet's kitchen at Giverny. His dining room floor consists of vanilla ice-cream colored square tiles with alternating amber tiles in a checkerboard design, a charming and rustic complement to the butter yellow-painted furniture.

Glazed Tile Floors Glazed tiles, ceramic tiles with a glossy, matte, or satin finish depending on the amount of sheen you want, are an excellent option for flooring and can be extremely colorful and decorative. In the sun room of the beach house, each bathroom was floored with glazed ceramic tiles from France; the walls were tiled as well for beauty and easy maintenance. Glazed tiles are appropriate in all bath-

rooms, and in many cases have more style than marble, another material commonly used in bathrooms, because of their bright colors and fresh patterns.

While too much marble can be heavy and depressing, this is not true of ceramic tiles. Tiles can be hand painted, so that every tile is slightly different from the next, adding subtle, understated beauty. Hand-painted tiles also have a unique luster that gives off energy and life. Even plain handmade glazed tiles are interesting because of their irregularities. An all-white tiled bathroom picks up tones of pinks, blues, and greens because of the unique alchemy wrought by the intense heat from the firing and the thickness of the glaze.

Delicately hand-painted white French tiles on a client's bathroom window ledge and tub surround lend a little refinement without being aggressive. They are infinitely more interesting than machine-made tiles with none of the natural imperfections. Whenever anything is too uniform, it becomes dull to the eye. Years ago, it was customary to place tiles halfway up the bathroom wall. Today, you are likely to continue up to—and perhaps even include—the ceiling, so you won't have the problem of steam causing the paint to peel off. (Glazed tiles are extremely slippery when wet, so it is wise to have a small area rug and bath mat in the bathroom to prevent falls.)

The sky is the limit in the range of tiles available, as well as in how much fun you can have designing with them. The variety of colors and patterns is boundless because you can custom order them. Some of the plain hand-glazed four-inch French tiles are so beautifully luminous that I use them undecorated, but the joy of tiles is in the bountiful variety that is available. If you're especially adventurous, you can even paint ready-made tiles and have them fired. Stores where you can do this are becoming more and more popular.

In my client's beach house, we installed turquoise French tiles in the basement bath and the beach shower, and rather than having custom-made matching grouting, we selected white to frame each four-inch tile. In the downstairs powder room, we laid a white tile floor and put up white wall tiles with hand-painted fish. From a porthole window you can see the ocean. One word of warning: The bathrooms you use the most should not have a bold, repetitive design that you'll tire of quickly. Once you go through the trouble and cost of renovating a bathroom, you shouldn't have to do it a second time. I always suggest

white porcelain fixtures in a bathroom for this reason, as well as to give you more freedom to use patterned or solid tiles and towels in favorite colors.

The bathroom floor *should* show dirt for hygiene purposes, so I generally suggest a light, bright floor. Low toilets were not designed for men, resulting in urine spattering onto bathroom surfaces. A hard, light, polished, easy-to-scrub surface is ideal. Perhaps it is time to reinstate the urinal or redesign the toilet.

Terra-cotta tiles can be treated to be as germ resistant as glazed tiles with a penetrating sealant specifically recommended for them. I often use terra-cotta tiles for bathrooms but never for shower floors because they're too porous. In a wood-paneled bathroom, a terra-cotta floor looks wonderful. To add a light design note, insert small, white, glazed tiles to create a pattern. The master bath of this beach house is all-white tiled walls with sculptured ceramic moldings, and the floor consists of eight-inch octagonal terra-cotta tiles with accents of white glazed tile. The shiny polished white contrasting against the earthy clay is most attractive.

The floor and walls of a bathroom can be coordinated in tile work for a cheery, colorful mood. If you think about the floor without considering the walls, you could miss the opportunity to integrate the two to reach a new height of cohesiveness and comfort. For example, the guest bath of the beach house was tiled in white squares hand-painted with blue flowers and green leaves. We used a blue-bordered tile as a baseboard and repeated that tile as a cornice. The upstairs bathroom floor is soft blue-and-white plaid tiles, and we repeated the same floor pattern on the walls and countertop. Rather than looking busy, the repetition actually opens up the space. The more duplication, the more harmony.

In a powder room in an old house in Connecticut, used only by guests, the client selected eight-inch-square white tiles hand-painted with purple and yellow pansies with leaves of different shades of green. Generally, the most beautiful designs and patterns are hand painted, insuring an authentic irregularity that adds interest and charm. Tiles that are lovingly decorated become animate. Though I prefer hand-made, hand-painted tiles to machine-made tiles for their beauty and authenticity, I would not recommend handmade tiles for the floor of a room where there's heavy traffic because they break too easily. A powder room is fine for a handmade-tile floor, but not a master bath. Even a can of shaving cream can severely crack a handmade tile if it falls on

Hand-painted tiles

a floor. If you use machine-made tiles for a floor and reserve hand-painted tiles for countertops or walls, the risk of damage from falling objects is greatly diminished.

For the floor in her daughter's bathroom, a client selected machine-made ceramic glazed tiles with a charming cobalt-blue–bordered design that resembles handkerchief linen. Though the tiles have held up well after several years, if you look closely, you'll see some cracks. Before installing a glazed-tile floor, it is wise to ask the supplier a lot of questions concerning the durability and scratch resistance of the tiles, to help you determine what would be best to use as a floor material, and what would be more appropriate to use on countertops.

A few cracked tiles on a ceramic tile floor doesn't mean the end of the world. When you examine any tile closely, you will notice crazing (fine hairline cracks) that occurs before and after installation, due to tension between the glaze and the fired clay. This is an inevitable characteristic of even the most expensive ceramic tiles, not a defect. Some people even ask to have their tiles intentionally crazed prior to installation so that they have an antique look.

Upon seeing their new stone or ceramic-tile floor, some dismayed clients immediately declare, "The tiles don't match. They're not the same size or color. I paid a lot of money for these floors, and they're a mess!" I always caution clients that when clay is fired in a kiln, or when natural stone has been cut, no two tiles will be exactly the same in size or color. A perfectly matched glaze is impossible as well because the intensity of the color depends on how close the tiles are to the heat source in the kiln. The variation will not be great, but it will be noticeable to the discerning eye. Though some people find these variations unacceptable, I feel that they are as captivating as the subtle formation of clouds. These inherent imperfections contribute to the integrity and richness of the material. The varying nature of things handmade is the soul of the maker felt in the object. Machines can mechanically make things precise, but they don't breathe life.

Setting ceramic tiles requires grout, a cementlike substance used to fill tile joints. The more skilled the tile setter, the tighter the joints and less grout needed, but the substance will still show at the border of each tile. To diminish its appearance, you can add pigment to the grout to match the color of the tiles or make the color blend in. Always pay attention to the grout used in tile setting. I've seen potentially beauti-

ful honey-toned terra-cotta tiles look hideous because the grouting was dark-gray.

Think of grouting as thread to a button: Contrast the color if you must but try to keep the grouting in the same color family as the tiles. Inquire when you purchase your tiles about custom-colored grouting. The beach house's turquoise-tiled bathroom and changing room was in an airless basement, so the white grout added energy and light. But in a city apartment bathroom counter, emerald-green tile should have tinted grouting.

Some people find the appearance of grout pleasing to the eye, adding a raw artistic edge. A white or ivory colored grout is usually used with colored tiles to set them off. However, I do not recommend using a colored grout with white tiles because the pigment can stain the tiles and calls attention to the spaces between the tiles rather than the tile itself. Also, be prepared for your bright white grouting to turn grayish over time. Cleaning materials can bleach out the discoloration. Grout is more porous than a glazed tile, so no matter how carefully you plan the installation, be prepared for some surprises in the aging process.

Brick Floors In a charming saltbox house in Westport, Connecticut, clients had a glassed-in sun room overlooking the backyard that had an old brick floor laid in a herringbone pattern. Indoor window boxes brimmed with sprawling geraniums, and the red-brick color and rustic texture blended well. A client in Texas had a similar terrace room with a herringbone brick floor. She turned the room into a paneled library, with a bay window overlooking her brick-walled garden. Over the years she had the brick floor waxed and polished, giving it a patina and richness without making it too formal. The floor, brick-lined walls, and view of tall trees and her rose garden worked together to create a warm, harmonious atmosphere. We found a beautifully carved eighteenth-century French stone mantel, a strong focal point to draw you into the far end of the space.

Herringbone brick floor

Thomas Jefferson's design genius is evident in his charming brick serpentine walls on the way to Monticello's Rotunda and lawn. I've seen herringbone-patterned floors set with little or no creativity that fail to draw the eye to their subtle details. Jefferson's herringbone patterns, however, are set at such an angle that there is a mysteriously pleasing grace and ease. He used this herringbone brick design in an oval

room on the ground floor of the Rotunda. The brick serpentine path to decorator Billy Baldwin's guest cottage in Nantucket had the same quiet beauty and charm, and I'm certain Billy had studied Jefferson's artistic achievements both at Monticello and at the University of Virginia before creating his own meandering garden path in a tiny space.

If you love old brick and want some in your house, you can lay it yourself and take great satisfaction in this charming, honest material. Every house needs a touch of brick. If you don't have a floor you want to cover in brick, but love the old mellow texture, you can install a brick hearth and facing for your fireplace. If you lay a herringbone brick floor in a garden room, an entrance hall, or library, begin at the center of the space and work your way toward the walls. Let the full bricks go as far as they can to meet the four walls, and cut the undersized ones you need in a uniform way on all elevations. Whenever you see an interesting detail in a brick floor, photograph or sketch it. You never know when you'll be able to work this new discovery into a future room plan.

One of the reasons we identify with brick floors is the feeling they give us of being outdoors in fresh air and sunlight, in an enchanted garden or on a secret, rambling path. For a client who is an avid gardener, I incorporated all his favorite flowers into a Portuguese needlepoint rug for his formal dining room where we had laid a brick floor so he could feel as if he were dining al fresco.

PRECAUTIONS REGARDING STONE, CERAMIC TILE, AND BRICK FLOORS

I love designing with ceramic and stone tiles, creating rooms that have a certain charm unattainable with other materials. But ceramic tiles, along with other extremely hard floor surfaces—stone, brick and marble—have disadvantages. The fact that these materials have a cold surface is a sure advantage in warm climates, but up north, a cold surface is hardly desirable. A rug would probably be required in the winter to make the room more comfortable.

Glazed-tile floor surfaces are also noisy, and when you drop the

occasional plate or glass, unforgiving. Fragile items often shatter, making repair impossible. Once when I was brushing my hair, my earring fell to a ceramic-tile floor and the inlaid stone broke in two pieces.

Probably the most significant drawback of ceramic or stone tile floors is their danger to persons who trip and fall on them. If you fall on stone, you will be more seriously injured than if you fall on wood or cork. This is especially a consideration if you have small children who are more inclined to get into accidents or if elderly people frequent your home. There is also speculation that pregnant women who spend long hours on ceramic or stone floors are more prone to miscarriages. If you have a bad back or knees, you'll be especially sensitive to how a floor physically makes you feel over time. Standing on a ceramic or stone floor for an extended time could cause you physical pain.

When designing a bank in Amarillo, Texas, in the early eighties, I spent a great deal of time watching a master mason install a beautiful limestone floor in the large atrium. When the bank was complete, my feet were ruby red and swollen. For weeks I winced in pain with every step I took. Pounding across a relentless limestone floor for hours proved to be lethal.

The harder the floor material, the less give and the more strain on your feet, legs, back, and veins. It is important to determine how much time you will spend walking and standing in a room before deciding the type of floor material you will use. You may want to reserve beautiful ceramic tiles, stone, or marble for bathrooms, countertops, or decorative embellishments.

Synthetic Floor Materials You build your rooms from the floor upward. The more organic the material you select, the more energy will be generated in your spaces. Imitation wood, marbleized vinyl, linoleum, and fake ceramic tiles may temporarily fool the eye, but they do not have this energizing effect because they have no life. Whenever possible, use the real thing because the integrity of your house depends on honest floors. If you choose vinyl, for whatever reason, keep it simple in design. For example, if you decide your elevator hall floor is to be vinyl because fire codes do not allow wood, select simple, eight-inch brown squares rather than pretending the floor is real wood. Blatant imitations lack integrity.

Many people are attracted to linoleum because it can be laid in one

piece, though some custom designs do have a few seams. If you choose linoleum, keep in mind that its great advantage of having no seams can also be a major drawback, because if one portion of the floor becomes damaged, you have to rip out the entire floor. For example, if a cigarette burn, a frying pan, or a hot iron damages a white tiled floor, you need only replace the one square, whereas with linoleum you'd have to replace the entire kitchen-family room floor. Even if you are insured, the inconvenience is taxing. Also, heavy traffic patterns wear down a linoleum floor surface in certain places, leaving a tacky impression. A floor may look fresh around the edges of a room, but unattractive where it is walked on regularly, and no cleanser will make it look the way you want it to. Vinyl tiles, because of the seams, will trap more dirt than linoleum, although both floors are easy to clean.

All synthetic floor coverings—whether due to scratches and dulling, stains and discoloration, or wearing thin in certain places—eventually need to be replaced. Vinyl tiles are relatively easy to lay yourself, whereas linoleum will probably need to be professionally installed.

Pay as much attention to your floors, room by room, as anything else in your house. Floors are your foundation, both literally and decoratively. Once you achieve the ideal look for your floors, you'll be free to make logical aesthetic choices for furnishing your spaces. In decorating, one thing always leads to another. Once you are satisfied with your floors, making them as good as they can be under the circumstances, consider yourself one third of the way there, headed in the right direction for the complete decoration of your house.

CHAPTER 8

Doors and Windows

I opened the doors and windows of America,
and let in the air and sunshine.

—ELSIE DE WOLFE

DOORS AND WINDOWS: CONNECTING OUR INTERIORS TO THE OUTDOORS

*D*oors and windows are the elements in a house that differentiate it from a box. Windows are the eyes of a house, connecting you to the infinity of nature and light. Doors provide you with the freedom to come and go and give a space both privacy and security. These apertures are essential to happiness and well-being in an enclosed space because they connect the human spirit to nature and the love of those who enter, and they allow positive energy, or ch'i, to flow through the space continuously.

One of the great joys of living in the country is being able to throw open the front door and lift the windows to refreshing air. A sun-drenched garden illustrates the beauty and grace of sunlight and nature colored by the magic of flowers. It is this energy, this expansiveness that you want to bring inside through windows and doors. The smaller your space, the more you need to make it feel more open.

Ideally, no enclosures would keep you from direct contact with nature. On vacation, people spend lots of time out in the open air. Whether you linger on terraces, beaches, and boats, or on the tennis court, golf course, or mountain trails, you feel most in touch with yourself when you are out of doors. Your spirits soar when you dine and

dance under the stars, and when it rains, you'd rather go under awnings than go indoors. How can you create this feeling of beyondness in your rooms? How can you find a balance between fresh air, sunlight, and oneness with nature and shelter, security, and privacy? How can your doors and windows work for you to enchant your spaces, creating privacy and sanctuaries that have the appeal of a secret garden?

Don't be frustrated if you can't change your windows or doors. Many people live in houses or apartments with some awkward architectural elements. Your challenge is to make whatever improvements you can to gain pleasure and harmony from all your rooms. Be Zen and learn from your situation. Everything can be improved. Even if you simply remove the old ugly air conditioner from the window, repaint the trim, and clean the grimy glass, you'll be uplifting the quality of your time spent in this space. A fan may be all you need. The old air conditioner may have blocked light and much of your view. If you can do nothing to alter your doors or windows structurally but want to change the way they look, other chapters on color, fabric, and hardware may come to the rescue.

Doors and windows have an important relationship to each other. In classical architecture, doors and windows are the same size. Windows go to the floor whether double hung or in the form of French doors. In most houses today, however, the windows are not the same size as the doors. For harmony, the windows and doors should line up with one another (the top of the doorframe should be at the same height as the top of the window frame) and be similar in design.

Doors as well as windows can bring in light. They can be paneled with clear glass, or mirrored to create the illusion of more light as they reflect a window on the opposite wall. Don't let a door be a barrier to sunlight. If there is a door that swings and blocks light when it is open, you can rehinge it. For example, in a bathroom, if the door hinges on the left so it swings into the room, blocking the window, simply rehinging it to swing into the bedroom allows you to keep the bathroom door open, adding the light of another window to the bedroom.

An open door connects one space to another. When not closed for shelter, privacy, or security, all interior doors, other than some closet doors, should be open so the rooms flow seamlessly together, allowing the ch'i to move freely throughout.

DOORS: GATEWAYS TO NEW EXPERIENCES

*D*oors have magical qualities. Throughout life, some doors will open to you while others close. There will be many doors in all of our lives, many chapters, many rooms, many experiences, many memories. A closed door may open to a surprise celebration or to a loved one. It may reveal an enchanted moment or lead you to a new experience, just as a garden gate.

Fan overdoor

The Entrance Door A door can be a significant artistic statement, establishing the character and integrity of your house. The crowning glory of most old New England houses is the elaborately carved doorframe surrounding a thick, solid raised-panel entrance door. There is usually an overdoor, a pediment, or triangular cap similar to a gabled roof, the most classical embellishment from ancient Greece. The front door may have a fan window. Most doors have an embellishment of some kind.

The entrance door to your house must be substantial for security as well as to establish visually the proper place of entry. The entrance door should always swing into your hall. An entrance door that hinges outward could cause the person waiting to come in to fall backward. In most cases, an entrance door is wider than the other doors in your house, but may be the same height. Usually a solid wood door is preferable for an entry door than one with glass panes because it feels more substantial, more protective, but a fan window as an overdoor will bring light into your hall. Glass panes and wood mullions flanking a solid door are also attractive. Though I prefer solid entrance doors, there are exceptions. For example, in a client's Victorian house located on a farm on the eastern shore of Maryland, the upper portion of the front door is etched glass, enabling you to see through to the back of the house and the Chesapeake Bay beyond. The house, setting, and opportunity for a see-through vista make glass appropriate in this case.

Pediment overdoor

You don't need a glass front door to achieve a sweeping view. In a house in Cold Spring Harbor, New York, you walk up the front steps to a solid front door that once opened reveals a view out the back of house to Long Island Sound. A house in North Carolina also has a solid wood front door, but a series of sliding glass doors to the left of the

Etched glass door

Contemporary door

Traditional raised-panel door

New England door

front door and on the opposite side of the house allow you to see through the house to the rolling green hills beyond.

Examine old houses, and notice the details of the entrance doors and frames. If your desired entrance door is a far cry from the one you have, and you are in the position to make an alteration, I suggest investing in a custom door made by a cabinetmaker. If you don't have an architect working on other areas of the house, paying a fee for an expert drawing of your front door will be worth the money. Have several different drawings made before you decide. The number of panels on your entrance door should be in proportion to the size of the door and the scale of the frame. If there is a pediment or fan window above the door, the configuration of the panels should be in harmony with the architectural design of the frame. If the doorframe is intricately carved, a raised-panel door should have enough refinement to complement the surround.

Interior Doors After you have solved the design for your front door, all other doors in the house—living room, dining room, family room, kitchen, bedrooms, bathrooms, closets, porch, laundry room—should be considered individually. Whenever possible, the design of the doors should be consistent throughout your house, especially in your main rooms. Tastes for styles of interior doors have changed in the past one hundred years. In Edith Wharton's era, doors were usually kept shut. One didn't feel caged in when inside these grand houses with dozens of single-purpose rooms, with lots of well-placed, beautifully

designed doors leading from one room to another. Today, houses are generally much smaller and should have doors that allow a flow of energy and light as well as provide a more expansive view from one room to another (except bedrooms and bathrooms).

When exploring your options for interior doors, first ask yourself whether you really require a door. Evaluate each opening separately. Why do you think a door would be useful? If you never intend to shut a door, remove it. Doors take up wall space, and if they're not essential for privacy, they simply don't make sense. If you have an opening in an awkward place, eliminating an unnecessary door will make the bad proportion less obvious.

Be on a quest to open up your house to achieve a greater flow of light, air, and energy and to give the interior an expansive feeling, as clients did in a New York City apartment. A pair of doors leads from the entrance hall into the library, where a huge picture window overlooks Central Park's reservoir and lots of trees, several planted by the owner as a donation to the city. The light from the library window pours into the entrance hall by day, and at night the view of the city lights and buildings is spectacular, so the double doors were rarely closed. Rather than swinging into the library, the doors swung into the entrance hall, banging into a pair of sconces on the wall. Instead of rehinging the doors or moving the sconces, we removed the doors and stored them in the building's basement.

Raised-panel double doors

Doorframe without door

Today you don't need doors to the living room or to other "public" rooms. When people had formal dining rooms and employed servants, a swinging door was necessary so food could be brought in and out of the room with ease. In a client's French Regency house in Connecticut, several doors were removed so she could enjoy a sweeping view throughout the house rather than literally hide behind closed doors. The door connecting the dining room and living room was taken down, as well as the kitchen door leading to the dining room hall, bringing the dining room fireplace into view from the kitchen. The door between the dining room and the stairs was removed, visually enlarging the space by exposing a stair landing and a door leading to the south of the house. Because the upper portion of that door is glass set in mullions, it expands the window elevation from two to three exposures. She kept the door from the living

room into the study so that someone could find privacy in the study while others gathered in the living room; she found the door leading from the study to the back hall unnecessary because it faces the back of the house where it is quiet.

A husband and wife who are both writers work in adjoining writing rooms, but enjoy each other's company at the same time. They decided to remove the pair of doors that separate their individual spaces. Of course, if one of these rooms were to be used for a different purpose in the future, a baby's nursery or guest room, the doors could be reinstalled. But for now, both rooms are enriched by more light and spaciousness. The decision has proven to be practical as well: The spaces flanking the opening are used for a stand-up desk and bookcase that holds reference books both of them use.

You may find that not only can you remove a door, but you can then fill in the space with Sheetrock to create more wall space. Rooms with more than one entrance should be examined to determine whether you should do away with an opening altogether. Any extraneous door should be reconsidered, even if it means a loss of symmetry in favor of a room that suits your lifestyle. A corner for a seating group, or more wall space for books and art, seems more practical and aesthetically pleasing than pairs of doors. Whenever you have an opening with or without a door, you are giving up seating space. Weigh your options. The way people live today with so many rooms flowing into each other, it is less necessary to have two doors on the same elevation because they serve the same purpose. But don't be too strict, either; the extra opening might lead to a hall or other space that lightens and opens up a room.

CHOOSING A DESIGN FOR YOUR DOORS

*A*fter you have eliminated all the doors you won't use, evaluate the quality and design of the remaining doors. If you decide to replace your doors but are unsure about what design you want, make a trip to your local lumberyard. There you will find ready-made doors of different designs, sizes, and woods. Your first priority when buying a door should be quality. If you are purchasing a wood door, make sure it

is solid. Hollow-core doors may be less costly, but in the long run you will be disappointed by their flimsy quality. If you have hollow-core doors, your priority should be replacing them with stock-size solid doors you can order inexpensively through a local wood supplier and paint yourself. Solid doors give your house a sense of permanency that is impossible to achieve with rickety hollow doors.

Approximately ninety percent of all new doors are made of clear pine. This wood is relatively lightweight, good quality, and reasonably priced. The only disadvantage is its vulnerability to markings because it is a softwood. This applies to pine floors, too, but the inevitable indentations and markings from exposure add character and karma. You can also select knotty pine for your doors. Its vigorous configuration offers a warm country charm, though it is more susceptible to warping because its grain is less tight. Poplar is the second lightest-weight wood and is also used for doors, though like knotty pine, it warps more easily than clear pine without knots.

Many people prefer oak doors because they are darker, heavier, and less vulnerable to wear and tear than pine doors. They are also twenty percent more expensive. If you want a light-colored door like pine but in a heavier weight, you can either bleach or pickle oak, or choose ash, a hardwood that is naturally light. Clients used ash floors and doors with a polyurethane finish for a beach house to give the space a crisp, lean, light, fresh appearance. If you want a door or pair of doors to be a focal point, mahogany is an excellent choice in a traditional room with mahogany furniture. Honduras mahogany is the top of the line, and its price reflects this. If you want one grand pair of doors leading from the entrance hall to the dining room or living room, highly polished mahogany doors with substantial egg and dart molding in the raised panels can be most handsome.

Egg and dart door molding

When purchasing wood doors, pay attention to their thickness. Eighteenth-century doors are unusually thin with deeply grooved moldings in four panels. Doors today should be at least one and three-eighths inches thick, though many carpenters agree that installing one-and-three-quarter-inch-thick doors is worth the additional thirty percent in cost. Get an estimate for the thicker grade because not only does it give a door a satisfying solidity but the eye will be well pleased. In an era where so many corners are cut to save money, substantial solid wooden doors are good value.

Once you decide to have a door, you must ask yourself whether you want a single door or a pair. A single door is always best in a narrow opening. If an opening is more than three and one-half feet wide, it is advisable to use a pair of doors. The weight of a single wide door makes it difficult and awkward to open and the door itself will be more susceptible to warping. If the opening is centered in the wall, you can widen the opening to allow room to install a pair of doors.

THE HEIGHT OF DOORS AND DOORWAYS

The height of doors is proportionate to the height of the ceiling; the higher the ceiling, the taller the door should be. The height of the door will then help you decide whether you want to add a pediment or a fan window. If you have high ceilings and tall doors with lots of wall space above, you're free to determine whether you want further architectural interest.

In a drawing room with two symmetrical openings opposite windows overlooking a garden, a client wanted the openings to appear higher than their six feet eight inches. By the addition of a mirrored fan window above each doorframe, the eye was drawn upward, making the doors seem taller than they are. In traditional pre–World War II architecture, ceilings were usually ten feet high, and doors were one inch shy of seven feet. In these older houses and apartments, you have more options if you want to add architectural components to change the appearance of a door. If you feel cramped, the door might be too low. If you're extremely tall, the height of the door should make you feel comfortable, even in an antique house with low ceilings. Doorframes in rooms with low ceilings can connect to the cornice.

THE ARCHITECTURAL USE OF DOORS

Doors can be used architecturally to add balance and prominence to an otherwise awkward space. A town house across the street from the Metropolitan Museum of Art continuously faced the

problem of guests mistaking the unremarkable entrance into the library for a bathroom or closet. Doors have a subtle hierarchy; it was clear that a "balancing act" was needed to rectify the problem. After we installed a pair of waxed Honduras mahogany doors with gleaming brass hardware, visitors in need of a bathroom or retrieving their coats knew to look elsewhere.

In a Georgian brick house in Connecticut, the architect had a grand pair of raised-paneled doors made for the hall leading to the dining room. Open or closed, they add richness and weight to the large hall. Your eye is automatically drawn to these doors, and you are delighted by their dignity and grace; your eye is led to the antique mahogany table and carved Chippendale chairs, and then out to the terrace, lawn, trees, and gardens. These doors frame the opening just as if they were framing a beautiful painting.

PANELED DOORS

A raised-panel door has elegance and depth, giving it a substantial presence. Some people try to achieve this effect by applying moldings to doors, though they tend to seem more as though they are bulging eyes than authentic architecture. If you have raised panels, they can be articulated with a contrasting paint color to enhance their beauty.

Look at the best examples in architecture and bring pictures with you when you make a trip to a lumberyard. Here you'll find many designs and sizes in stock. If you need to have a carpenter build your ideal door, the investment will be well worth it. Many lumberyards will give you the names of several local carpenters and cabinetmakers to contact for an estimate. By taking an interest in doors, you'll learn more about how they're made, and you'll have respect for the labor that goes into them. If you like to work with wood, you may be inspired to make your own.

For a simple, bold appearance, you can have one solid recessed panel that encompasses most of the surface area of the door or you may opt for multiple-panel doors. Your eye will know how many panels are ideal for the scale and proportion of your spaces. Most people choose

Raised-panel door

Recessed-panel door

Multipanel door

between two and eight panels for a standard door. I find most eight-panel doors too busy, drawing attention away from other aspects of the space. I prefer more basic, understated designs for doors, with the exception of an accent door or pair. All of the main interior doors in a client's New York apartment have one solid recessed panel, surrounded by a solid frame and molding connecting the frame to the center panel.

In a vacation resort on the coast of Georgia, all the doors were paneled in a chevron design, a pattern you usually see on wood or brick floors. Painted hunter green, they were a refreshing contrast against the sparkling white walls and the green-and-white geometric-patterned carpeting.

Flush door

Flush Doors Though it is generally best to repeat the same door design throughout your house, specific spaces may call for certain door types. Flush solid two-inch-thick doors, completely plain, are especially appropriate for tight spaces and rooms where quiet is important. A study next to a laundry room needs a door that, when closed, will ensure that the noise of the washer and dryer isn't disturbing. In a long hall where doors are a necessity but there isn't enough space to appreciate the details, flush doors are appropriate, to fool the eye into feeling the space is more open than it is. If you have a series of large, elaborate, raised-paneled doors in a narrow space, you sense a wall has been added to divide a once larger, more gracious space. Paneled doors appear too rich.

If you are creating a bathroom out of a small space, install a door with raised panels on one side and a flush back so you can mirror the entire door inside the bathroom. Tacking on a hardware store mirror that is not the proper size looks like a last-minute addition and is disturbing to the eye.

Single-panel door

Louvered Doors A laundry room off a narrow hall should have a single louvered door, or a pair, to allow proper air circulation. Because of the heat in such a room, it's important to keep the air moving so it

doesn't become suffocating. This takes precedence over any need for soundproof doors. Louvered doors are also appropriate for closets that need air circulating within them. In any moist climate, especially in a "garden apartment" where you are actually living in a damp basement, it is essential for the closets to "breathe." Either use louvered doors or one hundred percent cotton curtains.

Swinging Doors Swinging doors have largely outgrown their purpose in the decoration of houses. During Edith Wharton's era, many houses had swinging doors separating the kitchen and the dining room so that hired staff could easily transport food and dishes between the two rooms. Today, many people do not have separate kitchen and dining rooms, let alone a hired staff. If you have a swinging door in the passageway between the kitchen and dining room but you use the space as a family room, you could eliminate the door or have a standard door that matches the others installed throughout the house. Our lifestyles have changed so much in this century that a swinging door seems more appropriate for a restaurant than for your house.

Single louvered door

Alternatives to Standard Hinged Doors There are a variety of doors besides a standard door set on hinges. To decide whether a certain style of door is right for a room, evaluate each situation individually. Circumstances will dictate the best solution for each area, and sometimes general rules will need to be broken because of your unique situation.

Pair of louvered doors

French Doors While most people aren't in the position to install expensive French doors, I recommend always keeping this option in the back of your mind in case one day you have the opportunity to build your dream house. In a Georgian brick house in Jackson, Mississippi, the entire elevation of the living and dining rooms overlooks a lake through two sets of French doors leading to a columned porch. Rectangular glass windows above each door reveal a beautiful view of the sky.

French doors are not only used as gateways to porches or gardens, they are often used between rooms. This is a wise choice when you want a divider that falls between the heaviness of solid wood doors and an open space that makes privacy impossible. Installing a set of French

French doors

Concealed door

doors between a living room and a family room will provide a sense of openness as well as privacy. If you and your spouse want to listen to classical music and read by the fire, it's nice to have doors to close while the children are watching television or practicing the piano.

If you want a small private room to seem more open and expansive, consider fooling the eye with mirrored French doors. This effect was first employed at the height of the reign of the Sun King in France. The results can be magical. I often bevel the panes of clear glass in French doors for clients, but when you use mirror instead of glass, keep the mirror relatively plain so the eye isn't attracted to the source of the illusion. You see etched mirror and glass in public spaces, especially in restaurants, but in a private dwelling subtlety, not drama, is appropriate.

Concealed Doors In my decorating practice, I rarely use concealed doors, because they are expensive to execute properly, though I acknowledge their practicality in many circumstances. When concealed doors are executed correctly, all you see is a hairline crack on three sides of the door and a small finger plate that opens the door. Easier said than done, I assure you. If you choose to have a concealed door in your house, I suggest you leave the project in the hands of an architect with the genius of Thomas Jefferson—who himself loved to use concealed doors—and a foreman who takes great pride in his work.

In a narrow apartment hallway I removed three doorframes on one wall and mirrored the entire wall, including three concealed, flush doors. By using concealed hinges we created the feeling of a solid wall that actually led to several storage areas and a powder room. Each mirror panel was thirty-six inches wide, so it looked harmonious. On the opposite wall we displayed a rare collection of brightly colored Japanese prints. They hung from under the cornice molding to above the baseboard.

At times a hidden door is useful because a standard-size door limits your floor plan. Once you move your bed into the ideal spot in your bedroom, for example, you may find there isn't sufficient space for a proper end table. By removing the doorframe, narrowing the opening, and installing a concealed door, you may have access to additional space

without limiting your decorating plan. I've done this successfully in situations where there is a writing or sitting room off a bedroom that requires the privacy of a closed door. This hidden door is often kept open so that its complex hinge mechanism receives minimal wear and tear. But if the dressing room opens up to a guest bathroom, for privacy when guests visit, the concealed door can be locked. Or, if you choose to continue to use this space when you have visitors, you can lock the second door of the guest bath, providing the security of locking both doors.

Pocket Doors Pocket doors, the doors that slide in and out of a slot built in the wall, have their place in the decoration of houses, but to me they always seem flimsy and awkward. In a hotel it might take you several minutes to find the bathroom door. Fumbling around for your glasses and a light switch so you can locate the catch of the door is not something you have the patience for in the middle of the night. Pocket doors may make sense in a space that only occasionally needs to be closed off,

Pocket door

Sliding glass doors

but generally I find them more inconvenient than practical. I also object to pocket doors because when they are closed, you tend to feel more closed in than you would with a standard hinged door where the open-

ing is obvious. I find them most appropriate for commercial installations as well as in extremely contemporary houses where the interior look is not classical.

Sliding Glass Doors Sliding glass doors are often only appropriate in spaces where there is little traffic, serving more as a large picture window than a gateway. Too frequently unsuspecting people trip over the raised track, or walk into the glass thinking the door is open, endangering themselves. If you've ever stayed in a hotel with a balcony just deep enough to stand on and look out, with a two-inch-high metal track for the sliding doors, think what a hazard this could be if you tripped and flew over the railing. If the track is properly recessed in the concrete so the height of the track is flush with the floor, sliding glass doors are a more appropriate option.

Doors with frames usually have wooden saddles separating one room from another. The saddle is beveled so it acts as a mini-ramp, and the eye expects it. But with sliding glass doors, the metal track may stick up though it could be hidden behind shaggy carpeting. Often these doors open onto a sun room with a hard ceramic tile floor. Even an eighth-inch lip protruding could cause someone to fall and injure themselves. It isn't possible to look underfoot while carrying a tray full of drinks through the open door.

False Doors In thirty-six years, I have never designed a false door. I don't believe in installing false doors, even in the name of symmetry, just as I avoid nonfunctioning fireplaces. Only have a door if it leads somewhere, otherwise the illusion could prove to be more frustrating than harmonious. You're all ready to have an exploratory experience and you're locked out, permanently.

In more formal eras when certain rooms were used only for entertaining, this need for symmetry made aesthetic sense. But today it seems a wasted opportunity to do something more meaningful. If your house has classical architecture and you feel the door at one end of a room cries out for balance, consider having a bookcase built inside a doorframe on the opposite wall. Even with a pediment or fan overdoor, the books will be attractive if they are early edition leatherbound, and architectural balance will be restored.

DOORFRAMES

While metal doorframes are almost standard in New York City prewar apartment buildings, in houses you will usually find wooden frames. Metal frames have a strength advantage over wood frames, though hanging a door on a metal frame is more complicated than hanging a door on a wooden frame and should probably be done by a professional.

If you want to rehinge a door so it swings the opposite direction or from the opposite side of the frame, you will have to fill in the holes left in the metal frame with an automotive body filler containing two component plastic hardeners. This task can successfully be done by applying duct tape over the filled hole, then spackling it using your fingers to smooth the surface, then painting three to five fine coats of paint. If you have metal doorframes that are clogged with layers of paint, you'll be grateful you don't have to worry about gouging the surface with a putty knife as you remove dozens of layers of paint.

Stripping paint off old doors is not for sissies. Paint and hardware stores have how-to pamphlets and books on the best procedure. Whatever product you use, wear safety goggles, a surgical mask, and heavy gloves, and work in a well-ventilated room. If you live in a house, strip painted doors on sawhorses outside.

OLD DOORS VERSUS NEW DOORS

Throughout your travels and research, you will discover hundreds of doors that speak to you. I find that many of the most beautiful are in France, Italy, England, and Holland. (Some old mahogany doors are set in a revealed wall where the entire door doubles as a bookcase complete with leatherbound early editions.) Not only is the architectural style and detail of a door appealing, so is the color. I use old doors and antique carved doorframes whenever possible. If I can't find an appropriate old set, I have them made in a classical design.

When I designed a New York City law firm office, the partners wanted old mahogany doors for their entrance. We went to an antiques

Antique doorframe as bookshelf

dealer and selected six paneled mahogany-stained doors from an early nineteenth-century house on Fifth Avenue. Always look into old as well as new, because refinishing antique doors can be less expensive than buying new ones, and they already have a lovely patina from years of use.

If you have an antique French fruitwood door or a beautiful raised-panel mahogany door with egg and dart molding as a focal point, you can achieve cohesiveness in the space if all other doors are the same style or a simplified version but are painted white.

If you have old doors loaded with paint, strip them whether you intend to leave them bare or to give yourself a clear surface to paint. What a pleasant surprise to strip away a dozen coats of paint on your two-inch-thick eighteenth-century raised-panel doors and discover local pine the color of toast. By removing all the paint, you can turn these doors into architectural features in your house. Even a closet in your dining room or the door to the basement can be a mellow, warm wood.

The old doors we bought for this law firm had been previously hung in maids' rooms on the fifth floor of a mansion and were made of five different woods, never intended for anything but paint. After Sotheby's Restoration, restorer of fine antiques, got underneath all the layers of paint, they were able to blend the different shades and grains of woods with stains and faux graining, creating a texture and richness not possible in new doors.

MAXIMIZING THE BENEFITS OF WINDOWS

Windows are the prime source of natural light in your house. They connect you to nature, drawing earth's energy, or ch'i, into your spaces, magnifying your spiritual energy. Today's more open style of architecture that incorporates more windows, generally larger, as well as skylights that add considerable light and life to interior space, is transforming houses from dark, dull shelters to homes shimmering and humming with vitality. This is a positive trend that I hope continues in the decoration of houses.

The appearance of your windows influences the interior of your house as much as, if not more, than the exterior. Their placement can increase your perspective and view. If a window is high enough from the ground, you can look out without others seeing you inside, maintaining the feeling of your home as your private sanctuary.

It is a blessing when a house with close neighbors rests on an elevation higher than the surrounding houses. When you can sit in the living room and look out at people on the sidewalk who can only see the top half of your room and you are completely out of sight, you feel private yet also connected. If your house does not sit on a higher elevation than the neighboring houses, I suggest a simple window treatment such as café curtains to close for privacy when needed.

Never lose sight of the purpose of your windows. The importance of these openings cannot be overestimated. Not only do they represent the three chief essentials of comfort—light, heat, and means of access—but they are leading features in that combination of void and mass that forms the basis of architectural harmony. The more gracefully you solve practical necessities, the greater potential to achieve beauty. Whenever possible, make windows an architectural statement or make them as invisible as possible. The features and bone structure of a person are similar to a character of a room. The better the essential character and proportions, the less necessity to lavishly "treat" the windows.

Monticello triple-hung window

A JEFFERSONIAN EXAMPLE

*Y*ou won't always live in a house you're crazy about. But when you do, it is a blessing indeed. Classical architecture, with its bold scale, impeccable taste, and sensibility, delights you whenever you are exposed to its graceful harmony. For example, there's a certain resonance you may respond to when you're inside a space Thomas Jefferson designed. At Monticello, in the garden area, is a square brick structure with a majestic Palladian window on each of three elevations and a door that resembles the windows. The windows are actually triple-hung, consisting of three frames, and begin on the ground level. I can envision Jefferson sitting in a chair near a window on a heart of pine floor and, with his wondrous power of observation and scientific

curiosity, identifying every flower, tree, fruit, and vegetable in his impressive garden. He was an avid gardener, believing, "The flowers come forth like belles of the day." In this small, harmoniously proportioned space surrounded by oval flower beds, he could see forget-me-nots, periwinkle, Virginia bluebells, crown imperial lily, sweet william, larkspur, and poppies, as well as purple hyacinth and yellow narcissus. Inside his Palladian-inspired brick building, he felt as though he were actually inside his beloved garden.

Perhaps you will look at windows with greater reverence after studying the stunning simplicity of Jefferson's windows. No matter what type of window he designed, though they were usually inspired by Palladio and eighteenth-century French architecture, they were graceful and dignified. Think of his example as you sort through the various options for your own windows.

SELECTING WINDOWS THAT SUIT YOUR NEEDS AND AESTHETIC

Though most people usually keep the windows that come with their house for fear of exorbitant hassles and cost if they change them, the process is really not that taxing nor expensive as long as you keep the original opening the same size. I recommend looking into your options if you're unhappy with the look and performance of your windows. There are five basic types of windows, and several specialized designs.

Double-hung window without mullions

Double-Hung Windows The most classic window is the double hung with two sashes. A sash is the outer frame of the window that holds the glass. The top half of the double-hung window can slide down, and the bottom half can slide up. Each double sash hangs from a frame and is arranged singly or in pairs, with the moldings touching, one to the other. Study your windows and make note of how much, if any, wall space you have between the frames because this will help you to determine how you are going to treat them.

How many panes of glass do you have per window unit? The strip dividing the panes of glass in a window is called a mullion. Old houses

had small window panes and many mullions because they minimized the draft. Putting clear glass sheets in double-hung windows is a relatively contemporary treatment. Many builders install windows with a single sheet of glass, offering snap-on mullions for those who desire a more authentic look. However, these fake moldings, often made of plastic for "easy maintenance," lack integrity and I suggest avoiding them. Often the number of mullions on the top half of a double-hung window are different from those on the bottom, but I advise against this contrast because you will lose the visual harmony of identical openings.

The more mullions your windows have, the less light they admit and the more limited the view. If you're replacing your windows, use artistic license to create a pleasing appearance without sacrificing practicality or authenticity. Three or four panes across is fine, but be careful of installing more than this because, as is true of doors with too many panels, the look can be busy and distracting. When a window is particularly small, anything other than a single sheet of glass usually looks awkward.

Triple-pane double-hung window

If you live in a historic house, you probably want to maintain the look of the original windows. When the windows in an eighteenth-century house were replaced in the nineteenth century, carpenters usually installed double-hung windows with two panes across, the closest they came to a picture window at the time. The original windows were four panes across. The old handmade glass with its imperfections and less broken view are compelling reasons not to replace them even though they are not an authentic eighteenth-century design. Houses evolve over time; changes and additions are made. In an old Tudor house used as a seaside retreat, clients retained the original small panes in the front of the house. On the ocean side, they built a deck that cascades to the beach, and all the windows were replaced with sliding glass doors and solid sheets of glass, opening the house to the water without damaging the integrity of the original architecture viewed from the front.

Quadruple-pane double-hung window

Splayed Reveals and Window Ledges To bring more light into a room, you can create splayed reveals, where the window frame is set into a thick wall with extended angles, allowing a ledge or window seat under the window. Splayed reveals are welcoming to the eye, drawing you to look outside because of the wider opening on the inside. Their outward angle creates the illusion of a wider window. If you go to the

Splayed reveal

University of Virginia splayed window

Mirrored splayed reveal

Casement window

Rotunda at the University of Virginia, study the deeply splayed recessed windows in the oval room downstairs. Jefferson designed raised paneling in the reveals. The architecture needs no embellishments. These windows are complete as they are.

When I decorated a tower office in a Manhattan skyscraper, building codes prevented me from enlarging the small window openings of the space. Because I felt strongly that the space needed more access to the outdoors and sunlight, I expanded the openings visually by creating splayed reveals. In order to do this, we had to cut into the wall on either side of the windows to create angles between the windows and walls greater than the existing ninety-degree angles. We then mirrored each six-inch splayed reveal, as well as the ledges. As you move about the room, the mirrors expose views you wouldn't be able to see if it weren't for their angle of approximately forty-five degrees. There is no one formula for this technique; angle the splay to please your eye. The thickness of the walls determines how deep a reveal can be. Even a narrow splay can add grace to an ordinary window.

Think of a ledge under a window as a place to put beautiful objects, much as a mantel shelf provides an opportunity to add decoration. In addition to the practicality of offering additional surface space, the ledge, when painted white, bounces light into the room, enhancing the energy of the space. If you have bookcases on either side of a window, you have enough thickness to install a window seat flush with the front of the bookcases.

Casement Windows Casement windows hinge at the top and bottom of a frame and swing outward by the use of a crank, making them an extremely practical option over sinks, washing machines, counters, or any other hard-to-reach place. A casement window in a bathroom or laundry room makes sense because it allows a complete, open exposure without any visual obstruction at all, whereas sashes of a double-hung window obstruct the view.

Picture Windows That Swivel and Tilt When you have large picture windows, a swivel-tilt mechanism is practical. Depending on the way you move the lever on these windows, you can open them both sideways and upright. This design allows the top to swing into the room, providing ventilation, while the bottom remains in place. It also

allows you to place plants on the window ledge without risk of knocking them over when you seek air. Because of their large size and weight, only open the window partially unless you need to open it completely to clean the glass surface. In this case, you can swing them entirely into the room for a simple and safe washing, an advantage not possible with casement windows. In a house, this wouldn't be an issue for the first-floor windows, but in an apartment it is a benefit.

Swivel-tilt window

Awning Windows The awning window has a hinged sash at the top and swings outward from the bottom, resembling the wooden awnings of Caribbean cottages. Awning windows provide light, ventilation, privacy, and room for furniture beneath. This type of tilt window is different from the kind that tilts into the room from the top. In a bathroom where you want ventilation, this is an excellent choice.

Awning window

Picture Windows That Pivot In a cooperative apartment house on Fifth Avenue, the residents voted to change all the windows so the glass

Gliding window

frame sits on a center pivot, allowing the glass to move right and left, providing both light and ventilation. There are several advantages to pivot windows, including easy maintenance and the fact that only half the width of the window ever protrudes into the interior space. The disadvantages are that the thickness of the frame is vertically visible in the center when you have the window fully open, and if you have a lamp on a table in front of the window, it would not be possible to open the window very far. If the windows are average size and you have a reveal or deep enough ledge to receive the glass, your furniture near the window will not be disturbed regardless of how far you open it. Clients like the option of opening the window from the right or left, depending on the seating plan. One couple put a recessed light in front of the dining room window so a breakfast table could be placed near the wall, enabling them to sit by the view of the park and read between meals.

Bay window

Gliding Windows If you live on a beach, a farm, or in the woods, you probably want to have the most direct access possible to the openness beyond your house. Here, gliding windows serve their function. With two sashes, at least one slides horizontally on tracks in the frame, depending on the size of the opening. This window provides lots of ventilation and a view without being obtrusive in the overall theme and scheme of a room. Though their look is casual rather than classical, in the right location, gliding windows have their place.

Fixed Windows Fixed glass frames—picture windows, bay windows, fan windows, round and oval windows, and even skylights—are installed for light, a view, and aesthetics. Unfortunately, they cannot be opened. I love fresh air so much that permanently closed windows frustrate me unless they're out of my reach. Whenever feasible, have your windows operative. Windows that do not function for ventilation tend to diminish the pleasure of the times you choose to spend near them. If your windows don't open, you tend to let them get dirty. If you design a bay window with a group of three or more windows protruding outward at an angle of thirty or forty-five degrees, consider installing French doors, sometimes referred to as "French windows," that extend to the floor.

Most roof windows are fixed skylights and cannot open because of their height and the fear of leaks. But even in the ceiling

Skylight

your glass needn't be stationary. You can select a vent or vent tilt window that can be pushed open.

Whether you have a box window—a window with a ninety-degree configuration, resembling a box—or a bow window that curves gracefully, the more appealing the window, the more you'll be drawn to sit near it. Look at each window individually. Are you naturally drawn to it? Would you want to sit there and read, sip tea, or visit?

Bow window

THE JOY OF ROUND WINDOWS

*I*f you're building a house, you can probably find at least one spot for a round window reminiscent of Thomas Jefferson's beloved home, Monticello, with the Rotunda's circular and semicircular openings. Jefferson's love of curves, profoundly reflected in his Rotunda, was inspired by the buildings of ancient Rome. Whenever a client is building or planning extensive renovations, I always bring up the idea of a round window or opening between two rooms.

Round window

In a carriage house, clients installed a round window in a dressing room at the back of the house that matched a window at a stair landing in the front of the house. We echoed this window for symmetry even though the two would never be seen at the same time. When you're in the dressing room, with its ash closet doors and floor, and round ottoman in the center of the room, there is a feeling of being on a luxury yacht, though you're actually in a house in Nashville, Tennessee.

Look for a place to install a door with an elliptical top, curved as an old fan window is over the entrance of most old New England houses. When glass is shaped in half circles and half ovals, these windows can stand alone or over a casement, awning, or double-hung window. Often an arched door will be echoed with arched windows, or French doors and bookcases can share the same curved top. Repeat shapes to create harmony.

One of my favorite houses is in Birmingham, Alabama, where the front hall leads to steps that descend into a large living room with a Palladian window majestically soaring to the full height of the cathedral ceiling. The window is the crowning glory of the room, revealing

Half-oval window

the enchanted garden beyond, beautiful in all its changing seasons. We left the window bare to allow the power of its strong proportions to influence all who enter the room, casting a dignified, well-ordered spell.

Palladian window

Use Clear Glass Only

When selecting glass, my preference is always that it be clear. Sunny days should not be veiled under tinted glass. Not only is it depressing, but it alters the way you perceive colors. Interior designers always go to the window to look at the colors of a fabric or object, never making a selection under artificial light. Sunlight is the guide. No one absorbs enough energy from light when inside. No matter how brightly lit a room is, it is only a fraction of what we experience when we're out of doors. Resist tinted glass. Though you can't control its use in public spaces, you can keep it out of your home for a more healthy, uplifting, life-enhancing environment.

The Charm of Imperfect Glass

Imperfect or secondhand glass with bubbles and other flaws can add character to your windows. A crack in an old piece of glass is not a reason to replace it unless it is dangerous or causes a draft. A 207-year-old handblown fan window in a client's house has a crack, and he finds that it only adds to the authenticity of his house. Antique glass, however, is exceedingly expensive. Often, you can achieve a similar result using new glass that is imperfect.

Window Frames

Wood window frames with clear glass are the most traditional. While window frames can be either wood or aluminum, wood insulates better. We should pay attention to the energy efficiency level

of our windows. Manufacturers should guarantee efficiency. Light-colored window frames are more often used in traditional houses. A white frame tends to bring your eye back into the space more than a darker color. Ideally, your window frames will be the same color as all the other architectural elements in the room—cornices, door moldings, chair rails, and baseboards. White reflects light, whereas a dark color or stain absorbs it. Bronze-toned aluminum window frames are often used in modern spaces. Many believe the dark color allows your eye to expand outward, allowing the frame to recede into the distance visually, almost as though it were an unframed picture.

KEEP YOUR WINDOWS CLEAN

*E*ven if your window looks into an alleyway or directly into a neighbor's house, make the most of your windows and try to keep the glass clean. Dirty windows are depressing, creating negative energy. If you purchase new window units, always inquire about cleaning access so you don't have to rely on professionals except for hard-to-reach windows.

THE USE OF WINDOW TREATMENTS

*M*any windows need some decorative treatment due to bad views, or no views at all. In such cases it is not only appropriate, but essential to create an attractive illusion through the use of a window treatment. Ideally, a window opening serves as a picture frame for beautiful views of the outdoors, changing through the seasons. But most people have at least a few, if not many, poorly placed windows with undesirable or limited views. Rather than boarding them up, accept the challenge to rearrange the furniture so the window can bring in light and air without your having to look out onto something unpleasant.

A tall and narrow apartment bathroom window, double-hung, looks out onto a filthy, drab air shaft, offering no view or light, only ventila-

Venetian blinds

Aluminum slat blinds

Matchstick blinds

tion. In cases such as this one, you can hang some crisp white cotton curtains to divert the eye from the view to the curtains' charm. If you want a simple, minimal solution, consider shades, shutters, or a variation of the old-fashioned wood Venetian blinds. A modern aluminum version of these with narrow slats is available in a wide range of colors. All window treatments are dust collectors, so be forewarned that only a few rare angels will clean each individual slat, top and bottom. Chances are this meticulous task will be yours.

One of the least expensive window treatments is matchstick blinds. I especially like them for their straightforward integrity. The French fashion designer Givenchy chose them for some deluxe suites in a new hotel in Singapore. He used natural rattan furniture, an oriental altar table, and crisp matchstick blinds. The stark simplicity was refreshingly elegant. If your windows are too low, you can raise their visual height by installing matchstick blinds eight to ten inches higher than the top of the glass. The width should always line up with the outside of the window trim. By setting them above the trim, when you raise the shade fully, you're not blocking any light or view. Select matchstick blinds that pleat when you raise them (Roman style) and have a flap at the top, called a lambrequin, to give a finished look by covering the raised blinds. Interior designers use matchstick blinds referred to as "bambino" to connect a too-low window to a valance and draperies placed at a more proper proportion. The lambrequin of the matchstick Roman shade placed at the height of the valance connects the window to the decorative treatment. Just as some drapery panels don't draw, often the blinds are "dummy," creating the visual effect of a well-proportioned window in relationship to the ceiling height and room scale.

In sunny climates, you will need shades or some form of sun block. Every year new products are formulated that allow you to enjoy your views and sunlight without baking in the heat, squinting from glare, or having your fabric and rugs fade too much. Drawn shades or curtains during the day can create a sad atmosphere. I'd rather have clear glass windows with brightly colored canvas awnings outside. I understand the need to protect furniture, textiles, and art from damage, but I care more about the human spirit than I do about the objects in a room.

If you have priceless textiles or possessions subject to disintegration from sun or light, I suggest you donate them to a museum or put them in safe storage. You must strive to keep your connection to the energy

from the sun. In a town in India, Philip Johnson designed a church with no roof, so heaven can be experienced without barriers. Always try to think of the joy of being out in nature, free, with a direct connection to the outdoors. Make your windows as transparent as possible. You want to forget the glass is even there.

Explore the multitude of ways your doors and windows can create pure exhilaration inside your rooms. Ideally, you are able to align a window with a beautiful view, the way an artist paints the detail from a vast perspective or a photographer focuses on the ideal angle. But don't let yourself feel constrained by limited or unattractive views. Whatever your situation, there is a solution. Seek the energy of nature and light, and let common sense be your guide. The primary purpose of openings in your house, both doors and windows, is to allow you to be uplifted by the same energy, or ch'i, within your home that you experience in the beauty of the outdoors.

PART THREE

Creating Illusions

It takes years sometimes
for an idea to take shape.

—BEATRIX POTTER

CHAPTER 9

Lighting

The painter of today is more sensitive to the
quality of light as the great fact in nature.
It is light that gives mystery to shadow,
vibration to atmosphere,
and makes all the color notes sing
together in harmony.

—THEODORE CLEMENT STEELE

THE NECESSITY OF LIGHT

Lighting is the most essential element in the decoration of houses. In the course of thousands of house calls over thirty-six years, I've analyzed the role that lighting plays in a home. I strongly believe we all need to bring more light into our houses. Light creates, paradoxically, both reality and illusion. Light illuminates our treasured objects and highlights our favorite colors, as well as affects our mood, performance, and mental health on a daily basis. Light is the source of life, giving us needed energy and uplifting our spirits. Without light, life stops.

The next time you're near a swimming pool on a sunny day, study the undulating, interlocking shapes in the water caused by the wavelengths of light permitting you to see the energy and vibrant luminosity. Many houses are gloomy simply because they don't have enough light. Go outside on a sunny day and check the light meter on your camera. Then go back inside and, without making any changes to the

existing light, again check the light meter. If you don't mind wasting film, take a picture of your living room. When your film is developed you will witness how relatively dark and dreary your room appears.

I've spent my career as an interior designer quite literally trying to bring light and energy inside. One of the reasons I'm so attracted to early Impressionist artists is the way they chose to see the light in the world. They didn't paint reality, but created an ideal impression of what they saw and felt. Because they painted out of doors in the plain air, they infused their canvases with the dazzling, dappling, brilliant, vital energy they perceived from the sun.

Your light can be in effect a reflection of divine light. When you are inside rooms not fully exposed to boundless energy from the sunshine, create happy illusions with everything that is light catching, loving, and illuminating. In the beginning God said, "Let there be light." And there was light. And the last words of the German philosopher Goethe were "More light." Is your home a house of light? Even a house with lots of windows cannot guarantee sunny weather. But with artificial lighting, properly arranged, your rooms can shine brightly. You must raise your consciousness about the therapeutic benefits of light and make it a high priority in the decoration of your house. Without light, there would be no color, and when the light is dim, it dampens the vitality of a room and depresses your spirit.

MORE LIGHT

*L*ight as decoration is basic and scientific. A room has fundamental light needs. Restaurants hire lighting experts to advise them how to enhance the atmosphere, creating indirect light that pinpoints objects to highlight flowers in subtle ways so you feel they are luminescent, emulating your experience of them in a garden in bright sunshine. In the hands of a master, lighting can be an art form. A room becomes a vision of beauty, a place to *be*, a heavenly space. An art teacher once told me to "Look up." Everywhere you go, examine the lighting.

A decade ago, Seasonal Affective Disorder (SAD), also known as the "winter blues," was considered a rare disorder. Today, scientists believe

that between ten and twenty-five percent of the population in the United States suffers from some form of this ailment that causes people to sink into a depression in the late fall and winter months. Not surprisingly, there are more diagnosed cases of SAD in the northern areas of the country where there is less daylight.

Light therapy is the chief treatment for SAD. Light therapy re-creates the effect of a bright sky and has been shown to be very effective in treating patients with SAD by triggering biochemical changes in the brain to alleviate depression.

Most houses are light deprived. Statistics report that twice as many women as men are depressed, and many of these women spend their days at home in the dark while their husbands are in well-lit offices. If you travel frequently, carry your own light bulbs, because unless you stay in a top-class hotel, chances are there will be inadequate lighting in your room.

One of the joys of carefree summer vacation days is the luxury of tapping into your circadian rhythms. You can sleep without curtains, look out at stars and the moon, and wake up naturally to the light. In the dark of winter you have to set an alarm clock to awaken at five or six. In the summer, because of the light, you're ready to get up early because the sun is shining. Watching the sun rise from your bedroom and set as you sit on your porch, you are drawn to obey nature's schedule by going to sleep soon after the sun sets, and embracing the first glimpse of sunshine the next morning. On those days when the sun doesn't shine, you light the lights, turning up the wattage to your comfort level, and move about the house as if it were a sunny day.

TYPES OF ARTIFICIAL LIGHT

How can you re-create the ideal sunlight in your house? What can you do to bring more of this energy into your spaces? Can you increase your ch'i, your energy, by creating bright, shining rooms? Today, you have options concerning what kind of light you want your light bulbs to provide. Bulbs can be purchased in three different types of light—incandescent, halogen, and fluorescent—with the wattage you desire. Bulb wattage is the amount of energy consumed by

its use. The higher the wattage, the brighter the light. Bulbs come in clear, frosted, or tinted glass. There are companies that sell only light bulbs, so do research, ask questions, and make comparisons. A pink glow may make you look better in your room, but a yellow or white light may make you feel better.

Incandescent Light The most common artificial light is incandescent, a yellow light. Incandescent is rooted in the Latin word meaning to glow. Depending on how much wattage you have, a lamp, spotlight, chandelier, or any other artificial light source can shine very brightly with these bulbs. Their drawback is that they are not very energy efficient, so people tend to turn the lights out to save money on their electricity bill, not realizing they're creating a tomblike atmosphere that drains their energy. If the sun is streaming into a room, turn the lights on and off and see if you feel a difference. Natural light shifts under clouds so one moment it can be enough while a few minutes later you need artificial light. By paying attention you can supplement the diminished natural light right away before your mood shifts.

Halogen Light The greatest light discovery since Thomas Edison invented the light bulb is halogen lighting. Halogen bulbs give off a white light (really a blue light), the closest you can come to natural light; thus it is the truest artificial light available. Jewelry stores especially use halogens so the gems will sparkle, revealing their pure, vivid coloration. One of the first lamps with halogen was the modern-looking Tizia lamp, defined by its long slender arm and small, triangular metal shades. While many clients loved these lamps, it frustrated them not to be able to change the bulbs themselves because they didn't simply screw in like normal bulbs. They had to be set in a very particular way, or the bulb would be destroyed. Now, blessedly, halogen light comes in screw-in bulbs sized for lamps, floodlights and spotlights, and standing lamps. They are more expensive than incandescent bulbs, but also more energy efficient. (They are considered specialty bulbs, meaning that they are harder to find.) But halogen bulbs will become increasingly available, an exciting prospect for anyone who spends any extended amount of time indoors.

Many clients are switching their ceiling can lights from incandescent to halogen. One couple changed the lighting in their entrance hall

where they have several large Impressionist paintings. They selected 50-watt, 12-voltage flood bulbs, the equivalent of 65 watts in an incandescent bulb, recommended by a lighting expert who advises art collectors on how to illuminate their paintings. They were told they should have four to six fixtures. After four were installed, they realized they wanted more light and added two more fixtures, increasing the amount of light by one third. They now experience the room in a different way because it swims in light. The walls had just been painted pure white, and the Impressionist paintings of Provence look sun-drenched, refreshingly simple, and full of cheer.

Most halogen lamps have dimmer switches. Spot- and floodlights can be installed with dimmers as well. There is a faint buzzing sound when the dimmer is lowered in some fixtures, but not all. Clients who listen to music while reading never complain of the hum from their lamps, but those who read in silence have let me know of a slight noise irritation. If your standing halogen lamp hums, adjust the dimmer to a different level, and the noise should stop. Consider replacing all your standing lamps that take tubular incandescent bulbs with halogen bulbs, which seem to give off twice as much light.

Bright halogen light bulbs can reach temperatures of 970 to 1,200 degrees and should never be placed near curtains or other fabric that could catch fire and cause serious danger and damage.

Experts say that halogens will be used more and more often for flood- and spotlights, though incandescents will continue to dominate standard lamps. Use halogen where possible. Being inside on a dreary day with halogen lighting brings the sunshine to you, dispelling feelings of malaise.

Fluorescent Light If you feel a little off-kilter when you are exposed to fluorescent lighting, it is probably because this light is not constant; the buzz and flicker distracts some people. Fluorescent lighting has come a long way since I became a decorator, and some tubular bulbs don't flicker and buzz as the old ones do. They also now come in many colors and light tones, affording you many options. Chris Jones, my lighting guru, assures me that the new color-corrected fluorescent lighting gives off a warmer, softer light. Nonetheless, even though fluorescent is the most economical type of artificial light, I prefer other types of lighting.

WHERE TO PUT ARTIFICIAL LIGHTING

*T*here is a variety of light fixtures available that you can tailor to your needs, from recessed overhead lighting to track lighting to wall sconces, simple desk lamps, standing lamps, lanterns, chandeliers, and floor can spots.

Ceiling-Mounted Lighting Ceiling-mounted lighting, also known as overhead lighting, generally is used for overall illumination as well as to highlight objects of art, beautiful antiques, or flower arrangements. If you want a lot of illumination in a room without turning on several fixtures, overhead lighting is most effective. There are several options to consider when choosing the type of overhead lighting that suits your needs and taste, from track lighting to recessed fixtures to decorative fixtures.

Track Lighting In a city town house, art collectors used ceiling-mounted track lighting as the primary light source in most rooms. Surface-mounted track lighting is extremely practical because it allows you to add, subtract, and redirect the fixtures, offering functional flexibility, ideal for a growing art collection. Because it is stimulating to rearrange art, this flexibility is especially desirable.

Halogen track lighting

Until a few years ago, surface-mounted cans on tracks required large incandescent floodlight bulbs. Then a new, improved track-lighting system that uses halogen bulbs (much smaller than floodlight bulbs) allowed for small, unobtrusive fixtures. Clients are replacing their track-lighting fixtures with halogen light. The old standard tracks you buy by the foot are compatible with the new lighting and therefore do not have to be replaced. You will discover how much brighter and more even the lighting is, giving the illusion of strong natural light while effectively illuminating the spaces and highlighting the paintings.

Halogen's sunshinelike light beams have taken track lighting to new dimensions. One of the finest restaurants in New York has a surface-mounted, halogen spotlight directly over each round table, beaming down on small bouquets of spring flowers. Over the bar a track suspended from wires holds tiny halogen spots emitting a piercing white

light inundating the shiny mahogany bar, highlighting its six-inch-thick, bulbous, graciously rounded edge. The tulip-shaped crystal wine glasses look gemlike in this light.

Some people find track lighting offensive because the fixture projects into the room, but to me the abundant light justifies any intrusion. One of the largest collectors of Impressionist art hung track lights in a rectangle on his ceiling, with the tracks placed three feet in from the walls that held his paintings.

Recessed Light Fixtures Recessed fixtures, flush with the ceiling, are the least conspicuous of all ceiling-mounted light fixtures. Unfortunately, not every house or apartment can have recessed lights because the thickness of the ceilings may not accommodate the fixture's height. But there is always some crawl space above the finished ceiling height, so it is worth investigating. Clients who live in an old house installed several recessed ceiling spots that give a warm glow to the rooms without any structural interference. They had one centered over their dining room table and another over the round kitchen table. In an apartment that can't accommodate recessed lights, with the exception of a bathroom where it makes good sense to lower the ceiling substantially to create more harmonious proportions in a small awkward space, I wouldn't recommend lowering a room's ceiling.

Installing recessed lighting is far more expensive than using surface-mounted track lighting because of the demolition, replastering, and repainting required. Look into all options and talk to a lighting expert before you decide what is best for you. A large variety of different sizes and shapes of fixtures with a wide range of finishes is available, from polished or brushed brass to chrome, or black or white. You can see up into the unit, so make sure you choose a color that will not stand out. There is no reason to have a recessed light with a black interior on a white ceiling, just as it makes no sense to settle for a black lamp cord placed on a white table and trailing down a white wall.

A lighting expert, an architect, or an interior designer can help you select the most appropriate ceiling lighting. Traditionally, the ceiling wasn't used for lighting in old houses except for very expensive recessed spots installed only by serious art collectors. These lights are specially designed to evenly illuminate every inch of a master painting. Today, lighting takes more precedence in houses, and clients who wouldn't

have considered modern lighting in and on the ceiling are reconsidering it because of the advances made, including the quality of light and the diminished size of the fixture openings.

There is an art to the placement of ceiling fixtures, whether they are on tracks or recessed, and each room should be individually considered. Lighting tracks are purchased by the foot. They should run parallel to the largest walls and be centered on the ceiling unless you have four tracks three feet in from the walls. The fixtures should be placed along the track as symmetrically as possible. If you enter a space from a door that is off center, your ceiling lights should highlight the walls in a logical manner. In a garden room where the doors were not located centrally on the walls, a lighting expert installed four ceiling-recessed spots on the ceiling area where there was more adjacent wall space without a door, and two on the smaller ceiling area, placing none over doorways where there was no possibility of hanging art.

In a long hall he installed a series of twelve recessed spots, all centered in the space. The client has a collection of vibrantly colored still lifes of fruit and vegetables hung above a chair rail, and the question came up whether to have the fixtures aimed at the paintings on both walls or directed straight down. Spotting artwork that is framed behind glass can be tricky because of the reflection, but when we tried it in this space it worked wonderfully with no troubling reflection. We discovered we were able to highlight specific colors in paintings, adding interest to this extensive collection. When the spots were not angled, they brought too much attention to the flowered wall-to-wall carpeting, instead of to the art. In contrast, a client with a collection of old oriental rugs has her gems highlighted with spots that beam straight down. Common sense most often dictates what is the best solution. Always have the fixtures on a dimmer switch for flexibility. Art doesn't have to be the only thing you spotlight. Consider installing track lighting to highlight a furniture grouping or special object or to give the room a balance of illumination.

Wall Sconces Wall sconces are used primarily for decoration, and while they are not a major light source, they can provide indirect lighting that subtly enhances a space. But above all, they add ornamentation and embellishment to a plain room. Not all wall sconces require light bulbs and electrical outlets. Beautiful bronze sconces might look best

Sconce with bobeche

with beeswax candles glowing in them. To catch the wax, you need only to place clear glass bobeches on top of the base where the candle rests. You can purchase these inexpensively in any housewares store.

Treat yourself to looking at all the options available before you decide whether you want wall sconces or not. If you do, then ask yourself whether you want them electrified. Electrified sconces need gem boxes, electrical outlets placed on the wall that serve the same purpose as standard outlets. Gem boxes must be considered in an overall electrical plan because installing them requires cutting into the wall. I find it a wise choice to install gem boxes in logical locations even if you decide to place candles in your sconces, in case you'd rather have electrical sconces in the future. You will want the gem boxes to be as subtle as possible.

Gold-leaf sconce

In an octagon-shaped dining–garden room, where seven of the eight walls are glass French doors, clients used six small gold-leaf sconces in the narrow eight-inch wall space between the wooden trim of the French doors. The only large solid wall space is occupied by an

elaborately carved mantel with a painting hung above and an opening into the kitchen on either side. On both sides of the painting, we placed matching sconces for symmetry. We used a total of eight sconces, creating coziness.

If you don't have a lot of art, you can use a pair of sconces to frame a space. This allows a small painting to appear to be an appropriate size for the large scale of the wall rather than an isolated postage stamp swimming on a vast open space.

Many wall sconce designs do not feature exposed candelabra bulbs or require lampshades. One design I particularly like is a simple quarter

Sconces

sphere with the light bulb cradled inside, allowing a glow to spread out and up from the flat top. You can also take the same shape and have the arched, rounded part on the top, as though it were a fan window, and have the flat part on the bottom, allowing the light to flood downward.

Wall sconces can be carved wood, plaster, lacquer, or brass, and can be painted, glazed, or even marbleized to match or complement the wall decoration. Usually a wall sconce should be placed so that sixty inches lie between the floor and the center of the fixture, but do not go by this formula without questioning its appropriateness each time. The rationale behind it is that when you are seated in an average-height chair or sofa, the sconce will be at eye level. Because human heights vary, you may have to strike a happy compromise. If you have extremely high ceilings, you may want to raise the height.

Avoid wall sconces unless you use them in pairs. A single wall sconce in a room will disturb the feng shui and be unsettling to those who enter. Repetition is sympathetic, favorably inclining your eye in an agreeable way. The organization of the space is felt and appreciated.

Sconces do not have to be antique, but they do have to be beautifully made and aesthetically pleasing to have integrity. Magazines carry advertisements for lighting firms specializing in traditional lamps, sconces, and chandeliers, and designers visit these shops regularly. You can find sconces similar to wall brackets that can hold porcelain vases. In a yellow dining room, clients used four carved fruitwood brackets lit from the top showing off four antique pieces of Canton blue-and-white porcelain.

Picture lights

Picture Lights If you would like to highlight paintings, picture lights will serve this purpose. Many clients prefer to illuminate all their paintings in this way. I believe the artists would want their work to be experienced by viewers in good light. We have several artist friends who paint in even north light, and this is the light they desire to shine on their art. Have a separate switch for your picture light(s) so at night you can enjoy a quiet conversation as you bask in the beauty of your pictures.

Picture lights come in a range of sizes and lengths, and different fixtures are designed for various-size sockets. The standard sizes are nine inches and sixteen inches. Shiny lacquered solid brass fixtures are slim (just large enough to hide the tubular bulb) and serenely beautiful.

To avoid any dangling cords from the bottom of the picture frames, have a gem box installed behind the painting and in areas where you have or anticipate wanting to hang art eventually. I urge clients to put in more than they think they'll need in order to keep their options open.

Applying the light fixture to the picture frame is an easy task involving two or more screws that attach to the back of the frame. Removing it is just as simple if you choose to move a painting to a space where there is no gem box. You can connect all your picture lights to one light switch or, if you prefer to light your paintings individually, you can attach an unobtrusive switch to the bottom of the frame. Some clients keep one painting lit in each room all the time. Whenever they come or go, they see this work of art, always a burst of beauty and light no matter what time of day or night.

Strip Lighting Another useful form of indirect illumination is strip lighting, an ideal system for accenting objects and for placing under cabinets in the kitchen. I suggest always lighting cupboards and shelves with strip lighting to highlight books and favorite objects. Years ago these tiny lights, the size of clear Christmas tree light bulbs, were expensive and often needed to be changed. Today you can purchase inexpensive disposable strip lighting, easily installed with two-faced tape, and when the bulbs burn out you simply replace the entire unit. The bulbs can be stationary or may have a swivel mount so you can direct the light where you need it most.

The strips, available in polished brass or chrome or white- or black-lacquered finish, are a slim half-inch in depth and height, and come in standard lengths from ten to forty inches. They plug into a wall outlet and they have an on/off switch. Light-strip bulbs, currently available in incandescent light only, contain six watts of power per ten inches and last an average of forty thousand hours.

Use strip lighting wherever you want a simple added glow. If you have an antique hanging shelf, a pine corner cupboard, or a kitchen or bathroom with cabinets, consider using strip lighting. While I'm usually not in favor of anything disposable, these lighting strips are an exception. What a joy not to have to change these tiny bulbs, a process too delicate and tedious for large hands or short patience.

Single-swing Hansen lamp

Double-swing Hansen lamp

Swing-Arm Lamps

Swing-Arm Lamps One of the most practical light sources is the classic Hansen swing-arm lamp. The beloved decorator Billy Baldwin used this lamp in all his work. Our firm decorated a triplex on the East River for clients who employed no other lights in any space but these well-mounted wall lights. While people commonly used them for reading, installing them at either side of their bed or sofa, their genius design and functionality make them a contemporary classic suitable for any space.

There are hundreds of variations on the swing-arm lamp theme, but there is only one Hansen swing-arm lamp and it is sold to the trade only through Hinson and Company in New York. The original is preferable to the copies because of the quality. Harry Hinson, the well-known textile maven, purchased Hansen Lamps in the 1980s, so the lighting line is now called Hinson-Hansen. Mr. Hinson is also the owner of Mrs. MacDougall, a store that sells a high-end, tasteful line of furniture and decorative accessories. People often go to Hinson to buy fabric, Hinson-Hansen for quality light fixtures, and Mrs. MacDougall for handmade porcelain vase lamps as well as oriental-style lacquered coffee tables.

Swing-arm lamps come in two standard sizes. A single swing has a nine-inch extension, and a double swing has an elbow with an eighteen- to nineteen-inch extension. They can be mounted onto a gem box in your wall. The instructions that come with the lamps suggest an appropriate height, but let your own eye dictate whether you want yours higher or lower. If you are hiring an electrician to install a pair of gem boxes, be careful to figure out the ideal height and location.

I often install brass swing-arm lamps in bathrooms. The height of the sink counter should dictate the height of the lamps. If the counter is thirty-six inches high, a good height for the center of the backplate will be approximately eighteen to twenty inches.

Always make the decision based on your height as well as maximum convenience. The lamps come with three-way bulbs, enabling you to adjust the wattage. If you choose two 150-watt three-way bulbs and place them on a mirrored wall, the combined 300 watts will provide more than enough light for shaving or putting on makeup. In addition to the three-way switch with bulbs up to 150 watts, you can purchase them with a dimmer switch.

You need not hire an electrician to install gem boxes in all cases because the lamp is designed to have a brass or chrome strip that conceals the cord. When the lamps are being placed on a mirrored wall, gem boxes are necessary because you won't want to disrupt the flat line of the mirror. In these cases, the gem boxes must be installed ahead of time in holes that have been cut out. But in many instances you can surface-mount the lamps yourself with no need for a gem box, thanks

to the cord cover that can be crisply lined up under the rectangular base of the fixture. Because it is so clean-lined it is not unattractive. If you want to hang your lamps lower than usual, you can cut the cord down. It usually runs to a baseboard where it can be plugged in.

In a library with floor-to-ceiling bookcases flanking a sofa, clients installed a pair of brass swing-arm lamps on the outside end of the bookcases, hiding the cord behind the wood frame. If you are hanging the lamp near a sofa, the best location for the center of the backplate of the fixture is approximately two to four inches in from the edge of the sofa. If a painting or print over the sofa makes this impossible, let your eye judge what's best. If you have a four-poster bed, the fixture should be mounted several inches away from each bedpost, and a double swing is necessary for ideal bed reading. The higher the top of the mattress, the higher the fixture should be so you don't have to slump in bed to read. Sit in bed holding a book or newspaper and determine how high the lamp should be.

Swing-arm lamps used in pairs are a hand-some and practical light source in traditional houses as well as in modern interiors. Because they are available in a variety of finishes—pol-ished brass, polished chrome, brushed brass and chrome, white lacquer, gunmetal, or nickel matte—they work in any decorating scheme. Watch for this classic to be available with halo-gen bulbs.

Standing Lamps Years ago, before recessed ceiling lighting was acceptable in stately houses, white torch standing lamps were used in each corner of a dining room to flood light upward, creating a soft glow

Standing saucer lamp

and ambiance. Today, standing lamps are extremely useful for reading as well as for overall room illumination. The light provided by decorative table lamps is often insufficient for reading, causing eyestrain. Tall standing lamps that spread light upward, especially in rooms with no overhead lighting, can make a profound difference to your eyes as well as the decoration of a space.

Many lower standing lamps are adjustable in height, increasing their practicality (I find forty-one inches a good distance from bulb to book). A variety of well-made standing lamps are available through stores and catalogs, and many come with a dimmer switch or an adjustable shade so when you're not sitting in a chair reading, you can tilt the metal shade to light up a painting on a wall, or to illuminate a flower bouquet on a table. If you have a more traditional standing lamp with a cloth shade, you don't have this flexibility.

In recent years, standing lamps that use halogen bulbs have become immensely popular in all kinds of interior decorating. These lamps come in a variety of finishes and are usually seventy-two inches high, with a shallow round cup, or saucer, at the top of the shaft. I suggest using them in the corners of a room to keep the space evenly and amply lit. Try two lamps in the far corners of your living room. Just as you need two columns to create order, you should always consider using standing lamps in pairs. You can always break up a pair and still have harmony. But while a low standing lamp used primarily for reading can stand anywhere in a room and does not need to be one of a

pair, the tall, stately standing lamps have an added presence and are best located near walls, and in pairs.

Any chair that doesn't have enough light for you to read by feels emotionally uncomfortable. One hundred years ago, living rooms were for entertaining; today they're for daily living. A client goes into her living room early every morning to listen to jazz piano music, sip her morning coffee, and do her needlework. She finds that if the space is lit so she can do her fine stitching from every chair, the room looks warm and inviting. Before she chose the living room as her favorite place to do her handiwork, the space was grossly underlit.

Table Lamps Table lamps, used decoratively and as a light source in most houses, come in every possible size, shape, height, style, color, and sensibility. Usually, having several decorative lamps in a room adds warmth and charm, delighting the eye with their beauty and surrounding glow. They can be the crowning glory of a room, or they may be a hodgepodge because they haven't been well thought out as objects of beauty on their own. All table lamps should be elegant and provide decorative accents. Their shapes should be repeated in a room for harmony. While a room that is too predictable lacks style, usually two unmatched end tables are desirable for variety and charm when the lamps are a matching pair or of a similar shape and design.

The style of a table lamp depends largely on the delicacy or massiveness, and the subtlety or bluntness of the platform it sits on. One of the all-time favorite lamp designs is called "the bean pot," a bulbous lamp base that comes in every conceivable color and material. I especially love white plaster. While these lamps take up a great deal of physical as well as psychic space in a room, they are refreshingly charming and look good in relaxed, casual spaces with rattan furniture.

Always assess your lighting needs before placing a table lamp. Often you will find that the more beautiful the lamp, the less illumination it provides. In traditional living rooms, many people have several antique tole lamps. These hand-painted tin shades are malleable, making it possible to have elegant, graceful, oval shades. Because many shades are painted hunter green or barn red with gold decoration, the frosted candelabra bulbs don't provide much light, but they

Quimper faience pottery lamp

certainly are pretty. Fortunately, the substantial overall illumination you can receive from the standing halogen lamps in the room, together with several picture lights, makes up for the poor light these decorative lamps provide. Porcelain or pottery vases in classic shapes, hand painted or glazed, can turn the ordinary into the extraordinary. Almost any vase can be wired to become a lamp. You can also make lamps out of baskets and brass candlesticks. Quimper faience pottery from Brittany gives a room a feeling of country French. Many different styles of lamps are available in Quimper's peasantware-pattern collection. Each earthenware vase is hand painted and decorated with costumed men and women in colorful opaque glazes.

If you decide to turn valuable vases into lamps, do not drill into the porcelain. Have an electrician wire it from the outside using clear wire. Most traditional lamp vases rest on a base, and many have oriental detail. The darker the wood of a base, the more elegant the effect. Only once did a client ask me for elaborate bases of ormolu, the alloy resembling gold used to ornament furniture. They were hand chased, groove cut, and embossed with intricate flowers and other ornamentation by a master at the world-renowned hardware establishment, P. E. Guerin, whose founder Wharton and Codman wrote about in *The Decoration of Houses.* Ormolu bases for priceless antique porcelain vases cost as much as fine jewelry and are equivalent to Fabergé pieces.

Table lamps, much in the same manner as furniture, have distinct personalities. Often, the simple, classic shapes are the most satisfying and

can be found inexpensively in houseware and lifestyle stores. There are also oriental lamp shops around the country with excellent selections of tasteful inexpensive lamps. Before you look for a pattern, seek a pleasant form and color. Many people select lamps to go with specific fabrics in a particular room, but remember that materials come and go and you may move, so choose lamps that will be appropriate in many settings.

In a generously proportioned entrance hall, clients have a large French farm table against one wall. Placing one lamp on it, off center, would look odd because it would seem too intimate for the first room you experience in the house; you would feel as though you were walking into a study. At Sotheby's auction house we purchased a pair of old white faience lamps composed of three graduated bulbous shapes with delicate flowers where these balls connect. They are strikingly beautiful as a pair on the hall table. Another client filled a clean round bowl with sand and sea shells from a vacation in Florida to use as a lamp in her sun room in Ohio.

Lamps can be an accent color in a neutral room, so don't hold yourself back if you find an extraordinarily beautiful patterned or solid pair. Handmade pottery or porcelain vases in chromatically intense colors can be striking. Whether you go to a pottery studio and hand paint your own vase or find one you love in an antique shop, each lamp in your house should be charming.

HOW TO SCALE A LAMPSHADE

*L*ampshades are tricky, and when scaled by someone with a heavy hand, can destroy the integrity of a room. Of all the places to keep things simple in decorating, the lampshade is one of the most obvious. Remember, the primary purpose of a shade is to hide the bulb and soften the light. I believe well-scaled, inexpensive paper shades are always the most appropriate, even for vases of great value. Fussy, pleated, silk shades with gold and silver binding often appear dowdy and dusty, overpowering the lamp rather than simply softening it. Study pictures of rooms created by the top interior designers and you will be pleasantly surprised to see simple, underscaled, paper lampshades.

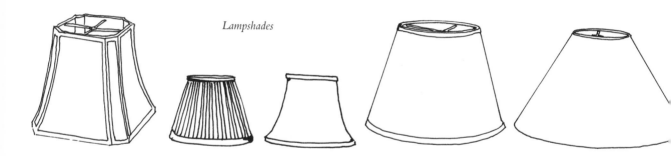

Lampshades

Lampshade sizing grid

Most commercial lampshades are too big for the lamp. Most lamps are too big or too diminutive for the tables they stand on. Achieving harmony in lamp placement is a fine art. Decorators have spent untold hours scaling shades and have yet to find a formula that works for all lamps. For example, if you choose to use a candlestick for a lamp, you will want the candle shaft to show above the candlestick. So I can't make it easy for you, but I can give general guidelines:

When scaling a shade, use grid paper. Begin with the height and girth of the base. Draw the lamp, one square grid per square inch of lamp. The bottom of the lampshade should float just above the lamp, looking as graceful as possible.

First, scale in an appropriate shade. To help you understand the method, pretend one of my ginger jar lamps is yours. Draw the ginger jar fourteen and one-half inches tall from the top of the porcelain to the bottom of the base (thirteen-inch-tall vase and one-and-one-half-inch wooden base). The vase is seven inches in diameter at its widest. At the top of the vase, indicate seven and one-half inches of metal base that will be placed on top for the bulb socket and a three-way bulb. If you're having a lamp rewired, be sure it has the capacity for up to 150 watts of incandescent light, and be aware that these bulbs are taller than those of lower wattage.

On your grid paper, draw an outline of a shade to the following scale: Count up ten and five-eighths squares from the center, count eight across the top (four each side of center), and fourteen squares across the bottom (seven each side of center). With a ruler, draw two slanted lines to connect the top to the bottom of the shade, which

should be eleven squares each. Three wires in the lamp converge into a center hole that attaches the shade to the top of the harp. The hole is slightly sunk so it doesn't show. Before you attach the shade to the lamp, is its scale pleasing to your eye? Either cut out the shade and put it on top of the lamp or use tracing paper.

This size lamp and shade requires a ten-inch harp (the metal piece that clips onto the top of the lamp with prongs on either side of the bulb and a screw that supports the shade). Because this is a standard-size shade, you can buy one at a lamp and shade store. A bigger lamp might require a shade with a ten-inch top, sixteen-inch bottom, and which is slightly taller, perhaps eleven and one half or twelve inches on the slant. Always keep the top diameter substantially smaller than the bottom so the shade has a graceful flair. All drum shades are awkward because the eye wants the top to be smaller, and when it is not, it overpowers the lamp. The shade should never be bigger than needed to harmonize the lamp's scale and proportion.

Most people mistakenly assume the harp on a lamp is permanent, though all you have to do is slide up two metal sleeves and squeeze the end of the two prongs to remove it. If the harp on a lamp is too big, replace it before you attempt to find a lampshade large enough to cover it. For a few dollars, you can buy harps between six and twelve inches, and you may want to buy several in various sizes. An inch can make a great deal of difference in the scale and proportion of shade to lamp, and for the nominal expense it is easier than lugging the lamp to the hardware or lighting store.

Opaque white paper is attractive for lampshades, but it doesn't let through as much light as a translucent shade. If you have other sources of light besides your decorative lamps, opaque paper shades are the most unobtrusive in a room, and you can buy them in a lacquered paper for more shine. They can be painted any color or covered with wallpaper or fabric. You can also faux finish them, but keep in mind that the shade is not the decorative feature, the lamp is. Parchment paper is organically pleasing, as is linen, if you want it to be translucent. Bottle-green opaque paper shades are attractive in paneled rooms or dark-colored rooms, and look charming on electrified candlesticks. The wire ring on the top and bottom can be painted gold, creating the illusion that the shade is tole (lacquered or enameled gilded metalware), when in reality it is inexpensive paper.

FINIALS

*I*f you feel that your simple, inexpensive lampshade is too dull, you can indulge in a touch of luxury and select a finial, the crowning jewel at the apex of a lamp. This small refinement adds elegance and draws the eye up to a finishing touch of color or brass. The commercial metal finials that come with the unit are usually cheap and detract from the integrity of the lamp's appearance. Lamp companies sell a wide variety of decorative finials. Antique lighting companies sell expensive, beautiful rock crystal finials with hand chasing and finials made of carved jade and other stones. Round balls in semiprecious stones can be found inexpensively. Satisfy your whim and have tasteful finials.

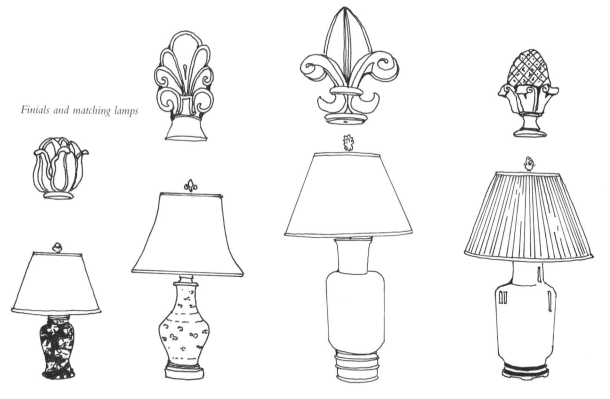

Finials and matching lamps

CHANDELIERS AND LANTERNS

*C*handeliers and lanterns are decorative ceiling lights that add grace and charm to a space when they're refined and appropriate. In a dining room with hand-painted yellow wallpaper and an

antique round mahogany table, an old Waterford crystal chandelier hangs low over the table. It is the shimmering focal point of the room. The effect is as beautiful as a sky full of twinkling stars. But this fixture costs far more than a college tuition, so while I celebrate the beauty and authenticity of truly fine chandeliers, I feel no need to have this extravagance in the rooms I decorate unless money is not a consideration. Even in rooms that call for a chandelier, sometimes it is wiser to go without one if it means the money can be spent on a beautiful painting, a piece of sculpture, or some quality antiques.

Be a purist if you choose to buy a decorative chandelier. If you can't afford finely cut crystal or rock crystal, simplify your scheme and choose solid brass, carved wood, iron, or plaster. Remember that simple real brass is always attractive, but pseudo-brass chandeliers never ring true. There are many beautifully decorative fixtures available today, and you don't have to be locked into any rules when selecting one that suits your aesthetic.

Over the table in a client's kitchen retreat is an iron chandelier painted white with four doves. Another breakfast room has a blue-and-white porcelain chandelier. Whether you have toile flowers that are hand painted in pastel colors or a wrought-iron fixture that is a replica of Alberto Giacometti's brother Diego's birds, you can hang any chandelier you love, that speaks to you, with success. If you want a chandelier to hang over a table, sit at that table and determine how low you want it to be. I always suggest leaning to the low side. No one is going to bump their head on it, and hanging the fixture low creates intimacy. Try three feet above the table and let your eye judge from there.

Lanterns

Lanterns are traditional, unpretentious, and handsome, adding stars to any room with their candelabra bulbs inside the glass globe. They light up a stairwell or a hall, and add architecture to a plain space. They are equally attractive hanging from a brass or wrought-iron chain but can also be mounted flush with the ceiling. If you have a low ceiling, a flush-mounted lantern will look attractive. Although they come in many materials and finishes including wrought iron, brass is usually preferable because it shines, and with the lights and the reflection of the see-through glass, you feel a sparkling quality to the light. Some lanterns have beveled glass, and you can also find lanterns with delicately etched glass.

Lanterns have integrity, and are always appropriate in any setting that welcomes you into the house. Most traditional houses have lanterns in the hall and stairwell. Edith Wharton and Ogden Codman recommended use of the lantern: "For the lighting of the hall there should be a lantern like that in the vestibule, but more elaborate in design. This mode of lighting harmonizes with the severe treatment of the walls and indicates at once that the hall is not a living room, but a thoroughfare."

One of my favorite decorative ceiling fixtures is a disk supported by three or four chains. The disk can be colored glass, etched, or smoked, and in the hands of a master glassblower, it can look as though the moon is above your head. In Claude Monet's dining room, a glass bowl, slightly less than a half circle, hangs over his dining table. The now-famous china by Tiffany & Company outlines a yellow border of the same shade with a band of blue on a white background.

Desperate Situations Call for Desperate Measures

*I*f you have a room that receives little or no sunlight, you will have to learn how to invent natural light or the room will be too depressing to spend any time in during the day. A room without windows often becomes a closet for storage. In a room that gets no natural sunlight, it is extremely important to have white walls that will expand the space, bringing light and cheer. When clients turned their dining room into a library, they made the mistake of painting it a rich, Chinese lacquer red. While the color was beautiful, it was inappropriate for a room with two windows that faced a filthy charcoal air shaft and looked directly into a neighboring building's dirty windows. They had to admit their mistake with this English men's club look and paint the room white. They had always avoided the room while it was red until after dark, and now they come and go without feeling deprived of light.

But in this case, even after painting the room bright white, it still was dreary. This couple had a choice: Either they had to figure out a way to illuminate this dead room, or use it as a storage space. Lighting can be magical, persuading your spirit to believe sunlight is flooding into this room. But I warn you, only do this drastic window treatment when there is virtually no hope of light or view from your window: Install inexpensive, pure-white vinyl spring-roller shades next to the window glass, as close as you can screw in the brackets. At the top of this white shade that you will always keep drawn, install Lumaline eighteen-inch-long tubular incandescent fixtures. These bulbs are long lasting and don't use up a lot of energy. To hide the light strips and create the illusion of a private, secret garden beyond, install interior white shutters in front of the lights and keep them closed. Use good brass hardware and an attractive brass latch to close them. When the window cleaner comes, make sure he doesn't forget about these windows. If you want air, open the shutters, raise the shade as much as needed, and then close the shutters.

By installing this light treatment in the library, this couple created the illusion of sunshine flooding in from the windows. This same solution can be executed with gossamer white curtains instead of shutters.

Another hopeless space with no natural light is a small bathroom with a small, narrow window. A client's two daughters share this bathroom that has two strips of makeup bulbs on either side of the mirrored

Makeup bulbs framing mirror

medicine cabinet. These round, glass bulbs can be clear or frosted, and are both useful and attractive. There are separate switches for the recessed ceiling lights and for the two strips on either side of the mirrored cabinet. The bathroom is completely tiled in blue-and-white, and the polished chrome strips that hold the ball lightbulbs shine brightly too, so the room appears to be smiling back at the occupants.

MAXIMIZE YOUR OPPORTUNITIES FOR LIGHT

*L*ight the lights. Go on a quest for more light in your rooms. Reveal light through shiny objects—brass, silver, crystal, chrome, copper, tiles, and mirror. Use plenty of white so you energize spaces and the light isn't absorbed into dark colors. Put strip lighting above your bookcases. Put a ceiling spot shining down on your stone mantel ledge.

A friend sent me a postcard with the wise words of Emily Dickinson: "Truth is such a rare thing, it is delightful to tell it." Above those words is a photograph of her writing table in her bedroom at the Homestead in Amherst, Massachusetts. The table is small, with one drawer, and tapered legs, and it is placed in front of a huge window with deeply splayed reveals. On the white ledge is a potted geranium and light flooded onto the table where she recorded the divine illumination coming from the outside to her inner core. I vividly recall dinner at a friend's farm in Georgia, in a log cabin, lit by candles. The hand-hammered copper plates shimmered in the flickering light, and the copper peppermill reflected onto the white linen tablecloth so the cloth was aglow with warmth.

All those photographs you take on gray days never turn out to be prize winning in your hearts. In the decoration of your house, let the light shine on you and your loved ones. Follow Claude Monet, who painted light and its depth. When Edouard Manet was out on Monet's studio boat, Monet sat idle, paintbrush in hand. "What are you waiting for?" inquired Manet. Monet answered, "The light." There are two choices in life: One is to seek the light, and the other is to dwell in darkness. Be a light seeker.

CHAPTER 10

Texture

These are our homes, our private worlds;
let them welcome us and make us happy.
Let them grow and not stagnate.
Let them be the mirrors of our personality
and not the reflections of others;
let them be splendid achievements
of self-expression.

—ELEANOR MCMILLEN BROWN

WHAT IS TEXTURE?

*N*ow that you're in the light, it is time to turn your attention to the full range of textures you can incorporate into the decoration of your house. Everything—animate and inanimate—has texture. Some materials feel heavy in a room, such as marble, while other textures feel as airy as a woven basket. To artists, architects, and interior designers, the use of different textures is an essential component in the creation of a composition or the decoration of a room. It is the interplay of texture, the contrast among materials and the feel of surfaces, that gives a room vigor, lifting it out of the ordinary.

Texture is the basic structure or composition of a substance. *The Random House Dictionary* defines texture in part as "the characteristic physical structure given to a material, an object, etc., by the size, shape, arrangement, and proportions of its parts . . . the characteristic visual and tactile quality of the surface of a work of art resulting from the way

. . . materials are used." Most people associate texture with textiles. But to fully comprehend the opportunity for texture in the decoration of houses, you must broaden your definition and experience of texture to include all the materials of the natural world as well as man-made materials. I'll discuss textiles later; in this chapter, I'll concentrate on non-textile textures.

NATURE'S TEXTURES

*T*exture exists everywhere in nature; we grasp it through our senses of sight and touch. We see the grain in wood, and feel its splintered or sanded surface. We see the shiny or dull surface of pebbles, and feel their smooth or rough surface. A seashell, a maple leaf, a wild-flower, grass, a cliff face, moss, soil, bark, sand, sea water—each has a unique texture that deepens our experience of nature. Think of an old New England farm. Among the trees, grass, stone walls, weather-beaten red barns with peeling paint and bales of hay, you can be alive to texture, nourished and stimulated by it. Stare at the intricate twisting of a basket handle and marvel at the braiding of wicker and cane. The textural impact of organic materials is fundamental in the decoration of houses. The more authentic the textures in your rooms, the greater your sense of fulfillment and stability.

As you increase your textural vocabulary, you expand your interest, knowledge, and experience in thousands of ways to bring tactile as well as aesthetic pleasures to your rooms. Know the ecstasy of seeing a pitcher full of white lilacs sitting on a silver, weathered, redwood table. Looking at dainty lilac pinwheel blossoms in the dappling sunlight is an advanced lesson in texture. The thousands of perfect clusters of fragrant white flowers have depth, texture, and style; the arrangement becomes an integral part of where it is placed. On the silver wood falls the lilac's lacy shadow, undulating gracefully in the wind.

No matter where you go, you can become a keen observer and collect energy from all the textural, tactile, sensuous experiences along

your path. Next time a wine steward hands you the cork from a wine bottle, stroke its texture for a moment. Buddha reminds us to be awake. Even in a cement city you can find amazing textures if you are awake to them. Think of a sidewalk sparkling with mica on a sunny day, or the glistening phosphorescence of a white marble mantel.

As in nature, everything in our home influences everything else. An ideal room expands our vision of this interdependence. As you concentrate on mixing textures as life does naturally, you'll bring out the charm and integrity of each object and add style, interest, and harmony to your home.

EXPERIENCING TEXTURAL PALETTES

*O*n your quest to deepen your knowledge and experience of texture, contemplate the many ways nature creates textural palettes. In my *Book of Color,* I discussed four color palettes straight from nature—The Garden, The Seascape, A Walk in the Woods, and "Fresh Enough to Eat." These four groups, along with a fifth category comprising the seasons, could easily define textures as well. I encourage you to make a list in your notebook of what these categories mean to you in terms of texture. In a stream of consciousness, jot down impressions of soft, hard, light, and heavy textures.

The Garden As you walk in the sunlight on a winding brick path, with moss and johnny jump-ups softening the cracks, grass, ivy, and delicate daffodils contrast with the rich brown soil. There are vines, stems, bulbs, and blossoms, rose petals and geraniums, peonies, and foxgloves surrounding a small marble cherub fountain and birdbath. Edith Wharton believed the three elements of the gardens were marble, water, and perennials—a reflection pond, a marble statue of an angel, and blossoms everywhere.

The Seascape Go to the beach and feel the warm sand under your bare feet. Examine its texture and color gradation, suggesting a pattern within the grains. Walk slowly toward the water and experience the transformation from hot, dry, granular sand to cool, wet, undulating sea

Garden urn

foam and waves. Study the fluffy clouds and then turn your gaze to some palm trees or bay grapes. Sift wet sand through your fingers. Gather a few seashells—a sunset, scallop, black jingle, Chinese hat (those blessed shells with a hole in them so you can string them together with dental floss and make a bracelet for a grandchild). Run a fingertip inside a mother-of-pearl mollusk, feeling its shiny, milky surface. Contrast it with a piece of coral.

A Walk in the Woods The textures of bark, pine cones and needles, rocks, ferns, and the leaves of trees—oak, maple, fruitwood, elm, birch, Japanese dogwood—create thousands of different patterns. When the light dapples through the leaves, they become transparent. You're surprised by a cluster of lily of the valley in the summer, and in the winter you are captivated by the ice on the tree branches, shining brilliantly in divine patterns.

"Fresh Enough to Eat" From the shiny layers of a white onion to the plump juiciness of a ripe tomato from the garden, your sense of texture is heightened every time you prepare or eat a meal. When you make a salad and the dressing, be aware of the several luminous ingredients you toss and mix together. What sensations do you feel when you bite into a ripe pear or eat a spoonful of gazpacho? How would you describe peeling a hard-boiled egg? Slice open an avocado and touch the soft, smooth surface. Why is the texture of citrus fruit so visually attractive? How would you describe the texture of a freshly baked loaf of bread? Corn on the cob?

The Four Seasons The four seasons have distinct textural palettes depending on where you live. The change of seasons in New England is a never-ending, exhilarating course in texture providing boundless textural delights that keep you in constant touch with the earth. In the springtime you feel the delicacy of new life, the fragile blossoming of flower petals. Summer brings the textures of freshly mowed grass, rambling roses on picket fences, the beach and salt water. Fall represents piles of fallen leaves in the front yard, a bushel of apples picked in an

orchard, freshly cut logs and a warm fire. Winter brings to mind cutting down a Christmas tree, crunching into deep snowdrifts, examining individual snowflakes, knowing that as with an individual's thumbprints, no two snowflakes are the same.

BRINGING NATURE'S TEXTURES INDOORS

*I*f the ideal is to be out-of-doors, in a garden, in the sunshine, by the sea, on top of a mountain, how can you bring this experience with you when you go indoors? What textures do you want to incorporate into your decorating schemes that will enhance your vital energy, your life force? If you begin to pay close attention to the different textures you encounter out-doors and their effect on you, you can become skilled in the fine art of combining textures in your rooms. You will be able to establish an interplay of materials.

Stone can be brought inside for floors, mantels, even walls. Marble, limestone, sandstone, bluestone, granite, and slate all have their own textures. Limestone, heavy in weight and with a feeling of permanency, looks as translucent as skin. Slate ripples, and marble has veins flowing through it as though beneath a babbling brook. All stones have inherent beauty. Even concrete, consisting of sand, gravel, and broken stone, can be colored and

polished and used for a floor. To add texture to a bland room, a scratch coat of plaster on a wall will add depth and interest.

Glass takes on different textures depending on whether it is cut, beveled, hand blown, spun into cones, or infused with a design. Metals, whether stainless steel, gold, brass, or silver, all shine and bring in light. Traditional houses have shiny brass hardware gleaming brightly as a textural contrast with carved or raised-panel doors.

Finely hand-painted porcelain has a different texture from country pottery, echoing a more elegant lifestyle. Leather sofas, chairs, benches, and books arouse a masculine refinement and sensuality, warm to the touch. Cottons and silks provide the softness a room needs for emotional and physical comfort.

Wood, the most popular material in most houses, can be carved and cut to any shape and size and always brings the energy and sensual beauty of trees inside. You can lay a wooden floor, panel your walls, and have wood furniture to maximize wood's energy in your house. To add variation to a room that's predominantly wood, you can place a terra-cotta pot on top of an eighteenth-century table highly polished with lemon beeswax, so that it gleams in the sunlight. A shiny fruitwood chair can have contrasting brass nailheads and a silk seat cushion. Many of the chairs in Edith Wharton's house, The Mount, were French Regency, made of carved fruitwood with caned seats and backs. Woodwork with cutouts brings in light, as a trellis does, and all wood can be painted to look new, or crackled to take on the patina of time. Some woods feel soft, while others have a harder appearance and tactility. Mahogany, when painted with a dark stain, takes on a formality that is more elegant, yet more rigid, than fruitwood or pine.

Flowers, fruit, and plants bring in the life force of nature. Lemons, limes, and oranges on a clear glass plate bring the warmth of the sun inside, adding texture with their bumpy rinds, shape, and color. Ivy is both firm and delicate in design. The leaves are strong in form, but also dainty, and contrast magnificently against wooden shutters, creating the illusion of a garden. Live trees in your house help create continuity between the outdoors and your house's interior. And the most delicious textures in the home are "at table," where you nourish your mind, body,

Caned fruitwood chairback

Mahogany Chippendale side chair

and soul. Create a textural tapestry in every area. Add emotional warmth to the foot of a bed with a handmade quilt and an understanding of how contrasting textures stimulate the spirit.

The essence of what you like, what you are drawn to in nature, should govern the interior spaces of your home. The textures that interest you will make a positive impression on those who enter your house. Before you can have the same textural charm of nature inside your man-made rooms, you must appreciate the authentic textural character of nature's objects. When you're outside in nature you seem to absorb textures more intensely than when indoors. Enhance your tactile awareness. A freshly mowed lawn is far from monotonous. The texture of the sky, with its contrasting flat, still cobalt-blue and puffy white cumulus clouds, eventually transformed into a fiery amber sunset and then a black expanse encrusted with stars and a moon, is enough wondrous, textural distraction for a lifetime. The moss on the terra-cotta flowerpot, the verdigris on the copper weather vane, the four-leaf clovers in the grass, the ivy that climbs the trellis, the way the light spills down onto the brick walk with the picket fence creating a diagonal pattern of light and shadow on the stone, are all textural epiphanies.

You should be able to make fine distinctions, so slight they are difficult to detect. How do you react to the vast number of materials you experience each day? Go around your rooms and jot down in your notebook the range of elements you have already in your textural inventory. How do they flavor your mood? Do they nourish your soul and bring you a sense of well-being, uplifting your spirits, or do they weigh you down? By exploring your bond with certain substances, materials, and elements in nature, you can translate those passions into the decoration of your house.

If you want to capture the effect of seaweed at low tide on Long Island Sound, rather than painting your walls a sickly seaweed color, find a yellow-green velvet and have it hand quilted "vermicelli" style, in wiggly, noodlelike stitches for a chair or sofa. If you love the bark of your old oak tree, you won't want to translate it into a terry-cloth towel, but you can install a cork floor in the kitchen. If you are restoring an old house and happen to be attracted to the color of the green mildew on the walls of your hall, you can replaster the walls and paint them in soft shades of green. If you love your rustic brick patio, have

Stone fireplace

Seashell lamp

old bricks laid in the sun room or in front of the fireplace. If you enjoy mountain climbing, you may want a stone mantel in your living room or family room. If you are in awe of the changing clouds, you can create that texture on your dining room ceiling by painting the flat surface with clouds to create the illusion of an infinite sky.

Should you love trees, you'll be delighted to have bare, shiny floors to highlight the grain of the wood, making you feel as though you're taking a walk in the woods when you come home. If you have a passion for sand on the beaches of the west coast of Florida, you can bring it home by using natural canvas on your rattan furniture in the sun room or bedroom. If you love the coral sand of Bermuda, fill a clear, cylindrical vase with this magical substance, place an electrical cap on top, buy a shade, and you'll have a conversation piece. If you sprinkle in some small shells, they will be as striking as Fabergé's eggs.

Rattan armchair

With a beautifully woven basket of white willow and cane handles filled with zinnias, you can achieve the effect of a summer's day in the garden. Many people who have wild, wonderful gardens live in houses that are dark, dreary, musty, and dusty. They have not yet made the connection between the textures they respond to in nature and the interiors of their houses. Edith Wharton loved gardens and always had bouquets of seasonal flowers in the spaces she occupied.

I have a few wealthy, eccentric clients who are uninhibited in expressing themselves in clothes and conversation, but they demand fierce formality in their homes. The charm of texture is wrung out in an effort to make everything perfect and uniform. I've had clients who have wanted to return an antique because it had a tiny dent, ink stain, or scratch, not realizing that these imperfections add texture, interest, and karma. The alternative—new *perfect* furniture—can create a sterile environment in desperate need of energy. The chair with worn patches from feet rubbing up against it is more real, more alive because of this

sign of age and use. One of the most rich, alluring, desirable textures of the home is the patina, or sheen, that develops on wooden furniture from years of use and maintenance through the buildup of wax and oil. Patina is a valuable detail, adding nuance and charm to a room.

THE ART OF COMBINING TEXTURES

*S*ome of the dullest rooms I've ever been in vary little in tone and pitch. The harmony in a room is similar to musical rhythms. The wider the range, the greater the emotional impact on the soul. Though the overall harmonious organization of a room calls for repetition, there are ways to stimulate a room texturally without disrupting the larger order of a space. A fabric-draped table can be placed on one side of a sofa, and an appropriately scaled fruitwood table on the other, and together they create harmony, whereas two new matching reproduction tables with a pair of identical opaque lamps could be deathly dull and static, reminding you of being in an impersonal hotel or motel.

Marble-topped table

Create a continual weave of textures in a room. Place soft against hard, matte against glossy, rough against smooth. Certain materials maintain a cool temperature that works well when contrasted with a warmer material. For example, if you have a marble-top table, balance it with a carved, fruitwood base. A basket or hand-thrown porcelain flower vase warms up the coolness emitted by a glass surface.

Count the number of different textures in your rooms. You may find that you already have the essential textural range and only need to place them in yin-yang, or harmonizing, contrasts. If there is too much repetition and consistency, you may be promoting dullness. Texture can be a

Glass-topped table

Wicker files

crack in a vase or a piece of missing gold leaf on a carved frame. Playing with the contrast and sympathy of one texture working synergistically with others is a quick and low-cost way to decorate and redecorate. Write in your notebook some of the textures of objects that give you immense delight, from a marble ball to a wicker file cabinet. Perhaps you love the texture of old leather suitcases, or the texture of the pigment on a favorite oil painting. The textural authenticity that exists throughout your house will continuously stimulate your passions.

BALANCING HARD AND SOFT TEXTURES

Consider the textures of the floors and walls as well as those of your upholstered and wood furniture, and all your accessories. When selecting anything, visualize how each texture will play off the one next to it. A glass table can appear cold on a bare wood floor because both have hard surfaces. But you can warm them both up by placing a brightly colored rug below the table. In your kitchen, the wood floor beneath the round farm table may seem bland until you put a cotton rag rug under the table. In front of the white porcelain sink place a blue-and-white striped cotton rag runner to soften the feeling of the hard, cold sink.

Balancing wood with fabric provides interesting tension between hard and soft textures. Fabric breathes best when set off against wood. In the living rooms of our apartment and cottage, we have a lot of upholstered furniture with ruffled skirts, so we use only a few small rugs because we enjoy how the waxed wood and the cotton fabric complement each other. On the other hand, if you have a great deal of wood furniture and few uphol-

Indoor window box

stered pieces, you may want to warm the atmosphere by contrasting the wood with a large decorative rug. Consider contrasting hard and soft textures at your windows as well. There are lots of ways to soften a window besides hanging fabric in front of and on either side of the glass. I often used indoor window boxes in apartments. In a bay window of a house I decorated in New Jersey, a friend keeps pots of cyclamen on the inside ledge, drawing your eye out to the terrace, the garden beyond, and the river. A textural feast!

A Touch of Luster

*R*ooms should have reflections, surfaces that gleam, radiating light, energy, and color. Have several reflecting surfaces—glass, decorative mirrors, clean windows, a red-, black-, or British library green–lacquered coffee table, sparkling silver and brass picture frames, a crystal vase with flowers. Consider a crystal, brass, or silver candlestick to catch the light. Porcelain fruits and vegetables also pick up light and give off energy. Or hang porcelain plates on the wall among framed watercolor botanicals for a texturally charming, lustrous effect. Remember that brass hardware and other brass objects need to be polished periodically. If you place a shiny brass watering can on a polished wood floor, the two materials mingle, each drawing proud attention to the other. A small, fine Louis XVI two-tier table with a single drawer has four sabots (brass shoes) on the bottom of its tapered legs, separating the wood floor from the wood table. When the sabots are polished, their gleam lifts up the room, displaying a texture of care and appreciation.

Kitchen Textures

*K*itchens have lots of hard practical surfaces—the stove, refrigerator, dishwasher, microwave, sink, and many countertops—that need to be balanced with soft textures to create a more welcoming atmosphere. Blue, green, and yellow Thai cotton-plaid cushions on

wooden side chairs add both physical and emotional comfort. A dozen inexpensive plaid, checked, and striped cotton dish towels kept in a stack next to the kitchen sink also adds softness.

In front of a window, put a flowering plant in an oversized terra-cotta pot, or plant African violets in pinks and purples in smaller flowerpots to keep on the tiled windowsill. Even an old metal watering can filled with freshly cut daisies can add a hint of nostalgic texture. One client has a wrought-iron rack painted periwinkle blue, displaying several towels in front of a kitchen window. Set out some fruit in a wooden bowl on Formica or tile countertops, for a soft contrast. If your counters are wood, try a pottery or glass bowl with fruit.

If you have ever been to Provence, you may have fallen in love with the classic French country kitchen, where the variety of textures plays a defining role. A client's kitchen captures the provincial flavor of the South of France, with gleaming copper pots hanging on the rough white, chalky, lime plaster walls. The unique sensation of walking barefoot on freshly mowed grass is captured in a cut pile rug containing various tones of green in front of the kitchen sink. The rich nubby wool next to the smooth cork floor accents the textural beauty of both materials.

This client's countertops are scrubbed maple set against a backsplash of floral hand-painted ceramic tiles in shades of blue and yellow. These vivid contrasts of texture and density of materials bring the room to life. The white porcelain sink with brass hardware shines against the dull surface of the bleached maple counters. The plain round copper bar sink has a high gooseneck brass spout with a swan design, a touch of decoration in an otherwise plainly executed space. Even the cork floor, soft underfoot and richly textured, complements the Brittany blue of the cabinets. Earth and sky elements balance the ch'i of the space.

*A*s with the kitchen, the bathroom's hard sur-faces should be balanced by soft touches. A tiled bathroom can be softened with a stack of terry-cloth towels on an old wooden towel rack. One of my favorite bathrooms is a client's guest bath with one huge stained-glass window, pink-and-white wide-striped walls, and a floor laid with ceramic tiles painted with flowers in shades of green and pink. The curtains are a subtle floral chintz, and in front of the window is an old white Victorian wicker music stand loaded with pink-and-green patterned towels, hand scalloped in white binding. Even the mirror over the sink is soft, hand painted with flowers in pastel shades of pink, green, and yellow. Across the old-fashioned tub is a brass tray, with a giant sea sponge and several bars of intensely colored strawberry and lime glyc-

erin soap. The generous use of towels, bath mats, and area rugs invites you to a private moment of sensual spa treatment. This grand bathroom has a walk-in shower and an oil paint-ing hanging over the tub,

beneath a bronze chandelier with white porcelain flowers that is a focal point. Here you can clearly wash away your tension and worries and emerge rejuvenated. The contrasting textures of the water, the soap, the towel, the silver cup filled with sweet peas, and the light coming through the stained glass all play together to create a unique, fulfilling textural experience.

To contrast the many hard surfaces of a bathroom, soften hard edges with a simple white eyelet shower curtain made of the same fabric as the curtains. This openwork material is pure and fresh. Fluffy white terry-cloth towels stacked on a stool or chair and hanging from a towel bar, and two hooded

terry-cloth robes hanging from the door, complete the atmosphere of endearing innocence. Another fabric with the same inviting effect is dotted Swiss cotton.

Painting some of the tiles in flower sprigs adds color and texture the same way a similar design brightens a porcelain teacup against its saucer. Some attractive, decorative rectangular and square border tiles are plain in the center, but have a simple hand-painted line border or design on all corners, providing a subtle pattern that does not intrude upon a room's simplicity. The white, four-inch-square, hand-glazed French tiles I use in bathrooms are texturally rich behind their smooth surface. There is a great variation in the tones of white: Some are more fluid and transparent, a bluish skim milk tone, while others appear more opaque.

BALANCING THE BEDROOM'S SOFTNESS

*I*f your bedroom is too soft with wall-to-wall carpeting, a puffy comforter, lots of pillows, and an upholstered love seat, add lacquered storage boxes, a green oxidized-copper lamp, or a wicker desk or side table. A hard texture will give you a more dynamic mix and an even greater appreciation for the soft objects in the room. The next time you take down the bed hangings for cleaning, don't hang them up right away. Let your eye absorb the more simple look.

In her bedroom, a client had three small texturally interesting white area rugs around the bed, one in front of a dresser, and one as you entered the room. When she removed them for cleaning, the texture of the old knotty pine floor brought her such joy that she gave the rugs to her daughter to use in her bedroom. My client realized that as attractive as the rugs were

Lacquered storage boxes

in her bedroom, their raised design resembling trapunto on an old quilt, the room needed space to breathe, making less more.

THE MANY OPPORTUNITIES FOR TEXTURE

What are some of your favorite textures? I love the look of old hand-painted wallpaper and decorative hat boxes made from antique floral wallpaper. French wired silk ribbons have such a luminous appearance and come in such luscious colors that you may want to fill a marbleized box with a rainbow of these magical streamers. The texture of hand-painted decorative tiles against the warmth of wood

is an epiphany. The feel of a one-hundred-percent linen sheet, with the look of pure snow but a hand-stitched edging, evokes memories of luxurious, happy sleeps.

Take time to develop the textures in your life. Some of your favorite delights may be as inexpensive and simple as sea glass collected with children, a piece of birch bark found on a walk in the woods with a loved one, a pressed flower, or a piece of rock crystal. One of my favorite textures is hand-marbleized paper and boxes, ideal for keeping pebbles and the pink-coral sand from Bermuda. I also love the feel of cork, polished fruitwood, and brass. I enjoy the texture of candles and the beeswax polish I use with a flannel cloth. Rubbing wax onto the surface of an Italian Directoire table with fine marquetry is a textural blessing. My favorite piece of furniture, a French Regency table with a cool, shiny marble top and delicate, deeply carved fruitwood apron and softly curving legs, is as fine a hard-soft textural balance as could be. I never tire of the sympathy between the warm browns of the marble and the sensuous carved wood.

One of the reasons I love to iron is that I adore the texture of old cotton, worn and softened from multiple washings. Whether ironing a striped oxford shirt or thirty-year-old scalloped sheets from Porthault Linen, I transcend into a world of luxury, elegance, and refinement. In

Madeira, Portugal, I bought a white blanket cover with pastel appliqué work with thousands of threads creating flowers and leaves. I appreciate any type of work done by hand, sensing the powerful energy of the artist. I collect hand-decorated boxes and baskets, inspired by the colorful brushstrokes that create textural trompe l'oeil effects.

Sinking into a down cushion on a chair or sofa, or squishing a down-filled Thai silk pillow behind you, is a treat in textural refinement. The feel of Thai silk, old quilts, and modest rag rugs heighten this experience. There isn't a texture that won't add ambiance if it is authentic. As you look into a flickering fire, appreciate the black-facing iron-relief work as well as the fireplace brickwork and the shape and texture of the logs.

Continue to bring inside different textures from nature. When you're in a natural setting, having a picnic by a mountain brook, absorb the contrasting textures of grass, rocks, trees, and the babbling, moving water, and how they blend harmoniously. As we end this century and embark upon a new millennium, the draw toward bringing more nature into our houses will only strengthen. Living rooms will become garden conservatories, providing the refreshment you seek outdoors. Whenever you use natural materials in your house, you provide emotional warmth. A cork floor and a potted ficus tree in the kitchen have a way of transporting you out into the woods. A sisal rug in a Fifth Avenue apartment living room with bottle-green cotton-leaf-designed damask upholstery and white overscaled botanical curtains created an enchanted garden mood. A basket made of white wicker filled with pine cones is a textural smile.

Provence garden chair

Treat yourself to the weather-beaten silver tone of a table that lives outdoors by bringing it indoors. I purchased four French garden chairs in Provence, and by leaving them outside one winter, I allowed nature to peel away the orange shellac on their back rails and seats. The rusty iron legs have never looked better. A glass-top wrought-iron table has been painted green dozens of times,

and by being kept outside, it has achieved a rich texture involving many greens in soft shades.

We had a three-paneled screen made of old window frames and had it mirrored for our garden. Several years ago it was severely damaged in a hurricane. I decided to hang it on the house to protect it from further destruction. I fell in love with the textural interplay of the white clapboard and the old wood-framed mirrored panes. When I put a white ceramic pitcher filled with daffodils on a table in front of this mirrored screen, it created additional interest.

TEXTURES OF DOMESTIC BLISS

The Swedish artist Carl Larsson's single most important artistic decision was to acquire an old farmhouse in Sundborn in the province of Dalecarlia in Sweden in 1889 with his wife Karin, a textile artist. In his autobiography, *Jag,* he wrote of his colorful watercolors of his old cottage filled with children and scenes of his wife in domestic bliss: "For it is of course a quite genuine expression of what I sense deep down inside me, my whole boundless love for my wife and children."

In an illustrated book of Larsson's work, writer Stig Ranstrom discusses how important these paintings were to Larsson: "They serve as snapshots of the daily life of a family in a home setting completely different from the usual dark-brown, gloomy, ponderous top-heavy style of the late 1800s. The home depicted here was light and airy, in warm, bright colors; instead of potted palms there were often colorful bouquets of flowers from the garden or the wide open meadows." Larsson's pictures, Ranstrom concludes, "may serve as a source of joy, relaxation and the experience."

Striped rag rug

Larsson teaches that the texture of his daily domestic life is love. Through nuances of textural sensuousness, you are comforted emotionally, gaining strength and balance. In Larsson's paintings, children always share in the banquets, sipping tea from porcelain, even at a picnic by the lake. They wear hats and wreaths of flowers, and are read to

in front of lush wildflower bouquets. To Ranstrom, Larsson was a "dispenser of joy," bringing out the cheery side of our temperament through his straightforward, refreshingly personal style, unconventional yet pure.

Several years ago we turned our cottage basement into a studio for creative projects. Simply entering the studio is a great textural experience, with the old stone walls painted white and the cement floor delphinium blue with Carl Larsson–type striped cotton rag rugs thrown around nonchalantly. There we play with different textures and stamp them with our sensibility. We have stacks of catalogs to look through and cut up as well as a whole inventory of objects—glass jars, an orange crate, and a cabinet full of fabric remnants to use in unusual ways. We hang art from a Day-Glo clothesline with old-fashioned wooden clothespins, as well as picnic tablecloths striped in primary colors to hide the furnace and boiler. There is a potting shed and a large iron sink with brass faucets; all the beaded board cabinets are painted white. Everywhere you look is color, texture, and inspiration. Light spills in from high horizontal windows, supplemented by lots of incandescent lamps.

LEARNING TEXTURE FROM THE MASTERS

A piece of Fabergé jewelry or decorative object can be out of reach, but these exquisite masterpieces of textural trompe l'oeil can teach everything you'll need to know about how the use of varying textures can create magic. The mystery is in the carefully guarded technical secret of how his artists applied up to seven layers of transparent guilloche enamel, a glasslike fluid. Mineral colors in 145 hues were applied to a metal surface. "A coat of transparent orange under the last layer gave white, pink and pale blue enamels a scintillating oyster-shell effect," writes Geza Von Habsburg, a renowned authority on Fabergé.

One of the most startling examples of texture created by Fabergé exists in his "Basket of Lilies of the Valley." This single piece so perfectly captured the essence of May, with its mood and smells. This basket con-

tained moss made of gold, dewdrops made of silver, and diamonds at the end of pearl blooms, freely flowing gold stems, and leaves of the most translucent nephrite, a jade with colors ranging from off-white to deep-green.

Fabergé raised nature to a fragile, divine status in his work, helping people see its beauty through his eyes. He demonstrated how beautiful the shape of an egg is and how sweet it is to behold one small sprig of cranberries, forget-me-nots, lilies of the valley, or wild roses. His use of nature's textures—Russian semiprecious stones, gold, silver-gilt, enamel, diamonds, and pearls—was ingenious. The Forbes Magazine Collection, the Virginia Museum of Fine Arts, the New Orleans Museum of Art, and the Cleveland Museum of Art have excellent collections of Fabergé that I urge you to experience. Fabergé's genius, the skill of his five hundred artists, and his unparalleled color palette are a treat to the eye, mind, heart, and soul.

A LIFE'S COURSE ON TEXTURE

Continue to study the masters of texture as well as experience the many textures nature offers. The paintings of Jan Vermeer, the seventeenth-century Dutch master, teach us to put white cotton next to gold silk, gleaming brass on top of a light-absorbing oriental tapestry. Carl Larsson depicts potted plants in every room, with vines climbing up to the ceiling. A wooden kitchen table is covered with a white linen handwoven cloth made lovingly by his wife Karin, and there are flowers in a see-through vase, a cut crystal bowl filled with fruit, a wooden tray with brass handles, and tea set up with breads and sweets, with children participating in the scene. To brighten the kitchen, a tall storage piece with glass doors is painted Chinese lacquer red. Candles are lit in the dining room beyond.

Wherever you travel, be on the lookout for beautifully carved wood, such as the doorframe I found on an old house in Charleston, S.C. Seek the texture of the elegant, free-standing staircase spiraling unsupported on three floors in the Adam Nathaniel Russell House in Charleston, S.C. Observe the delicate mantels and friezes. At the Winterthur Museum in Delaware, study the integration of different inlaid woods

and the selection of brass hardware in the superb American antiques.

When you see an earthenware teapot in the form of a cauliflower, enjoy the intricacy of the textures and colored glazes. If you see Claude Monet's museum in Giverny, observe the blue-and-white cotton ruffled curtains on his kitchen window and the glass back door overlooking his herb garden. His walls are tiled in blue and white, and work well with the gentle curtains. On the black iron stove are gleaming copper pots and pans, and rush seats warm up the ladderback chairs against the cocoa-colored hexagon-tiled floor. Stroll over the Japanese bridge with the white wisteria creating deep shadows on the grooved boards.

It takes a child, or an artist such as Carl Fabergé, to remind us of how magical everything is right in front of our noses and under our feet. Walking on village commons recently I saw hundreds of dandelion puffballs in the grass. They reminded me of Fabergé's exquisite enamel masterpieces that elevate the most simple elements of nature, such as the dandelion, to a divine status. How many of us would revere a puffball? How many of us still make a wish and blow away the silklike whips and seeds, feeling young and vital all over?

Remember to create nature's movement and change in your rooms. Use contrasting textures as your guide along your path. Bring into your rooms woven rattan furniture, baskets, flowers, plants, candles, and all the textures of springtime, love, and laughter. Let the light stream into your rooms where you have a rich, diverse family of organic materials that fill your soul with well-being and harmony.

Color and Paint

Color is light, energy, vibration, and love.
Look at people's colors and you
see their spirit. We should paint
uplifting colors in our life.

THE GARDEN AS TEACHER

*I*n thirty-six years of striving to create beauty and harmony indoors, my passion for color has been my primary guide. With color, you can transform a mundane, mediocre atmosphere into a joyful expression of your love of life. Because color is free, everyone can afford to surround themselves with colors they love and that speak for them. With color you can live more ideally, decorating your house with the vitality of clear, fresh colors. Color is the visible aspect of things caused by varied qualities of the light reflected or emitted by them. Color, *The Random House Dictionary* informs us, is "the quality of an object or substance with respect to light reflected by the object, usually determined visually by measurement of hue, saturation, and brightness of the reflected light; saturation or chroma; hue." The spectrum of color is the distribution of energy supplied by a radiant source, arranged in order of wavelength. The longer the wavelength, the more energy. It's a virtual miracle that we can control, direct, and manipulate the quality of light, energy, and color in our immediate environment and, in turn, our inner consciousness. The colors that make your heart skip a beat speak to you louder than words.

Long before you can read or write, you begin to develop a sense of color. Throughout life, you experience color through nature—gardens, trees, seashores, mountains, even fruit and vegetables. I credit nature for the creation of all beautiful colors. Having learned early in life about the pureness of nature's colors and the role that sunlight plays in their clarity, I found it easy to apply my knowledge and passion when I began decorating. Every color I bring into the rooms I decorate has a direct counterpart in nature. Even when I'm working on an apartment with an uninspiring view, I use the colors of nature to transform the spaces into an enchanted garden living room, a beachside bedroom, and a walk-in-the-woods hunter green library.

You, too, can carry all the accumulated wonder, mystery, and energy of nature indoors with you, making the transition from outside to inside as seamless as possible. Don't be concerned about color trends, what's fashionable or hot, but what colors speak for you. See yourself in a daffodil or a tomato, or in the foam of a wave, or in an African violet. Be passionate about gemstones, the sky, the leaves on a house plant, and the energy you feel from being exposed to vibrant, pure, clear colors.

The link between love of color and love of all living things is indelible. A few years ago a study revealed that gardening is the favorite leisure activity among Americans. Because of the garden, you never need to be color deprived. In the winter, when the outdoor gardens are asleep, look to fruit, vegetables, and flowering house plants for color as you pore over seed catalogs. Order Florida pink grapefruit and oranges to provide color as well as for vitamin C, keeping the citrus fruit out in bowls. In the summer, travel to the seashore to absorb the beauty of the ocean, the beach, seashells, and sunsets. Whether we gaze at the blue ocean or the subtle veining of a lily as sunlight filters through the soft pink and baby-green petals, the clear, pure colors of nature are nourishing. A visit to the seashore, a hike up a mountain, preparing and eating fresh food, arranging a bouquet of colorful flowers from a garden, all leave lasting imprints on you, bringing cheer.

CREATING A COLOR SCHEME:
CHOOSING THE KEY COLOR

*O*f all the elements in your rooms, nothing is more revealing than the colors you choose. What's right for one person's color palette isn't necessarily right for the next person. Just as each unique soul is on his or her own spiritual quest, each person has an exclusive color scheme. By the time you finish reading this chapter, you will have the necessary tools to know what is right for you.

When you decorate a room, you are an artist dressing a three-dimensional space. Choosing a color scheme for a room is similar to putting together a wardrobe: first you pick one key color to be the dominant hue, and then you incorporate secondary colors that work with the key color. How you select a key color and combine it with other colors is a very personal experience. One color should dominate a space. It is the North Star, the lead actor. Be careful that the key color you choose lends itself to complementary shades and hues; these will support the key color's mood and spirit.

When people speak of hue, they are referring to color—red, orange, yellow, blue, green, violet. If you mix one hue with another, it changes the hue, or the color. A hue's value refers to its lightness or brightness. The three primaries—red, yellow, and blue—have the strongest values, therefore the most wavelengths of energy, and cannot be obtained by any mixing of colors. It is these three primary colors that make up all other colors in the spectrum in various combinations of hue, value, tint, shade, and tone. Each primary color evokes a distinct mood in the decoration of houses.

Red Red has the most power, heat, and activity of all the colors. It has the energy and aggression of a charging bull. Red comes forward to greet you. Use red as punctuation in interior decoration, an occasional exclamation point, but never as a dominant color in a room. For example, use red for pillows, napkins, or fabric trim. If you love red, use it in your wardrobe rather than in your rooms—red coats, suits, dresses, scarves, rain slickers, boots, and mittens. If you like red, you will find ways to use it, whether for the engraving on your stationery or the interior of your car.

Keep in mind the appropriateness of a color for your purpose. If you

have a room with no view, red curtains draw your eye back into the room. Diana Vreeland, the fashion designer, had a red living room as she loved *everything* in red. Too much red in a room, however, can have the obtrusive effect of a police siren. But touches of red can add a cheer and energy that only red can achieve. Every room should have some touches of red—perhaps a Chinese lacquer red table or lamps, paintings with red, red leather books, a bowl of red apples, a red picture frame or red tulips. The accent of red is hot, alive, and stimulating.

Yellow Yellow is sunshine. It is a happy, cheerful color. Unlike red, it is appropriate in large quantities in the decoration of houses. Yellow is a welcoming hue, ideal for an entrance hall because it brings sunshine into the house where there are few windows. In a north room, yellow gives the illusion of direct sunlight. Yellow has a compassionate, energizing effect, warming the heart, opening the senses. In rainy weather, put on yellow sneakers, a yellow slicker, and yellow rain hat and step out the front door. Neighbors may greet you with "Good morning. You look like a canary," though you feel like a daffodil.

Many people associate yellow with gold. Use gold only for gold-leaf picture frames, brass objects, and jewelry. Lemon peel yellow with white trim and a more subtle yellow ceiling, however, can be a heavenly beginning for the decoration of a beautiful room. But not everybody shares a love for yellow. It's important continuously to be in touch with how each color relates to your personality as well as your body chemistry. Don't let anyone talk you into living with a color that doesn't make you feel comfortable.

Blue Blue is the third primary color. It is cool and receding rather than warm and vital like its counterparts red and yellow. Blue is a key decorating color. All tints of blue are a good counterbalance to the sunshine, both literal and decorative, flooding into the room. Many share my deep, abiding attraction to blue, directly related to a passion for the sky and water, and are instinctively energized through this association. What can be more celestial than ultramarine? (I helped clients decorate a large beach house on Fishers Island using shades of blue with accents of sunrise and sunset pink in each room; the entire house complemented the out-of-doors from sunrise to sunset.)

Blue calms us down, soothes our jangled nerves, and creates an

atmosphere conducive to relaxation, contemplation, and meditation. It is a mature color. Most Americans choose a tranquil blue bedroom. But blue, I have found, is not for everybody. Blue is a timeless and appealing color for those who feel it refreshes their spirit. A city library can take on the feeling of a beach house by the use of blue and white. You benefit psychologically and physically from the associations made between a room and an island escape, because of the feeling of expansiveness blue engenders.

Secondary, Tertiary, and Quaternary Colors All other colors can be achieved through mixing the three primaries red, yellow, and blue. The three secondary colors—orange, green, and violet—are the colors between the primaries. Orange is between red and yellow, green is between yellow and blue, and violet is between blue and red. Secondary colors result from mixing equal parts of two primary colors. The secondary colors are important in the decoration of houses. The color most often used in large amounts is green. Consider green a spiritual primary. It is important to have something green in every space, even if only a potted ivy plant. Rooms yearn for green because it is the color of spring, freshness, new birth, renewal, and youth.

A primary hue mixed with a secondary hue creates a tertiary or intermediate color. The tertiary colors are red-green, red-orange, red-violet, yellow-green, yellow-orange, yellow-violet, blue-green, blue-orange, blue-violet. Quaternary colors are created by mixing two primaries with one secondary, or one primary with two secondary colors—red-red-orange, or green-green-blue. By swinging the hue closer to a primary or secondary color, you will alter the color according to the direction you're seeking in your color scheme.

COLOR SATURATION AND THE ART OF TINTING, SHADING, AND TONING

A color's saturation, or chromatic intensity, depends on the pureness of the hue. The purer the hue, the more saturated and chromatically intense the color. A tint is a lighter version of a hue that results from mixing pure pigment with white. The more white

added, the lighter the color. A shade is pure hue mixed with black, a process that happens naturally when sunlight, or artificial light, is diminished, causing partial darkness. A color tone is obtained by adding white and black, or gray, to a pure hue. Tinting, shading, and toning decrease a color's intensity and brightness. A color containing no white or black has optimum saturation.

USING COMPLEMENTARY COLORS

Once you select the key color for a room, it is best to combine a tint, shade, or tone from an opposite, complementary color. Complementary colors are red and green, blue and orange, and yellow and purple. If your key color is yellow, a pleasing secondary color would be a tint, tone, or shade of purple, because this stroke of color highlights the whole room. Even a slight variation in a complementary color affects the quality of the atmosphere. Adding these subtle strokes of color is as easy as placing a pot of ivy in a red room or a bowl of oranges in a blue room.

Study famous artists who demonstrate these complementary harmonies so brilliantly in their paintings. Matisse understood how to balance the relationships of opposites, using a small percentage of the aggressive colors—reds, oranges, and yellows—with a large amount of recessive hues—blues, greens, and violets. When Matisse designed the stained glass windows for the interior of the Chapel of the Rosary in Vence, France, he chose blues and greens dominating brilliant yellow to depict the Tree of Life.

Study a book of Matisse's paintings. A woman on a red chair in a red dress has a green scarf draped over her shoulder. In a room with blue wallpaper, a woman wearing blue and white is seated in a green chair at a table holding a huge bouquet of flowers in a green vase. The white flowers are accompanied by an abundance of green leaves interspersed with hot pink leaves with yellow centers. The aggressive red tones are exclamation points in an otherwise cool atmosphere. In a room with green-and-blue wallpaper, a bouquet of cool iris and white lilacs sits on a green table covered with a blue-and-white–patterned cloth. A draped red curtain complements the recessive scheme. A red interior has a blue

table and an open window leading the eye out to a cool forest of trees. Against a blue background, the face of a young girl dressed in green is warmed by her red lipstick and yellow hair ribbon.

One of Matisse's best examples of the power of complementary colors is his famous oil painting *Goldfish and Sculpture* in New York City's Museum of Modern Art. A large green glass bowl containing three goldfish and a tall green vase with three red flowers adorn an entirely blue room. The green of the fishbowl is repeated in a backdrop fabric and in a hanging shelf. Though there is very little red—three fish and three flowers—its effect is emphasized by the abundant use of opposite hues.

LIGHT AND WHITE

*L*ight should always be the key consideration when selecting colors for your rooms, because it articulates and affects the relationship and juxtaposition between colors. A cornflower-blue house turns the most fragile lilac shade at sunset. Colors change a thousand times a day depending on the time, weather, and use of artificial lighting. Light must enhance each color you use and complement them when you mix them in a scheme. As sunlight brings out the pureness of colors, the use of bright white, the equivalent of sunlight in color, sharpens all hues in a color scheme. White is your tool, your talisman to create heavenly rooms. The purer the white, the more luminous the colors surrounding it will feel, as though divine light were bursting through a blue sky. Everything you have been socialized to believe about bright white being cold is wrong. Think of white as energy, as life force, as your instrument as a painter of light. White is the sun shining in your spaces, the energy that keeps your color palette clear, clean, crisp, and delicious.

HOW COLORS AFFECT EACH OTHER

*J*osef Albers, a teacher, theoretician, and artist born in Germany in 1888, wrote a seminal work entitled *Interaction of Color*. The

book describes the simultaneous contrast effect, showing how a pure hue can appear different because it is changed by the colors next to it. If you have white walls and dark-green carpeting, the white will appear seafoam-green. White woodwork looks blue-green reflected in mirrors. In a pink room with mirrors, the white cornice and baseboard look pale blue-green. A shiny brown floor will make a white wall appear beige. The clearer your tints, the more luminous the contrasting effect. Just as there is no absolute truth, there is no pure hue.

COLOR-MOOD ASSOCIATIONS AND "COLOR-LOVE"

Josef Albers had his students analyze the personality of each color, whether it was happy or sad, old or young. Try this exercise yourself. I find dusty colors sad, because they make me think of old, feeble people living in dreary, dusty rooms because they can't see well enough to keep things from looking run down. But so many people willingly choose to live with these dirt-camouflaging colors because it is safer for them to have no clear colors than to expose their inner world. If you really like dusty, musty colors for your rooms, you must understand how much your mood and energy will be influenced by them. If you want to be less cautious, less afraid, now is your chance to sparkle. If you found yourself in a dark room with orange and black napkins on the tables after a carefree day at the beach, filled with the colors of the sea and sky, it would seem unconscionable. House paints have a full range of muted shades many people think are appropriate for room interiors, but I disagree. Who, in the clear light of a sunny day, wants to be in an atmosphere that is clouded over? Just by being inside, you are deprived of ninety percent of the light of brilliant sunshine. You need clear fresh colors and lots of white to counteract the partial darkness cast by your walls that diminishes the energy from light. Americans are most comfortable in a spic-and-span house, yet they accept dirty colors on their walls, floors, and furniture that dampen their spirit.

One of the serious decorating traps people fall into is ignoring the opportunity for sunshine, choosing a dull beige-gray palette because they feel it's safe or creates a presumably sophisticated look. The burnt-

earth pigments—ochre, umber, and burnt sienna—are the very colors that daring Impressionists abandoned in their depiction of nature, escaping the somber, pompous aesthetic of the Academy. One of my personal rules of decorating is that if something has to be dyed to achieve an earthy color, I don't want it. When designing a bank in Texas, I used no neutral colors except in the organic materials, including the wooden furniture. Organic objects that are naturally earth-toned are energizing, such as butcher-block counters, antique furniture, marble-top tables, and cork floors. Decorator Billy Baldwin was horrified when he ordered gorgeous Thai silk curtains, naturally beige, for a client and instead received curtains made of a synthetic material dyed beige. "They'll never know the difference," he was told by the manufacturer. Well, Billy did, and he insisted on the real thing.

A machine can mix paints to achieve any color, but it is incapable of understanding how much energy you will feel from the hue. You must gather the hues and tints that give you the most pleasure, inspiration and, ultimately, life. If you are a city dweller and work in an artificial atmosphere, you'll want to bring ecological elements into your interiors so you will benefit from nature's energy. Think of color as a mystical force that can enhance and stimulate your nonbiological self—your psyche—or depress it. While certain colors elevate your personal, vital energy, others darken your spirit. Think of yourself as an alchemist capable of transmuting base colors to radiant, golden light. In color you have a magic wand that you can use in hundreds of ways every day to create more joyful moments where you feel you are living in pure light.

Claude Monet's famous words "I'm good for nothing but gardening and painting" is certainly an understatement of his contributions to all who seek beauty in color. The artist Marc Chagall believed Monet was a true genius as a colorist. He spoke of the artist's "color-love" rather than "color-light." All Impressionists teach us about "color-love" because each day they went outside to greet the luminous envelope, stretching their vision, wisdom, and capacity with each fleeting moment in the fresh, intoxicating air. How can you have more color-love? You have to wrap your heart, mind, and soul around pure, vibrant hues, and look to nature and artists who see life as a beautiful place for inspiration. And you have to trust your intuition when selecting colors for your personal color palette. Don't look at fashion trends or be guided by what's displayed in showrooms and stores. So-called experts may try to convince

you that bland, artificial, "neutral" tones are calming, whereas in reality they are more likely to shut down, not soothe, the human spirit.

The human eye can distinguish approximately ten million colors. Why have dreary colors that make you think you're drowning in the murky, muddy, polluted waters of Alligator Alley? How do these light-absorbing, flat colors make you feel? How long can you sustain your energy and optimism in these artificially dark, draining atmospheres? A friend was quite upset to the point of wanting to quit her job as a publicist when the furniture manufacturing company she worked for boarded up the windows in their showroom and painted all the walls dark brown.

Taupe is an appallingly depressing color to me. This brownish-gray color's name comes from the Latin *talpa,* meaning mole. Why paint a room the color of a small rodent that digs tunnels in dirt and destroys gardens? Colors should have heavenly associations that lift your spirits, not make you feel trapped under a rock. Never live with a color that dampens your spirit. Far wiser to run to the paint store than to a doctor. Color is the cheapest and easiest form of change in the decoration of houses. There's a reason cheerful, inspiring people live with fresh colors. They recognize instinctively the powerful, emotional feelings colors evoke.

There is naturally plenty of brown in the rooms of your house. You probably have wood floors, paneled doors, and brown-stained furniture. It is easy to be passionate about antique wood, caressing your antique pieces as you wax and polish them. What interior spaces cry out for is clear, unmuted tints of color, to contrast with and highlight the natural beauty of wood and counterbalance the graying down of their freshness because of all the unavoidable shadows.

Go to the heart of a primary color, red, yellow or blue, and tint it up to divine light with white. The beauty of a space stems from architectural correctness combined with a cheerful eye for color. You feel the divine energy within when you are in a yellow room because of the pure white mixed with chrome yellow. You absorb all the vitality from the wavelengths of energy as though the primary color were the sun or fire. Every five years you can repaint to recreate the freshness of your confident vision. Far better to have a pale, fresh tint than a heavy dull color. Age naturally tones colors down, but you should always start out fresh.

Choose only colors that carry positive associations for you. Look through decorating and gardening magazines to explore what colors attract your eye. Study the palettes of Claude Monet, Pierre Bonnard, and Henri Matisse. Remember how colors speak for you and about you. Your personal color palette is your integrity, your voice; it should never be compromised. Let your colors refresh you, uplift you, and caress your inner light. Become a colorist *and* an artist who paints with life-sustaining colors that bring hope, increase faith, and make everyone feel happier. There is a superiority in clear, saturated colors. In art, textile design, and other objects, colors should make your heart leap for joy. If there is no luminosity, no refreshing crispness or childlike clarity, chances are the colors are for someone else.

TINT UP, DON'T TONE DOWN

In creating your own color scheme, the most important step is to make a commitment to cleaning up your color palette, to seek clean, fresh, pure hues. Even one murky color in your palette will throw off the collective harmony of all the other colors. In the decoration of houses, you have to go all the way and tint clear colors with white for a warm, vital palette. It is a mistake to tone or shade them to create a brown, earth-tone palette, because the result will be a house without life force. As you concentrate on saturation and chroma, elements that govern the pure intensity of a color, understanding you can have as light a tint as you wish, you will be infusing your colors with a glow, a feeling of sunlight. When you make a commitment to this fresh approach to colors, the natural, neutral textures and materials you select in furniture and fabrics will contrast with the colors and ground your rooms the way a wood floor does. Wood sings when contrasted with a fresh, pastel tint on a wall.

In determining whether to use a tinted up or shaded or toned down color scheme, always remember how much the light in a room affects color. No color exists in isolation; there are always outside influences. Even the brightest colors are constantly being toned or shaded by lack of light, shadows, and the colors reflected from the floor, furniture, and all other objects in a space. Most of the surfaces in an interior space are

in a shadow; therefore they are toned down simply by the shadows cast by the solid walls. Windows, doors, artificial lighting, and even candle-light distort colors. Your rooms should be decorated for both day and night use. Because you'll be enjoying your home in the evening, you need intensity in light colors. Most house paints unfortunately are toned down with ochres, blues, browns, and blacks. This happens naturally anyway, as day becomes evening, so you shouldn't start with a lot of toned or shaded colors. By mixing pure, unadulterated hues with white, colors maintain their energy and are refreshingly clean at all times of day or night.

TOOLS OF THE COLOR TRADE

*T*here are several tools that will help you in your quest for the right color schemes. I find the Pantone 1000 color system—a color formula guide that demonstrates to the eye the results of mixing pure color with white, black, or gray (tinted, shaded, or toned respectively)—to be the most useful. The system includes tear-out color chips of more than 600 pure hues as well as three tints and three tones per hue. There are more than 4,500 chips altogether in the Pantone book. You can purchase the Pantone 1000 system at paint and art supply stores.

When a friend who designs books picks colors for her work, she takes out the Pantone book and selects a bright hue. She then works with this color, adding white to achieve a fresh, tinted pastel. If you want pale peony-colored lacquered walls in your living room, use ninety-five percent white, five percent red. To ensure an accurate paint color, always provide the paint store with a Pantone chip of the color you desire.

Once you buy your Pantone 1000 color system, go to a housewares store and buy a tiny flashlight, the kind you use in restaurants or theaters to read the menu or program. Always have it handy when you are working with color. Clear your mind of all you see in store windows or what you read in magazines that cater to fashion trends and simply attune yourself to how *you* respond to colors in light. At an art supply store, treat yourself to a dozen or more pencils in any colors you are

attracted to, being careful to examine the color of the pencil, not the color sprayed on the outside of the wood.

Grouped together, the colors should be pleasing to your eye. Don't be self-conscious about your selection. This could be the beginning of a new, better color palette for your home that will increase your ch'i and lighten your heart. Don't concern yourself with where or how you will use these colored pencils. Over the years you may collect hundreds of tints. Keep them in see-through water glasses so you can doodle and have delightful moments of pure color experience. When you play with color, you intuitively reach for those you love. These are the colors you should use in the decoration of your house.

What associations do you make between these colors and nature? Are they aggressive, bright colors or are they receding, cool colors? Match each colored pencil to a Pantone color formula guide and find out what percent they are tinted with white. How many are toned down or shaded with gray and black? If you add black to chroma-intense, aggressive colors—reds, oranges, and yellows—you end up with muddy browns and greenish browns. But if you mix black with receding cool colors—greens, blues, and violets—you add richness and depth.

Adults who have never explored their artistic side are more apt than children to be self-conscious, but the most fun way to improve your sense of color is to play around mixing colors. You will find from such experimentation that sixteen parts of a violet-red color known as Rubine mixed with four parts black makes the lovely shade of merlot wine. Only by experimenting with your own eyes and hands can you truly sense how colors are made and their effect on you.

In my illustrated book about color I made two suggestions to help readers reveal their personal color sense. First, find a box and line it with a piece of white tissue paper. Photograph boxes available at most housewares stores are ideal. Call this box your color palette box, and don't tell anyone what you're putting in it or why. This box is for you to collect objects with pleasing colors—a sheet of stationery, a fabric swatch, a colored pencil, a crayon, a feather, a marble, a piece of wrapping paper, a ribbon, a pastel-colored Jordan almond candy. Always look at your colors in natural daylight against white. When you browse through magazines, tear our pictures with colors that catch your eye and glue them on pure white paper to add to your box or put in a folder or scrapbook.

To find your personal schemes, mix and match the objects in your box, and put color chips next to the photographs you cut out from magazines. You will begin to see a consistency in the colors you are drawn to. You will also notice that the colors you like look harmonious together. You can see yourself in the colors you've selected because they have a history, associations, and meaning. Do you see an idea for the color of your living room walls? Are there some clues to the color-love you'll sprinkle around your house? If you're married, have your spouse do the same exercise and see if you can fuse these two palettes into one masterful composition. Children love to participate in this color game, too.

Once you have selected your colors, play with them in various combinations, to see those you like best together. Think about the colors that will best amplify your room's charm. Keep referring to the work of your favorite artist. When you study Monet's water lily paintings with their blues, greens, and purples, you may have found the ideal color scheme for your bedroom. Do you have a collection of favorite art postcards? If not, start one. An art postcard collection will be an immense source of inspiration, informing you as well as bringing hours of pleasure.

Once you have put together several colors that please you, usually three to five plus white, give the scheme its own title based on why it inspires you or why you're attracted to it. You might choose "Bermuda," "Caribbean," "Provence," "Monet," "van Gogh," or "Matisse." Let your imagination run free. Continuously think of nature's energy and colors for inspiration. "The flower bed" could be a good title for strong pastels—pinks, yellows, pale blue, salmon, and fresh, light greens. "The seaside" could be made up of sky-blue, sandy-coral, seafoam-green, and sunset-pink. "A path through the woods" could be a symphony of greens, while "the fruit and vegetable garden" could be tomato-red, lemon-yellow, pepper-green, and berry brights.

THE COLOR WHEEL

The best way to see at a glance how colors tint up with white from their original full chroma-intensity, and what colors deepen with black, is to buy an artist's color wheel to use along with

the Pantone system. It is used by amateur colorists and professional artists and designers alike and is available at paint and art supply stores. To use this flat, cardboard item, you simply turn the color on the dial to one of the pure colors—red, orange, yellow, green, blue, or violet—on the outside of the dial. In a window you will see what happens when you add one of the three primary colors—red, yellow, or blue—to any other colors, and also what happens when you add white to a color as well as black and gray. There are twenty-four basic colors on the color wheel that represent the entire spectrum. Play with your color wheel so you understand what opportunities there are for you to grow in color knowledge. After mastering the primaries and secondaries, you can move into analogous schemes, made up of tints, tones, or shades at ninety-degree angles on the color wheel.

Before you choose paint colors and become the resident master painter, think of all the opportunities to increase your color-love in the commonplace things you have around your house. Everything man made can be in a color that speaks to you. You can use transparent-blue recycling bags for garbage, for example, if you don't like the dull brown ones. Be fussy about every color you bring into your home because cumulatively these colors will speak your language, no matter how insignificant they may seem individually. Put your color stamp on everything, and continue to search for new opportunities to please your eye and delight your spirit. Make every day a color-discovering day. After function and form, think color.

OPPORTUNITIES FOR COLOR IN THE DECORATION OF YOUR HOUSE AND LIFE

eyeglasses	scissors	sneakers	file folders
pencils	ink	stationery	stamps
clipboard	flashlight	boots	teacups
storage boxes	balloons	toothbrush	rubber bands
transparent tape	wrapping paper	envelopes	marbles
candy	towels	sheets	soap
quilts	clocks	tablecloths	napkins
tiles	plates	pillows	paintings
flowers	trays	paperweights	furniture
rugs	fabrics	countertops	walls
ceilings	floors	doors	hardware

mattresses	glasses	pots	pans
flatware	vases	urns	books
glasses case	sweater	notebooks	buttons
socks	scarves	ribbons	bookmarks
stapler	staples	candles	straws
shirts	ties	bathing suits	beach balls
umbrellas	coats	pyjamas	nightshirts
underwear	slacks	pens	food
wine	lamps	handkerchief	watch straps
tissue paper	hat box		

THE ZEN OF PAINTING

*U*nlike major renovation work, the skill of painting is within the reach of most people. You learn a lot about your house when you paint the rooms yourself. The more you put of yourself in your rooms, the greater the satisfaction, and the greater the karma. Rooms are felt as well as seen. Doing physical labor for your house is good exercise. Getting up on a ladder hundreds of times builds strength and burns calories, and a lot of bending and stretching is involved as well. The only way to have vertical striations from the brushstrokes on the walls is to use a brush. But I concede that rollers are now refined so they don't leave the wall looking as though you were in a pizza joint with rough plaster walls. Being the master painter brings joy and pride as you feel the accomplishment of having transformed the space yourself.

Some people would rather go to prison than spend hours on a ladder. But you may discover that holding a brush to a wall is as comfortable as putting pen to paper or threading a needle. Whether putting sparkling white on the walls, sky-blue on the ceiling, or lilac on the door moldings, you're free to daydream and think about loved ones as you become absorbed in your own world. Even assuming you have no intention of painting all the rooms of your house, you will be better equipped to deal with professional painters' proposals and estimates if the mystique is eliminated from the process.

The handyman in your apartment building or a neighbor or friend may come to your rescue, removing a few molly plugs, spackling the holes, and painting the ceiling a heavenly shade of blue in less than thirty minutes if you provide the paint and are knowledgeable about

what needs to be done. If you don't want to risk falling from a high ladder, you can decide to paint the walls and seek help for the ceilings. As soon as the ceilings are finished you can carry on and paint the walls a dazzling, high-gloss white.

FINDING THE WHITEST WHITE
IN PAINT

*F*inding a truly white paint for your walls is not as easy as it sounds. All white paints have been toned down to make them cover a surface more easily. In order to paint one or two coats instead of a primer and three coats, paint companies have toned down the whites so they will look opaque in one or two coats, disregarding the color. I'll continue my search for the whitest white, and until then I'll use the best I'm legally allowed to use.

Whether the walls of a room are white, a pastel tint, or a strong, saturated color, I usually suggest that all woodwork be painted white—doorframes, window frames, baseboards, chair rails, and cornices. Not only does the white paint reflect the natural light from outside, but by providing contrast, it brightens the other colors in a space, increasing the vitality of the room. Be sure to use high-gloss paint on your wood trim to add sparkle and to mirror your other colors, adding harmony to the space. Select one white paint and use it throughout the house. This will create a unifying connection among your rooms, and you can touch up easily whenever and wherever needed without worrying about matching color. Whether you use white for walls or trim, you can use the same paint.

If you are color shy, and in the past have hidden behind beige, you may want to paint the entire interior of your house white as a first step. Once you achieve this fresh new environment, then decide if any of the rooms should be tinted with a color hue or left white. Delicate pastel tints always look freshest over a clean, brilliant-white surface. In a small space, you may want white walls because they give the illusion of more space. If you have a grand room, you can paint the flat of the wall a rich, saturated color such as hunter green or wine-red and paint all the trim or woodwork white. However, if you want to paint an architecturally

awkward room a rich, deep color, you will probably want the trim color to match the walls. If you have a small room with a high ceiling and a window with a nasty view, the darker the color, the richer the space will appear. White trim would accentuate the ugly view and the bad proportions. Think of white trim as a picture frame on a favorite painting. The finer the architecture, the better the white will look in contrast to the wall color. In a richly colored room, such as a dark, wood-paneled room, white trim would be too startling. Paneled rooms require trims in rich colors.

Generally I like to use medium- or high-gloss paint on walls so that they have a twinkle and bring light into a room. Shiny surfaces smile at you. They're longer lasting and can easily be wiped clean. The darker the color, the greater the need for shine because a flat, dark painted surface absorbs too much light and tends to look chalky and sad. But be aware that high-gloss paint will reveal every imperfection in your walls. Lacquer is the ultimate way to achieve high gloss walls, though it requires more time and can be expensive unless you do the labor yourself. Next to lacquered walls, a smooth surface with high-gloss paint has the most stunning effect.

TESTING PAINT COLOR

The most essential first step when painting your walls and ceilings is to purchase the right paint in the right color. Color on walls reverberates and intensifies. Rather than going from paint chips directly to all four walls, buy a quart of paint and test it on several patches of walls. Also pour some paint into a white cardboard paint bucket, swirl it around, and let it dry. Trust what you see, because this is what you'll get when you paint the four walls of a room. Look at the color in daylight and at night for several days to observe the color in varied weather. If your walls are a color other than white, put white paper on all four sides of your paint sample so you can see it freshly rather than being influenced by the existing hue. Don't be afraid. The worst thing that can happen is that you'll need to add or subtract white to the saturated chroma-intense hue. Making the adjustment is as simple as one additional coat of paint. But you won't make a mistake if

you're patient and go through the process of making large samples on different elevations and observe them carefully.

If you don't want your ceiling to look gray or dirty, don't paint it white. Ceilings are always in shadow. Tint the ceiling with approximately seventy-five percent white and twenty-five percent wall color. If your walls are white, select a pastel tint that recalls a hue in the room scheme. Pastel blue, green, or pink ceilings are appropriate with white walls. Adjust the percentages until you get the color balance that pleases your eye. You will need a second coat of paint for the ceiling, so you can lighten or saturate the color in the final coat. Contrasting the ceiling color with the wall color can add an extra dimension to a room. A pink room can have a pale seafoam-green ceiling. If you paint a ceiling blue in a pink room, the pink will appear violet. A yellow room can have a blue or green ceiling. Make a strong contrast between the wall tone and the floor, otherwise your rooms, and you, may suffer from blandness.

PAINT CONTENT: OIL VERSUS LATEX

*T*here is an ongoing debate over whether oil or latex paint is better. Oil-based paints are considered by experts to be better for semi-gloss and high-gloss finishes because they have more depth, but many experts who have used high-gloss latex believe this is the paint of the future. Latex is being used more often today in all finishes because it's easier to apply, dries more quickly, is just as durable as oil, doesn't have the odor of oil paint, and is a fraction of the expense. Latex walls are also washable, and they do not discolor, whereas oil-based paints yellow over time.

Lead-based oil paints are no longer manufactured, but oils do contain certain volatile chemicals that are unlawful in certain states; therefore latex paints are safer environmentally. I've switched to latex paints because I find they perform better now that oil paints have been altered for safer use. Pay what it costs to get good paint in fresh colors. If you can't find a paint in the Pantone color you want, it may be worthwhile to pay a little more to have it custom mixed.

THE PAINTING PROCESS

*N*inety-five percent of a good paint job is preparation, so if you do take on a painting project, be professional. Protect your floors, remove all hooks, spackle, and sand. First remove all the loose paint. If you see a crack, chances are there is damaged plaster underneath. If there has been water damage from above, you may have to chip away at one large area until you're down to the brown coat of plaster. After plastering the hole caused by the water leakage, apply tape, spackle, sand the surface smooth, and keep adding spackle and sanding until the wall is smooth and even. Use your fingers to fill spaces and cracks with spackle. If you see a hairline crack, try to open it up with a putty knife and remove whatever plaster is loose.

When preparing a room where there are loose areas, once you open them up, you may discover loose canvas under several layers of paint. Open it all up, remove the strips of canvas, and spackle and sand the entire area until it is smooth. The flat end of a three- to four-inch putty knife will smooth the differences between the canvased wall and where you removed the canvas. Keep adding spackle and then smooth the wall with sandpaper until you are satisfied.

Pay attention to the grade of sandpaper you use. The rougher the wall, the coarser the sandpaper you will need. Conversely, the smoother the wall, the finer the sandpaper. Use 450-watt lighting to be sure the walls are smooth before you begin to paint, or you'll have to start over. Be sure to wear safety goggles so you don't get paint and plaster specks in your eyes. Also, buy disposable masks by the dozen, using a clean one every day so you aren't breathing in yesterday's plaster dust. Always paint with the windows open for ventilation. When painting a closet, keep a fan on so that the air circulates. After painting, continue to have fresh air flow through the spaces for several days until you can no longer smell the paint. Paint stores have all the equipment you need to go further than simply applying pretty colors to your walls. They have magazines, books, and videos to aid you in your color-love. Bring your spouse and children. It's easy to glaze walls, put clouds on ceilings, and stencil a cornice. Anyone can become a fine artist in the home.

If you have never done any faux finishing, you will discover how easy and fun it is to do it yourself. Hiring an artist is expensive. There are special rags, sponges, and combs you can buy to create strié walls, and all

kinds of glazes, including crackled glazes, color washes, and marbleizing kits you can experiment with. Go to the paint store, explore, and ask lots of questions. You'll soon be on your way to becoming a professional.

DARE TO BE PLAYFUL

Continue to explore your artistic self through color in your home. The gift of the artist-poet Carl Larsson is to arouse in us a hearty charm, a longing for the unprepossessing lifestyle where the elements of your rooms, namely the colors, speak of a love of life, home, family, and objects fine-woven by our human heart.

You can sense Larsson's ecstatic energy when you study his watercolors and read his writings. In many ways he is a greater teacher than Edith Wharton because he made do with little money, and was able to fling charm in all directions through his genius use of color. Edith Wharton never had children and her entertaining was more formal than most lifestyles can afford, or desire, today. She knew about the decoration of houses, but Carl Larsson understood the pure joy of the culture of the home.

Writer Hans-Curt Koster tells us of Larsson's timeless motto: "Love, children, people, nature, all things." He was an ingenious interior designer, raising the creation of a home to an art, and his "House in the Sun," now a museum in Sweden, was his sanctuary. His lifework was centered around his family, and through his use of color and texture he teaches us today, a hundred years later, to loosen up: to paint a bed—a flea-market find—orange, to have bold horizontal orange-, red-, and white-striped bed hangings, to paint a door in wide vertical stripes of yellow, to leave the beds unmade in favor of playing on the white-painted floor with several of his seven children.

Use color to transform your rooms so that they abound with vibrancy and light. When you live in a cheerful, bright house, you will be living with greater joy and energy than you could ever imagine. Paint the ceiling of a pink room green. Do what Claude Monet did and paint the kitchen door lilac. It makes his blue kitchen seem to be bathed in a never-ending sunset. Elsie de Wolfe painted the posts of her clothesline in green-and-white stripes to remind her of the posts at the

Gritti Palace on the Grand Canal in Venice. Let your imagination liberate you so you feel illuminated by the mystery and magic, the power and the glory of living color.

COLOR COMBINATIONS FOR YOUR ROOMS

*T*here are an infinite number of ways to combine colors in fresh, unusual schemes. I will give several specific examples that you may want to consider, or perhaps they will simply help you get started playing with color combinations. Certain combinations may shock you into thinking more creatively, freeing you from conventional rules about color that limit your self-expression.

Notice the variety of moods these color combinations evoke. Once you learn what happens to colors when you combine them, you should liberate yourself to create color schemes that speak of and to your spirit. Once I set forth several examples of room color schemes, I will list color combinations for you to incorporate into your space in your own way, as only you know what works for your space.

Favorite Living Room Color Schemes

- **pale blue walls with white trim**
 soft-blue tint of wall color for the ceiling
 blue, red, yellow, and white fabrics and rugs
 fruitwood-colored wood floor
 fruitwood furniture

- **pale pink walls with white trim**
 pale green ceiling
 green, yellow, fuchsia, and pink fabrics and rugs
 fruitwood-colored wood floor
 fruitwood furniture

- **pale apricot walls with white trim**
 pale green ceiling
 apricot, green, yellow, purple, and pink fabrics and rugs
 fruitwood-colored wood floor
 fruitwood furniture

- **white walls with very pale blue trim**
 pale blue ceiling
 blue, white, and pink fabrics and rugs
 fruitwood-colored wood floor
 natural wicker, rattan, and pine furniture

- **pale green walls with white trim**
 very pale green ceiling
 green, yellow, pink, and white fabrics and rugs
 bleached wood floor
 natural wicker, rattan, and pine furniture

Favorite Bedroom Color Schemes

- **white walls and doors with white trim and lilac striping on door moldings**
 pale blue ceiling
 yellow, orange, purple, green, and violet fabrics and rugs
 bleached wood floor
 white wicker and rattan furniture

- **pink walls and doors with white trim and pink striping on door moldings**
 pale pink ceiling
 pink and white fabrics and rugs
 bleached wood floor
 oak furniture

■ **white walls and doors with hunter green trim and green striping on door moldings**
pale green ceiling
white, red, and hunter green fabrics and rugs
bleached wood floor
oak, pine, and rattan furniture

■ **pale lilac walls and doors with white trim and white striping on door moldings**
very pale lilac ceiling
lilac, white, and pink fabrics and rugs
bleached wood floor
white wicker and rattan furniture

■ **pale blue walls and doors with white trim and white striping on door moldings**
very pale blue ceiling
blue and white fabrics and rugs
bleached wood floor
white and Chinese lacquer red furniture

Color Palettes to Nurture Creativity

■ **white**
blue
green
yellow
fuchsia

■ **white**
blue
black
red

■ **white**
blue
green
red
black

■ **white**
cool blues
a touch of yellow

■ **white**
green
blue-green
purple-pink

■ **white**
chartreuse
cool blue
fuchsia

■ **white**
green
pink
yellow

■ **white**
blue
black
yellow

- white
 violet-pink
 greenish blue
 yellow
 hot pink

- white
 dark purple
 seafoam green
 geranium red

- white
 orange
 fuchsia
 reflex-blue
 bluish green

- white
 pale blue
 blue-green
 yellow-green
 cantaloupe

- white
 bottle-green
 red
 yellow

Now that you can visualize rooms with certain color schemes and sense the mood of each—romantic, soft, sweet, soothing, striking—you can look at colors in a more daring way and combine them to create a harmony that suits your spirit. Remember that colors convey light, medium, and dark values. For substantial impact, use a chromatically intense, saturated color for a coffee table, flower vase, or pillows. Begin every scheme with white because white is light and energy, and will illuminate all of the hues in your scheme. If your scheme doesn't include yellow, remember Mrs. Brown's dictum: Every room needs a touch of yellow. Yellow brings out the flavor of a room just as salt does in food. Also keep in mind, as discussed, that there is ample natural, life-enforcing brown in a room with wood floors, furniture, baskets, boxes, and the red-brown of terra-cotta pots, so you should avoid incorporating any artificial brown hues into your schemes.

"These are a few of my favorite things."

My book My Favorite Things *is concerned with the senses that go into the making of a home: the pleasures of textures to feel, sounds to hear, foods to taste, everything to see. And it is about that other sense too—sensitivity to others, to their needs and their comforts, the sense that brings the house alive.*

—DOROTHY RODGERS

Furniture

A decorator should . . . be blessed with a sixth sense—a kind of artistic alchemy which endows the articles of furniture with that elusive quality of livableness which transforms houses into homes.

—ROSE CUMMING

APPROACHING FURNITURE

You will continue to create delightful illusions in your home for the rest of your life, improving the way the background of your rooms looks and feels. You will also bring in more light and fresh colors. Now it is time to equip your rooms with "a few of your favorite things." The furniture you place in your spaces reveals your taste, style, and psychological as well as physical needs. Every piece should hold special meaning, and over time grow to be your friend.

Your priorities should be to select inviting, comfortable pieces that are functional for your lifestyle while also being aesthetically pleasing. Your needs will change as you go through your life chapters. Assess your current circumstances. You might discover you're in a position to begin building a furniture collection of beautifully made, finely proportioned classical pieces.

The biggest change in these past one hundred years since the first *Decoration of Houses* was published is the unrealistic expectation of being able instantaneously to set up a background for your home life. A century ago clients with money and taste hired decorators to set up their rooms attractively so they could best display their collection of fine old possessions. There was no need to rush because there was no place to

go. These families had "arrived," and their houses had an ease, a lack of pretension, and a softness that is missing in houses decorated too quickly.

Walking into a room that is tasteful but that has no soul, no energy, is as disappointing as spending time with a physically beautiful person who has no personality or interests. The furniture you select and place in your rooms should speak of your personal style of living and joy in life. Having a house full of impersonal furniture would feel as though you were a stranger in your own home.

Carl and Karin Larsson put their charming rooms together with inexpensive flea market finds that they painted bright colors, as well as with furniture they commissioned from local cabinetmakers. Each piece of furniture should have a story to tell. What is the provenance behind all your furniture? Do you own some old furniture? Do you live with some antiques? Where did you find each piece? When you found a bargain at a country fair, what did you do to make it yours?

So much of the integrity of a home can be found in the furniture that inhabits it, and in the history each piece imparts to the whole. The unity, sense of completeness and soundness of a house will always be more than what meets the eye or is realized through the senses.

CHOOSING APPROPRIATE FURNITURE

*B*eauty soothes you more than a La-Z-Boy chair. If you're comfortable in your own essence, you can sit in a wooden side chair and feel wonderful.

The furniture decisions you make are significant. View your furniture as building blocks, as individual pieces that make up a whole. Each piece must have integrity, be able to hold its own individually, please the eye, and serve your physical and spiritual needs. But where should you start the process of acquiring an appropriate collection of furniture for your house? First, assess your needs. What do you do in your house that requires furniture? Start with the basics—sleeping and eating. Bathing can also be included, though buying a new bathtub or installing a new shower is a priority for few people. Bathroom fixtures will be discussed in a later chapter.

Every dwelling needs a proper place for you to sleep. Furniture for sleeping includes everything from the standard mattress and boxspring beds to their many variations, including daybeds, futons, sofa beds, bunk beds, inflatable mattresses, and more. Their comfort is determined both physically as well as metaphysically. Whether you have an antique sleigh bed, a rustic iron bed that looks as though it came from the garden, a wooden-frame bed, or simply a mattress and boxspring on the floor, it is easier to be clear-headed about a bed than most other furniture because you have to sleep in it. It must feel right to you. The bed you select is an inner-directed decision, though you may want to dress it up with a headboard and hangings to make it more visually attractive.

Next in importance to finding the right bed is buying a table and chairs so you have a proper place to eat meals. If you cannot afford a dining table, a card table and a few folding chairs is an ideal temporary solution. When you are ready to buy a permanent dining table, don't rush the process. It is important that the table where you break bread with loved ones speaks to and for you, whether it is an antique, a contemporary piece, or an antique reproduction.

Just as your true colors all tend to go together harmoniously, your furniture should also tell a story. Whenever you become attached to something, it becomes alive. You have to care about each piece of furniture, so it is serving you rather than creating still lifes in the rooms of your house. What would an archeologist learn about you if all your possessions were discovered a thousand years from now?

When exploring your furniture options, always keep in mind that decorating parallels the art of living. It should be a loving process that evolves over time. To fill a space in a hurry so you can get on with life is as shortsighted as feeling you can be properly nourished eating fast food on plastic plates. It is best, however, to purchase matching upholstered furniture pieces at the same time, otherwise you run the risk of your fabric being discontinued. You can buy extra fabric in anticipation of future pieces, but you will probably want to recover all pieces simultaneously so they age in unison. A chair with slightly faded upholstery will look ancient next a chair of the same pattern with a brand-new fabric.

Constantly remind yourself of what you literally need in your house in terms of furniture. You *need* beds, chairs, and tables. Sofas, love seats, and ottomans are optional and should never be purchased to fill a space,

but should be considered when the time is right to add comfortable seating. A common problem in houses is not the lack of furniture, but the overaccumulation of furniture. Many people have rooms that need to go on a diet in order for the ch'i to flow more freely.

LIVING WITH ANTIQUES

When building your furniture collection, you will want to pay special attention to acquiring at least some antique pieces. Not only do these old pieces tend to be beautiful in their artistry, they have soul that turns inanimate objects into living artistic expressions of life's value. Furniture from a quieter, gentler era balances out the high-speed machines of today. If you have a passion for antiques, try to add one new piece to your collection each year. Rooms breathe with energy and truth if you give them "gifts" of old furniture.

Why do antiques bring so much emotional comfort? What is it about an old piece of furniture that energizes a space? The answers to these questions all stem from the rare beauty and craftsmanship that have been treasured by generations. Antiques take you back to an earlier age, a time of handmade artistry long before the dawn of the information age. When an artist puts his heart, hands, and soul into his work, the object is infused with his spirit. Over the years, this piece of furniture has

Windsor chair

been rubbed, polished, mended and tended, sewn and restored. Antiques are more than mere possessions scattered around the house; they are indeed your friends, physically and viscerally adored. As you move these lovable objects from place to place, room to room, or house to house, they bring warmth and continuity wherever you live. They share your life with you.

Antiques connect you to the past, reminding you of men and women who lived by the natural rhythms of

Chippendale corner chair

Queen Anne lowboy

the day, waking at sunrise and going to bed at sunset, at a time when people took pride in their workmanship. Patience was a necessity in order to accomplish the degree of refinement expected in handmade objects. Antiques also tie you indelibly to your own past. As a child, you may have eaten informal meals sitting in old Windsor chairs at an antique farm table in the kitchen. The dining room of your parents' house might have been formal, with Chippendale chairs around a double-pedestal table, or it might have had an old French fruitwood farm table surrounded by ladderback chairs. Perhaps one of the reasons people are drawn to these creations is that they evoke a period in history when life seemed more serene and optimistic, and less complex and cacophonous.

Chippendale bonnet top with urn highboy

I have vivid memories of my mother and godmother cutting up antiques magazines and mounting pictures of antique furniture on shirt boards, labeling the dates and cabinetmakers, and writing descriptions of the finer qualities of a Philadelphia Chippendale highboy or Newport lowboy. They discussed cabriole legs and claw and ball feet, and spoke of cabinetmakers with reverence and respect. They swooned over Chippendale, Hepplewhite, Sheraton, and the Adam brothers' work. I appreciate more and more the blessings of growing up in well-ordered, attractive, resurrected houses furnished by connoisseurs of fine antique furniture. The integrity of old and beautifully designed and built furniture will invariably enhance any space.

Chippendale chest of drawers with claw and ball foot

If you don't fully trust your eye, it is well worth the commission price to hire a professional interior designer to help you buy antiques. Even competent decorators sometimes hire individuals with great

Chippendale pie-crust tripod table

Newport shell block, Goddard-foot chest of drawers

Bow-front Hepplewhite chest of drawers

Hepplewhite
tall chest of
drawers

Sheraton drop-leaf table with
vertical X stretcher

Adam console
table

Sheraton side chair

Hepplewhite side
chair

Adam wheel-
back side cha

taste and knowledge to help them buy antiques in France, Italy, and Spain. The founder of Parsons School of Design, William Odom, helped many decorators, including Eleanor McMillen Brown, in the selection of the antiques displayed in their showrooms.

Edith Wharton preferred the richness and artistry of European designs to the more practical, simple styles of American antiques, but I believe some of the most beautiful antiques ever made are American. Eighteenth-century American and European antiques should serve as the benchmark of quality for antiques in the decoration of houses. Just as no human being feels the same pride about his work on an assembly line as he does when he creates with his bare hands, no machine-made furniture has the beauty and depth of an old chest of drawers with the initials of the cabinetmaker carved on its bottom. Machinery can do amazing things, but turning a table leg on a lathe is not as satisfying as taking a piece of wood and carving a concave and convex design on a graceful curve created with simple tools, patience, and pride.

French Directoire table

When you take the time to explore antique shops, you will stumble upon pieces that were simply "meant" to be yours. When hunting for antiques in Santa Fe, you may find a sturdy Mexican side chair that speaks to you and that you want for your bedroom. The pine high-back love seat in your garden may actually have been a church pew. Listen to your heart when buying antiques. Never buy antiques for investment or resale because the home is not the best place for commerce. Beautiful old pieces that speak to your heart should be lived with until death and then passed on to future generations.

A client confessed she often bought pieces that were a bargain. But when she moved into a smaller house and needed to sell some of her furniture, she discovered that the pieces she bought because they were good deals were the most difficult to sell. Nobody wanted them. Antiques need to be loved to have soul, and this adoration can be felt. Anything you find, fix up, live with, and love will increase the ch'i in your rooms and your connection to your space.

Mrs. Brown's Venetian red-lacquered secretary

Everyone should have at least one treasured piece of furniture. Eleanor McMillen Brown had a Venetian red-lacquered secretary she

FURNITURE

French Provincial dressing table

French farm table

Apothecary chest

felt was "meant" to be hers. This is how I feel about my French Regency carved fruitwood marble-top table. There are also pieces that I inherited that hold great symbolism for me. The French provincial dressing table my mother left me brings me back to my childhood when she would braid my hair, and now when I sit there I feel her presence. I keep her silver powder compact as well as some of the same framed pictures she had on the table to further keep memories alive. Living with an antique that was loved by someone you love keeps their spirit alive in you on a daily basis.

Mass-market furniture has its place, and when it is beautifully designed and graceful in line and proportion, you can embrace it as an alternative to living with the original old pieces from the past. But you should always seek the presence of antiques in your house, even if only in the form of a footstool. You can become wildly enthusiastic about the old apothecary chest with dozens of square drawers that you may have at the top of the stairs in your house. The fruitwood French farm table you use in your study as a desk is a priceless treasure because of its value to your happiness. Sitting at this desk, caressing the surface, rubbing your fingers across it with the tenderness of a lover's touch, you feel a subtle connection to the eternal energy of its soul.

AFFORDING ANTIQUES

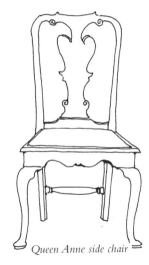

*T*he euphoria resulting from living with antiques is in everyone's reach. You may only buy one or two antique pieces in your life-time, but the investment is well worth it. I bought my first antique at an auction when I was sixteen and have built my collection over forty years.

Not all antiques cost an exorbitant amount. If you are the industri-ous type, you can find antiques in poor condition and restore them to their past glory for relatively little money. No matter how dreadful the condition of a piece, you can "love it up" and expose its beauty anew. Purists and dealers don't like to buy pieces that have had a lot of repairs, but for your home, they're fine. They will have more value than a new reproduction and a lot more ch'i. You only need to be willing to hunt,

Queen Anne side chair

unrushed, enjoying the process, to begin to discover hidden treasures, one after another.

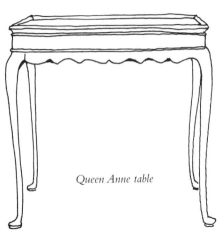

Queen Anne table

You can make a hobby of finding diamonds in the rough, authentic antiques hidden under layers of abuse and neglect, and reveal their beauty and integrity. Be willing to strip, sand, mend, glue, and refinish anything that sparks your interest and passion. You will be able to find rare, beautiful items that others over-looked simply due to their less than

Shaker rocker

perfect condition. You can acquire a striking collection of authentic, soulful bits and pieces of inventory that are the building blocks of the mood of the home.

There are courses to take and good books to read on furniture restoration. The most important thing to remember is that if you're willing to get your hands dirty, you can perform miraculous transfor-mations. Let furniture speak to you. Open up to the life breath of the wood buried underneath its dirty, dark finish. Be excited to reveal the charming, soft wood. When you commit time, energy, and money to gathering antiques for your house, you will be benefiting future gener-ations as you spend golden years appreciating their quiet grace and beauty. Antiques are truly priceless.

Shaker side chair

FURNITURE FOR SLEEPING

*I*f you are starting from scratch in the decoration of your house, the first piece of furniture you buy is usually the bed. More than tables, chairs, or a sofa, you need a bed.

The bedroom is any space where you choose to have a bed. Turn your bed into your personal haven. Beds are a sacred place because this is the one spot where we come for regular rest, relaxation, and recovery. A client with great taste told me years ago, "My bed is the most important piece of furniture to me. I always want to feel as though I'm a beautiful, ageless, timeless princess in my bed." What style beds do you like? What would be ideal in your room? How do you feel about the bed you now have? If you don't have a lot of money to spend on a bed, the least expensive way to approach this important purchase is to buy a metal Harvard frame on casters. Its only function is to hold a mattress and box spring. This way you can take your time finding a bed you're attracted to, or you can buy a decorative headboard and screw it into the Harvard frame. An inexpensive dust ruffle or flounce will hide the frame.

Harvard frame

THE MATTRESS

*W*hen purchasing your bed, always keep in mind that a good mattress is more important than a headboard. It may make sense to delay purchasing a headboard until you have acquired more practical pieces of furniture for your home. Because regular sleep is so important to our overall health, and we all have different bedtime comfort specifications, it pays to invest time and money to have a good mattress. If you suffer from back pain, arthritis, or sleeplessness, your mattress should be therapeutic. Though mattresses are hidden under layers of bedding, their impact is immeasurable. One night on a too soft or wobbly mattress can put you in agonizing pain for weeks. Everyone's back reacts differently to a mattress. This calls for some careful experimentation. You may prefer a soft mattress while your mate requires an extra firm one. One back can't be sacrificed for another's comfort, so in this case, I recommend putting separate twin beds together to become a

king-size unit. For many, a night on an old, worn-out mattress is a sleepless one.

People are in such a rush they order mattresses over the telephone. But there are so many factors to consider that you can't rely on a fast-talking "professional" who doesn't know what goes into making a good mattress to sell you one. I insist that my clients take ample time to lie down on several in a showroom before deciding on a particular design. One couple were so comfortable on the extra firm mattress in a custom bedding company showroom, they fell asleep.

I prefer a very firm mattress of a standard seven-inch thickness. Manufacturers have made mattresses deeper, up to thirteen inches, but I feel that more than seven inches is superfluous. Even though many people believe that bigger is better for beds and thicker is better for mattresses, the most important consideration when purchasing a mattress and frame is your physical size, weight, and comfort. I prefer queen size to king size because of the proportions, but I recommend king to people who are larger. The key consideration is who will be using the bed and the secondary concern is how the bed will look in a room. King-size proportions in four-poster beds are too cumbersome, too square. If your size warrants a large bed, far better to give up the notion of a canopy and be comfortable.

Once you have bought your mattress, remember to periodically turn it over to maximize its life span and support, especially if you sleep with someone who weighs more or less than you. If you or the one you sleep with is much heavier, turn it over more frequently. I recommend turning the mattress once a month. Flip it from left to right one month, and from top to bottom the next. After you strip the bed, always let the mattress air in a ventilated room. Also make sure you clean the quilted blanket protector at least once a month.

A company that makes quality custom mattresses, Charles H. Beckley, Inc., was founded in the twenties, and the standard height of their mattresses today is identical to the height of those they made seventy years ago. The president, Ted Marschke, believes, "The old way is the better way." These days they receive few calls for solid horsehair mattresses; most of what they sell are hand-coiled five-and-one-half-inch innerspring mattresses with cotton felt laid over the coils and horsehair placed on top of the felt. Every inch is hand stitched to maintain the same fine quality of handcraftsmanship they began with seventy

years ago. A handmade quality mattress lasts ten to twenty-five years depending on many individual factors, including perspiration that eventually seeps into the mattress.

Today mass-produced mattresses are made thicker and thicker because the consumer has been brainwashed into thinking this is a better look and provides more comfort. In reality, the consumer may be getting a lower-quality mattress with inferior materials. Even if a coil count is 360, as Beckley's are for a fifty-four-inch full bed mattress, the effectiveness depends on the quality of coil used. A too-thick mattress also weighs a ton, deterring people from turning it regularly to increase its life span. They'd rather let it wear out and buy a new one in five years. And if you have an antique bed or a classical replication of an earlier style, a too-thick mattress will damage the shape.

I feel strongly you should have a finely made mattress over a proper boxspring. Between the individual coils of the mattress and those in the boxspring, you have a balance between support and give so you, and your back, will feel refreshed after a night's sleep. If you do have a mattress custom made, be sure to select a ticking that pleases you, because you'll see it regularly. Paying attention to details such as this maximizes your pleasure and comfort.

HEADBOARDS

*A*n attractive headboard can add considerable charm to a bedroom. A sturdy headboard is important if you like to read in bed. While doctors don't recommend sitting up in bed for patients who have bad backs, with a firm mattress, back support from a headboard, and your feet elevated, you can enjoy hours of pleasure and comfort each day reading, writing letters, or making phone calls in bed.

Wood headboard

When I started decorating houses in 1961, bedding was hidden under heavy, cumbersome quilted bedspreads and pillows lay flat under shams so the headboard was prominent. Now, often French square pillows are placed flat against the headboard with several smaller pillows in front of them, highlighting the pillow cases and shams rather than the headboard. If you invest in a wood, iron, or upholstered

headboard and want it to be a focal point in your bedroom, be sure it is tall enough so that it won't be hidden from view by pillows. The thick mattresses common today make the surface of the bed so high that the headboard's traditional height of forty-five inches is now too low.

Custom-made upholstered headboards are especially expensive because of the materials and labor, so it would be a waste of money simply to have it as a backdrop for layers of pillows. If there is a shape to the headboard in the form of an arch so that there is a peak in the middle, the center portion will be fully exposed. If you choose an upholstered headboard, be aware that oil from hair can discolor the cotton or silk fabric, so you may want to have one French square back pillow to protect the fabric when you're reading in bed. To be safe, select a style of headboard that can be slipcovered.

Headboards can be designed to your individual specifications. I designed a simple, white, lacquered headboard years ago for a client that I continue to use with success in single, double, and queen-size beds. It is a basic, four-inch-thick half circle rounded from the front to the back so there is a huge bullnosed edge. The look is clean, crisp, and charming. You can spray it in a variety of different lacquer colors as well as make it in exotic woods, including a beautiful elm burl.

If you have a chronic illness or for some other reason are confined to a bed with an electrical device that elevates your back and feet, you can still have an attractive-looking headboard and a pretty bed flounce. Don't accept the brown plastic hospital-issue head- and footboards, because they will inevitably depress your spirit. If you have an ugly headboard now, either remove it or make it more attractive by refinishing, painting, reupholstering, or slipcovering it.

Because you never know where your bed will

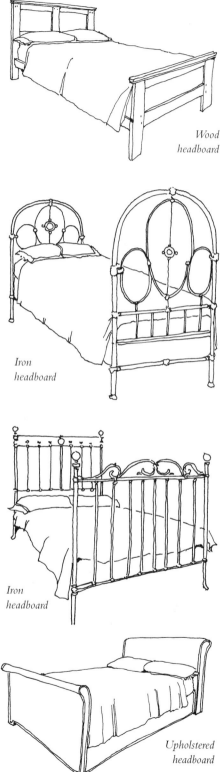

Wood headboard

Iron headboard

Iron headboard

Upholstered headboard

eventually be placed, examine the back of the headboard before you buy one. Most mass-market manufacturers assume that the headboard will always be placed against a solid wall so they don't bother finishing the back. What's especially irritating is when you can see the hideous black numbers stamped on it as though it were prison-issue. Such corner-cutting laziness and lack of respect for the intelligence and aesthetic sensibility of the consumer is insulting. Even if the bed were against the wall, the hidden part should also be attractive. Examine and feel all sides of any piece of furniture you buy, especially a bed.

THE "UNMADE BED LOOK"

I'm an advocate of the "unmade bed look." This is not to say you should keep your bed literally unmade, but exposed, visible bedding is more inviting than a substantial bedspread that hides the sheets, blanket covers, and pillows. Not only is this more practical when it's time to go to bed, but pretty sheets are beckoning and sensuous, especially when complemented by an abundance of pillows. How the bed looks may indicate the happiness of the occupants.

Four-poster bed

FOUR-POSTER BEDS

*A*n antique four-poster bed has a quiet charm and can make you feel as elegant as a princess. A ten-year-old living in a city apartment feels warm and cozy in her canopied bed, the one private place where she can go to be alone.

Antique four-poster beds, however, are not only hard to find and extremely expensive, they are often not strong enough to support the weight of an adult. Consider purchasing an unfinished pine four-poster bed and distressing the wood to give it the look of an antique. There is a wide range of designs to select from at reasonable prices.

Bed Hangings for
Four-Poster Beds

*P*ermanent fabric bed hangings that cannot be cleaned without the custom workroom taking them apart, cleaning them, and putting them back up are a big, costly ordeal. Cotton looks best washed, not dry cleaned, but once cotton is lined and interlined, you have no choice but to use chemicals instead of soap and water. With the help of

Four-poster bed hangings, no flounce

Four-poster bed hangings with back-hanging and flounce

a talented cabinetmaker, I designed a four-poster bed of Canadian maple with chamfered (grooved) bedposts (similar in design to fluted columns) and detailing. On top of the removable bedposts, I designed four fat round ball finials. This allows the client to stand on the mattress, remove the four finials, lift up a canopy board, and shirr (gather cloth) a bed hanging onto the board. The heading of a sheet works brilliantly because it can be shirred onto the board directly with no sewing involved, and the bed hangings can be changed as easily as the sheets on the mattress. The handsome, solid four-poster bed looks elegant when not draped, and can have any kind of bed hanging desired. This way you can remain open and flexible, using a variety of different fabrics, textures, and weaves.

This four-poster bed has striking height, and looks suitable in both large and small bedrooms. If you have a small bedroom, one option is to have a large, bold bed and very little else. A bachelor in Texas selected for his twelve-foot-square bedroom a giant Mimi London tree trunk design bed in white oak, and the only other furniture in the entire room was two tree trunk end tables. By putting a television on a support extending from the ceiling he didn't have to close in the space with a standing chest or table. Because he had a separate dressing room, his bedroom didn't need any storage space. The bed became the dramatic focal point floating in the center of the space with a white wooden paddle fan above.

DAYBEDS, SOFA BEDS, BUNK BEDS, AND BEYOND

Iron campaign bed

For a small apartment or bedroom, consider a daybed. Using a daybed as a sofa by day and a bed at night saves space and money, and is especially practical in studio apartments. A young journalist bought an eighteenth-century French iron campaign bed for her one-room apartment. The ornamental ironwork provides textural interest and a French ambiance, and she is able to pull up a table, add some folding chairs, and have a dinner party, using the daybed to seat two friends. A few hours later, she can move the table back against the wall, toss the back pillows on a chair, remove the quilt and crawl into a heavenly bed, cozy and content.

Any twin-size bed can easily be transformed into a daybed. Consider buying two iron headboards and creating your own daybed. Another space-saving bed idea is a trundle that rolls out on casters from beneath a daybed, creating an extra mattress for a guest in any location. In Edith Wharton's era, guests didn't sleep in the living room. Today, however, this is a common practice due to space limitation. I suggest, when possible, to avoid the temptation to purchase a sofa that converts into a bed. I find these contraptions more of a nuisance than a convenience. You usually have to move furniture to make room for the bed, disrupting your space, and they're apt to be less comfortable than other options.

You may hear people argue that it is only polite to have a guest bed where a couple can sleep together. I find this attitude overly sentimental and impractical; the lack of privacy you experience sleeping on a sofa bed in a friend's living room would seem to chill any possibility of romance. Far better to have two daybeds, even if they're adjacent to one another, so the room can remain orderly.

Instead of placing a sofa bed in your living room, consider a sofa that has a tufted mattress as the cushion. This model, called St. Thomas, has loose bolster and back pillows, freeing up the space for sleeping at night. By upholstering the mattress it is disguised. You make the bed over the upholstery. If it is to be used regularly you can slipcover the mattress so the bedding is hidden underneath. Another option is a daybed that doubles as a sofa. If you need to provide shelter for a friend in need, a futon, preferably on a wooden frame, works well. Today stores also sell inflatable mattresses that come with electric pumps for easy setup. The main appeal of these mattresses is that they take up very little space when they're not in use.

Sofa bed

Children love the adventure of sleepovers and don't need a "proper" bed when they visit for a night or two. There are trundles and bunk beds with ladders as head- and footboards that are ideal for children. Any room in the house can be used for sleeping, with the exception of the kitchen and bathroom, of course (though if you've ever been in a hotel room where there wasn't enough light to read by, and ended up in the bathtub with pillows and a towel over you as a blanket, anything is possible). Mattress companies are quick to disagree, but the floor gives good back support. A two-and-one-half- to three-inch foam exercise mat that rolls up is a perfectly decent "bed" for a grandchild or a healthy teenager who comes for the night.

If someone is terminally ill, place the bed in the prettiest room with the best view. A client who was dying from cancer decided to live out the rest of his days at home. The sun room was transformed into his bedroom where he could look at cows, horses, trees, flowers, and a brook. His prognosis was death within a few weeks and he actually lived four and a half months. A client waiting to have a heart transplant wanted his bed in the living room so he could listen to wonderful

Bunk beds

music and see his children at play in the garden he planted and loved. When an attractive bed is deliberately placed in an unusual space for a logical reason, it takes on a spiritual beauty that is touching.

PLACING YOUR BED

The right location for your bed cannot be determined by an architect or interior designer. Many people will say the proper position for the bed is with its headboard centered against the longer wall of a room, but the only right answer is what feels best to you when you're in bed. A bachelor's bed stood opposite the two bedroom windows, across from an apartment building where he knew several families whose bedroom windows overlooked his apartment. On a floor plan it would look as though it were the perfect spot because it was symmetrically placed centered on the wall opposite two windows. In reality, however, it was quite dreadful. The first thing I did when hired to renovate and decorate his apartment was to help him relocate the bed. The repositioning of the bed to a corner hidden from neighbors gave him privacy, in addition to allowing him a better, more open view, ideal for feng shui.

Place your beds for privacy and view. You don't want anybody to be able to peek in at you, nor do you want someone to be able to barge in on you. Feng shui practitioners believe the bed should never be too close to the door. By placing the bed in an apartment as close to the window wall as possible, allowing enough space for a window ledge and end table, you can free up the rest of the room to use for sitting. By simply relocating the bed, you can magnify the usefulness of the space.

OTHER BEDROOM FURNITURE

A person's bedroom is the most important room in the house because it's a world unto itself, a private haven, a sanctuary from the hustle of everyday life. Once the bed size, design, and location are set, you're free to use the room in any way you wish. In order to

fully enjoy the space, carefully thought out additional furniture is a must. Even if you have a separate dining room and living room in your house, if you love to spend time in your bedroom and have space for more than a bed and end tables, expand your possibilities for this room by adding additional pieces of furniture that are both aesthetically pleasing and functional for your needs.

In our New York bedroom, "the garden," as we now call it, because of its pastel colors, fresh white walls, and abundance of flowers and plants, has a seating area big enough for six to eight people. There's a love seat against a wall underneath a large oil painting. On either side of the love seat are antique wicker chairs, a side chair, and an ottoman. Two Chinese lacquered low tables are stacked on top of each other. The room is light, airy, and sensuous. When we had a wedding shower for a daughter's friend, twenty-four guests came into this room for the opening of presents and toasts, using folding chairs and the bed for additional seating. Everyone loves this room so much, we even bring friends in for afternoon tea or after-dinner coffee. When we gave a bridal dinner party for our niece, we set up two card tables for the eight guests who were in the wedding—a party within a party. By freeing up floor space

Night table

in a bedroom by locating the bed in a place that is deliberately off center, you expand your options for use of the room, including exercise.

If you are a writer and write longhand or enjoy correspondence, a "social desk" in the bedroom is a blessing. But if you use a computer, I suggest you find another room if you have one. The bedroom should have the same aesthetic refinement as the living room, whether you use it for yourself or share it with others. Music, candles, a chair where you can meditate and read, are essential in the bedroom. End tables with ample surface space, perhaps with a tier to store books, are a necessity. Even a small dressing table is nice for a woman to have in a bedroom because

Small dressing table

Chaise longue

it provides her with a moment to pause, reflect, and do something to pamper herself. Women who never take these spontaneous moments to brush their hair, put on lipstick, dab on perfume, or file their nails are missing the soothing joy of little indulgences. Certain activities are more gracious when you're seated because you are more at ease than when standing. A dressing table in a room too small for a desk can double as a writing table.

If you don't have any dressers, ask yourself whether you even want any in your bedroom. I prefer transforming a closet, regardless of how small, into a clothing center, freeing all the bedroom space for living, not storing. Putting all your wardrobe necessities in one central place makes dressing more efficient. If you have a beautiful antique blanket chest, a highboy, or an armoire with clothing inside, try to position it near the closet so you feel organized and not scattered when dressing and putting things away.

In some people's opinion, the chaise longue may be an old-fashioned piece of furniture whose time has come and gone, but I disagree. A comfortable lounge chair with a built-in foot rest is more appealing now than ever because it has a way of slowing you down, helping you to relax. If you can't sit back, put your feet up and just be—in your own house—you aren't living in a true home. But even if you rarely sit on a chaise, it has a symbolic air reminiscent of a hundred years ago when relaxation was an essential element of civility. While the chaise is most often considered a bedroom piece, people are moving it into living rooms, family rooms, and guest rooms where family and friends can unwind together.

For many dog owners, a bed for the pet is as important as that for a child. Clients usually wrap a piece of their curtain or bed hanging material around the bed cushion.

A bench at the foot of the bed can be useful as well as attractive—a handy perch when the bed is made. It also tends to diminish the size of the bed, drawing your eye to the detail and design of the bench. If a child comes into the parents' bedroom, this is a good place to sit and have a visit.

In the decoration of your house, the bedroom should always be given priority because this is where you're likely to spend one third of

your time. This room should be infused with your spirit and energy more than any other room. If you're lucky, you will spend several happy *waking* hours—working and relaxing—in your bedroom each day, and will appreciate the thought and care you have devoted to the room. When you acquire bedroom-love, you truly have a private sanctuary within your home.

Upholstered Furniture

After purchasing the right bed and establishing at least a temporary setup for eating meals, your next priority in furniture should be to acquire a few pieces of upholstered furniture for your living room or living area if you do not have a separate living room. Comfortable, well-constructed upholstered chairs, love seats, sofas, and ottomans add warmth, comfort, color, and beauty and are a great place to start. Chances are you will collect wood pieces and other types of furniture over time that will share the space with your upholstered furniture.

Some of my clients with large houses, who have no choice but to spend a lot of money on furnishings for their home, tackle the living room last. In one house in Florida, clients used blue-and-white canvas sling beach chairs for a year before they invested in upholstered sofas, chairs, and large round ottomans, because they wanted to get a feeling for the changing light, where the most desirable places for seating were, and what colors complemented the ever-changing sky and water.

How many pieces of upholstered furniture should you have? There is a tendency to plan for too many pieces because it looks better on the one-quarter-inch-scale floor plan (I will explain floor plans in more detail later in this chapter). Remember to include space to breathe, a notion integral to interior design in Japan, where the rooms are practically bare, but not empty. There is no rule for how many pieces of upholstered furniture you should have in a room. Over the years, you will rearrange it, move it to other rooms and houses, and recover it. The key is getting started, taking your time, and judging your present needs as well as what pieces are most appropriate for you, your space, and your budget.

Good upholstery is expensive, but it will outlast the inexpensive alternatives. Although it is best to buy all your upholstered pieces at one time so that the fabric ages uniformly, cost may prevent you from doing so. In this case, start by buying only the key pieces—a sofa and two chairs, for example. Once you choose the fabric, order extra bolts in case it is discontinued before you are able to purchase all your desired pieces.

Even when clients can afford to buy all the upholstery for a room at once, some automatically double their order and keep a bolt in a closet so they can recover all their upholstered furniture pieces in the same fabric when the time comes. A client in North Carolina allowed her three sons to put their feet up on the upholstered furniture. She replaced grimy or worn-out areas only. If a love seat is stuck in a dark corner and never sat on, it doesn't need to be recovered at the same time as armchairs that get constant use.

CUSTOM-MADE UPHOLSTERED FURNITURE

When you select upholstered furniture, take great care in making your decisions. Upholstered furniture, like sweaters, comes in small, medium, and large. There are different shapes, sizes, and details that affect overall comfort. The top of the line is custom-made upholstered furniture, the equivalent of clothes made to measure. I recommend made-to-order upholstery to anyone who can afford it because it will usually last forever. In the years I have been decorating, clients have recovered their custom-made furniture, but they never have replaced it. By selecting graceful, classic shapes, your selections will be suitable in the years ahead. As your taste develops and your decorating schemes change, your upholstery should remain a consistent presence.

Custom-made upholstery is all worked by hand, from the hardwood frame, usually maple, to the final details. Each spring is hand-tied for strength, the webbing is hand-stitched, and hair-filled stuffing is distributed throughout. Cushions are made of foam in the core and pads of top-quality goose down on each side, so you have both the comfort of down and the convenience of not having to plump the cushions each time someone gets up. It takes approximately fifty hours of labor to

make a custom sofa, and approximately twenty hours to make a chair. Custom furniture allows for more detail work as well as for modifying the piece to fit your needs. You can raise the seat, lower the back, change the pitch, and deepen the sofa or chair. Upholstery is designed primarily for comfort, and when it is finely made as well as gracefully designed, its substance gives off good vibrations.

Not all dressmaking details are fussy; they can offer refinement and quiet luxury. You can use buttons or tiny bows rather than the standard covered button for tufting. You can add contrast binding or welts, or even rosettes. Working out these details so the look reflects your personality is exciting.

If you love a chintz but some of the flowers are too large, skilled craftspeople can tuck them into folds. Each piece of furniture may use a different part of the pattern, so rather than perfectly matching each chair or sofa, you can turn the room into an Impressionist garden. Custom workshops are filled with artistic men and women doing work they learned from their parents and grandparents. A real sense of pride goes into each creation. Every community has these talented, caring people who can make high-quality upholstery that will give you and your loved ones thousands of hours of pleasure, and your spaces good karma. I've never had a disappointed client—after they've gotten over the initial shock at the price—because fine upholstery builds a quality room with a solid foundation. In an age where architecture isn't always graceful, the refined proportions and craftsmanship of the upholstery detailing add tremendous grace to a room.

Often when clients bring their own upholstered pieces to be recovered, the custom workroom has to start practically from scratch because the ingredients and workmanship are usually inferior. Often clients have to be told that their sofa, now stripped to the frame for reupholstering, is in such poor shape that they may want to invest in an entirely new one. To avoid disappointment in future years, buy the best upholstery you can afford. In a fast-changing society, it is important to build from a strong structural base, and a room with good upholstery looks and feels solid and offers incomparably subtle luxury. When you opt for the least expensive upholstered furniture, it will probably begin to show signs of wear and tear within a year, and these pieces are usually not worth repairing because the cost of reconstruction will be higher than the original price of the furniture.

ALTERNATIVES TO CUSTOM-MADE UPHOLSTERY

What are the less costly alternatives to custom-made upholstery? Consider using rattan-framed furniture. Most people make the mistake of making their living room more formal than their lifestyle, creating a stiff or even stuffy atmosphere. Selecting reeded frames for sofas and chairs is refreshingly unpretentious and charming. But if you really prefer to give your room a well-padded, upholstered look, try estate auctions, because custom upholstered furniture from the 1930s is so well built that often all you need to do is add a slipcover. Also, upholstered furniture, as with reproductions, usually has a poor resale value, so you can find real bargains buying secondhand.

SOFAS AND CHAIRS

When looking at a sofa, consider whether you like a one-part back, where the entire back is a single cushion with no dividers, or three-part back, with three cushions. A two-part back is less gracious, just as two mattresses put together with a single headboard are never as satisfying as one solid mattress (even though it is often a necessity).

Square-back-and-arm sofa

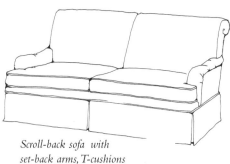

Scroll-back sofa with set-back arms, T-cushions

When you go to test out furniture, be yourself. Take your shoes off, and sit the way you would on Sunday afternoon in the privacy of your home. A Chesterfield sofa has a back and arms of the same height, and you can dangle your feet over one end, lie flat on the cushion, put a few pillows under your arms, and have a nap. Study the look and style, then lie down or curl up. Work out the details that are suitable for your lifestyle. Do you want a tailored look or a more cozy, relaxed, loose appearance? Do you want a loose-pillow removable back or an attached back? The

Curved-back sofa with large arms forward

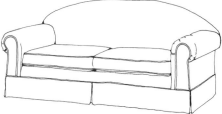

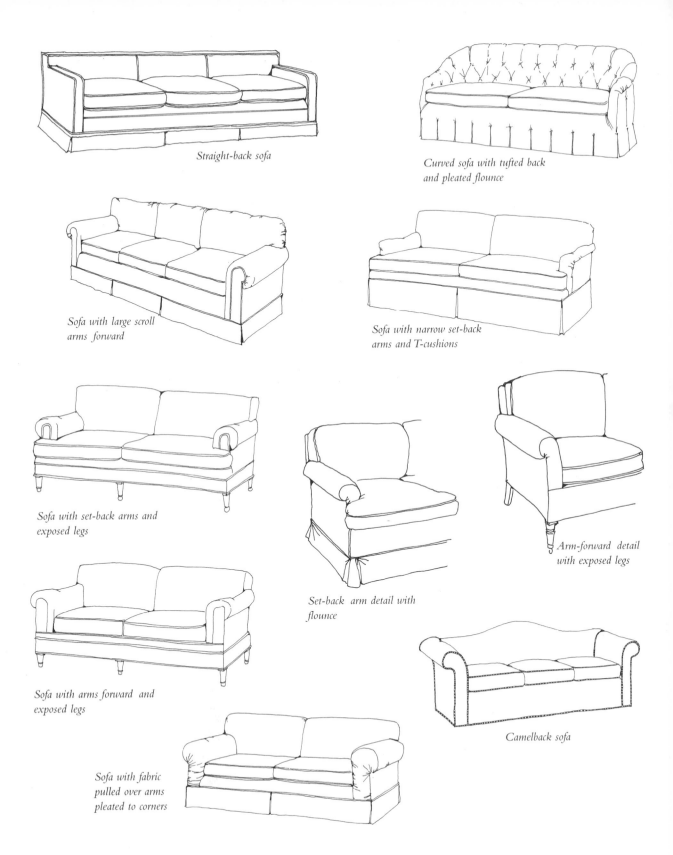

Straight-back sofa

Curved sofa with tufted back and pleated flounce

Sofa with large scroll arms forward

Sofa with narrow set-back arms and T-cushions

Sofa with set-back arms and exposed legs

Set-back arm detail with flounce

Arm-forward detail with exposed legs

Sofa with arms forward and exposed legs

Camelback sofa

Sofa with fabric pulled over arms pleated to corners

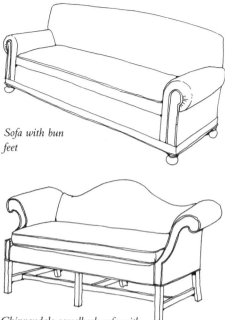

Sofa with bun feet

Chippendale camelback sofa with exposed legs

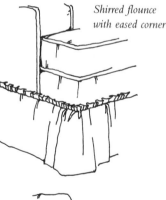

Tufted Chesterfield sofa with bun feet

St. Thomas, mentioned earlier, is a favorite model because it's long enough for you to nap on or for a friend to comfortably spend the night on.

What classical shapes are you drawn to? Do you prefer a square, scroll, or rounded back? Do you want a curved back, making tufting necessary, or a clean and straight back? Do you like loose seat cushions or semi-attached? Reversible cushions are more practical, but they also require more fabric. Do you like large, massive arms or skinny, delicate ones? Do you like arms set back or forward? Do you prefer pulled-over fabric or a panel? Do you like welts or not? Do you want finished legs or a skirt to hide the wood? Or do you prefer bun feet? If so, do you want them covered in the fabric of the sofa or stained?

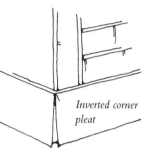

Inverted corner pleat

In a typical living room, the sofas and chairs should be compatible in line, scale, and design. The tailoring should also be consistent. However, if the chairs have a ruffled flounce, to avoid making a room look too frilly, you can use bun feet on the two sofas, giving the illusion that the sofas are floating off the floor. By covering the round bun feet with fabric, you maintain continuity.

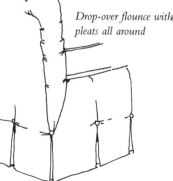

Shirred flounce with eased corner

You can have many different skirts on a sofa or chair, from the most basic inverted-corner pleated skirt to a skirt shirred or plain with eased corners only. The skirt can drop over the top of the seat from the platform to create a clean, fresh, tailored look. If you don't have a rug, the skirt can touch the floor. When you buy ready-made furniture in stores or through a catalog, you probably won't have many custom options. Any special requests may raise

Drop-over flounce with pleats all around

the overall cost. However, it is better to pay for some details you desire than to settle for something you won't be happy with.

A few extra words on sofas: Never consider a sofa longer than eighty-four inches. Not only will it look awkward, it might have to be hoisted into an apartment or house through the window because it won't go up the stairs or fit in the elevator. Rarely do more than two people sit on a sofa together. Also, when possible, purchase removable cushion covers made with Velcro closures so you can wash them easily. To extend the life of the arms, buy a second set of covers. If the manufacturer charges more than you can afford, and you are a capable sewer, make your own. Consider using upholstery pins (heavier versions of straight pins that won't bend when you work them into the sofa or chair arm) to give the covers a tailored look.

Generally, you get what you pay for in upholstered furniture. Quality and life span increase with price. Think about what kind of investment is most appropriate for you at this stage in your life. You may decide to use a daybed as a sofa because it is the wisest choice for your budget now. One mattress, a Harvard frame, two headboards, and some pillows make up a daybed. Eventually you can detach one headboard, buy another mattress and frame, and have twin beds.

An upholstered chair should look graceful from all angles. Look at furniture from the rear, side, and front. Buy chairs in pairs. One main sofa is the anchor of a room's seating area. You are not likely to move a large, poofy Carr sofa placed opposite the fireplace, but you can always

Armless love seat with shirred flounce

Two-cushion love seat with flounce

rearrange love seats, chairs, and ottomans, and you should as the spirit moves you. I designed a love seat with no arms and rounded seat cushions, making it welcoming when tucked into a corner of a room. It recalls the design of an Odom chair.

Keep in mind the interrelationship of the shapes of a sofa, love seat, and chairs. Consistency in shape, design, scale, and proportion is key.

SWIVEL CHAIRS

Whenever a client buys a custom-made upholstered chair, I always recommend putting it on a swivel. Many people prefer a rocking mechanism, but I feel chairs are most comfortable when they swivel. I love the freedom of looking into a fire and, without getting up from my cozy spot, being able to turn around and watch the sunset. In your living room, you may have three or four seating areas, and the swivel chairs can create a sense of ease in the arrangement of the furniture, as well as encourage spontaneous conversations between groupings.

SLIPPER CHAIRS

*A*nother favorite piece of upholstery is the slipper chair, a fully upholstered side chair made popular by interior designer Billy Baldwin in the 1950s. These chairs take up little space and have a tenderness to them. In a grand master bedroom we placed a slipper chair on either side of the foot of the bed so children could visit their parents without sitting on the bed. However, today it is rare to have space for this grace note.

*Shaped-back slipper chair
with shirred flounce*

THE OTTOMAN

*M*any people consider ottomans (low, cylindrical, upholstered stools topped with a cushion, or poof) to be superfluous. But I consider ottomans to be among the most multipurpose and practical pieces in a room. They provide a place to put your feet up, to sit, and to put things on, including a drinks or tea tray, and because they're on casters, they scoot easily. Sitting on an ottoman is like sitting on a stack of pillows, though it's much easier to get up because their wood construction makes them sturdier than pillows, and they can be made a few inches higher than usual if you're tall. They range from eighteen to forty-two inches in diameter. I love these charming, soft additions to upholstered pieces, and urge everyone to indulge themselves with an ottoman. Even if you don't feel inclined to sit on it, your family and friends will be happy it's there. Put it between two swivel chairs in front of a fire, and you and a friend can both put your feet up while you read.

Ottomans

FLEXIBILITY IN FURNITURE
ARRANGEMENT

*U*pholstered furniture should look attractive in a variety of places. In the summer you may want to rearrange your furniture so you have more access to the sunlight rather than being focused on the fireplace. Your bedroom love seat could be moved to the foot of your bed so you can enjoy sitting in the light and be nearer to the open air or air conditioner. In the winter, you could put a twenty-six-inch-high table in front of the fireplace so you can eat suppers by the fire seated in a pair of swivel chairs.

Furniture is meant to be rearranged. Rooms breathe with more life when they are not rigidly contrived. For a refreshing change, take all the furniture out of the room with the exception of the sofa and rearrange your seating groups. Rather than limiting yourself to one arrangement, rethink how you enjoy using the space.

A client moves his upholstered ottoman from place to place in the winter so he can put his feet up and read in the best light. Every summer clients move their two love seats from the fireplace seat-

ing area and place them adjacent to the window with a large, low coffee table between them so they can look out at their garden in bloom. Remember, you only have this freedom if you have furniture with harmonious shapes and classical proportions—they will look attractive in many different arrangements.

SEATING ARRANGEMENTS

*P*ay special attention to how you arrange your seating areas; you want seating arrangements to invite good conversation and human interaction. Everyone should be able to pull up a chair easily. The distance between pieces of furniture in a seating area should be no more than four feet or people will have to stretch to hear each other. When you have more than eight people in a seating area, some will stand. People sit a great deal at their workplace, in the car, and on buses or trains, so it isn't a bad idea to let people stand and move around at will. Arranging intimate small groups in a large room allows people to move in and out with ease. I love being able to have a conversation in an area ideal for two. In front of a window, place two chairs with an ottoman between them to hold drinks or tea. One seating group is allowed to be "rude" to the next by showing the back of a head, because this permits the guests to enjoy a more intimate conversation with one or two people without feeling forced to participate in other conversations.

You will constantly weigh the aesthetic, tasteful aspects of your furniture arrangement against practical considerations. Henry David Thoreau, when he lived at Walden Pond, reminded us that we only need three chairs—one for solitude, two for company, and three for society. Where you want to sit in a room is probably where others will want to sit, too. Move things around so that all your furniture is there to receive you and loved ones.

If you are taller than average, you will probably feel more comfortable in rooms with larger-scale pieces of furniture but fewer of them. You can have both large- and medium-scale chairs in a room if they are

the same or similar models. It is more important to have consistency in design than in scale. If you find a chair model you love, buy two—one large and one medium. This way you can always have your favorite reading chair without its looking out of proportion and inharmonious.

DINING FURNITURE AND OTHER WOOD PIECES: THE MOVABLE FEAST

Pedestal dining table

In Edith Wharton's time, eating was confined to proper, designated dining places—the dining room, the sun room, the garden. However, because of her habit of writing in bed every day, even when Henry and William James were guests, Edith Wharton had breakfast on a tray in bed. Today, eating is a movable feast, no matter what the meal is. When selecting a dining table, remember it doesn't need its own room. An architect incorporated a dining space at the end of a client's living room by knocking down the wall. The traditional mahogany double-pedestal table with Chippendale chairs enhances the appearance of the upholstered sofas and chairs in the living space.

Every meal a family eats together is a small ceremony, a ritual that fills a home with warmth and love. If it is feasible, you should consider having several places to dine. One hundred years ago, servants often were the only people to spend time in the kitchen, so no effort was made to create an attractive atmosphere there. Now, happily, the kitchen is the heart of the house. You should have an attractive table in your kitchen if there is space. Because of all the appliances and equipment, an old wooden table can add considerable—

Farm table

and much needed—charm. But a contemporary wood table with a protective coat of polyurethane will also serve you well. It will be both indestructible and inexpensive.

Search carefully for a table where you will eat meals with loved ones. You are likely to spend countless hours "at table," and you will want them to be enriched by the table, the high altar for the ceremony of breaking bread. If you are tall, spend extra time sitting at a table before you purchase it to assure your legs fit comfortably under the apron. If you are a woman, bring a pair of high-heeled shoes with you to the furniture store because they elevate your legs when you are seated. Feel the part underneath the apron. If it isn't smooth, stockings and trousers will snag. Keep in mind that no person is "average" size, so "average" heights mean very little. If you prefer a thirty-one-inch-high eating surface, you can put cushions on your chairs to increase the seats' height.

Parsons table

Daytime meals should be enjoyed in a light, cheerful environment, so a sun room would be more enjoyable than a dark dining room. Your needs will evolve and your circumstances will change, so select a table in a wood that speaks to you, not one that merely echoes the taste of your parents' generation. Dark hardwoods in formal designs replicating the work of famous English cabinetmakers may be too old-fashioned and rigid for a young couple with small children. A client with two boys with perpetually sticky fingers wanted a practical eating table, so we designed one of Canadian maple in a simple, straightforward style with an inset of white tiles hand-painted in flowers, fruit, birds, and herbs. Not only is the table decorative and cheerful, the surface can be wiped clean with ease. When having a more formal dinner party, they can set the tone with a tablecloth, napkins, and table decorations.

Butcher-block table

Another client wanted a practical everyday table that could be dressed up for company. She selected a Parsons table in a lemon-yellow lacquer. Durable finishes now available give the table surface the look of glass and are as easy to clean.

A client's breakfast room doubles as a dining room and has a banquette against one wall. A modern maple butcher-block table rests on a sturdy block pedestal in front of the

banquette. Here again, the table can be dressed up with fine china and cut crystal, but the rectangular shape and surface is also a comfortable, convenient place for family projects and for children to create art and do their homework.

If your table is to function for multiple purposes, a rectangle or square is the wiser choice. I like round and oval tables for eating, but for paperwork I prefer a straight edge with right angles, similar to a standard desk. A client has an old rectangular farm table he uses for a home office surface between meals. The shape and size of a table depends on many factors, especially the room's size. A small round table in front of a fireplace in a large bedroom is a wonderful place to sit and have breakfast and read the paper as well as an ideal place for afternoon tea.

Many of my clients love their dining table so much they light candles and set an attractive table for nearly every meal. If you have a traditional formal dining room with extra space, it is nice to have a small round table in front of a window for times when you are alone with a spouse or child and don't want to use the large table. Certainly when family gathers it is wonderful to be able to seat everyone at one table but not always possible. For this reason I recommend tables with extra removable leaves. The French farm table that seats eight can seat sixteen simply by your pulling out two leaves, far less work than the English habit of storing additional leaves in a closet.

The main consideration is everyday living. How many people, on average, will be sitting down for regular meals? Once you find a place for regular dining, you can fine tune your needs for celebrations. If you enjoy having a few people at a time, you probably can accommodate them at your everyday dining table. If you do things on a large scale, you probably need several card tables with forty-one-inch-round folding tops to seat six or eight. Remember that although place mats can be an attractive touch, they take up more space than necessary for an ordinary place setting. If you do use place mats, make sure their shape repeats the shape of the table. Rectangular place mats on a round table will look more awkward than attractive.

Be extremely opinionated about this important table because there is no one solution for all households. Selecting a main table requires thought and research, and is well worth the time.

OTHER WOOD FURNITURE

*M*ost people associate comfortable furniture with soft cushions and pillows, but there is another dimension to comfort that involves emotional comfort as well as physical solace. Look around some beautiful houses. Other than the upholstered furniture—sofas, love seats, chairs, and ottomans—most of the furniture will be direct, firm, softened only by a seat cushion or a pad on a wooden arm. But the beauty of the wood provides its own kind of comfort, with its appealing silhouettes and gentle links to nature and, if you own antiques, to the past. You need wood furniture pieces to balance the softness of fabric-covered furniture. Chairs, stools, benches, tables, desks, chests of drawers, armoires, jelly cabinets (two-door hutches or high pieces), or secretaries, whether painted or stained—these are the pieces that will give your room personality and character.

Wooden bench

Drop-leaf desks

Chests of drawers

Window bench

Two-door hutch

Two-door hutch

Secretary

One of the reasons I'm so attracted to country furniture is the down-to-earth honesty and charm of wood, but I'm equally comfortable in finely decorated rooms with elegantly proportioned eighteenth-century antiques from England, France, and Italy. While I love the unpretentiousness of pine with its light, simple appearance, I also appreciate the beauty of delicate marquetry where three or four different fruitwoods are intricately inlaid. In an old New England house, pine furniture looks fitting in bedrooms, because it creates a bright and informal atmosphere tying in with the wide pine floorboards. You can use lots of old pine in combination with white antique wicker. One client ordered a Canadian maple four-poster bed, so we decided to use old pine for all the other pieces so the wood tones complemented each other, just as trees have different yet harmonious characters and stature.

Different woods have different looks as well as feelings. Fruitwood and oak are both medium-colored woods, yet I prefer the character and grain of fruitwood to oak in furniture because fruitwood has a softer, more refined and delicate texture, and tones of yellow, brown, and dark brown that add to its warmth.

Dark woods such as mahogany, valued for its hard reddish-brown character and appearance, tend to look more formal and serious. Cabinetmakers used mahogany when they intended to carve intricate designs in the wood. If you choose dark wood furniture, you should also consider having a dark wood floor. Dark objects on a light floor can be unsettling, though some people like this dramatic contrast. If your furniture is not ideal, blend wood tones so the eye is not drawn to particular pieces. If you want

Secretary with broken pediment

Armoire

Armoire

a light-toned room, be sure to select woods to enhance your scheme, remembering that dark colors absorb light.

There has never been more furniture available to the public at reasonable prices than today. If you can't afford an antique, manufacturers give you the flavor of the classical past in well-made reproductions. You can buy an eighteenth-century chair model and paint it any color or finish you wish. You can buy a kit to distress wood yourself to make it look antique. One of Carl Larsson's friends was the local cabinetmaker, who made him lots of pieces, but Larsson also found bargains at flea markets and painted them decoratively, balancing out his costs.

One of my favorite pieces of wooden furniture is a bright red bookcase shaped like a triangle with a sawed-off top and a picket fence design. It is new, fun, and inexpensive. One client selected a long bench and two smaller ones stained pale green and painted with gold stars. They are colorful, playful, and amusing, and the design is as simple as a sturdy carpenter's bench.

Triangle bookcase

LACQUERED WOOD FURNITURE

*L*acquer is a glossy pigment coating sprayed on wood sanded so fine it has the feel of marble. There are no brush marks and the surface always looks shiny and wet. The colors and texture of lacquered furniture enrich most rooms. Many traditional English rooms have at least one lacquered piece. Today, lacquer is most popular in coffee tables, an American invention, and it can make this large, practical piece of furniture the focal point of the room. Whether you paint a coffee table high-gloss hunter green or Chinese lacquer red, it will be a spark of energy in a room. Even a wood console table in an elevator hall can be lacquered a shiny bottle-green to make the surface look eternally fresh against yellow walls.

Coffee table

Every room should contain a piece of lacquer. Its opaque, glossy texture and often intense color contrast brilliantly with the different shades of brown and distinct grains of the other wood pieces in a room. Lacquer does scratch, but so does wood; these signs of use are inevitable and in antique lacquered pieces add considerable charm. The more for-

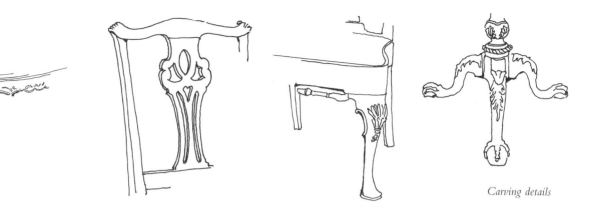

Carving details

Bullnose

Demibullnose

Ogee

Reeded

Flat

Round bevel edge

Flat bevel edge

mal the room, the richer the tone of lacquer should be. Blue-black, bottle-blue, eggplant, Chinese lacquer red, and black are classic colors for lacquer. White lacquer, however, is always a mistake because it turns beige in time.

DETAILING

The lines of the wood often reveal when it was made. Depending on the detailing, a piece of furniture will look simple or ornate. The Parsons table, created by design students in the 1920s, is an example of pure simplicity, whereas the quality carving of a French Regency marble-top table and some carved Regency chairs are examples of eighteenth-century refinement and quiet luxury. The deeper the carving, the higher the relief. The way a marble top is edged, whether it is a bullnose, a demibullnose, an ogee, reeded, flat, or has a round or flat bevel edge, makes a difference in the way the piece feels. You will naturally be drawn to particular details in wood as well as in stone. By training your eye to register what you like, and then analyzing why it pleases you, you will refine your taste and improve your aesthetic sense.

Bringing Traditionally Outdoor Furniture Inside

Teak bench

The third category of furniture is furniture that once was reserved for outdoors or porches—wrought iron, hand-hammered metal, wicker, and rattan—but is now being brought indoors to add a breath of fresh air to your spaces. I will also add teak, a type of wood not used for standard interior furniture, as well as other pieces of furniture that were intended for outdoor use.

As demonstrated by this desire to bring outdoor furniture indoors, people feel more freedom than in Edith Wharton's period. I am enthusiastic about this trend and believe it is a healthy direction for the future. As people become more ecologically conscious, this interrelation between outside and inside is something I embrace fully. Now, not only can you bring the garden indoors but the furniture and garden ornaments, too. The relaxed designs and natural materials of furniture originally designed for outdoors does wonders to bring the garden spirit inside. For example, a teak bench in your entrance hall adapted from the

Marble-top wooden pedestal table

original that Claude Monet had in Giverny, with the arching back and comfortable contoured seat, will instill a garden feeling. If you let it bleach to a silver tone outside, it will be pleasantly mellowed. The old-world craftsmanship of hand-forged wrought iron with split rattan is as exotic and enchanting as a secret garden.

The whole range of hand-carved oak, maple, and walnut pieces designed for outside use is equally appropriate for our interior spaces. A marble-top wooden pedestal table with a brass base from a Greek sidewalk café can be put in a kitchen in front of a window and look quite natural.

Many wrought-iron tables are designed to have a glass top. Though I find this look refreshing, I'm always afraid children are going to break the glass and hurt themselves. If you do have a glass table top, make sure the glass is protected all around by a frame, and that the table is surrounded by chairs to prevent rambunctious children from breaking the glass and hurting themselves.

A well-designed, solidly constructed iron chair with a herringbone close-weave back and seat is not only tasteful and full of great style, but it also brings the garden inside. Whether you select a rope-woven side chair, a rattan settee, or a teak dining table with a hatch top, what matters most is whether the piece has meaning to you.

Iron chair

A bank in Texas had rattan furniture in the garden atrium. Woven-reed furniture finds its way into the finest houses. High style needn't be fancy. Diego Giacometti, the brother of sculptor Alberto Giacometti, cast most of his brother's pieces. His studio is outside Paris, where my client and I commissioned him to make a coffee table and several lamps for the living room of their eighteenth-century house in Paris.

Rattan settee

Iron table with glass top

The iron table is not only pricelessly charming, but it works with all the more formal eighteenth-century French antiques in a formal but vitally energetic living room. French garden chairs merge beautifully around a round fruitwood farm table. A pair of bentwood chairs with carved seats looks harmonious with a marble-top Greek café table. Many clients use iron tables with glass tops in their garden in summer and bring them into a sun room in the winter beside a window covered with geraniums that bloom all year.

Bentwood chair

MODERN/CONTEMPORARY FURNITURE

Contemporary furniture can be inspiring if it has clean, simple, refreshing lines. Sometimes a room needs some relief from curves, carving, and excessive detailing. Suitable contemporary furniture depends on good craftsmanship, proportions, the use of organic materials, and inspired design. Every piece has to have a point of view and be beautifully made.

Drum table

A company I admire makes drum tables in a range of colors with ash and bird's-eye maple veneers. The aniline-dyed finishes come in luscious colors they call lollipops—cherry, lemon, lime, orange, grape, and blueberry—and are very cheerful. The "monoforms" in rounded squares, half rounds, drums, cubes, and rounded triangles in lacquers, colorful stains, and veneers, as well as wrapped in leather, all have a place in the home. The texture of the granite tops on these lacquered drums is contemporary looking and simply beautiful.

Caning wrapped over wood and lacquered and glazed in any color is an attractive modern approach to old shapes and styles. This concept can be used for a coffee table, end table, dining table, even a headboard.

Caned side chair

The small round table with an iron or brass spiral base and a glass, marble, or lacquered top can be a beautiful, modern addition to any house. The twelve-inch diameter and fifteen-and-three-quarter-inch height of the table looks ideal next to a chair, and provides a practical surface for books, a drink, or the telephone. This

Small iron two-tier table with glass top

model is as attractive as the contemporary swing-arm lamp and equally versatile; it can be placed successfully in a bathroom and in the most formal living room. Another pleasing contemporary table is the glass-top table with a brass bamboo design frame that works best as an end table. This table can be made to order in any size and is most attractive with a middle tier for magazines and books.

When exploring the possibility of having a few contemporary pieces of furniture in your rooms, keep in mind that the well-designed, beautifully made modern furniture today should become classics in the future.

Two-tier brass bamboo frame table with glass top

FLOOR PLANS

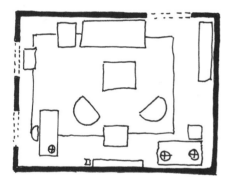

*I*f you hire an interior designer, the first thing he or she will do is measure each room and create a floor plan detailing furniture arrangement. This helps the client visualize furniture groupings and free space for the flow of traffic, assessing comfort and balance. Before I tell you how to draw up a floor plan, I want to ask that you not refer to it too often. Always be flexible rather than literal, and remember that what looks "right" on a floor plan may not be what's best for you. Because you acquire furniture over time, floor plans should be no more than a general outline or guide for how you place your furniture.

Decorators draw floor plans using a one-quarter-inch scale (one quarter inch per foot of space). You can buy house-furnishing templates at art supply stores or design school shops that are useful in drawing in the shapes and sizes of everything from a piano to a wing chair, Windsor chair, side chair, coffee table, night table, and dining table.

To make a floor plan, measure your four walls, indicating the width of each molding, door, opening, and window. Measure in inches, on site, and then transpose them into feet when you're back at your desk. After you measure your rooms, you can either use a scale ruler in the one-quarter-inch-per-foot proportion, or simplify your life and use French grid paper, where one square equals one square foot. Buy tem-

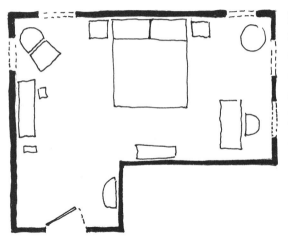

plates or make your own furniture cutouts to a one-quarter-inch scale to place on the grid. Move these shapes around your floor plan until you feel they are placed harmoniously. The shapes will help you see traffic patterns as well as what pieces are compatible next to each other.

FILL YOUR ROOMS WITH LOVE

*O*nce you have your bed, a simple table for meals, and a few pieces of upholstered furniture for your living space, finding furniture for your house should be approached as a lifelong treasure hunt. Be sure to enjoy all the stages of your furniture hunt, from the purchase of your bed to your first antique to other favorite pieces you acquire over the years. Let your rooms take on the charm and grace of many beautiful pieces of furniture, lovingly collected over a long, happy, adventurous life. May your journey of self-discovery and aesthetics bring you and others great joy and pleasure in those priceless hours at home.

Fabric and Rugs

*Fabric and rugs provide rooms with color, pattern,
texture, style, and spirit of place.*

FABRIC: AN INTEGRAL PART OF EVERY HOME

*F*abric is one of the true blessings of home. The softness and comfort associated with childhood—the blankets, quilts, pillows, and teddy bears—are connections you can keep alive throughout your days with the use of fabric. Fabric is also art. Antique quilts used as bed coverlets or wall hangings are an art in textile form and the creators are artists. After laboring all day on the farm, women would stay up late at night after the family had gone to bed and sew thousands of tiny stitches to create abstract Impressionist patterns out of fragments of used clothing.

The French textile designer Manuel Canovas is a colorist whose ability to capture the freshness of a spring garden on fabric is artistic genius. Master of textiles Jack Lenor Larsen travels around the world teaching local weavers some of the complex artistry in woven cloth of their ancestors. Larsen chose a career in textiles over architecture because he found he could weave together all the different interests of his life on a loom. He reveals ancient art forms through his textiles.

Some of the most beautiful art is woven and printed on textile. Just as some artists use pigment and a brush on a canvas, other artists weave their design into a textile. Some combine the two by painting canvas to

be used as fabric rather than hung on the wall. The more you appreciate textiles as art, the better you'll be able to warm up your rooms with beautiful materials. The opportunities for using fabric in the decoration of houses are infinite. You already hang terry-cloth towels in the bathroom, and tuck fine cotton sheets on your beds; there is fabric on your windows and, of course, on upholstered furniture; you drape it over tables and use it for napkins, pillows, and tassels. Fabric provides sensuality, luxury, elegance, and refinement in a wealth of textures and patterns.

A textile is a cloth or fabric, or fiber or yarn for weaving. What are some of your favorite textiles? Do you like glazed cotton chintz, printed linen, silk velvet, woven wools, cotton damask, or Thai silk? Do you like brocades, crewel, cut velvet, corduroy, embroidery, taffeta, satin, or moiré, the fabric with a water-stained appearance? Or do you like dimity, the simple cotton cloth with a pattern weave and vertical ribbing used in the eighteenth century? Do you prefer dotted Swiss or eyelet fabric? Because of their exposure and experiences, everyone is attracted to a variety of materials. I have always found informal fabrics such as cotton chintzes more alluring than fancy, elaborate damask and brocaded materials for decoration. While dressy woven textiles may be appropriate for formal rooms, I far prefer cotton, chintzes, woven wools, and Thai silk in living rooms, and seersucker coverlets and antique quilts in bedrooms.

The fabrics I'm most attracted to all are inspired by the colors of nature. I've never outgrown my passion for fabrics as fresh as flower petals, lemon peels, and fuchsia peonies. Color gives us energy, and fabric is an excellent way to bring this energy into your home. When buying in Bangkok, Thailand, for the Singapore government's permanent residence in New York, I had Thai silk woven in clear, saturated, lively colors to fill the rooms. I've had a continuous love affair with one of Canovas's cotton chintzes he aptly calls *Joy*, and when I see its vibrant pastels, my spirits soar. Having upholstered furniture, curtains, or bed hangings in this whimsical floral print is to live in an atmosphere of pure joy.

THE RISK OF OVERDOING

*H*ow much fabric you use in a room is up to you, but whenever someone is unsure about how much to use and money is not an important consideration, there is also a tendency to overdo. On the other hand, when someone is trying to save money by having a skimpy curtain, the atmosphere can look sad.

When seeking quality, luxury, and understatement, always look to the bones of a space, using enough fabric in a room to add grace and luxury without having a heavy hand. When you have symmetrical classical structure, you don't need to hide it under layers of fabric. Just as if you have a lean physical body, you look best in simple tailored clothes, a room that is honest in scale and proportion doesn't need a lot of frilly fabric treatments. Before the turn of the century, at the age of ten, Edith Wharton returned to New York City from a trip to Europe and observed the narrow houses "so lacking in dignity, so crammed with smug and suffocating upholstery." Having too much upholstered furniture in a small room is just as wrong as closing in a window by shrouding it in too much material.

When choosing the amount of fabric you will use in a room, remember that there has to be tension between soft and hard in a space, and too much or too little fabric inhibits a room's balance and disturbs the eye. If your furniture is covered in an especially lush, brightly colored fabric, you should be restrained in your selection of curtains and rugs. But if your furniture is all on stilts, because no fabric falls to the floor, the room will cry out for the warmth, softness, and coziness of fabric draped at the windows and of rugs on the floor. Often it isn't a question of how many yards you use but how well they are distributed. Shutters at the window and a bare wood floor could look well as long as you have enough upholstered furniture to anchor the room. If you have elaborate drapery treatments and furniture with exposed wood frames, reducing the amount of fabric required, you'll need an interesting rug to tie the room together. Decide where you want the heaviest concentration of material—either in upholstered furniture or in window treatments.

THE VIRTUE OF ORGANIC WEAVES

All the fabric I use in the decoration of houses is organic, and though I realize the practicality of synthetics, my personal preference is for one hundred percent cotton, wool, or silk. I use blends when what I want in color and design is available only in combination with other fibers.

In the late sixties, many textured synthetic fabrics appeared on the market, and decorators all leapt to use them. One yellow chair in Greenwich, Connecticut, turned gray within a week. The husband would get up early and sit in the newly covered living room chair drinking tea and reading the paper before his drive to New York. The static electricity in the synthetic behaved as a magnet for the newsprint. The only recourse was to recover the chair in one hundred percent cotton chintz to match the rest of the room. So much for that "practical" new fiber.

While synthetic fabrics have been greatly improved, they still cannot replace the natural, organic materials that prove, over time, to be so satisfying. Fabric blends combining organic textiles with synthetics can bring the cost down as well as increase the durability of the material, but buy the best you can. If you can't afford pure silk or wool, remember the virtue of simplicity and quiet taste and use sailcloth. If you are not a purist, synthetic awning cloth (used for outdoor awnings but available by the yard for upholstery, slipcovers, or cushions for both indoor and outdoor use) is stain and water resistant and inexpensive, and comes in stripes and solids in bright primary colors. But keep in mind that certain textiles have intrinsic integrity when they are what they appear to be, and one hundred percent cotton is hard to beat.

TEXTURES

When selecting a fabric, pay close attention to its texture, especially if you're considering it for a sofa or chair. If you're often bare-legged when you lounge, you may be sensitive to anything that is scratchy. Years ago a client selected wool for her library sofa and had to replace it with cotton because she couldn't sit on it for more than a few

seconds without itching. Wool would be ideal in a room where you plan always to be fully clothed, but these days such a room is rare. If you're a woman watching television in a nightgown or a man wearing shorts, you might not feel comfortable on a wool-upholstered sofa or chair. If you are vulnerable to skin irritations, live for a while with a memo sample or a third of a yard of a prospective fabric before you invest in a rough texture. The fabrics you select should *feel* good to you. While a mohair throw might look cozy draped over the arm of a sofa, it may feel prickly against your skin when you curl up in it while reading, whereas an old cotton quilt would feel softer.

Despite this warning about textures scratching you, woven textiles are beautiful and add richness to any room. Art collectors find the subtle pattern in woven fabrics an ideal relief for their art; any busy design might interfere with the visual impact of their collection.

Cotton chintz

COTTON CHINTZ

Chintz was once the "poor man's fabric," and people who used it were considered "chintzy." Today, however, the more chintz, the more luxurious the feel of a room can be. Chintz is no longer "chintzy."

Years ago, when chintz was used for upholstery, it was usually quilted to add durability. However, as with any fabric, constant use leads to signs of wear and tear. When the threads from the quilting break off, and they do, the fabric begins to look sad and dull and the only remedy is to recover the furniture.

Chintz is endlessly versatile because it comes in a rainbow of solid colors as well as a variety of patterns to suit everyone's taste. I'm partial to using patterned chintzes in the decoration of houses because it is uncontrived and fresh, and looks good even after years of sun and use because many different colors give it life and interest.

If your upholstery is extremely tailored, chintz softens the straight lines. In most cases, use smaller-scaled patterns in small rooms and larger ones in bigger spaces. The more you repeat the same fabric, the quieter

the room becomes. Rooms that are overly contrived, where too many different fabrics are used, even if the patterns don't clash, become unnecessarily busy. Your eye is exposed to too much at once, as though you had too much food on your plate, all glopped together. Patterns on patterns should be executed only by those who have a great deal of experience. There are safe, successful exceptions, however, that usually look attractive. For example, in a room where you primarily use chintz, small amounts of a geometric-repeat fabric on chair cushions, pillows, or an ottoman look good when the colors repeat one or two of those in the chintz.

The cost of chintz has little to do with the quality of the actual cotton, but is determined by the intricacy of the designs and the number of screens required (each color requires a different screen). Other cost factors are the location of the mill (fabrics manufactured abroad will usually be more expensive than ones made locally), labor costs, price of cotton, overhead of the company, and even royalty fees to licensed designers. If you find an inexpensive chintz that is appealing to you, be grateful.

Most chintzes are glazed, giving the fabric a sheen. The higher the glaze, usually the finer the glazing process. If you wash your chintz cushions or slipcovers, eventually the shiny glaze will wear off. If you don't like the sheen of glazed chintz but enjoy the look of cotton chintzes, there are plenty to choose from printed on an unglazed ground.

While few people can easily maintain white background chintzes, these are among the most attractive, especially when the print is a classical tree of life with flowers and leaves, and the fabric is used in a room full of lovely, polished antiques. While I prefer clear colors, a champagne or sandy tone background in a formal room, with a print of flowers so delicately detailed they look hand-painted, can be elegant in a room with marquetry tables and porcelain vases made into lamps.

THAI SILK

The sheer beauty of Thai silk, with its chromatically intense hues, enlivens any decorating scheme, mingling excitingly with

Thai silk

oriental lacquer and porcelain. There's something so exotic about this silk, with its natural slubs and shimmering iridescence when the weft—the horizontal threads—and the woof—the threads that run crosswise—are woven in different shades. Thai silk blends beautifully with cotton chintzes, and on textured upholstery, this material looks rich and sensual.

My love of exotic textiles in saturated colors began in India in 1959 during my life-changing experience of traveling around the world. I learned that wearing colorful costumes was an integral part of the Indian culture, confirming for me that colors with high wavelengths of energy uplift the spirit, and that with fabric we can achieve this transcendence in our homes. Madras is as cheerful on the cushions of wicker furniture at a beach house as on a man dancing under the stars in Bermuda. In Bangkok, during the same trip, my love affair with Thai silk began at Jim Thompson's shop. He was the bright, talented man who awakened people all over the world to the beauty of Thai silk in decorating and in clothing.

You can weave this magical silk into all your decorating schemes. It is remarkably versatile, available in different weights: a lighter weave for sheer pillows, bed hangings, and curtains, or a thickly woven version for sofas and chairs. You can find places to use it in your living room, dining room, bedroom, and study, and the effect will be irresistible. Because of its texture, sheen, and purity of color, it is enormously satisfying.

Thai silk woven in an ikat design can be successfully used as a wall covering, transporting you to another land, or as an exclamation point, where you use a small amount for a seat cushion or some pillows. Thai silk bed hangings need no lining because their glorious luminescence is beautiful from both sides. You save considerable money with a material that needs no lining or second layer.

Some bold, daring designs and

Thai silk ikat design

color combinations in Thai silk are available today due in large part to Jack Lenor Larsen. After Jim Thompson's mysterious disappearance decades ago, Larsen began his mission to ensure that the traditional art of weaving would not be lost to future generations. By traveling to remote villages all over the world, and teaching the people how to weave in the tradition of their ancestors, Larsen continues to help cultures rediscover their artistic heritage. His involvement spans the entire weaving process, from the quality of the yarn to the color and design of the fabric.

Because Thai silk is hand-loomed and imported, it is expensive. But it wears well despite the common perception that silk is fragile. If in contact with regular direct bright light, it will fade and disintegrate. But even when it is threadbare, the silk yarn retains its sublime beauty, never becoming depressing. In four decades of using Thai silk, I have never heard a complaint from a client, even when they tell me something has to be recovered.

USE ONE PREDOMINANT FABRIC

A key part of my decorating style is that I tend toward using one fabric predominantly in a room. When there are too many contrasting fabrics in a room and not enough of a single fabric, the eye is confused, causing an unsettled feeling. All too often you see furniture upholstered in a confusion of prints and textures, making you feel as though you're in a showroom displaying how furniture looks covered in different textiles. In most living rooms I design, the upholstered pieces are all covered in one material. I believe this brings the room balance and harmony.

Joy fabric

In one of my favorite rooms is Manuel Canovas's *Joy* fabric in a mellow ground covering a large Carr sofa, two Marshall Field barrel-backed tufted chairs, an armless sofa, and a classic Lawson love seat. The welt, also called piping, and contrast binding on the flounce is lilac, picking up the darkest purple from the leaves of the flowers in the chintz. (The welt is fabric cut on the bias, filled with cording stitched between seams that can be made of the same mate-

rial—a self-welt—or made of a contrasting fabric for emphasis. Contrast binding is a flat band of fabric similar to a ribbon, sewn so half is seen on the front of the furniture and the other half is hidden underneath. If you prefer, the entire width of the band can show, turning it into a braid.) I chose this material to predominate in the living room because of its light and cheerful pattern and fresh, pure, bright pastel colors. The scale is average and the design is evenly distributed, making the fabric appear sprinkled about as though in a garden in full bloom. Avoid bold patterns that don't flow gracefully.

Always repeat the same fabric and design treatment on all windows, regardless of location and size. You have more room to experiment with contrasting fabrics on upholstered furniture, but bear in mind that every time you use a different fabric, you are calling attention to a chair, sofa, ottoman, pillow, or draped table.

SECONDARY FABRICS

Once you have chosen a key fabric, all other materials, whether textures or prints, will be subordinate and should be smaller in scale. As with music, the melody predominates and everything else supports the composition. Pick small, modest, simple patterns as complementary materials to enhance, refine, and enrich the key fabric. Plaids and checks can create a subtle country appeal. Dots, stripes, and striés all add simple charm, much the same way these more humble materi-

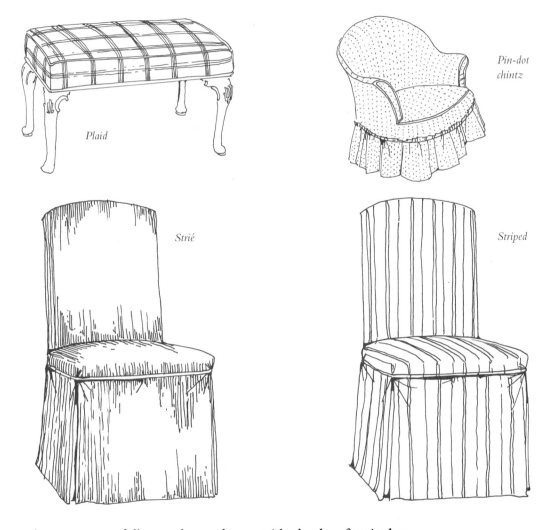

Plaid

Pin-dot chintz

Strié

Striped

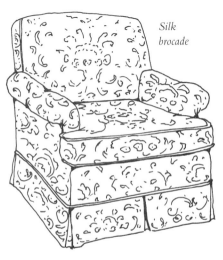

Silk brocade

als are successfully used on the outside back of priceless eighteenth-century open-arm chairs. I have used museum-quality silk brocade on the front of a chair and a simple cotton check on the back, as plain as a dish towel. This same concept can be used when detailing a room. For example, you can line silk-taffeta curtains in a glazed pin-dot cotton chintz. Always use fabric strips cut on the bias, or diagonal, for contrast binding and welts so they will not pucker.

Though it is a general rule that a sofa should not be upholstered in one fabric and a pair of chairs in another, there are exceptions. In a grand-scale room or one that is notably formal, if the curtains are the same chintz as the upholstery, I prefer to contrast the sofa with a plain Thai silk

or a texture on other pieces that complements the chintz. If there are a love seat and some antique open-arm chairs in a corner, and a fine painting above, flanked by windows draped with chintz, the love seat should be in a soft, fresh green or a color picked out of the chintz, not the painting. Fabrics you are drawn to will naturally have a color palette similar to your art, but it is labored and diminishes the art to deliberately select materials that match a color, or several shades, of a painting. Paintings should always be free to move around from place to place and room to room and not be taken for granted, stuck in one location. Art is not wallpaper, glued in one place.

Rooms with a dominant color as well as one main fabric have a spontaneous, refreshing lushness without being contrived. A rule of thumb is to buy a bolt or more of one fabric, anywhere from forty to fifty-five yards, in a living room with upholstered furniture. To repeat the *Joy* chintz on the upholstered sofa, two love seats, two large chairs and four pillows in one client's living room required seventy yards of material. Because of the light, happy quality of this impressionistic, flower-strewn fabric, and the considerable size of the living room, we decided to go over the top with a good thing. Through the room's five large windows, the eye is drawn to the grass, trees, and lush flower beds that surround the house, making the repetition in fabric satisfyingly subtle. It is possible to use only one fabric design in a room and have beautiful, alluring results. This glorious room in Texas is unlike any other room in town because it is so refreshingly simple. The abundance of this soft sweet pea–patterned material with colorful flowers made the atmosphere one of enchantment. In this case, contrasting materials might have broken the spell.

The rule that one rotten apple spoils the whole barrel applies to textiles. One sad fabric, even on a single pillow, drags down the whole scheme. All fabrics should be in harmony, pleasing to the eye. By observing how classical rooms are put together, you can see the interconnection between one textile and another. Fabrics in a room must get along, not be competitive or too loud.

To accompany matching upholstered furniture in your room, if you have a simple mahogany bench, you can cover it in grass-green leather, and for the cushions of wooden side chairs and open-arm chairs use a cotton weave of green or yellow with white snowflakes; simple but not dull. A favorite carved Regency open-arm chair can have a pale green-

Ruffle designs

Gimp cord

and-white ikat weave in Thai silk. Sofa pillows can be covered in *Joy* chintz, with two additional Thai silk pillows with a pinkish lilac on one side and a spring-grass green on the flip side. Because these pillows have a knife edge (come together without boxing), a silk cord in green, pink, and yellow, adds a grace note of refinement. If you have a few small stools, you can repeat the same snowflake weave in green so you won't introduce a new fabric that could make the stools inappropriately stand out. It is always advisable, even with rare treasures, to err on the side of understatement. Let the inherent quality sing without a chorus.

Tassel

Consider adding subtle details as accents to upholstery without being showy. When you want to elevate a small bench, stool, or pillow in stature, you an add a gimp cord or tassels without making the piece look overdone. A narrow binding in a soft tint may be more effective than a bold contrasting fabric. If you have plain, pink-glazed chintz curtains in your daughter's room, you can add a sassy four-inch double ruffle to them without overdoing. For a little girl's room I had Manuel Canovas curtains made in white with random pink polka dots, and lined the double ruffles in solid pink. Why two ruffles? Just to add a fun, novelty fabric detail that is feminine without being pretentious. If you use striped material, cut the stripe on the bias so that it becomes a candy cane, a detail to use when you want to add whimsy and innocence.

Narrow binding

SELECTING THE RIGHT FABRIC

*W*hen you look at a piece of material, fondle it and enjoy the way it feels, and let its color and pattern speak to you. Trust your

Ruffle

intuition and use it in the decoration of your house. Choose fabrics that create the atmosphere you want. Just as Claude Monet designed and then planted his dream gardens at Giverny, so you can create any mood or spirit you wish, and choosing an ideal fabric is a whole lot easier than the backbreaking work of a master gardener. If you're drawn to a fabric, don't immediately look at the price tag. Try to get a true sense of its energy and karma. Hold it up to the light and look at the colors bursting with sunshine. Who knows, you may be pleasantly surprised by the cost per yard. If you fall in love with a fabric and its price is beyond your budget, consider using it for pillows, a footstool, or a small chair cushion.

If you feel a special affinity for the wildly bright colors of Marimekko from Finland, you can always find places for them. This fabric house offers more than three thousand color patches and uses objects from nature, such as trees, flowers, and leaves, as well as geometric patterns for its cotton prints and stripes. Even if you don't know where or how you want to use some of their designs, you can buy several swatches to display in a sewing basket until you use them for a pillow or set of napkins. A client uses Marimekko in her children's rooms, and even laminated a piece of one of their wild striped fabrics containing reds, oranges, yellows, blues, greens, and purple to use as a play mat in the family room. She also bought several boldly patterned pillows in Marimekko's clean, clear palette. Her children have had many joyful moments jumping up and down on the play mat and having somewhat affectionate pillow fights.

I have always used colorful textiles in decorating to create a mood and represent a spirit. In a New York City town house owned by a French family, I used French cotton fabrics with a geometric design for a group of rooms on the top floor, evoking a feeling of Provence. The

Geometric Pierre Deux fabric

colors of the South of France—strong blues, greens, ochre, and reds—can be mixed together because they are all of the same sensibility. You can find these fabrics at Pierre Deux, a charming New York store with many international locations that sells French provincial antiques in addition to fabric and other specialty items from France. Whether you have a tablecloth and napkins, or chair cushions, curtains, bedspreads, or bed hangings, or even upholstery, you can achieve the mood of sun-drenched Provence.

A husband and wife team decided to use their artistic talents to hand paint canvas for curtains and upholstery for summer houses or purchase by people who always want the summer sun to shine in their rooms. Over the years I've spent a lot of time with Mrs. Leslie Tillett, whose passion for her work and enthusiasm for the art of using hand-painted canvas for curtains and furniture, rather than restricting it to paintings framed in gold leaf, is infectious. You feel the energy of her brush strokes, and every client who has commissioned Tillett art treasures its authenticity. She makes you want to hand paint your own canvas.

One reason Carl Larsson's house was so charming was that his wife, Karin, was a textile designer with a great eye. Textiles played a fundamental role in their household, as illustrated in his paintings of home scenes. There you find looms with wavy stripes of orange, white, blue, and green yarns and a bedroom with white sheets and a red bed coverlet, and white curtains with a red border. In the kitchen, hiding the storage area, is an irregular horizontal-stripe curtain in soft peach. In front of an easel is a green stool with a blue, pink, and red cushion with red and white tassels, deliberately not aligned with the four corners of a square-seated bench. When a window is open, a gossamer white curtain or valance balloons into the room, inviting the viewer to enjoy the fresh air.

Larsson stool

On a side chair, obviously painted white over an original dark stain, is a loose slipcover in blue and white. A white-painted settee has a ruffled skirt hanging eight inches off the floor, exposing the wooden legs. A white bed coverlet has complex weaving, and a handmade white

blanket dangles down with a handkerchief detail on the edge. Even the huge towel next to the washbowl has an orange plaid woven into the white linen, with a sassy fringe on all sides. A light-catching textile brightens a brown table. Tab curtains with stripes of embroidery in "X" stitching and amusing geometric shapes dangle from one side of a high window for a playful accent.

On their dining table was a silver lamp with a white glass globe, and at meal times Karin usually covered the table with an unironed white tablecloth to create a memorable family moment. Karin displayed her textiles everywhere, even draping them over the back of a chair or on a red settee cushion, inviting a child to come play. Napkins were made of cotton and linen and embellished with bright colors in simple flower motifs. Carl and Karin magnified the art of family life with fabric, creating emotional comfort in their home through their bold and playful use of fabric.

COORDINATING YOUR FABRIC WITH OTHER ELEMENTS

*T*he fabrics in your rooms do not stand alone, but work with all the other elements of decoration to create a mood and energy, to tell a story. When a magazine published an article on a client's apartment, the headline read: "Fruit Punch—Strawberry, lime, lemon, and blueberry—the happy mix of nature's colors in this duplex apartment with terraces gives everyone who visits a welcome lift." The article commented, "It's all done in a pretty palette of sunlit pastels with a sprinkling of natural wicker, fresh greenery, American antiques and collectibles."

Mrs. Tillett's fabric art, saturated pastel stripes brushed over white canvas, covers all the cushions on the rattan furniture, accompanying green walls with white trim and bleached white oak floors. The sofa and daybed pillows are also covered in a Tillett design with pastel solids

Rattan chair covered in a Tillett design

strié with white on one side and teardrops floating on the other. The two coffee tables are round lacquered drums. When I had asked the client what color she wanted the tables, she handed me a purple hyacinth, and looking at the tables now brings back the hyacinth's vivid scent. To further the garden theme, we applied used trellis for the radiator covers, drawing the eye to the white gazebo on the terrace. A Roger Mühl painting of houses in Provence in summer hangs on one wall. A white quilt with a pink basket design is thrown over the arm of a chair, where my client sits in cozy comfort to read to her two boys.

Because this client loves bright, breezy, dazzling colors, we carried the pastel shades into her kitchen to soften the "city galley" space. We chose pastel green-and-white kitchen hand towels to complement the pink-and-green cabinets and yellow counters. They looked so attractive, we hung duplicate towels at the window. Using three pairs, we looped two towels at a time over a spring rod to create a valance, and sewed eight-inch-long grosgrain ribbons to the tops of the towels every four to six inches to tie them to the rod. This soft green-and-white pin stripe is charming at the window as well as for drying dishes.

We painted her dining room a bright pink and hung a pink floral appliqué quilt on one wall. A pine hutch holds her collection of hand-painted plates, and on the wicker and rattan chairs, Manuel Canovas's *Joy* with a blue background ties in the brilliant blue glass chandelier above a table made of hand-painted flower- and vine-decorated tiles set in white maple. I designed this table especially for this client to create a cheerful atmosphere when she has meals with family and friends. She sometimes uses white lacy embroidered place mats so the tiles can be seen and appreciated through the thin cotton. For more formal dinner parties, she uses a floral tablecloth and lights candles.

Clients whom I helped create a sunny atmosphere for a huge house on the water were delighted to use Mrs. Tillett's fabric art in all the rooms of their beachside home. We used the colors of the sky, water, and sunset to make the walls seem to disappear, connecting us to the sea below the house. In the living room we used strié blue slipcovers on all the furniture. We added white stripes on the throw pillows for punch and scattered lots of patchwork quilts for pattern and texture. At the windows we hung hand-painted French blue canvas with irregular white stripes.

The blue-and-white cotton dhurrie rug's three-inch horizontal stripes draw your eye to the terrace, the pool, the ocean, and the sky.

In the dining room we used Pierre Deux cotton on the ladderback dining room chairs, in the color of a perfect sunset in shades of blue and pink, double stitched and quilted in blue. In a charming sitting room connecting the dining room to a glassed-in breakfast room off the deck, we used a small geometric blue Pierre Deux cotton. All the chair cushions in the house have a two-and-one-half-inch ruffle all around with one-inch-wide self-ties attached to the back legs. A pine card table with four ladderback chairs doubles for puzzles and games and a teatime setting. We bought the old white linen cloths at a country fair. Marked with indelible creases from being folded the same way thousands of times, they add charm when the moment calls for tea.

The glass walls of the breakfast room bring the water of Long Island Sound into the room. My client likes to warm up a white round laminated pedestal table with a checkered tablecloth and matching napkins, a wonderful look against the Mexican terra-cotta tile floor that gleams with reflections of the water. The Claude Monet blue, yellow, and white china together with a bouquet of yellow roses from the garden and some yellow lilies in an old watering can on the floor next to the glass wall makes breakfast an epiphany.

If you have a house near the water, even if your view is blocked by neighbors' houses, you can bring the spirit of water inside by selecting an appropriate upholstery. Consider a blue-and-white–striped floral chintz with blue ribbons and lots of peony pinks, recalling the sunrise, sunset, blue sky, and water.

THE FADING OF FABRICS

I have often said, "If your fabrics aren't fading, you should move." I love the way fabrics fade in the light. We should start out with colors as fresh as crayons in a box, and accept the inevitable bleaching over time from the light and warmth of the sun. It's real, and the fact that our spaces are regularly kissed by the sunlight is a blessing to be continuously appreciated. No new material is as charming as one that has been loved up by sunshine. The energy from the sun penetrates the

textile and, however subtle, is felt. Just as teenagers love faded jeans and even buy them in this condition, so bleached-out fabric, a symbol of hours of sunlight, should be cherished. To live in the dark to protect your textiles is a sad waste of potential vitality.

In a small study the only window is off to the left as you look out from the desk into the garden of a client's Charlotte, North Carolina, home. The upholstered love seat nearby is covered in a small-scale yellow floral chintz. The side of the love seat opposite the window is faded so that the once butter-yellow is now almost white. The other half of the love seat is a mellow version of the original yellow. This happened quickly because my client never closed the shutters. Rain, snow, or sun, she enjoys the light and looking outside. She also loved the yellow chintz because when the sun wasn't out it cheered her up. When she asked me what to do, I told her that the look was charming, that she should keep the shutters open, and turn the seat cushions over regularly in addition to alternating the right- and left-side cushions to ensure even fading.

When It's Time to Reupholster or Recover Your Furniture

*M*ake sure your fabrics haven't become grungy from too much use. On a sunny day, examine all your fabrics with a critical eye. When you walk into your living room and are struck by how tired it looks, and a spring cleaning doesn't help, it's time to reupholster or recover. The rule of thumb is to reupholster or recover every five years in rooms that are frequently used, though some rooms can look fresh for decades if the upholstery is professionally and regularly cleaned.

Will you want to replace the material with the same color and pattern, or will you want a different look? If you have some extra yards of your existing fabric but not enough to redo the whole room, you can recover a few chairs and make arm covers for the sofa and they will fit into the "shabby genteel" category. If your upholstery is a chintz you love that has given you years of pleasure, but has been discontinued, it may be difficult to find a substitute that works as well, delaying your decision to redo. Even though the glaze has worn off and the fabric has

faded into a more mellow presentation, it is real, like the Velveteen Rabbit. You can lovingly hand wash the cushion covers and iron them dry. Though you may miss the high glaze and piercing colors, cotton upholstery softened by age is charming.

Remember, if you have dull colors when you start out, the room will look dreary sooner. Always start out fresh, so as the room naturally tones down the atmosphere will still be cheerful.

UPHOLSTERY AND WINDOW TREATMENTS

To ensure your rooms will not be too top heavy, select fabrics for your furniture before you consider fabric window treatments. Generally speaking, the heaviest materials should be in the upholstery and the lighter, more airy fabrics at the windows. If you desire rooms to feel as though they are floating in the sky, use most of the colorful, printed, textured fabrics for upholstery or seat cushions, and lighter fabrics for higher elevations. If you use a bolder chintz on the windows, the result will weigh you down and distract the eye from any art on your walls. In a city apartment kitchen where the window is behind bars because of a fire escape, a bright, bold print will fool the eye by hiding the obtrusive security bars.

You may want to use the same fabric in both the upholstery and the window treatments. This is most successfully done with a well designed, freshly colored, traditional floral chintz. If you want striped curtains, a solid or subtle pattern would look well. If a white background chintz is well designed and soothing to the eye, using the same fabric for curtains and valances will lift your spirits, making you feel light as air. You can't go wrong when you coordinate the window fabric to the upholstery as long as the scale of the fabric pattern is neither too small, causing monotony, nor too large and thus overpowering. Some beautiful chintzes look best on sofas, chairs, ottomans, and pillows, but aren't as successful when draped into folds, hiding the attractive flow of the design. Often an overpoweringly large-scale repeat looks in proportion with the other elements of a room when draped, but make sure you have a large enough sample to pin up and live with for a while before

having the curtains made. Buy a yard of any fabric you intend to use for curtains and bring it home to get a better sense of how it will translate to and be experienced in your house. A beige raw-silk curtain material could look pretty in the morning light, contrasting against woven wicker walls, as you look out onto a garden in bloom with flaming bougainvillea, but when these curtains are drawn and the lights dimmed, the lack of color could be more sad than inspiring. Drape a large swatch of material at the window. Think of your fabric in the glory of sunlight and on a stormy evening. Hold textiles up to the light. I prefer cottons and silks because of their potential to be enhanced by divine light. Witnessing sunlight pour into a room through color-saturated cotton or silk curtains causes the heart to skip several beats, and is cause for celebration. Today, with the increased availability of textiles from every corner of the world, you can find silk materials that look lush unlined, because the print is saturated so the cloth appears to be reversible. While linings give body and block light, sun streaming through a silk print can be heavenly.

In a dark-paneled or dark-painted room, use a dark ground chintz. In a light, bright room, use a white or pastel-tinted ground. A client's large Georgian walnut-paneled study had been draped and upholstered in white damask. It looked as though sheets had been placed around a room that had been vacated. The room cried out for some rich colors and life. We selected a bottle-green–ground chintz with trees, flowers,

Fringe detail

Braid detail

Cigar-shirred welt detail

and birds and the room immediately had unity. If you want to lighten a dark room, after installing good lights, if it still seems dark, consider bleaching the paneling or painting it a cheerful color. There is a lot of ordinary plywood paneling that is depressing when brown but can be attractive in a pretty green or yellow.

If you decide to have cotton chintz or Thai silk fully lined, custom-made curtains, they are likely to be quite costly. But even if you want curtains for luxury as well as privacy, if you keep them simple, you can avoid putting a strain on your budget. Rather than spending money on a costly fringe or braid, you can have a cigar-shirred welt (a fat cord where the fabric is gathered or bunched together) sewn down the leading edge. You can have the heading shirred on an inexpensive pole and do the simple sewing yourself. Or you may select indoor shutters or natural blinds made from bamboo and grass with a simple, understated, classic look less formal than many fabric window treatments.

LEAVING FORMALITY BEHIND IN WINDOW TREATMENTS

The treatment you select for your windows will determine the room's formality or informality. Edith Wharton advised one hundred years ago that the better the window and the view, the less need for fabric treatments. Thick fabric around a window prevents access to light and view and, when extended to the wall, takes up space that could be used for furniture, bookcases, or art. More and more people are opting for simple curtains or none at all. Formal, heavy, rigid, full-length draperies tend to suffocate a room unless they are beautifully detailed in colorful fabric. And they can be very costly. Today people are finding ways to have luxury, refinement, and elegance without depleting their bank account.

If you are undecided about what kind of window treatment to select, wait until the room's decor further develops before you make your final decision. Begin with the simplest possible solution and build from there, always keeping in mind the cost of curtains. (The *Joy* fabric I love is cotton yet costs as much as a fine piece of silk. When you multiply its cost per yard by the yardage required per window and add labor

Tambour Swiss panels

Tambour Swiss panels with valance

Break at floor

Puddled on floor

costs, you realize that you could buy a painting for the same price.)

In many cases, when clients want something to soften the window but don't want a dressy look, I recommend a single white-on-white fine Swiss cotton striped fabric for every window in the house. Many houses have windows that don't cry out for embellishment. Because you'll want every ounce of light possible to flood into your rooms, white fabric at the windows brightens a room's appearance. The curtains can tumble freely in the breeze when you throw open the windows, adding to the rooms' freshness and simplicity. These curtains can be hung from shiny white one-inch dowels, café style, with one rod hung from the top of the trim and the second one in the center where the frames of the double-hung windows meet. You can make your own wooden brackets, or you can buy them inexpensively at a lumberyard. This is the least expensive kind of window treatment, and it adds a rejuvenating touch to every room.

Often clients request embroidered tambour Swiss panels with exquisite handwork on all three edges; all you have to do is sew the heading and hang them on a rod. These white panels are crisp and refined, looking especially beautiful with the light filtering through them. If you want a simple, elegant window solution with privacy, this could work for you. These panels come in a variety of lengths, widths, and embroidery designs. While they are quite expensive, they do not cost as much as custom-made curtains.

Clients wanted privacy for their breakfast room because the two windows looked out onto a traffic circle where passengers in the cars had a clear view of the kitchen table through the lower two thirds of the window. Rather than blocking the entire window, they hung a thin brass rod two thirds of the way up the window and attached curtains there.

Bay window with shirred valance and tieback curtains

In more formal rooms where the curtains are made from more substantial fabric, be sure the curtains fall to the floor, either breaking at the floor or creating a puddle of several inches. Unless you have simple, modest, unlined cotton curtains, all curtains should extend to the floor. Nothing is more unsettling than to see an elegant fabric amputated at the window ledge, or suspended between the ledge and the floor, dangling aimlessly.

If you have a bay or bow window, consider hanging the curtains on the outside edge so you won't cover too much glass. This will free you to have both a window seat and the elegance of floor-length curtains. Shades can be installed in bay and bow windows if you need sun control. If two windows are close together, you can treat them as one, using a panel on the outside left and the outside right windows. To join the two, install a strip of mirror between the two inner window trims. This will fool the eye. A graceful, soft balance will help connect the two panels. If there is too much space between the two windows to use one pair of curtains, have three panels—on the left, right, and in the center. They can still draw in the standard way, but it is always more gracious to have a complete flow of fabric, rather than two groups of fabric that don't connect.

A pair of windows with mirror between, valance, and tieback curtains

Install the curtains approximately six to eight inches outside the trim so they will not obscure the glass.

Windows dressed with beautiful curtains or draperies can be as elegant as a pretty woman in a long, flowing evening gown. You can add both softness and sensuality to your rooms with appropriate window treatments. But always remember to open your windows and let you and your curtains breathe fresh air. Rooms hermetically sealed to keep the dirt and sun out may feel claustrophobic. Pretty curtains, no matter how much you value them, should not take priority over comfort. Curtains can always be cleaned and, when necessary, replaced.

THE VIRTUE OF UNLINED CURTAINS

*C*ustom-made curtains often have lining and interlining of flannel or black sateen to add weight and thickness, but once fabric is lined it completely blocks light when the curtains are drawn. When the panels are stationary, the fabric becomes dull because it is only seen in folds. Question whether this is the look and feel you desire. When you hold up certain beautiful fabrics to the light, observe the luminosity that will be killed by a "black-out" lining. You should know in advance how a material will look when it is lined or left to breathe freely in the sunlight.

Clients wanted a pastel-flowered chintz for their bedroom with white walls. We decided on white curtains for the windows and a pale blue background chintz with pinks, yellows, fresh greens, and purple for bed hangings. The fabric is simply draped over the rail of their bedposts, catching the light that seeps through the unlined curtains. No light is blocked. Lining and interlining add body and enhance the way the panels fold, but there is a sensual pleasure in receiving light through a thin veil of cotton; you are enveloped in a glow where everything around you has a glorious tint of color, as though you exist in a prism of light. The experience of these magnificent moments when the sunlight pierces the clear color palette of a fabric makes it worth considering unlined curtains. And because the bed hangings are draped over either side of the rails, it appears as though the light glows from within the fabric when it is exposed to direct sunlight.

Always consider how light will affect color. You may love to see sunlight filtering through cobalt-blue water glasses, but the light streaming from halogen lamps makes the blue glass alive and breathtakingly beautiful. Just as a handmade, white Swiss cotton dress on a child is refreshing, full of light and air, so many of your favorite materials look their most beautiful when they are not used in excess at the window, allowing light to transform them. For practical considerations, it makes sense to have upholstery and slipcovers that aren't translucent. But if you want light from the windows to filter through your curtains, it is necessary to pick a delicate fabric. Does the sun rot fabric? Yes. But a literally sun-drenched fabric is often more sensuous than one that is protected by heavily lined, drawn draperies. Curtains that blow in the breeze, bustle in the wind, billow, and have an ease about them can be graceful, refreshing, and satisfying.

HOW FULL SHOULD YOUR CURTAINS
AND DRAPERIES BE?

*M*any of my clients want beautiful fabric panels on either side of their windows but have no intention of ever drawing them. In the past, people drew their curtains in the evening; now most prefer to leave them open. Given this preference, how full should curtains or draperies be? Whether they draw or not, the eye wants to be pleased by an abundance of fabric, so that if the curtains were drawn, they would cover the window. I always recommend curtains that draw. It costs as much to have a stationary rod as one with a track that moves, so why not? It's always best to keep your options open, and never say never if you can help it. Curtains that draw are as comforting as a daybed that can house a friend for the night. You never know.

When determining fullness, remember that the fabric pattern becomes increasingly concealed the more fullness you have. Unlined sheer curtains need more fabric than heavy lined and interlined curtains, because the lushness of the fabric increases with each fold. But if you use a fine white Swiss-cotton embroidery, you want minimal fullness so that the detail and refinement of the material is revealed. Because there is no one way to adorn your windows with curtains, each circumstance will dictate how full and how long curtains should be.

WINDOW VALANCES

Simple valance

*O*nce you've really thought through your windows and have determined that you want some form of decorative fabric treatment, decide whether you want or need a valance or whether you prefer to show off the heading of the curtains. A valance can greatly improve a window's proportions. When you have a low window, a well-proportioned valance should be installed extra high to hide all the wall space from the top of the window trim to the ceiling molding. Designing a simple valance that will not block light and adds grace to a window is always the goal. The result will be refined, understated, and harmonious.

Though I love luxurious fabrics and use silk brocades and velvet for

furniture, I rarely use elaborate valances at the windows, even in the grandest spaces. Because of the fine architectural proportions of the windows, some rooms need only to have beautiful fabric panels hanging straight from a decorative crystal, brass, wood, or fabric-covered rod. In a Left Bank house in Paris, clients wanted to reveal the classical architecture in all its glory. Because the property was protected by walls, we were able to light lanterns as well as have floodlights in the garden, so that even in the evening the indoor and outdoor spaces appeared seamless. The French doors were in ideal proportion, so there was no need to use valances. The straight hanging curtains, in typical French manner, were gently tied back. In a dining room with hand-painted yellow wall panels, museum quality eighteenth-century antiques, and a priceless Waterford crystal chandelier, the window was adorned with lemon-yellow Thai silk curtains shirred on a silk-covered rod. The effect was stunning, both exotic and classic. In the small dining room overlooking a terrace and garden, the clients selected luxurious hand-painted plaid silk taffeta swags on a rod covered in the same fabric with long jabots for their bay window. The window seat and pillows are covered in the same pastel silk plaid.

Custom workrooms make their own poles and wooden rings for hanging curtains, so any scale and finish is possible. I often suggest wooden poles and rings, hung from brackets with big ball finials. But if curtains are purely decorative and will never be drawn, one option is to shirr the curtains directly on poles. The heading of a curtain can be extremely decorative. When you've seen a pencil-pleated heading, you don't want to hide it under a valance.

French doors with tieback curtains

Thai silk curtains shirred on rod

Curtains shirred on rod

I generally find constructed valances heavy and rigid, but there is one I recommend called a Turkish shirred valance. Though they are available in any depth, they are meant to be narrow, usually eight or nine inches. Our workroom pads these boards with rounded corners, and shirrs the fabric on the diagonal. The look is crisp, tailored, and charming, ideal for a room with one or two windows with an ugly view because it forces the eye to focus on the valance and curtains and not look out the window. When

Plaid taffeta swags and jabots

Turkish shirred valance

you want to boldly frame a window, you may not want to use a Turkish valance. A favorite soft valance is a running scallop-shaped shirred valance. At each end, dip the material down gracefully into a bell. Because the lining shows, line the valance in a simple, contrasting fabric.

SWAGS AND JABOTS

*S*wags and jabots can be exciting features in a room. Swags are looping folds of fabric hung above a window that dip down and then gather up on both sides of the window. Jabots are the pieces of fabric on either side of a swag with vertical folds cut on an angle to reveal the contrasting lining. Jabots rarely are longer than the window ledge. For a Georgian mansion in Alabama, clients used unlined mint-green-and-white-striped silk taffeta for the swags and jabots in their dining room, and the same bold stripes in sunrise-yellow for the great hall, with no side curtains. Seeing the light come through these folds from a twelve-foot ceiling takes your breath away. The luxury is in the luminosity of the color lit as though from within the folds. Whenever you have the freedom to have a fabric to enhance a window, think of it as making a style and color statement. Style in this case is the result of restraint.

Swags and jabots

WINDOW SHADES, CAFÉ CURTAINS, AND BLINDS

*P*leated shades are often a desirable alternative to full-length curtains in less formal rooms. In a kitchen with two windows over a sink, a client used a lemon-yellow woven matchstick pleated blind. In the breakfast area she selected café curtains in a small-scale yellow-patterned chintz hung from a brass rod and small rings, with a one-inch ruffle on the leading edge and across the bottom. This small space, where the window is closer to one wall rather than centered, would have looked and felt closed in if this window had been treated with full-length curtains. Because of the window being off center, curtains would

Raised balloon shade with shutters

Austrian shade

have called attention to this awkwardness.

In an apartment with a library with two windows overlooking a dank air shaft, clients wanted a window treatment that would disguise this dark ugliness. Above the window trim, a blue-and-white–printed cotton balloon shade was installed. The shade is always left open so that the light, which in this case comes from strip lighting placed above the window, can beam through the indoor shutters. The heavy cord that adjusts the shade is fastened onto a handsome brass hook on the wall.

Some people find balloon shades and Austrian shades too puffy and feminine, but if you repeat a simple cotton used on the sofa and chairs or on a bed, they can look relaxed and attractive. A balloon shade is an expanse of swagged material; an Austrian shade is similar to a balloon shade but has more gathers, making it appear more formal. In an apartment powder room with an ugly view, the client selected bold spring-green-, white-, and raspberry-striped cotton chintz balloon shades that billowed into the space, pleasing the eye as the stripes picked up the colors of the tiles and hand towels. A client with four bedroom windows wanted balloon shades that could be lowered at night. When the shade is released to cover the window completely, it flattens, resembling a simple fabric-covered shade. If you prefer to retain some softness in the fabric

Released balloon shade

when it is down, put a simple ruffle at the bottom to give it some style.

If you like the concept of a fabric-covered shade but want it to be very tailored, the Roman version with its simple accordion pleats may be right for you. A blind made of wood slats in a wide range of patterns and finishes can be installed under a valance. The blind can be lowered far enough just to clear the top window molding. If you never intend to let your blinds down, you can have them made to measure. These are called dummy blinds. Or you may enjoy a blind that drops down completely,

Roman shade

Wood slat blind with valance

allowing the light to filter in while providing privacy and protection from the glare. This way the curtains can remain open and not eliminate the outdoors.

BINDING CURTAINS

I always bind or trim curtains unless they are white and unlined or made from a modest check or plaid material. If you use a patterned chintz for curtains, you will inevitably have to cut into the design, and a binding that folds along the curtain's edge provides a necessary finished look. For decades traditional designers have been using Scalamandré Silk's ribbon binding, a woven silk in colored stripes especially designed to go with traditional chintzes. If you can't find a stock color that complements a fabric, for a small set-up charge the mill will make one to order. You can use this ribbon as a braid by sewing it flat along the edge of the curtain, or you can show half of the ribbon by binding it. We often use this binding for the border of upholstered furniture as well. The same colors can be woven into a cord with tape that can be easily placed in the seam of a curtain edge or as welting on furniture. These details can make the ordinary extraordinary.

A binding always adds refinement. Even in the most tailored room, bound curtains add subtle embellishment. Approximately three quarters of an inch is a good width for curtain and upholstered furniture binding. Clients who are willing to pay for this refinement almost always want it to be a contrasting color so it shows. Depending on your wishes and budget, you can have binding extend down the leading (inside) edge, across the bottom, and up the outside edge of each curtain panel to achieve the full decorative effect.

Curtains and valance with binding

FADING OF CURTAINS

B ecause curtains are exposed to more sunlight than any other fabric in the house, the leading edge of curtains will fade at a faster rate than all other upholstery. The edges of curtains can be folded

back and stitched down if the fading disturbs you, but chances are it will look charming, a simple sign of the natural process of change and transformation. One idea from the English, is to dip the chintz in tea to rid it of its newness, giving the impression that the people, house, and furniture have been around for a while. I think any attempt to imitate natural is senseless because only true, natural fading over time adds character, and tea just dulls the fabric. Interior designers have also tried to imitate this relaxed, natural ambiance in their work, but it is never as meaningful or refreshing as when it's real, authentic, and central to the life energy of the family who lives in the home.

It is natural to be afraid of fabrics fading or rotting. However, if you are preventing your house from being a home by keeping the shades and shutters closed at all times, you should rethink your priorities. See the sun as a blessing, not a nuisance, because while it fades fabrics, it also washes your spirit with heavenly light and refreshes you. Light and energy deprivation is too great a price to pay to keep your fabric in pristine condition.

FABRIC AND CHILDREN

What kinds of fabric should you use when you're raising children? I can't imagine anything more practical than machine-washable fabrics. This means cotton slipcovers. Keeping them clean is as simple as removing cushions, throwing the covers into the machine, and putting them back on the sofa or chair when they're still slightly damp. I recommend having your cotton preshrunk professionally, or washing it twice yourself before having it made into slipcovers, because all cotton shrinks. The joy of having children underfoot far outweighs the trouble of soaking slipcovers in stain remover and making trips to the washing machine. Don't buy fabrics that hide dirt and stains well because they are usually in depressing colors. Just as you don't dress your children in brown to hide the chocolate icing on their smocked dresses or rompers, the fabrics in your house should be as light, sunny, and happy as a child's nursery. The lighter the fabrics, the more sunlight and vitality we bring into the home, whereas the darker the material, the more dreariness.

Another mistake some well-meaning parents inadvertently make is to try to decorate a room dark as pitch so their child will sleep late in the morning. Children should never be drugged by darkness and lack of air, deprived of the morning sunlight's energy. A room composed with a vision of clarity and vibrancy can create as much pleasure as an Impressionist painting dappled with light and freshness. Through the use of happy, pretty fabrics, you can help to change people's attitudes about the world, offering an escape for the imagination, allowing a deeper reverence for life.

THE COUNTRY CHARM OF QUILTS

Quilts immediately bring you to a country cottage. When you use quilts in a city apartment, you will be sure to delight the heart of all. In your bedroom, if you are a quilt collector, you can use a quilt as a bed coverlet, stack a coordinating quilt at the foot of the bed and, if you have more, fold and drape them over a chair back or on a stool. They'll bring you joy and over the years will become softer, quieter, and more soulful.

In a simple colonial house in New Hampshire, a client's seventeenth-century French bench is directly ahead as you enter the front hall. She collects antique quilts as well as making her own, and she stacks them

on this antique bench and on the rack on the opposite wall. On a side chair, believed to have been owned by Susan B. Anthony, a quilt is folded as a seat cushion to add more texture. If you refold the quilts in different ways, they won't develop permanent creases. Whether you hang them up, stack them, sit on them, or lie under them, handmade one hundred percent cotton quilts are comforting and charming.

In the warm months, you can drape a simple blue-and-white quilt over the back of a painted high-backed pew bench in your garden or use a quilt as a tablecloth. When you leave the garden or the gazebo, bring the quilt inside so you don't have to worry about a summer rain. Not all quilts are pricelessly valuable, and they are so decorative and colorful, they should be used and enjoyed.

If you are passionate about quilts, hang one on a wall in your laundry room, and let the hundreds of colorful calico pieces give you energy as you do the family wash. By attaching it to the wall with Velcro, you can easily change it as the spirit moves you. It is often in these private moments, when you are working, that you can be surprised by the impact of beauty for its own sake, as its own reward.

PILLOWS AS TREASURES

*S*plurge on pillows. Pillows help support your back when you're seated, they're cozy to lean against, and they're fun to use as an

arm rest. They add softness wherever they land, and are an excellent way to use expensive fabric in small doses. Pretty pillows that speak of the mood and spirit of a room are like a flower bouquet. They satisfy the eye's need for delight.

A client who adores pillows has a large white wicker basket hand painted with pastel flowers on the outside and painted seafoam-green on the inside, where she keeps dozens of baby pillows. Not only are they tossed onto her own bed, but put in chairs as well as on her chaise. The pillow cases stacked on a shelf in the linen closet looked too pretty to hide, so to enjoy them daily she bought several inexpensive Dacron pillows. The basket holds a great deal of memories. The pillows are quite an indulgence, because most of the cases are hand scalloped on four sides in a contrasting hand-stitched binding, made by Porthault, a French linen company. What began as one Porthault baby pillow, now threadbare and bleached out, for her daughter's baby carriage is now a cherished collection that she adds to each year. No machine has been able to re-create the deep scallops and the hundreds of tiny stitches of

Porthault pillow shams, and their cheery floral and small-scale designs in clear primary and pastel tints are timeless sources of joy in her household. You can bring these pillows to the hospital when giving birth or having surgery, and sleep with them every night. Many of my clients travel with a Porthault baby pillow or a smaller elbow pillow ideal for tossing in a tote bag for comfort and karma when away from home.

When covering a pillow in a solid material, I suggest selecting one fabric for the face and a contrasting material for the back, so the pillow can be flipped over for variety and interest. If using a floral chintz, however, cover the pillow with the same material on both sides, and add a chintz ruffle lined on the back with the same contrasting binding as the curtain or upholstered furniture in the room, or with a favorite color in the pillow fabric. There is an art to making pretty pillows, and along with the knowledge and experience required there is the expense. Most of the pillows you see are mass produced, often knife-edge squares where two identical square pieces of material are sewn together, not allowing for the thickness of the filling. As a result, the pillows have rabbit ears, with triangles sticking up on all four corners so they no longer look soft and charming. The workroom

that does all of my custom upholstery work for clients uses paper patterns that allow shaping the pillow to accommodate the filling for a more graceful appearance. Though the pillows look square on a sofa, they are actually elliptical to accommodate the down or filling.

Porthault baby pillows

Pillows provide physical and emotional comfort, and are perfect for indulgence. Just as a silk scarf adds a touch of elegance to an otherwise plain suit, pretty pillows speak of your sensual vulnerability. On the two Chesterfield sofas in a client's sun room are two pairs of raspberry-pink, highly glazed pillows with a white pin-dot design and a sassy one-inch ruffle. When peonies are in season, this room is all aglow, allowing the eye to look out the windows to the flower beds beyond.

FABRICS IN THE LINEN CLOSET

*O*pen your linen closet and look inside. How would you describe the wardrobe for your bedrooms and bathrooms, the truly private sanctuaries of your home? The sheets you experience as you pull up the covers and turn off the lights and then awaken to in the morning, and the towels you use to dry your body after bathing, are of paramount importance in the decoration of houses. The art of living well at home is to have the eye pleased wherever it wanders, and some of the most important fabrics in our home are stored in the linen closet. You get a good idea about the mood of a household from looking in the linen closet. Just as you are particular about the softness of a cotton nightshirt or pyjamas against your skin, you should never compromise on fine linens. (I keep a blue-and-white enamel pillbox on my Zen desk at the cottage. On the lid are the words "Never economize on luxury.") After twenty years you may have some Porthault or other cotton sheets with a high-quality thread count that are so old they're full of rips, but they still feel so soft and luxurious that you can't bear to part with them. The ultimate luxury is to use your finest linens every day. Indulge yourself, your family, and your guests by having a wonderful, eclectic selection of sheets, pillows, shams, blankets, bath towels, and other bed linens.

To be sure your bed linens, terry-cloth bath towels, and dining room tablecloths speak for you, go back to your basic, personal color palette. Sheets are just as important as clothes, and I suggest you spend time, energy, and money collecting pure cotton, linen, or even silk bed linens to enhance your private sanctuary and to nourish yourself aesthetically. You owe it to yourself to add spice, fantasy, and elegance to the most intimate moments of your life. Don't hold back on purchasing a new set of good sheets or buying three or four new pure white or brightly colored terry-cloth towels to spruce up your collection. Express your love of color in the bedroom and bathroom. Even if you prefer white sheets, they can be embroidered, trimmed, scalloped, or bound beautifully in a fresh tint. You can collect old white pillow shams, napkins, tablecloths, and hand towels for years. You may enjoy having a very fine, white cotton, square embroidered tablecloth draped over a round pine three-legged table in the bedroom to delight the eye and to inspire a glass of iced tea and a visit.

Each sheet, bath towel, tablecloth, napkin, pillow, and hand towel is part of the tapestry of home, enticing you to ritualize your daily activities. Here is where you can quietly and regularly have function and convenience as well as luxury, elegance, and refinement. The seductive details make a difference when you're loving, and they comfort you when you're sick. Dinner at the kitchen table becomes a celebration when you light a candle, put a fresh flower in a vase, play music, and enjoy pretty cotton napkins. If you want to know more about yourself, look at your cotton napkins, tablecloths, towels, and sheets. Look at your striped and flowered cotton hand towels, tea cloths, and cocktail napkins. All the colors can be from the garden, the sky, and sea.

These sweet refinements should be among your greatest treasures of home life and will grow in meaning as the memories of happy times with family and friends accumulate. Your house needs as many seasonal "clothes" as your body. When you build a collection of fabrics that are sensuous and inviting, you will feel uplifted in spirit, always having a variety to choose from that will complement your mood, the weather, and the time of year.

SIMPLE REDECORATING
OF THE BATHROOM

*W*hen you change the color of the towels in the bathroom, you can transform the feeling completely. There is a great opportunity available for flair and imagination in a simple bathroom. Especially if your bathroom is white, when you scoop up the bath towels, hand towels, bath mitts, bath mats, and cotton rugs, pay attention to how much color all the cotton provides, and how easy it is to change the look and feel of the space by putting out a new set of fresh supplies. You can have a blue-and-white theme, where everything matches, from the terry-cloth towels to the quilted rug. At other times you can decorate with a palette of solid pastels and toss down a rag rug with a rainbow of the same colors.

Keep a stack of cotton hand towels and change them at whim. One week they can be mint-green and white, and the next they may be pink-and-white check. Or you can put towels of different plaids or checks in a pile. For everyday use, the cotton kitchen hand towels from Williams-Sonoma or other housewares and kitchen supply stores are ideal. They're inexpensive, absorbent, colorful, and don't need to be ironed. If you enjoy a pastel color palette in the summer, in the winter you may choose sunrise-yellow and grass-green. If all the colors you pick have the same chroma intensity, they will work well together. Just as the rainbow harmonizes different colors, so can you. The key is always in the clarity of hue. Never mix toned-down, neutral colors with clear colors. The eye will reject the dull color in favor of the clear one.

SETTING THE TABLE

*B*eing emotionally comfortable in your bedroom and bath is essential to the art of home, and equally important is the way a table looks and feels. Mealtime, including teatime, provides the opportunity to pause, to appreciate the moment, and to restore your equilibrium, nourishing your body and soul and stimulating your mind in shared conversation. The most versatile way to provide instant change is to have a range of textiles that evoke a scope of exotic, international moods. If you use French provincial fabric to set your table, you will evoke the South of France. If you're serving a curry dish, you may want to use madras from India. As cultural differences are diminishing in our global village, textiles that are traditional to countries, with their unique textures and designs, can be inspiring.

Whether you use a sarong from Thailand as a tablecloth or a few yards of fabric you bought while traveling, you will enrich your home and the time you spend at table with family and friends. A table should have a varied wardrobe. The cloths and napkins needn't be ironed, but the idea of surprise that stimulates and creates a celebratory mood is well worth the effort. The table where bread is broken among loved ones is the altar of the home and should be adorned daily. All cotton is machine washable, and salt helps get out red wine stains, so don't worry about spills and messy eaters. The joy you feel from a wide variety of textiles from around the world brings the globe to your intimate table.

Draped table with overcloth

If you have a round table, drape a cloth to the floor and cut it ten inches too long with pinking shears so you don't have to hem the bottom. You can tuck the edge under, creating a balloon look. A small square overcloth looks well on a skirt draped to the floor. If the draped tablecloth is patterned a white square looks especially attractive. Try a colorful silk scarf to add vibrancy to a solid cloth. Let your eye dictate how much overhang you want. Don't be afraid to experiment with mixing colors and patterns. By doing so you will breath new life into your meals and your home. With a patterned tablecloth, try a range of solid-colored napkins. With a solid tablecloth, use a mix of patterned napkins. Keep the colors and the scale of the print compatible to maintain harmony. Continuously expand your scope of possibilities.

Keeping the excitement at the dining table is a key ingredient to the celebration of home. A meal could be Chinese food delivered to your door, but if you pay attention to the table decoration, creating a Zen mood complete with chopsticks, you will feel enriched as well as increase your enjoyment of the flavors of traditional Chinese cuisine.

Tray with linen napkin

Think of a tray as a small table that you can adorn with a place mat or napkin as a cloth. Place a square napkin in the center of a rectangular tray, and then twist it so the top and bottom of the napkin generously overlap the tray edge in an upside-down triangular shape. Just as there is an art to folding napkins, there is an art to setting up a tray or table with fabric to enhance any home dining experience and continuously please the eye.

Just as an attractive gift box doesn't need to be wrapped, a beautiful table doesn't need a cloth to make it festive. If you choose not to cover your table, you can run ribbons the length and width of the table, and lace them together. You can even make your own tablecloth by weaving ribbons together using a solid-colored cloth underneath so the ribbons will show off against a background color. I've made two ribbon tablecloths for festive moments, one for a client and one for me to use in the colors of pansies—purples, whites, yellow, and fuchsia on an apple-green undercloth.

Chest of drawers for linens

Ribbons always add to the gift of celebration. You can tie a bow around a vintage napkin, a flower container, or a curtain rod in a coat closet. Ribbons can become tiebacks for curtain panels, or be sewn on the backs of cushions of wooden side chairs to secure the cushion to the chair legs. They can be used for a decorative braid on a curtain, sofa, or chair flounce, or as bookmarks. The decoration of your house will be more fun when you have a supply of colorful ribbons. Buy them by the bolt to save money.

Wherever you travel for the rest of your life, you will continue to collect textiles to use as napkins and tablecloths. And

when you have attractive cloths and napkins you won't want to keep them hidden behind a closet door. You'd rather look at them regularly and be inspired to use them every day. A client has a huge antique blue high cabinet with open shelves where she keeps sheets, towels, napkins, tablecloths, baby-pillow cases, tray covers, place mats, and handkerchiefs for maximum visual enjoyment.

If you have a collection of cotton table linens you love, washing or ironing a favorite set of napkins or tablecloth can envelop you in their beauty. Whether you're hand washing, ironing, or hanging a floral table-cloth on the line, your heart can always be sweetened by the colors and accumulation of memories. Handling these nostalgic pieces of cotton adds to the anticipation of future events as your present is enriched by the past. Enjoy putting some of your favorite table fabrics around, indoors or outside, anchored with pitchers full of flowers or a potted geranium.

CREATIVE OPPORTUNITIES FOR FABRIC

In addition to furniture uphol-stery, curtains, and table and bathroom linens, there are dozens of opportunities for you to incor-porate fabric into your decorating scheme. While buying antiques in Avignon for a client several years ago, I found an old French table and was touched when I noticed that the inside of the

French Provincial paisley-lined drawer

drawer was lined with a French Provincial paisley. We all love to be sur-prised when opening a box or drawer to find a pretty textile. Clients with collections enjoy stretching fabric on the inside walls of a high dis-play cabinet, and when the tiny lights hidden under the shelves are turned on, the texture of the silk or velvet highlights the beauty of the porcelain or crystal. Rich dark-green velvet enhances the light-reflect-ing silhouettes of the crystal objects.

You can cover padded hangers with a favorite fabric, or make small laundry bags for hand wash. The ironing board, one of the household's

Fabric-lined display cabinet

most used pieces of equipment, can have a pretty sarong or slipcover resting over it when not in use. To protect your computer from dirt and dust, drape a favorite piece of cloth over it. If you have a lightbox for slides, fabric will protect it from scratches. Pot holders and mitts can always be made from pretty fabric, as well as aprons with pockets for cooking and cleaning. A chest of drawers can have a bureau scarf, and your sewing basket can be lined in a colorful fabric even if it is just a napkin. Consider lining the vegetable bins in the refrigerator in a check or plaid hand towel to absorb the extra moisture.

Lampshades can be pleated in a fabric that coordinates with the room colors. Hat boxes also can be covered in a chintz with gimp or ribbon crisscrossed and tacked down so you can use the lid as a memory board where you can tuck treasured snapshots, postcards, and notes. Using glue or Velcro, place ribbon on the edge of the linen closet shelves. Storage boxes for files can be fabric covered to make the practical aesthetically pleasing.

An armoire looks attractive with shirred fabric behind the glass or wire front panels. In an old-fashioned pantry with glass cabinet doors, a cotton material shirred on thin rods top and bottom adds color and harmony, hiding the hodgepodge of china and glass within. In a storage closet, a fabric skirt can conceal supplies. A closet can have a curtain rather than a door, or a room can be divided with a curtain made from fabric whose two sides coordinate with the rooms' schemes. An end table can be draped in fabric, and even the cushion of a dog's bed can be slipcovered in a material that coordinates with the room.

Pantry with shirred fabric doors

Line the wells of dressing-table drawers in fabric. Glue a piece of silk or velvet to the back of a standing picture frame so the mirror on the wall behind will reflect a pretty color. Glue wool felt on the inside surfaces of storage containers. Storage doors can be framed in wood, made to slide, and covered in fabric. A portfolio on your desk can be covered in fabric or needlework, and tied in a ribbon. Your tote bags, duffel bags, laundry bags, eyeglass cases, change purses, cocktail napkins, jewelry

pouches, handkerchiefs, exercise mats, and tea cozies are all opportunities to sprinkle fabrics around that delight the eye.

Always stay true to yourself and surround yourself with fabrics and ribbons you love. Look at each piece of fabric in your house and ask yourself, "What does this say about me?" If you reach under the sink to grab a rag and it looks like a dead mouse, it will frighten you. Why should you even use depressing colors for rags when you can clean with beautiful, cheerfully colored ones? When you finally have to retire an antique blue-and-white pillow cover, you now have a fancy cloth to dust and polish your antique tables with, and it makes all the difference. Worn-out pyjamas, nightshirts, and shirts can be cut up for cleaning and polishing. One hundred percent cotton softens with age, so it feels wonderful to the hand as you work to put some shine around your home.

A LOVE AFFAIR WITH RUGS

Fine rugs can add a great deal of color and texture to a room, but people have been fooled into believing they must have a rug on every single floor in their house including the kitchen, basement, and bathrooms. When clients hire me, they usually want to look at rugs right away rather than contemplate the possibility of bare hardwood floors. When people don't know what to put on their floors, they often end up with wall-to-wall beige carpeting without paying attention to the unique spirit of each space. When I insisted that all the floors in a couple's eighteenth-century house be old wood, not wall-to-wall carpeted, I was confronted with two long faces. I explained to my clients that each room deserved to be treated according to its individual function and aesthetic vocabulary.

I have designed rooms with fine old rugs as well as with colorful contemporary ones and know that when they're right, they're a brilliant addition, but when they're wrong, they're disastrous. Rugs are too often dark, heavy, light absorbing, and dirt collecting. When they have too high a pile (thickness), they tend to make you feel seasick and your furniture wobble because the floor is too soft, not the desirable terra firma. I'd far prefer a cotton or wool dhurrie rug or striped cotton rag rug,

the kind Carl and Karin Larsson lived with, to a sculptured, bordered wool rug that gives off an air of pretension. Sculptured wool rugs are expensive to buy and cumbersome to transport, store, and maintain. They curl at the corners, fray, stain, wear out, and wrinkle. Thick is more expensive but not necessarily more attractive. A good rug should have integrity on its own, not be contrived to match a specific room decor. Custom-colored and –designed rugs should be whole unto themselves; when they are they will add an aesthetic dimension to your room.

TOO BEAUTIFUL TO WALK ON

*I*t is perhaps because I love beautiful handmade rugs so much that I am cautious about using them. There are rugs, and there are rugs that are true pieces of art. There is nothing more fun than hunting for a one-of-a-kind rug that speaks to and for you. When the weave, pattern, and colors are put together by an artist, they have a beauty that adds quality, warmth, and refinement to a room. But often such rugs are so exquisite, you can't stand to have people walk on them.

George Wells rug

When George Wells, a renowned maker of hand-hooked rugs, designed a vegetable garden hooked rug to go on the floor of a Texas kitchen, the client ended up hanging it on a wall between two windows so he could appreciate its beauty and artistry from the dining room and living room. For a square entrance hall of a house in New Jersey, I designed a rug that consisted of geometric shapes and swirls similar to the pattern of an Emilio Pucci scarf in bright pastels with touches of black. My client refused to put this masterpiece on the floor, instead hanging it on the large wall opposite the entrance door.

Another client commissioned George Wells to make a flowered rug with a ribbon border for her large entrance hall in Birmingham, Alabama. When the rug was delivered, she locked the front door for fear that someone would walk on it and track dirt. Everyone—friends as well as family—now has to enter her house through the garage. On rare occasions the front door is unlocked, but only after clear plastic runners are placed on top of the rug, rain or shine.

People can become needlessly obsessive about their precious rugs. In 1961, when I lived in a dark, depressing apartment down a few steps

from the first floor at the rear of a building, I bought an inexpensive, reversible, wildly colored and patterned wool rug from the Tunisian Trade Center on Fifth Avenue. This was the only art we had in the entire apartment, and I always made my guests remove their shoes and wear white cotton Japanese tabi when they entered the living room. While I've overcome my fear of dirt, many clients haven't. I have a client who hides a vacuum cleaner under her bed flounce because she never wants her jade-green wall-to-wall cut pile wool carpeting to show any footprints. When I went to a client's house early one morning, the maid admitted that after she vacuums the bottle-green cut pile stair carpet, she uses a sticky lint remover to pick up all the lint and light specks of dirt.

Why subject yourself to the misery of constantly worrying about your two high-strung poodles staining your white wall-to-wall carpeting? The floor, whether covered with rug or not, is to be walked on, and everyone doesn't have a mud room. If you're a perfectionist, any rug will do you in. At an island beach house, a child sat on a blue-and-white rag rug in a wet bathing suit and the dye ran, bleeding into a pool of blue ink. The rug had to be returned to Haiti to be repaired. You can't assume anything, especially with rugs. To save money, a client tried to clean her wool hooked rug herself, and the red dye bled into the other colors. Another client complained to me that the expensive flower-strewn rug at her front door is constantly being used as a doormat where her guests wipe their feet. One client called me screaming in anger that the carpeting in her sun room was defective, only to learn from the inspector that the culprit was his cat who was pulling all the loops loose.

Once clients took me to their mother's house, where we showed her the printed linen we were using for her son's library curtains and the gold Thai silk we had picked out for his sofa. She got up out of her chair, walked to the hall and, with the strength of a construction worker, hauled out a rolled-up rug, untied the strings, and unveiled the most beautiful antique oriental rug I'd ever seen. She'd never used this rug because it was so fine, but she felt it was meant to be used, and obviously in her son's library. She gave him the rug as a house present. This rug has tulips in a loose, uncontrived design, and the colors and pattern couldn't have been a more attractive complement to the curtains and sofa. The antique walnut partner's desk, the floor to ceiling books, and the yellow-glazed walls in this distinguished room were an ideal background for this museum-quality rug.

The Genius of George Wells

The hand-hooked rugs by George Wells are among my favorite decorating elements. After thirty years clients still love the rugs he created for them. His design capabilities range from a rug with squares of flowers and fruit appropriate for a traditional English living room, to one with birds in flight for a ranch in Texas. One client had Mr. Wells make a rug for each of her children. Her daughter had all her favorite things in her rug, including a doll house, a cantaloupe, a bluebird, and ribbons. Her son chose a barnyard theme, with a red barn, animals, and a white picket fence as a border. Mr. Wells died a decade ago, and though his shop, The Ruggery, in Glen Cove, Long Island, continues to make hand-hooked rugs in his style, his signature "W" is no longer woven into the wool. Rugs with his signature are collector's items, and popular at auctions.

Small, charming George Wells rugs come in ovals and rectangles as well as octagons, and in a limitless variety of subject matter, including animals and flowers. One oval rug has geraniums in a basket, another rectangular one has tulips in a row, showing their bulbs. He made rugs as well as stair runners incorporating all the interests of the family. For a client who was an avid gardener, he hooked in thirty-nine of my client's favorite flowers for a stair runner, trimmed on both edges with a striped ribbon design.

A client enjoys designing his own rugs and hooking them himself. He's set up a corner in his study to work, surrounded by Shaker baskets inherited from his parents' collection filled with vegetable-dye yarns. Because he was such an admirer of George Wells, he'd go to Wells's studio and watch him and his staff work. For years Mr. Wells sold my client his yarn. Today, The Ruggery can mail rug canvas to you with different designs and yarn so you can hook your own rugs. If you want a larger rug and you can't afford to have them hook it, inquire if they'll design it, help establish the colors, and draw the canvas for you.

Selecting a Rug

There are as many types of rugs and carpets as there are different textiles. Whether you like oriental or Turkish rugs with their

Turkish rug

Sisal rug

Portuguese needlepoint rug

rich colors and strong patterns, the southwestern look of Navajo rugs, Indian dhurries, or stripes and plaids in rich colors, there's a rug that will speak to you. There is even a wide range of natural-fiber rugs—sisal, jute, and sea grass to name a few—that come in natural colors or dyed and give an earthy texture and a subtle pattern to the floor.

Some of my favorite rugs are Portuguese needlepoint: I use them in living rooms, studies, bedrooms, and sitting rooms. I have used a few in dining rooms, but they aren't very practical in spaces where chairs constantly rub back and forth.

Fine old rugs from the East are subtle and beautifully designed, but they are also exceedingly expensive. New oriental rugs are not as soft and subtle, usually having a heavy color palette, and they tend to take over a room. I prefer the woven wool or cotton dhurrie rugs from India to new oriental rugs. They have a light and cheerful style, and their geometric, striped, and floral patterns can lift up any room. They're relatively inexpensive and reversible and can be custom-made both in design and color. Old dhurries are also available in cotton; many of these are treasures and much preferred. The wool versions are made specifically for the American market.

Oriental rug

For formal rooms, I particularly enjoy Spanish hand-knotted cut pile rugs. They have a soft, luxurious appearance in gentle coloration, so they look especially harmonious in a room full of chintz. Because these rugs have a cut pile, they are appropriate for a formal dining room. For a client who lives in a brick Georgian house in Connecticut, we created a soft pastel palette combining the trees, flowers, and birds in the state.

When you want a rug with texture and a more casual feeling, something that is more tailored, more handsome than pretty, consider a braided rug. Braided rugs are not only Americana but can be quite stylish in the right colors and setting. I once custom ordered a braided rug with several shades of green

Navajo rug

with white for the bedroom hall of art collectors, and it works well with their paintings.

I find cotton rag rugs charming for vacation houses, ranches, beach houses, informal cottages and apartments, and children's rooms. I keep a stack of small, colorful cotton rag rugs to use as runners in the hall and on the bathroom, kitchen, and bedroom floors. Rag rugs can be multicolored or monochromatic. They are an inexpensive option because they are literally made from short scraps of cotton. The dying process has improved, so the colors don't bleed like they used to. They're easy to incorporate in any setting, particularly more contemporary rooms, sun rooms, and rooms for the young at heart. Rag rugs are reversible, and the small ones are ideal for closets, bathrooms, kitchens, and the laundry room. Placing one on each side of the bed is a grace note. With a rag rug, the cotton is rolled, looking like short straws and held together with thin thread so it looks extremely textural because of the irregularities. These rugs provide fresh, cheerful colors, and have the spirit of leisure and happy times. They can be made in any size.

I usually prefer loop to cut pile rugs unless the rug is antique, because they have more interesting texture and don't show foot marks. Fine, handsome rugs can be a combination of loop and shirred, where the rug is woven with a loop, and the artisan randomly cuts some of the loops so you see the end of the yarn and not the side. In the hands of master craftsmen, such as V'Soske, Inc., yarns can be ombré dyed so a color is irregular in tint, lending a subtle variation that adds depth and interest.

I advise against laying a velvet pile rug because the velvet crushes too easily under furniture legs, causing permanent damage to the rug in spots. If you ever decide to rearrange the furniture, you will reveal every blatant chair or table leg imprint. Temporary yet obvious shoe prints are also unavoidable as soon as anybody enters the room. This type of rug is used in a room where few are invited to enter, the furniture is never moved, or the maintenance is constant.

Berber wool rugs and carpets have heavy, irregular slubs of wool, creating a nubby look. They come in a wide range of natural colors and weaves, and are appropriate for informal rooms. While they are usually used wall-to-wall, they can be made into area rugs, bound at the edges in the same color.

Loop pile

Cut pile

Area rugs, islands on a sea of wood, come in all shapes and sizes. Thomas Jefferson loved ovals, creating oval rooms, flower beds, and rugs. However, I prefer rugs to mirror the shape of the room, and most of us don't live in oval rooms. A square rug in a square room is appropriate. The size isn't as important as the shape and how the rug works with the furniture. Area rugs range in size from four by six feet to sixteen by twenty feet. Using the grid paper with your floor plan, doodle with rug sizes that appeal to you.

In thirty-six years of decorating, I have never cut out a rug around a hearth. It is always best to start a rug flush with the edge of the hearth molding. Round and oval rugs are difficult to place under furniture that is rectangular. If you have a rug custom made, be sure to measure carefully. It's better to have it a few inches too small than too large. Once I special ordered a handmade Portuguese needlepoint rug for a dressing room that, despite specific measurements, was two inches too wide for the room and had to be cut down. The company sells all custom-made rugs, for example, "approximately nine by twelve or twelve by eighteen." If the design works out so the weaver needs a few extra inches to make it symmetrical, the weaver has aesthetic license. So beware. Some rugs are made on narrow looms and have seams; accordingly, ask to see a seam plan before you order a rug. Never have a center seam; it will be more obvious, and will unravel. It is better to have one seam on either side than a central one that is destined to get the most wear. Where there is a center, there should never be a seam. This rule applies to all decorating decisions, including mirrors.

When hunting for a rug, wait until you find one that speaks to you. Once you find a rug you like, you might be surprised that it isn't at all what you thought you were looking for but much more interesting and alluring. There is no rule that dictates what size the rug should be; it depends on how much wood floor you want exposed. You need not have one big rug in the living room, for example. One of my favorite living rooms had two old, soft-green patterned rugs. A client had given us one of these rugs when she moved, and later we found a rare mellow pastel that went well with the other. Buying a rug merely to cover the floor lacks integrity unless you are drawn to it aesthetically. Keep an open mind and heart about size. Ideally, all four chair and table legs should be on or off the rug, but with a sofa and an upholstered chair you can get away with having the rug underneath the front legs only.

Generally, the flatter the rug, the more subtle and fine it is. Look at some woven silk rugs and you'll agree. Go to auctions, showrooms, department stores, and home furnishing stores as well as specialty shops. You will be amazed at the variety of possibilities and you will learn more about your preferences.

WALL-TO-WALL CARPETING

*T*here is no substitute for exposed wood floors, and I feel that most wall-to-wall carpeting should be ripped out. It is usually either dull, dirty, or both. In hotel rooms, lobbies, and movie theaters, the carpeting can give you indigestion because it is so busy in order to hide dirt. I've had to be the bearer of bad news dozens of times, telling people their carpet was hopeless. One client had a synthetic green wall-to-wall carpet throughout her house. The dog's urine made orange spots that cleaning liquids could not erase. Although wall-to-wall carpeting absorbs noise and is soft underfoot, I almost always discourage its use. If you have worn patches or permanent stains, you'll have to rip out the whole installation or learn to live with it. Both are painful options.

One example of an appropriate place for wall-to-wall carpeting is in a long hallway in an apartment where children run up and down continuously. In one such case, a client with young children had a wide runner in her hallway that was always puckering. Even when it was nailed down this recurred regularly. When she redecorated, carpet layers installed instead a soft-green floral wall-to-wall carpeting, firmly nailed in place. With the soft-green walls above a white trellis dado (the lower portion of a wall when designed differently from the surface above), and dozens of botanical watercolors, the hallway now looks like a garden. The carpeting also makes the hall seem much wider than when there were two brown stripes of wood on either side of the runner.

Wall-to-wall carpeting also makes sense in a tiny dressing room or closet, or in a home office where you need sound absorption, though I'd prefer cork, wood, or tiles in all cases. Even if a floor is in horrendous shape, it can be fixed. Floorboards can be replaced. Wool wall-to-wall carpeting with quality and style can be as expensive as a new wood or ceramic tile floor.

Many people in America have wall-to-wall carpeting because they never considered the alternatives. If a carpeting is desired for safety reasons—to cushion the fall of active children or unsteady walkers—then the option is appropriate.

If you choose wall-to-wall carpeting, select one hundred percent wool if possible because as a natural fiber it is more beautiful, more durable, and easier to clean. Choose a loop pile because, as mentioned, cut piles show every footprint. But be sure your cats and dogs don't scratch at it. Cut piles are probably more cat-friendly than people-friendly.

Never use wall-to-wall carpeting in a bathroom. It is unsanitary and will smell bad within a week. Try to avoid using wall-to-wall carpeting in the living room, entrance hall, and dining room. If you want carpeting on your stairs, don't completely cover the treads and risers. Wood should show on either side. A runner with wood borders is usually most appropriate in an upstairs hall unless the space is exceptionally narrow. Always use a lining under any rug, but in a long hall you may want to further anchor a rug with small-headed nails to avoid bad falls.

RUG LINERS

All rugs should have liners for safety. The rubber or hair of the liner may discolor the wood floor over time, but it will provide necessary protection to the underside of the rug as well as to the floor. Usually carpeting liners are made of forty-ounce hair and jute, whereas flat-area rugs—dhurries and needlepoint—use a one-eighth-inch rubber nonskid liner. I advise that you have a safe rug with a rubberized backing in your bathroom.

LET FABRIC AND RUGS ENHANCE YOUR HOME

Rugs turn your floors into art. In a friend's dining room is a soft-blue dhurrie rug with flowers and vines in pinks, greens,

and yellows. This cheery rug is charming with her dishes, napkins, and tablecloths. In a client's living room is a custom-made raspberry-and-white–striped dhurrie rug that looks enticing with her ribbon chintz. If you love doing needlework, consider making a rug for your living room hearth, leaving the rest of the floor's gleaming wood to reflect the firelight.

Fabrics and rugs surround you with favorite colors, sensual, rich textures, pleasing patterns, and above all, your expression of beauty. These tactile textiles and weaves can be enjoyed throughout the day, in every room and closet. Take time in all your selections and have fun in the process. The fabrics and rugs you choose will be with you for a long time and should be life enhancing, opening up your heart and soul to intimate private pleasures as well as allowing your eyes and those of family and friends to feast on the tapestry of your home.

Art and Collections

Whatever you can do or dream you can, begin it;
Boldness has genius, power, and magic in it.
—JOHANN WOLFGANG VON GOETHE

THE RELATIONSHIP BETWEEN YOU
AND YOUR ART

What is art? There is no single answer to this question because everybody has an individual sense of art. Many people define art as self-expression, though I feel that for something to qualify as true art, there must also be beauty. Through art, you bring nature's beauty and light into your home. In every house, however, a soulful connection must exist between the owner and the art that is a unique expression of the heart and soul of the personality who lives there.

In your own home, you are the artist. You paint the canvas that radiates light. In the privacy of your home, you're free to express your enthusiasm and passions. When you follow your heart at home, without looking over your shoulder, you will decorate your house with art and collections that speak of who you are, what you enjoy, where you've traveled, and how you view the world.

Money alone can't turn a house into a personal autobiography; in your journey through life, you will accumulate a wide variety of tangible objects. You will acquire collections that are an exclusive expression of your lives. Certainly there will always be show-offs, but whenever a house is put together to impress others, it reflects that type personality. On the other hand, when you surround yourself with inanimate objects

and pictures that speak to your soul, your things connect you to others, and become animate, alive with your spirit. Everything, ultimately, should project your sense of ideal beauty and harmony. When the statement you make comes from deep within your heart, you will really feel at home, and so will others.

THE MIND OF A COLLECTOR

*A*nyone can be a collector. All you need to do is begin. One seashell is a decorative object. Three or more seashells is a collection. When you collect, you gather things together, you accumulate. The collector transports himself into a better world. Not everything has to be useful. The more varied your interests, the more dynamic your collections. Collecting elevates your mood. And, when you are attached to the things near you, possessions are no longer mere merchandise. When you gather meaningful objects together while you're here on earth for such a short time, you become the curator of these personal treasures. You will leave them behind for future generations, as traces of your humanity, as more permanent footprints in the sand where you've walked on your path.

Two different personality types decorate houses. One wants to decorate the house once and for all; these people have other things to do with their time and want to get on with the business of living. The other type understands life as a process of unfolding, and the decoration of houses as an integral part of that process. Each day is an adventure as you experience daily appreciation at home, surrounded by intimately important possessions. You discover new collecting interests, become more knowledgeable, and, in time, experienced. On trips to exotic island beaches you gather seashells. From working at a fashion magazine you collect black-and-white photographs. Because you inherited your grandfather's train set, you develop a passion for collecting antique toys.

The person who rushes to decorate a house is probably not a collector. Everything is bought for a precise place, and once it is "in place," there it stays. If this person is fortunate enough to have domestic help, you often hear about how he or she is compelled to make sure that everything is put back in exactly the same place. These objects lose,

don't gain, meaning over time. They remain separate from the owner rather than having an alive and breathing presence in the home. Unless objects are fondled, moved around, and cherished daily, they lose meaning and energy.

I find it bizarre when a client feels it necessary to know exactly where everything will be placed before any purchases are made. There should be a sense of play with these favorite things, these objects of affection. When you love something, you want to touch it, move it from place to place, rub it, hold it up to the light, mother it. These things you love have spirits, and when you genuinely care for them, you are deepening your connections to the past and future. You learn about yourself, over and over, by the heart-pounding, surprisingly powerful effect that objects of beauty have on your soul. Recall Albert Einstein's strong belief that "imagination is more important than knowledge." When something sings out to you, use all your creativity, inventiveness, and resourcefulness to envision five hundred different places where this something you love can go.

Your home is a projection, an extension of your heart and soul. The reaction to one's immediate surroundings matters to contemplative spirits who want their house to represent their ideal. As your aesthetic becomes more defined and refined, you will wish to make changes that reflect your growth. Claude Monet stretched his artistic vision, including improving his garden, until he died. Carl Larsson and his wife Karin continuously made changes and additions to their beloved homestead. The house can be a constantly evolving, rich resource of beautiful works of art and objects speaking a language that communicates your inner passion.

The urge to collect begins at a very young age in most people. My passion for collecting began with seed packets. My eyes grew as big as saucers each time I ventured into the general store where I could buy them for a few pennies each. Then I began collecting five-cent art postcards, putting them in shoe boxes, feeling that I was a real art collector. After my seventeenth-century English oak joint stool purchase, I bought my first oil painting, a sailboat with a yellow and lettuce-green sail at sunset that turned out to have been painted by an English Impressionist. I made both modest purchases at auctions when I was a teenager. Early in life I had the fever to become a collector of art and objects that made an impression on me. I was discussing the joys of col-

lecting with an antiques dealer from England, and he said, "If you buy one antique a year, in ten years you'll have a collection." This is how I became a collector of art and antiques. I began my journey with two thirty-five-dollar auction finds in the late 1950s, and now I'm able to save money to purchase a painting as well as one good antique a year. The novelist Henry James defines this passion as the "mysteries of ministration to rare pieces."

When I was twenty, my mother bought me my first Roger Mühl painting. I was sent by my boss to see the first exhibition in America of this contemporary French Impressionist and select a painting for a client in New Orleans. Walking into a room filled with his paintings for the first time was a life-changing experience. At that moment I knew deep inside that I'd eventually find a way to collect paintings by this artist. I decided to share my newfound passion with my mother, who purchased for me my favorite painting in the exhibition, a generous gift that jump-started my most meaningful collection.

Rushing this process is always inappropriate; it robs you of a sense of anticipation, adventure, and meaning. There should be many tender affinities that connect you and your art, that draw together the inward soul and objects of affection so that the two become one. Rooms build over time and anytime they are falsely, mindlessly, put together, a dead, sterile atmosphere results. When you explore antique shops, country fairs, auctions, art exhibitions, and galleries, with the goal of adding one picture or one decorative object to your house, over time you will accumulate favorite possessions that will become increasingly important to you, and many are likely to rise in monetary value. Because you'll have to save money and sacrifice to acquire these real objects, they become a source of energy that cannot be duplicated by a random object purchased with little thought to go on the coffee table. Without a strong point of view that comes from your heart, rooms look like gift shops with a hodgepodge of random objects. You are more likely to regret what you don't do, rather than what you do. Better to wait for a soulful connection between you and an object of art than to settle for mere acquisitions.

Collecting a "few of your favorite things" over a lifetime is a joyful way to hone your aesthetic and teach your eye to see and understand the most subtle details that add grace and charm to a work of art. Because of this lifelong affair with the decorative arts, I've grown to appreciate a wide

range of objects of art. You'll learn to trust your heart completely after you've made several purchases you feel are meant to be. All the things I've owned that weren't acquired out of love and passion I've given away to others. I only want to live with things that speak to me. And I've found that whenever I'm true to myself, I'm also a part of someone else's pleasure in experiencing a connection.

As you collect objects of art that attract you, you will invariably see a cohesiveness, a repetition of theme, shape, and form among them. If you're attracted to clocks, you can have a small grandfather clock, several brass carriage clocks, and small enameled clocks on end tables. They may differ in design and scale, but they are still all clocks and therefore work well together. If you love boxes, you can collect them in a range of sizes and materials: Tea caddies,

small porcelain pillboxes, and letter boxes all work together as a collection because they are all boxes that speak of your spirit. You may be attracted to crystal paperweights or pieces of crystal and stone, eggs, hand-painted marbles, or stone balls. You might collect pitchers in clear or colored glass and in painted porcelain. If you love bells or old magnifying glasses, or if you like old quilts, antique books, or porcelain and glass fruit and vegetables, your vital interest in these collections will tie them together aesthetically. If you like trompe l'oeil objects, it doesn't matter what you collect, the different pieces will go together.

EVERYONE CAN BECOME AN
ART COLLECTOR

*E*veryone can afford to be an art collector because there are so many beautiful things to collect in such a wide variety of categories. If you do not have the budget at this stage in your life to buy

paintings, you can collect prints or lithographs or inexpensive watercolors. You can buy reasonably priced frames at art supply stores that look elegant and professional when hung. In many museum stores you can purchase eight-by-twelve-inch prints that cost about twice as much as postcards and are charming when framed and hung in a group. Another inexpensive alternative to original paintings are artist's catalogs. Cut out your favorite pictures and frame them for an attractive addition to your room. I fell in love with a flower still life by Henri Fantin-Latour when I spotted it in a magazine. I knew I would never be able to own this painting, so I cut out the striking painting, framed it, and included it in a grouping of other flower pictures. Every time you look through a magazine, keep a pair of scissors with you. Keep these clippings in a box so you can indulge your eye whenever you want a quick dose of refreshment and inspiration. Display a few favorite postcards on small easels or frame them.

Some people are incurable collectors, leaving home or work to do a simple errand and returning with a shopping bag full of new finds that may range from a teacup and saucer and cobalt-blue English poison bottles to an old inkwell, a brass carriage clock, or an antique child's chair. Stonington Village in Connecticut, where my husband and I live, has lots of antique shops on Water Street. Living in an eighteenth-century house draws us to collect things for every room, including the kitchen. We find old tools, watering cans, and wheelbarrows as well as old shutters, windowpane mirrors, and ladders to use decoratively outside and inside. We've grown not to worry about the distinction between what belongs within our interior space and what belongs outside our walls.

The treasure hunt never ends for collectors. Whether you explore dealers' garages and auctions or travel to all corners of the world, somewhere there will be something destined to come home with you. Then you'll love the object, use it, care for it, delight in it, and pass it on to your children. The process is as much fun as the find. Whenever you go snooping around, picking up clues and letting your intuition lead you to places where your eye is nourished and your love of home is fueled, you're blessed.

Think of your house as an artist's studio. Alexander Liberman's important book *Artist in His Studio* reveals the objects of inspiration for

a number of famous artists. By sensing the karma and inspiration of certain treasured things, you can use the rooms of your house as your medium for artistic expression. When the very air you breathe is full of loving energy, and everything in your home has a story to tell that is etched in your soul, when there is a sense of unity, peace, grace, and harmony enhanced by the significance of the objects you accumulate over a lifetime, you become a master in the art of living and are forever blessed and content. It's human nature to desire more than the purely utilitarian in your home. You do not collect out of restlessness but out of a passion to connect to the energy of the art that a fellow man has created. You can draw pleasure from the individual aspects of the decoration that form the mood and spirit of your surroundings. They become a part of you and you of them, and the mystery continues to unfold and evolve and enrich the fabric of your daily life.

Anne Gordon porcelain

PROTECTING YOUR ART

Just as the sun fades fabric and rugs, it can also destroy watercolors, lithographs, and prints. Even the light from table lamps can damage nearby art. To prevent this, use museum glass or treated Plexiglas in framing and regularly rotate your pictures so they're not exposed to the same light intensity regularly. If you have a collection of watercolors, you should be sensitive about preserving them. Try to hang them where they never get direct sun. But if you live with art, you have to tolerate a certain degree of fading.

CONNECTING WITH THE ARTIST

When a client asks me to help select a painting, I go along for the ride but always wait for them to make a unique, personal connection to a particular piece of art. It's that brief moment that catches you off guard where you see a painting or object and immediately get a lump in your throat, followed by a sense of lightness of being, a joyfulness that means you're hooked.

In the late seventies I began collecting Anne Gordon's contemporary porcelain fruit and vegetables as well as watercolor botanicals painted by her husband, Alastair Gordon. My passion led to an invitation from the antique dealer to meet the Gordons when they were visiting New York from their home outside of London. Over the years I'd collected her delicious, colorful trompe l'oeil cabbages, lettuces, apples, pears, lemons, limes, eggplants, asparagus, artichokes, pea pods, and cauliflower. Now she wanted to see them in our apartment. Because she is one of the the premier potters alive today and her pieces remain incomparably beautiful, I was grateful to meet her and make the human connection between the artist and the work. Over the years I've learned more about the creator's process, how a piece is formed, put in a kiln, and hand-painted. Learning that her method is hundreds of years old deepened my appreciation for all porcelain. Because of my passion for her work and her husband's masterful botanicals, I became their dealer in New York for more than ten years, a most joyful experience.

When a client heard lectures on French Impressionism at the Metropolitan Museum of Art in New York, she developed an intense interest in Claude Monet. The next year, she and her husband made a pilgrimage to his house and gardens at Giverny, France. Being able to meander through Monet's gardens, walk on the Japanese bridge overlooking the lily pond, stroll through the flowers and trees he so dearly loved and painted, and then wander through his house led this couple to see color in a new, illuminated way. While they know they will never own an original Monet painting, the framed Monet print in their breakfast room and Monet-inspired fabric in their family room keeps alive the connection they feel with the artist.

DISPLAYING PAINTINGS AND OTHER COLLECTIONS

When you have a collection of certain decorative objects, such as porcelain animals or brass carriage clocks, it is best to display them in groups. Do as museums do and gather "like-spirited" objects to display as a collection. But when a lot of different items are scattered all over

the place, the randomness will cause you to feel unsettled. Most paintings or objects by the same artist will look compatible together. A collection of baskets, even though the baskets may be different designs and sizes, can be grouped together successfully because they share essential characteristics. Whether you have a collection of watering cans, umbrellas, walking sticks, flags, school bells, magnifying glasses, medals with ribbons, pitchers, pens, or teapots, because they are all of a certain type of object, they will look attractive and gain impact when grouped together.

You should always have at least one common denominator when displaying your collections. If you have a collection of blue-and-white Chinese export porcelain, the pieces will look good together regardless of shape and size. If you collect children's chairs of different period styles and woods, these differences will add interest to the collection. Items of the same color or color combination, all blue or all white, for example, work well when displayed in a cluster. The same applies to materials: silver, brass, and wood all are enhanced when grouped with their own.

If your paintings are not by the same artist, they should have similar frames, color palettes, or subject matter so that they appear more harmonized. If you have photographs of family and friends framed on the walls of your study, have the same style frame for each picture regardless of size or whether the picture is black and white.

Extremely delicate objects with subtle detail and a small scale, semiprecious stones or hand-blown glass eggs or balls, for example, look best when displayed as a collection on a plate, dish, or tray so that they don't become lost among larger items on the same table or look too lonely. If you have small porcelain objects, you can place a decorative hand-painted plate behind them as a frame for needed emphasis. If you have a pen collection, you may want to lay several of the pens flat on a ceramic or glass plate where they will make a statement. If you have several small leather books, put three or four on top of each other and place two or three of these stacks together on a table.

Don't be too neat or exacting in your displays. If you line up objects of a collection too rigidly, the treasures will lose spontaneity and panache. Arrange your possessions with a "studied casualness" allowing freedom to move objects around. You may need to use a piece in one of your collections, a pitcher for example, and you do not want its absence to leave an uncomfortable void.

You can display a collection of colorful trays by resting a few against a wall with one or two hung above. Crystal paperweights will look most attractive displayed on a dark surface that contrasts against the crystal and highlights the colors. But a word of warning I learned the hard way: Do not place a crystal paperweight in direct sunlight. I went to my office at Fortieth Street and Park Avenue one Monday morning and a high pile of papers had a charred hole in the center, all the way down to my French eighteenth-century

desk. My imagination ran wild and I immediately placed all the paperweights on top of a table between two windows.

Favorite objects displayed on an open shelf will be appreciated more than those enclosed in a glass display case. If you have a corner cabinet with glass doors, keep the doors open. Clients have a collection of antique porcelain trompe l'oeil fruit and vegetables in a corner cabinet in their dining room, and they find that keeping the glass doors open

adds emphasis to the collection. When the rambunctious grandchildren visit, they simply close the doors.

Once you have your objects of art grouped together, throw in a few surprises. Among a collection of brass boxes, place a few silver frames with family pictures. The two light-catching metals will be compatible, gleaming on a waxed wood table. Should you have a collection of tea caddies, open the lid of one or two of them and place a water glass with a peony, rose, or some pansies inside.

Never concern yourself with where to put an object or painting. Not all art should be hung on walls and not all paintings need to be framed. If you have a small oil painting, you can put white tape on its four edges to hide the nails that attach the canvas to the frame. Galleries tend to overframe pictures in order to make them look more important, but in too many cases the chosen frame is overpowering. If you have a Bonnard watercolor, you don't need his name on a gold-plated plaque to experience its beauty. Be modest. The "swan" is my favorite frame for watercolors and lithographs. (It is the most graceful frame for every kind of artwork under glass because the rounded form curves toward the wall, so it looks gracefully generous when you see it from the side. Because of the lovely flow of the shape, the swan frame picks up light and the gold leaf sparkles.) Because of its inherent simplicity, it never looks overdone and can be scaled up or down to achieve the right proportion. Real gold leaf is only appropriate if it's affordable and doesn't overshadow the painting. (I'll cover framing in more detail in the next chapter.)

Artists don't need to be well known for you to feel comfortable purchasing their work. Your appreciation for your child's flower watercolor may be equal to or greater than your attachment to a painting by a more established artist. A client hung her favorite granddaughter's colorful drawing so she can enjoy it each time she goes up or down her stairs. She framed it in a gold-leaf swan, the same frame she uses for older, better-known artists.

Tea caddy

Art should be placed anywhere it can bring visual delight. In a client's bathroom, all the walls are mirrored except for the area beneath the tiled sink counter, painted soft seafoam-green over white with a dry brush so it looks like transparent linen. On this section of wall she hung a series of small framed prints so she could soak in some art while taking a bath. Another client had two framed lithographs on either side of his bathtub.

Paintings do not have to be hung on the wall, contrary to popular belief and practice. Mrs. Brown began a trend in the twenties by resting a small painting on the back of her sofa. You can also place a picture on an easel or put it on the floor, resting it against a wall. As a collector, you will always find a place for your favorite objects of art.

DISHES AS DECORATIONS

*E*ven objects you put to practical use every day can be part of a collection in your house. Your teapots, teacups and saucers, and decorative bowls and dishes become central to the spirit, mood, and atmosphere of the house. Look at your necessary everyday things. Do they represent a wide range of styles and tastes, or is there a unifying theme?

Decorative dinner and dessert plates can be hung on a wall with inexpensive spring-clip brackets. We all have pretty, colorful plates that would look attractive displayed in a group on the wall. I have clients who collect Canton blue-and-white china that we hung on the lemon-yellow walls of their dining room accompanied by tureens and vases in the two white corner cupboards. You can also mix decorative hanging

plates with paintings or other objects. I've hung hand-painted flower plates in our kitchen among shiny copper pots and pans interspersed with amusing trompe l'oeil plates. If two plates are the same size, you can hang them one over the other symmetrically. But when decorating a whole wall, hang them to please the eye, not a measuring stick.

The strength of color and decoration and the size and shape of the plate all have an impact on how the eye sees them. When you place them according to literal measurements, they may look static. Start with one, and then build from there. If you collect trompe l'oeil plates, using your eye is the only way to measure how they'll look in a grouping on a wall. Remember to move objects around to keep your eye refreshed.

I enjoy the refinement of porcelain dishes and display them throughout our rooms, including our bathroom where one hangs behind the sink. Their sheen and dainty designs look particularly attractive on old

wood. I also love to fill the decorative dishes with small objects, such as colorful stones, Venetian spun-glass eggs and balls, and hand-painted marbles in a rainbow of colors and place them on tabletops. Because I am so passionate about hand-blown glass, I have several clear dishes with colored cones of hand-blown glass on display. Hand-blown glass plates, bowls, and glasses bring abundant beauty to tablescapes, and can be found at craft fairs and department stores. You can begin by collecting hand-blown glass dishes in different colors for use at the dinner table, and then bring the objects into your other rooms, such as your bathroom, as soap dishes or water glasses.

Plates are also effective decorative pieces when placed on racks on a mantel or table, and are best displayed in pairs. I often have a pair of plates on a horizontal surface with an assortment of porcelain fruit and vegetables, creating a still life. Remember also your rooms can have seasons as nature does. If you feel the urge to change the blue-and-white china to a set of flower-decorated plates for summer, it is quick, fun, and easy to make the switch.

If a cup breaks and is beyond mending, use the delicately decorated saucer as a candy dish. If you have a colorful hand-blown glass plate you adore, enjoy it on a coffee table, add cucumber and tomato tea sandwiches, or biscotti or chocolates for a grace note over after-dinner coffee. Or use it to create a still life of pears or as a dramatic dish to place

underneath a vase filled with fresh flowers. Or gather six or eight votive candles and create a cluster of twinkling light.

THE JOY OF BASKETS

Beautiful handwoven baskets can be found in all materials from all regions and cultures. Aside from being handmade and functional, they're extremely decorative. I hang them from the ceiling and on the wall with brads, rest them on high shelves and atop cabinets, and group them on the floor. One of my favorite rooms is a dining room on Fifth Avenue with simple French provincial furniture, where a collection of Shaker baskets in graduated sizes graces a large sideboard.

Whether you place a basket filled with needlework or knitting in the living room or use it for stacking books or newspapers, it adds texture to a room and reveals the artist's hand. As form follows function, baskets are a work of art. They're useful, symmetrical, beautifully designed, sturdy, handsome, and soulful. Whether you store wood in a basket or use it for waste, this material of woven vines is always a welcome sight. I enjoy painted baskets in bathrooms, and use pastel baskets for waste as well as storage bins for pillows in the bedroom and for holding rolls of inspiring hand-marbleized paper in the study.

I have such a large accumulation of baskets that I store several of them under the butcher-block table in the kitchen for fruit, vegetables, as trays, and for picnics. I also have lots of old baskets that I put under a dessert table in the dining room. Sometimes I keep them empty, but often I put things

in them. Wherever you place them, whether in a bathroom filled with rolled towels or a collection of soaps, or in the library filled with an assortment of stationery, the baskets you use in your daily life add warmth and coziness to your rooms. All your bedroom and bathroom wastebaskets can be painted and decorated brightly. New baskets are inexpensive and are fun to paint for adding color to a room—a great project for the winter months. Painting the inside in wide horizontal bands of two colors can add cheer to a utilitarian necessity. Keep several white paper doilies in the bottom of your baskets, so they are always clean and fresh.

DECORATIVE BOXES

*B*oxes can provide decoration that is both refined and practical. You can accumulate a wide assortment from different countries and cultures. You may collect delicate antique enamel pillboxes, porcelain boxes, lacquered boxes, marbleized-paper boxes, and hand-painted papier-mâché boxes. Perhaps you have a special affection for antique

wooden letter boxes, mailboxes, or decorative flowered hat boxes. These make excellent storage containers for papers, socks, stamps, and other items. Later I will discuss using decorative boxes as storage containers.

Enamel boxes

Because most gifts are given and received in boxes, there is mystery and intrigue associated with them. Just as a cabinetmaker is proud of his dovetail drawers, a box maker is concerned with a box's inside. It is therefore not surprising that many boxes are most beautiful and interesting with their interiors exposed. One of my favorite tea boxes is lacquered cobalt-blue with silver Chinese rice paper inside. When I remove one of the two inside lids to put in the box a flower in a clear water glass, I nonchalantly leave the delicate lid on the table. A client has a lettuce-green, pink, and yellow Majolica ceramic box with a lilac interior; she always tries to leave it open so the surprisingly joyful inside shows.

We have several campaign boxes with brass edges. One is outfitted

with cut-crystal decanter bottles and lined with red silk velvet. We have a coin box with one hinged front panel that opens to reveal a series of pencil-thin drawers, all lined in velvet with different-sized circles for coins. Hours go by unnoticed as we play with this treasure. Another wonderful box has a hinged front panel opening to dozens of chubby drawers ideal for stamps, paperclips, and elastic bands. I keep the panel open so we can appreciate the details and the sweet brass pulls.

Campaign box

We have several document boxes. One we hold especially dear came from the Incurable Collector, Inc., a shop once located on Fifty-seventh Street in New York, owned by Alastair Stair who also owns Stair and Co., where Anne and Alastair Gordon's works of art—her porcelain and his watercolors—were sold. This rare black-lacquered box, originally intended for fans or handkerchiefs, has gold fan embellishments and "Easterbrook" inscribed on it, because it was brought to America from China by Captain Phelps Easterbrook, of Salem, Massachusetts, circa 1815. This box has meaning for my husband because his ancestors, the Estabrooks, are evidently of the same line as the Easterbrooks of Salem. Such associations heighten affection for objects.

Tea box with flower

If you purchase a fine old box, put the invoice in a small envelope tucked inside. This way you have the provenance handy in case you want to check on its history or pass it on with its pedigree. If you prefer, you can tape or glue the information on the bottom of the box, a finishing touch that is a grace note.

The floor is a great place to nest and stack beautiful boxes. Before letting your tabletops become too cluttered, remember that right underneath there is a perfectly fine space, framed by four legs, to display a few of your favorite boxes. Group them by scale and material, not shape. When you repeat stained wood, painted wood, or lacquered boxes, the variety of shapes will provide ample interest.

Coin box

FAVORITE COLLECTIONS

What do you collect? Who are some of your favorite artists, past and contemporary? What objects do you have a weakness for and find utterly irresistible when you happen upon them? Where do you go looking for your treasures? Do you have dealers, scouts, and

friends on the lookout or do you enjoy doing your own research? Do you read books to broaden your knowledge? Do you find your passions have changed over the years? Have you grown to appreciate new things?

Perhaps you collect memorabilia, saving mementos to preserve your family history for future generations. I have a client who is the keeper of family history for his extended family, and even frames menus from banquets as well as letters from friends and people he admires. Often he'll include a photograph of the person in the same frame.

Memory boxes

Over the years, I have put together several Florentine paper "memory boxes" that contain sentimental memorabilia collected over the years—everything from a theater playbill to a postcard, snapshot, or note. I keep dozens of them stacked in the library. Taking a box from a stack, putting it in your lap, and sorting through this potpourri of memories is a wonderfully colorful journey, and I'm glad the rest of the family enjoys looking back to learn more about their past, and reinforce the memories of their childhood. While most guests who come to visit never see the inside of these boxes, the boxes themselves are a feast for the eyes and grouped together are a beautiful collection.

When someone is considering hiring me to help with the decoration of his house, I always ask to be taken on a guided tour so I can study the art and collections. One client who was an archeologist had French blue wool felt installed inside the custom-made shallow drawers of a bookcase in his study for his beloved Roman urns and other ancient clay fragments. He also displays several mysterious objects on tables highlighted by halogen lights. Another client who is interested in conservation, preservation, and restoration has a vast collection of New Hall porcelain. When asked about these beautiful objects (she is as thorough as a museum scholar), she explains how she originally thought they were a Chinese export, only to learn later that they came out of an English porcelain factory that existed from 1782 to 1825. There are about two thousand different patterns, and many pieces were made with bumps and other flaws but were sold anyway. As she points out their delicate and charming sprig patterns, she comments, "My mother gave me a teacup and saucer, and look at me now." Her favorite piece is a basket with ribbons. When she moved to an apartment with no fire-

place in the living room, rather than putting a fake one in, she made her porcelain the focal point of the room. Housed in a refined Sheraton cabinet, the pieces provide a wonderful feeling and energy because of her obvious reverence for them. On an antique stool beneath the cabinet are several books on New Hall porcelain.

Whether you collect silver, wine, or old books, you will never be bored and your home will never seem sterile. In one home, a client has a glass-shelved display cabinet with dozens of beautifully hand-tooled leather books with a prominent sign on the cabinet that reads "Fore-edge Books." When I inquired about the meaning of "Fore-edge," the client took a red Morocco-leather book down from the glass shelf, caressed it tenderly, and pointed out to me the top, side, and bottom edges of the book and then the binding, all beautifully engraved in gold leaf. The book was quite magnificent, but I was still curious about what made this book fore-edged. Then, in slow motion, he fanned open the edge of the book like a deck of cards to reveal a splendid watercolor as delicate as a Fabergé creation, depicting a French eighteenth-century château with gardens. I was totally amazed. He proceeded to put back the red book and bring out the blue one. When he fanned open this book, he revealed a painting of people walking in a garden that looked like the Tuileries off the Place Vendôme in Paris. I was instantly drawn to touch one of these books, but I didn't want my thumbs to devalue one of the mint-condition treasures. The miniature art was so fine and detailed it looked as though it were painted on a solid sheet of paper rather than on the ends of all the books' pages. A subtle, understated refinement of rare value and interest teaches us there is no end to the adventure of collecting.

Whether you're interested in collecting stamps or Shaker baskets, old letters or old toys, there are people out there who love what you love. There are conventions and newsletters, exhibitions and seminars, where you can fuel the flames of your passion. There is always more to learn about a subject that interests you, always a way to broaden your appreciation. My library shelves bow under the weight of all the books I've read about art, and nothing teaches me more about an object than being face to face with its wondrous beauty.

I have a client who is a serious wine collector. His passion began with a fondness for the taste of wine, and expanded from there. He reads, travels to vineyards, goes to wine tastings, and, above all, shares his

Sheraton display cabinet

fine wine with friends—a wonderful way to have people share in your passion. One of his requests was to turn a maid's room of his apartment into a temperature-controlled wine room. This room, with its glass door and excellent ceiling lighting, highlights his collection as true art. His wine bottles are the focal point of the room, and can be seen on guided tours or as you pass by on the way to the powder room.

To bring their love of gardening into their house, clients have paintings and prints of gardens and flower bouquets hung throughout their rooms and display porcelain flowers on side tables. If you are a gourmet cook and love to spend lots of time in the kitchen, chances are you have many collections of objects associated with the table, from dinner, salad, and dessert plates to a variety of glasses, napkins, tablecloths, and rings, to candlesticks and pepper mills. I have a special affection for pepper grinders and found a miniature wood and silver one at an antique store several years ago. While it doesn't hold many peppercorns, it looks delightful on the hutch in our dining room along with several others of the same shape.

People who are collectors tend to have not only more interesting rooms, but homes that are more welcoming than houses where the inhabitants don't express their personal passions. I've been in the privileged position of helping people put collections together, gently urging them to listen to and follow their hearts. Their houses make a statement, have a point of view, reveal their personalities, and tell an autobiographical story. Show me your art and collections, the things that give your home a breath of life. Once you ask people to show you their favorite things, you'll see a twinkle in their eyes and feel joy in the atmosphere. Absorb the energy, and the enthusiasm will be infectious. If you love sailing, chances are you have an affinity for paintings depicting the marine environment. If you enjoy hunting, you'll probably want hunting scenes on the walls in your library.

Being a collector opens up infinite beauty and new perspectives, thoughts, and appreciation to you. Your collections become the archives of your experience, authentic vibrations of your soul. Because our culture is besieged by technology, you need to balance your life at home with art of timeless beauty. Home is where you can indulge in the world of the heart, dreams, and illusions.

The ultimate purpose of a harmoniously decorated house is to mirror your entire self—body, heart, mind, and soul—so the atmosphere is an exaltation of who you really are, and who you are becoming. The Swedish scientist and theologian Emanuel Swedenborg (1688–1772) believed the body is an extension of the soul, and the house is an extension of the body. In the Swedenborgian philosophy, the house is not merely a mirror of the soul, but a glimpse into the great mystery that we can't grasp through our mind or our senses.

The house then, with its art and collections, creates our intimate surroundings and becomes a way to reinforce and enlarge the soul, expand our sense of awe, wonder, and, ultimately, our capacity to appreciate and pursue beauty. The human spirit contemplates and then tries to refine and build. This irresistible instinct makes us vibrate with expectation. Treasure this lifelong journey of collecting beautiful art and objects that extend the boundaries of your four walls and your spirit, so the exterior objects of art are a confluence, a gathering together of your essential nature and personality, for your own enjoyment and for those you know and love.

CHAPTER 15

Finishing Touches

*I approve of clutter if it is the true taste of
the person who has brought it about,
but if it is dictated from afar it becomes
an affectation.*

—BILLY BALDWIN

CREATING A SPIRIT OF PLACE

The finishing touches, the minor personal details in your rooms, are what truly bring the ordinary to a place of glory. The lemons you place in a ceramic or glass bowl, the real pear you place next to a porcelain trompe l'oeil pear, the fabric swatches you keep in a handwoven basket, the colorful candles you place in bold brass candlesticks, the fresh daisies you put in a cobalt-blue pitcher—all speak of your love of home and your passion for doing things for the pure joy of self-expression. There are ways to improve the look and feel of a room with the simplest details, regardless of particular taste and style. You can take a room full of flea-market furniture and, through your own ingenuity, attention to intricacies, nuances, and subtleties, make the space sing. Having some basic strategies that work for you is useful. Through your interest in making where you live truly yours, you can learn thousands of ways to add flair to your rooms.

Of all the elements of the decoration of houses, the finishing touches are the most revealing. These sometimes minute details sprinkle your love of life in all directions. Colored pencils in clear glasses can reveal your love of color. The basket of red and green apples on your hall table

may speak of your love of nature and simplicity. The African violets thriving in the south light of your kitchen window tells us about your love for nurturing life. The lit candles at the supper table announce your grace, and the blue-and-white hand towel beside the kitchen sink welcomes you as you wash and dry a few dishes in the quiet of dusk. The glow of the fire soothes the rough edges of the day, and the sweet spicy smells coming from the kitchen perfume the air, creating a spirit of place.

REVEALING YOUR PASSION AND CREATIVITY

Through finishing touches you can increase your affections, multiply your pleasures, feel a deep sense of being on your path, and always be awake to the new interests, ideas, and inspiration that come with each day. You add grace notes daily to the song of home, and this is exhilarating.

Your creative energy longs to be released, and here, in the privacy of the home, you can unselfconsciously reveal your passion and creativity. If you love color, then this passion should be evident in every inch of your space. You can keep pastel candies in glass jars, colorful paperweights on desk and tabletops, and beautiful flowers in pretty vases throughout your rooms to complement and enhance your art and upholstery. Open your closets to see what colors you like to wear when you're not at the office and this will give you clues to the colors you are instinctively drawn to.

The juiciness you bring into a space through finishing touches must come from you. Your rooms should be titillating, fill you with excitement, arouse your senses, so that when you are in them the experience is gratifying. You must be honest and bold. All who enter your rooms should feel your presence, your passions, your love. If you are unsure of your taste and style, choosing your finishing touches will be a challenge, but just remember that the more you reveal your self, the more love you disperse throughout your home. Everybody has a capacity to increase their aesthetic dimension so their surroundings resonate in a glow of

shining glory. Putting this polish in your rooms is a matter of focus and common sense. Look out onto the water or at the flowers and trees in a garden and you'll see a generosity of spirit. Look at the snowcapped mountains in Colorado against the abundant, blue sky. A home—your home—can give you those same feelings of euphoria and expansiveness.

Think of finishing touches as being generous to your rooms, going the extra mile to add flair, polish, grace, and love. If you think of your spaces as the flowerpot, soil, and water, then the objects you put in them will grow and flower, adding color, beauty, and fragrance. You will have a deeper connection and feel more attached to your surroundings. The more generous you are to your rooms, the more nourishment you give yourself and share with others. This is your private world of retreat, your haven, and it is not enough to have it look attractive; it must be a mirror of you and your life, loves, and passions.

MINOR DETAILS MAKE A WORLD OF DIFFERENCE

*E*xpand your exuberance in your space by keeping in mind certain concepts. But remember, there is no absolutely right way, only ideas for paths you can take. If you place or hang a mirror opposite a flower bouquet, for example, you double the impact of both. Also, any picture frames placed in front of mirrors should have a pretty backing to reflect in the mirrors, perhaps marbleized paper or a piece of fabric. When you have a small picture framed and intend to place it on an easel on a table, rather than gluing brown wrapping paper on the back, use an attractive sheet of colored paper instead.

An attractive alarm clock on your bedside table that will be seen and touched thousands of times offers beauty and refinement. A small embroidered pillow on a love seat, a quilt

draped over the back of a rocking chair, or a hand-knitted throw laid over one arm of a chair adds warmth to any living space.

A flower in a bud vase next to the sink, rose water in a pretty blue glass bottle, a colorful ribbon tied around a set of towels, a lit candle on the bathtub ledge will add excitement to your bathroom. A colorful dish with white almond soap smells heavenly and is inviting. A pot of ivy on the windowsill trailing down to the counter brings a touch of nature into this intimate space. A small painting or postcard on an easel or a set of framed black-and-white photographs softens the hard lines of a bathroom. A narrow ledge can display a collection of spun-glass bottles from Murano, Italy. A small tray can hold a few perfume bottles of different shapes and sizes, and your water cup can be your own silver baby cup.

A favorite finishing touch for the kitchen is placing a pitcher of fresh flowers in the refrigerator for a feast of beauty each time you open the refrigerator door. You can always remove the pitcher, place it in a room where you are reading, and bring it back to the refrigerator when you leave. The flowers will live twice as long so you'll enjoy them twice as much. If you have a pretty decorative tray that you frequently use, rest it against a wall to add color while you cook. You can also display colored glasses on counters or ledges—hiding these gems in the dark, behind cabinet doors, would be missing out on an opportunity for visual delight. If you have a passion for swizzle sticks made from a variety of materials—glass, wood, clay—display them in clear water glasses to be appreciated by all. Hanging a pretty apron over a cabinet door gives added coziness to the kitchen and is handy. You can also use colorful glycerin soaps at the kitchen sink.

Colored glass

THE WONDROUS EFFECT OF CANDLES

*I*f you love light, you probably have an affinity for candles. Candles add light, energy, color, and luxury to a room. Have a collection of colorful candles, including citronella for the yard, as well as several glass hurricane globes that are always accessible. Don't limit your candle colors to ecru or off-white. Candles provide delight in a rainbow of clear, saturated colors. Place an assortment on your living

room mantel. Store candles in a glass container so they can be seen when not in use, but don't place them in the sun or the color will fade and the wax may melt. Or you can display them on a favorite dish. Beeswax candles smell wonderful, and if you put them in the freezer for a while before you light them, they will burn longer. Scented candles are delightful, and there are some whose fragrance is so potent they will transport you to a rose garden, a field of lavender, a tangle of honeysuckle, or a fruit orchard. At the hardware store, buy inexpensive clear glass bobeches to place on top of the candlestick so the wax won't drip on the table.

The squat church candles called votives that stand in tin frames so they don't make a mess add charm and warmth to any intimate moment in the home. Clip the wick to about an eighth of an inch in order to avoid unnecessary soot. If you use a votive that does not have a protective frame, put a quarter inch of water in a dish or cup so that the dripping wax won't stick to the dish and become difficult to remove. Inexpensive clear glass, frosted, or colored holders approximately two inches tall are perfect votive holders and are worth purchasing by the dozens. Here's a special tip: If there is a draft, put an additional dish under any candlesticks holding tall candles to ensure that the wax doesn't drip on the table.

Candles in hurricane globes

CANDLESTICKS

*I*f you collect candles in all shapes and sizes, you need to have a wide variety of candlesticks and holders. Your collection can include twisted crystal candlesticks bought for a modest price at a housewares store, as well as those of antique brass and fine porcelain. Whether you have brass, ceramic, marble, or wood candlesticks or big chubby candles on a dish with a glass hurricane globe, candles are an important decoration and can dress up or dress down a room. Candles can turn any moment into a celebration, especially when you have a variety of decorative candlesticks to choose from.

THE GLORY OF FRESH FLOWERS
AND PLANTS

I've made it a rule in my home to enliven the space by always having something organic in each room to counteract the inorganic. Fresh-cut flowers and flowering plants do more for your sense of wonder, awe, grace, and faith than any other object of beauty. Flowers feed the soul, increase hope, and provide you with every color scheme you'll ever need. Even in a space with brown woodwork and dark-colored upholstery, a rainbow of flowers in primary colors is magical.

There is no substitute for fresh flowers and plants. While illusions are necessary in the decoration of houses, the false appearance of fake flowers should be understood. They may fool the eye temporarily, but upon close examination you will inevitably notice dust on the fake petals. Better to have field flowers you gather from a walk, or a clear water glass brimming with buttercups and dandelions. Even one bud floating in water can become a delightful scene.

With fake flowers, you miss not only the fragrance, but also the beauty of the emergence of a blossom. Watching peonies, tulips, lilies, and daffodils open to their full glory, or the surprise blossoming of a dormant orchid or African violet, is an essential part of the experience of fresh flowers. Tending, arranging, and rearranging flowers, and the moments of contemplation you spend with your nose in a flower, pondering life's deepest mysteries, are central to the human spirit. No artificial flower can come close to the splendor of a fresh, living flower, the precious ones that perfume the air—honeysuckle, gardenia, lily of the valley, rose, tuberose, freesia, lilac, peony, lily, and paper-white narcissus.

The fragility of a flower is a metaphor for life's brevity and preciousness. You have to take time to enjoy the flower in bloom and appreciate it fully while it is alive rather than miss it all and settle for the potpourri. Fresh flowers in the house increase your pleasure in daily tasks. One morning I brought the bouquet of peonies into my Zen room to keep me company as I worked and something magical happened. Looking up from my white notepad I witnessed an intensification of light that illuminated the pink, ruffled, leaflike petals of the fully open blossoms. On the white wall was a rainbow. My heart pounded in rapture and I realized that next to my right arm was a clear crystal paperweight causing this marvel.

If you love flowers, make them a priority in your life. They are as important to our spiritual nourishment as fresh food is to our physical bodies. Your house is crying out for blossoms. Whether you want to build some indoor window boxes for geraniums or have flowering plants in your rooms, surrounding yourself with flowers in bloom will uplift your spirit and the spirits of those who enter your home.

FLOWER CONTAINERS

*I*f you love fresh flowers, chances are you have a special affinity for vases. A New York philanthropist's passion for flowers and flowering trees led her to donate trees and flower beds to line the narrow islands along Park Avenue, sweeping up from Grand Central Station to Eighty-sixth Street; the next ten blocks are beautifully decorated by the Carnegie Hill Neighbors Association. Park Avenue is now a visual feast year round, bursting with tulips in the spring, begonias in the summer, and evergreen trees with lights during the holiday season. When I had the special opportunity to visit the philanthropist's magnificent, charming apartment, I was taken into her pantry where she kept hundreds of clear glass and crystal vases in every shape and size imaginable. I was deeply moved by how her love for flowers, generously shared with all of New York, was elaborately expressed in her home.

Some flower vases are works of art and are attractive even when they're empty. Any container can become a flower vase even if it has to be lined with a glass bowl. Generally, the simpler the container, the greater the presence of the flowers. If the stems of flowers are interesting, such as tulips, daffodils, and lily of the valley, a clear glass or crystal container is most appropriate. If the stems are ordinary looking, a colored glass or ceramic container is a better choice.

If you have a passion for flowers, you should have a supply of containers in a variety of sizes, shapes, styles, and colors. My favorite container for potted plants is terra-cotta, and I always place a dessert plate underneath as a saucer to catch seeping water. Glazed pottery cachepots with colorful decorations on them are also enticing, but the more beautiful the bloom, the less need for an embellished pot. Old white-

glazed porcelain cachepots with gold trim look handsome on a high white mantel brimming with trailing English ivy.

Valentine Lawford, one of my favorite American botanical watercolor artists, enjoys putting one or two cropped flowers in drinking glasses and placing them on old polished wood surfaces. If you have a cut crystal glass, the facets will catch light and add a glow and sense of luxury.

I adore colored glass, and often I place six or eight large drinking glasses, or recycled mineral water bottles, on a window ledge with one yellow rose in each. The repetition of shape, color, and flower adds style and impact. I broke the lid of a Quimper casserole dish and now enjoy using the dish for flowers or a plant. You can use teapots, resting the lid next to the arrangement. Pitchers are among my favorite vessels for cut flowers. Using one type of flower abundantly can have a dramatic effect. A dozen deep purple peonies in a cobalt-blue hand-blown glass pitcher from Le Biot, France, looks striking. Le Biot glassblowing technique leaves tiny bubbles in the glass, creating a blue sky twinkling with stars. Being surprised by the joy of flowers is a transcendent experience. Peonies, with their heady, intoxicating aroma, have tiny nectaries that secrete beads of the sweet drink of the gods. Flowers can alter your state of consciousness. Put a bunch of wild roses, irises, or daisies in a watering can, or place a bud vase with a tiny sprig on the ledge of a sink, in a cabinet with your ceramic collection, or next to a bed. My mother put fresh flowers in our rooms when we grew up, and we're never without herbs in pots or something growing. Flowers and plants make a room vibrant and juicy. The tending and care they require is always a blessing, a gift you give yourself. Flowers should not be reserved for special occasions; enjoy them as a finishing touch to your home every day of the year.

The Art of Filling Beautiful Bowls, Baskets, and Boxes

If you have collected beautiful bowls, baskets, and boxes over the years, you have multiple opportunities to fill them with finishing touches. You can fill a ceramic or glass bowl with fruit to keep casu-

ally on the counter or kitchen table, or you can create a cornucopia of assorted fruit, vegetables, and nuts to use as a centerpiece. Surround it with nutcrackers, fruit forks, knives, and small dishes to create a warm, relaxed, and edible room ornament. Any time you fill a bowl with fresh fruit, vegetables, nuts, pastel candies, glass eggs, or marbles, the effect is simple, appropriate, and beautiful. Filling a crystal bowl with orange clementines in December, sitting by a fire, talking, sipping hot cocoa, and tossing the fragrant, oily clementine peels into the flames is a memorable experience that can be repeated throughout the cooler months.

The space beneath side tables is perfect for baskets or decorative boxes filled with pine cones, a few bottles of aging red wine, or a colorful collection of ribbons. In a bathroom, keep a basket filled with rolled towels or a collection of soaps. A client puts flowers in a vertical, rectangular fruitwood box with a hinged lid so they are enhanced by the antique marbleized paper lining of the box. These easy finishing touches are charming and can serve as a rich still life to feast the eye and stimulate the imagination and curiosity.

Pretty open boxes or baskets filled with an assortment of stationery and stamps add coziness to any room. Inkwells, pens, pen rests, lap desks, clipboards, and other writing paraphernalia can be displayed in baskets and boxes to highlight the art of the handwritten letter. Bundle up a stack of handwritten letters from loved ones with a pretty ribbon and place it in a favorite basket to add karma to your space, or keep it on your desk secured by a colorful paperweight.

Whether you place five lemons in a clear bowl as a centerpiece, float small candles in a bowl filled with water, or fill a bowl with Christmas tree ornaments (arranged so the hooks are concealed), always look for ways to put your bowls to daily decorative use. Baskets can be hung on the kitchen wall for holding mail or stationery when they're not being used for a picnic. You can also use baskets for serving raw vegetables at a party or for sewing supplies. Boxes can be filled with loose photographs, love letters, or a collection of art postcards.

FAMILY PHOTOGRAPHS

*M*any clients hesitate before decorating their rooms with family photographs, fearing that visitors may find it narcissistic or too intimate. I have always felt that if you want to sprinkle or even inundate your rooms with photographs of loved ones, don't let anyone or anything stop you. Anything can be overdone of course, even when your heart is in the right place. Over the years, family and friends enlarge, and if you displayed every picture of them, there wouldn't be any space for other finishing touches. I believe framed sentimental family photographs should be rotated, or "take turns," so they don't overwhelm your rooms.

Often, candid pictures of family and friends have more energy and charm than expensive formal portraits. Wedding portraits of a bride may even be best suited for albums and scrapbooks because they rarely represent the true persona and energy of the person. Snapshots of loved ones where they're completely unaware of being photographed often reveal the most and have spontaneous panache.

Place as many of your favorite photographs as possible on tables that butt up against a wall so the back of the frame is not exposed. I have framed pictures of mentors and friends, and rather than having them "float" from place to place, I have hung them on walls in a study. If you want particular photos to stand out more than others, choose a place where they will provide you with the most pleasure. There are other places to rest pictures of your daughter's wedding than on the piano. Hanging large framed pictures in a hall or bathroom makes sense because they can be enjoyed regularly without overshadowing smaller objects in a room. A bland powder room can become more interesting with a display all over its four walls of a family history consisting of framed pictures from vacations.

Another option is to keep cherished photographs in fabric-covered or leatherbound books on a shelf or table, inviting family members and friends to have a look. One client is an avid photographer and scrapbook keeper to ensure that future generations will have a window into their past. She also keeps current photographs of her children and grandchildren on a shelf in the library. She adores receiving new pictures and can always find a spot to put them. Be sure to initial and date all your photographs on the back to assure that great-great-grandchil-

dren will know their ancestors better. If a picture is taken on vacation, indicate where and when. This is an invaluable practice for documentation.

Books as Finishing Touches

*B*ooks, to genuine booklovers, are often the best ornaments in our rooms. They bring color, texture, interest, and mystery. You can pick up a history book and go on a journey. I've made a point of having my favorite writers in all my rooms, going back to the ancients from Greece and Rome, authors of rank who have stood the test of time, classic exemplars of universal wisdom. I have a few dozen authors whom I hold in especially high esteem, though I am inspired by all the writers who have expanded the intellectual and spiritual knowledge of human beings. Having their books at hand is an intellectual blessing and spiritually uplifting. (A woman whose husband was going to be a missionary in India took a course on how to live simply, and was told she could find contentment wherever she is if she has sunshine, books, and flowers.) A thousand years ago the Grand Vizier of Persia had his precious collection of 117,000 books carried along—in alphabetical order—by a caravan of four hundred camels, we're told by Alberto Manque. Books are friends, and you always feel comforted when you are among your favorite authors' works.

While I adore trompe l'oeil, fake books that can be bought "by the yard" with familiar titles but no content are as lifeless as artificial flowers. I'm not nourished by looking at the menu; I want to partake of the banquet. The wonderful reality of good books is their timelessness. Books that expand your mind and spirit never become obsolete and the first editions can become more valuable to you and others over time.

When you run out of bookshelves, you can stack books on the floor and on tables. When a client ran out of bookcase space in her library, she put a selection of early edition leatherbound books on an old walnut French hanging shelf, among hand-painted porcelain plates, fruit, and vegetables. When a literary friend came for a visit, she was delighted to watch her reach for *Montaigne's Essays and Selected Writings, Life of Cicero, Works of George Eliot,* or *Ben Jonson's Works.* However, her friend

was forced to remove an extremely fragile porcelain pea pod and stalk of asparagus from the shelf in order to retrieve the books. Though these objects looked charming in front of the leather books, resting on a curved, carved shelf on top of a marbleized ledge, she learned that porcelain and books do not work well together. True readers don't just look at the spine, they often grab for the book.

There is an art to book placement. When I was faced with floor to ceiling bookcases in the library, a friend helped me create some still lifes with botanicals, porcelain objects, and brass. He showed me how displaying a book on a rack on shelves between solid stacks of books can add interest and beauty. This was great fun, because I enjoy experiencing art and treasured objects among the books I love. There is a great temptation among book and art collectors to rest paintings in front of books. I even hang paintings on the plain pilasters of the frame of the bookcase. But to avid readers, it isn't fair to hide cherished volumes behind pictures and it can drive someone crazy to spend time searching for a book only to discover it was hiding behind a picture frame.

All of you with an insatiable appetite for books and learning will inevitably be forced to stow books on high, hard-to-reach shelves. A handy piece of equipment to have under these circumstances is folding library steps. Some of my favorite books are actually placed on the higher shelves because they're easier to locate and seem safer up high. On lower shelves, you can break up the mass of books by stacking some horizontally, and, when there is room, you can lay them flat side by side, inviting people to touch and open them. On a round blue-lacquered drum table in her apartment library, a client loves to place fruit or flowers, and stack books around its circumference.

If you love books, be sure to display a few of your favorites in a way that will invite visitors to pick them up. Books should have a lively presence, opening you up to spontaneous adventures. If you want to place a few treasured books on a table or lying flat on a shelf, not because they're coffee-table picture books but because you want family and friends to notice them, put a grosgrain ribbon in each book as a bookmark, luring people to see what's inside. It rarely fails to strike up a conversation. People are naturally curious, and will ask you why you like the book or whether you know the author. Books have a powerful way of connecting people.

To further lure potential readers, move large books over the table edge to add drama. Lining up books and objects perfectly appears rigid and can cause the air to become static. Artists demonstrate to us this power of placement. Henri Fantin-Latour, the French still-life master, would place a book over the ledge of a table in a painting to draw your eye to the scene, capturing your attention and curiosity to look, see, and feel. Look at Vincent van Gogh's painting where a blue paperback lies on a table beside an exuberant flower arrangement. You become fascinated by the book because it extends beyond the table, drawing your attention and sparking your imagination.

A client who calls her living room "the book room" has a twenty-six-inch-high rectangular pine table with stacks of books on all four sides, some extending over the table edge. Just as when stacks of quilts are too perfectly neat they lose some of their charm, a certain amount of relaxation and casualness is appealing when displaying books. When books are too neatly placed, they're not inviting.

If you have some chairs that are too fragile for normal use, a stack of books will create intrigue and ensure that no one will sit there. A client has two matching side chairs designed by a craftsman whose eye knew how to create graceful proportions, but because of the way the legs curve, they can't hold more weight than that of a grandchild. He keeps them against the wall on either side of a commode and uses them as beautiful surfaces for stacks of large art books. If you have a book with sumptuous photography, open it on a table or on a book or music stand and turn the page every day or so to reveal a different picture.

PICTURE FRAMES

If you love to display photographs of family, friends, and travels, picture frames are another finishing touch that should abound in your rooms. A collection of odd frames comes in handy. Keep a box or shelf where you store a variety of frames in different shapes, sizes, and materials, and keep a pair of scissors inside the box so you can easily crop a picture.

For black-and-white photographs, I recommend simple gold-leaf or black-painted frames. For an elegant, traditional look, select a black frame with a gold band. For color photographs I recommend Lucite with no frame for an inexpensive, flexible solution that allows you to change pictures with little effort. For small pictures, silver or brass frames are always appropriate but do need regular polishing, though lacquered brass does not require polishing. Colored plastic, painted, or stained frames bring out a predominant color in a picture that complements your room's color scheme.

A thick beveled mat can double a small picture's impact. Most framers will urge beige mats, but the color of the mat should be compatible with the color of your walls. I prefer white mats to those with a neutral tone. Rarely do I tint the bevel with a color, but when framing a color photograph this touch can be quite attractive. Usually colored mats on photographs look best when framing landscapes or seascapes, not people. But by experimenting you may find a colored mat helps bring out the colors in the photograph. If you are framing a lot of pictures in one mat and one style of frame, the colored mat makes the display more cohesive. Colored mats are a good alternative to off-white. When I frame botanical watercolors I have the soft-green mats hand-watercolored to add gentle visual texture. The English are masters at framing, using several colored lines to articulate the mat to subtly draw out and highlight the colors of the picture. If you're patient and neat, these can be fun to make yourself. The fine lines can be put on with a pen or you can buy different-width strips of tape, including silver and gold.

There's something charming about resting a small painting, framed photograph, or book on a simple brass rack or old wood or carved gilt stand. If you find one in a flea market or at a country antiques show, you will find a wide variety of uses for it. Think of this finishing touch

as a performance stand that illuminates something of interest, much the way a pedestal elevates a piece of marble or bronze sculpture. We have a small painting of strawberries by Roger Mühl that we deliberately framed in a carved gilt antiqued frame to give it prominence. Because the painting is small, and the frame is rich, it looks infinitely better resting at an angle on a stand that sits on an eighteenth-century fruitwood surface than it would if it were rigidly hung flat on a large wall. A rack or stand also calls attention to a treasured photograph, whether it's of a cat, a dog, or a friend. The picture becomes a focal point on your tablescape.

FINISHING TOUCHES BRING A HOME ALIVE

*T*here is no end to your ability to add your own creativity to a room. As long as your possessions speak to and for you, as long as you feel an emotional connection to as well as an aesthetic affinity for these treasured objects, then there will naturally be a cohesiveness among your personal touches and embellishments. You as the "artist in residence" are the arbiter of taste. Finishing touches demonstrate your personal flair. Only you can decide what finishing touches best represent you. Only you know what makes you feel most comfortable.

The seventeenth-century French philosopher Blaise Pascal was upset that his friends "upon seeing some pleasant object, have given themselves up and attached themselves to it." But you are not being a materialist by recognizing that inanimate objects can have soul; throughout history, objects—rings, mirrors, crystals, and stones—have held magical and symbolic powers. What are some of your talismans that can become finishing touches in your rooms? What objects do you hold sublime? What finishing touches are filled with a sense of the supernatural?

Finishing touches are not status symbols. John Ruskin, the nineteenth-century British writer and art critic, believed in the "mysterious sense of unaccountable life in things themselves. *You have the power to animate things.*" Eighteenth-century German idealist philosopher Immanuel Kant spoke of "the thing in the thing." How you value a tangible object is the mysterious alchemy where something inanimate

and commonplace becomes animate. A transmutation of seemingly magical power takes place and is somehow indisputable. Your soul awakens a thing to life. Your essence connects to the essence of an object. You can take ordinary objects and make them uniquely yours by their use in your home.

Every finishing touch should echo your personality, taste, and aesthetic appreciation. This is your house, and it will reveal you. If you paint the inside rim of your kitchen cabinets lilac to make you smile each time you reach for a glass, tie a silk tassel on a drawer key because you love the sensuousness of colored silk, have a sewing basket with a silk velvet remnant, or garnish some canapés with flowers, you are using your ingenuity. These flourishes need not be expensive. They make every room more interesting and more fun. In becoming enthusiastic about going the extra mile with grace notes for your home, you awaken your passions and become enveloped in joy.

You always know when something hits the mark. Be faithful to your inner life so the simple can be splendid and sublime for the meaning it holds in your heart. Home is not a place to be governed by fashion. Awaken to your artistic, playful, eccentric outlook as well as your taste and aesthetic. When you liberate yourself from the bland uniformity of trends, you can grow more enchanted with your own finishing touches. And through your finishing touches, you can eloquently express your true, unique vision of domestic bliss.

Practical Necessities

Many things difficult to design prove easy to performance.

—Samuel Johnson

Closets and Storage

*Closets and storage do not only provide opportunities
to put your house in order
but spaces to create color and beauty as well.*

FACING THE INEVITABILITY
OF STORAGE NEEDS

The process that begins with confronting empty space ends with having to organize years of accumulated things. In nature, the expansiveness of the sky and horizontal planes broadens your vision and sense of possibility. But rooms, unfortunately, have limits to how much they can house, and eventually the mass you accumulate begins to press on you negatively, inhibiting your sense of freedom, turning your living space into storage. Children never fully leave the nest, filling their bedroom closets with out-of-season clothing and every available closet corner and shelf in the house with their own odds and ends. Your find that your once-open, light, and airy environment has become weighed down by overabundance, throwing the rooms out of balance.

You will inevitably confront a shortage of closets, shelves, and drawers in your house or apartment. Solving this problem is fundamental in the decoration of houses. There's a balance to strike between being obsessive about neatness and surrendering your home to chaotic piles of "stuff" so high they could cascade all over the floor at any moment.

Just as it is uncomfortable for some people to confront empty or spare space, many feel unglued if the corner of a room is messy. You need to seek a happy medium between what you display and what you

store, and learn a masterful approach to filling your storage spaces. When you open one of your closet doors, you shouldn't have to fear an object falling on your head. You should be able to find readily the things you need. This sound sense of order is organization with style.

THE ART OF DE-THUGGING

*A*s your life changes and evolves, so will your storage needs. The first step to organization with style is to evaluate what's important in your day-to-day life *now*. Begin by taking inventory of what has become the overflow of your possessions. Every area of storage needs to be attacked, from dried-up paint brushes to rusty nails in the tool box to bent shoes that never fit to old clothes you'll never wear again, even assuming they do come back into style. Touch everything and see it in the light of the present.

Now it is time to edit. What do you need and what can you do without? What things do you want to have out in the open, and what would you rather keep hidden? What items do you want out of sight, but at your fingertips at the same time? Do you need certain tax papers but don't want them visually to bog you down? Do you have clothes, sports equipment, or linens you need to stow away for the summer? Are there sentimental things you want to save for future generations, though they are not appropriate for display in your current life? Is it time to pack up your childhood library to make room for the books you've accumulated since?

An essential part of the editing process is figuring out what you can live without and either give or throw away. If you haven't used a set of dinner plates for a year, as with clothes, chances are you simply don't like them and they are merely taking up valuable space in your kitchen cabinets or closet. If you have a slide collection containing twenty slides of the same scene, you need to pick the best and pitch the rest. I call this process "de-thugging." Over time you will discover that it is a good idea to have regular de-thugging sessions to weed out unnecessary bulk. Not only will you feel liberated, you'll feel grateful when you're able to pass on unneeded things to charities, thrift stores, or church fairs.

Editing your things can be an emotional process. Human beings have an extremely hard time letting go of their personal stuff, no matter how much sense it makes to do so. Helping a loved one, especially a saver, decide what to get rid of requires great sensitivity. Some people are hopelessly nostalgic, racing around in the present clinging to memories of the past, framing every early report card or sketch they stumble across. Most people are guilty of having old clothes they can't wear hidden in the back of their closets. Perhaps something that you once loved has been stuffed in the back of a high shelf in your linen closet for years, causing you to scrunch new acquisitions into wrinkled bunches. When you become a collector, you risk having cluttered rooms. Be grateful if your household has a standup attic and basement, two whole floors where you can squirrel away excessive accumulation. Even so, de-thugging will eventually be a liberating necessity.

It's important to respect the pieces of each person's patchwork quilt of possessions, because all of these things are clues to who they are today. One friend still has her childhood seed packets, another saves fortunes from cookies, and many still have their baseball trading cards from decades ago. Many mothers keep locks of their children's hair. Having the things you love in your house is precisely what makes a home sing; however, there is a line to be drawn. And being able to edit the good from the bad, the relevant from the irrelevant, the treasured memories from the dated items, to throw out certain things or pass them on because they are not useful to you is an art, and one you hone over years of thoughtful contemplation.

Each individual is different in personal needs. You may enjoy having colorful personal things out in your rooms where they'll be seen and appreciated, rather than stowing them inside a dark closet. But space becomes suffocating when it is overcrowded, no matter how beautiful all the objects are. In small rooms, for example, less is more, and you have to be strict in order not to contaminate the space with clutter that turns to chaos. The Japanese exhibit self-restraint by keeping collections of objects concealed behind shoji screens to ensure that the space to breathe is not jeopardized. The goal in de-thugging is to achieve a wise and wonderful balance so you have space to breathe while holding on to all the things you need for comfort and well-being.

*T*here is a logic to organizing supplies, tools, and necessities of a household to avoid littering precious space. By having storage sorted into categories, you can have everything you need in one place for each area of the house. Once a system of classification is in place, you can quickly turn clutter into accessible storage and eliminate unnecessary stress.

Because no two households have the same space or storage requirements, no one storage system can be right for everyone. Family members' ages and unique interests and hobbies all play a determining role. To establish an ideal system, begin by assessing available storage spaces. In many houses, there are not only closets, cupboards, shelves, and drawers, but also space under beds, in file boxes, and in trunks. If you have the luxury of an attic, basement, and garage, consider yourself fortunate. If you live in a small apartment, you might have access to a storage bin in the basement. If you currently don't have adequate space to house things you love, you may choose to pay for a private storage unit until you move into a larger home. After you've located physical spaces, determine what your specific storage categories should be. Begin with the general areas of storage and then move onward to your more unique requirements. You may want to start by getting the household properly set up for eating, sleeping, and bathing.

THE KITCHEN

*E*verybody has the obvious kitchen gear—plates, bowls, glasses, mugs, pots and pans, flatware, small appliances, and staple foods that need to be easily accessible on a daily basis. Rather than putting the most frequently used dishes and glasses in one place, have everything separated into groups. All glasses go in cupboards so you see the whole range at a glance. All dishes should be visible as you reach to make a selection. Store your flat silver side by side with your stainless steel. Don't have a hierarchy for "everyday" versus "best" because when your finest things are out of reach or out of sight, getting them down for the holidays or other special occasions will be an exhausting process. Every

day is a celebration, and you should use some of your favorite things to ritualize meals with your family. A favorite dessert plate can make some fresh strawberries an elegant and delicious experience. Even in the smallest apartment, make room for your finest and favorite possessions. If you have to give up some things, they should be the dishes and glasses you don't love to make room for your best. Meals are ceremonies that should be as beautiful as can be.

By grouping your necessities into specific categories, they will look organized inside your cupboards. You can now easily locate a stemmed glass for your orange juice, and a pretty porcelain dessert dish for scrambled eggs. Think of upgrading what you use, not downgrading. If you have space restrictions, eliminate the items you don't like, not your favorite "good" dishes. Inevitably you'll come across some odds and ends, gifts you don't like but you like the giver, presents from children you can't part with, and some overly ornate objects you now know were a mistake to buy because you've only used them once. Spend some time assessing your categories and strike a healthy balance.

Continue to categorize methodically until you have examined each pot, pan, mixing bowl, and small appliance. The kitchen is a natural gathering place for unnecessary gadgets—the doughnut makers and waffle irons you haven't used in twenty years. You might be appalled at

the blackened, greasy cookie sheet taking up space in your kitchen cabinet. No item should be depressing, no matter how necessary. The life span of kitchen miscellany isn't equal to your own, therefore you should treat your household to an upgrade throughout the years. Always try to balance the practicality of a kitchen article with its design. The tools of the eating ritual should be beautiful as well as useful.

Do you have a good place to store wine, liquor, juice, and soft drinks? Do you have a specific spot in the kitchen for flower arranging near where you store flower containers? Do you have a drawer for candles and holders so it is easy to reach for a few and light them for a simple meal? Do you have a place for napkins—both paper and cloth—where you can see at a glance what you want for the occasion? By being strict about your categories, no matter how varied the sizes, shapes, color, and materials, you will be putting your house in desirable order. When all your kitchen paraphernalia, including trays, baskets, and aprons, are in designated places, the family can help you keep these objects in their places.

THE LINEN CLOSET

The demands made on household linen closets are varied. Besides sheets, pillow cases, blankets, comforters, mattress protectors, extra pillows, bed throws, towels, and bath rugs, you may also need to store sewing supplies, tablecloths, and linen napkins. Some may store in closets out-of-season leisure clothes that don't need to be hung up. Where there is a question where to put what, focus on convenience and use common sense. Continue to group specific categories together. If your linen closet is used for several purposes other than bedroom, bathroom, and dining room supplies, designate one area for miscellaneous objects so the linens will all be kept in order.

When organizing the bed linens in your linen closet, consider placing different-sized sheets on separate shelves to avoid having to unfold a few to find the size you're looking for. When two or more beds are the same size, be sure to keep a variety of different sheets for use in all the rooms, never using certain sets in only one room. If you want to have a gift-giving section, find a large, colorful box, label it, and place it on the floor of the linen closet to house presents you accumulate throughout the year. Another box of the same size can be used to store holiday decorations, and another for gift wrapping needs—wrapping paper, ribbons, scissors, Scotch tape, and cards. This way, the box can be brought out to the kitchen counter when you need it, and then easily put back in the closet.

Gift-wrap box

BROOM CLOSET

*T*he key to maximizing the space in a broom closet is never to store anything there that isn't specifically for cleaning the house—brooms, mops, dust pans, dusters, a floor waxer if you have one, and the vacuum cleaner. Space restrictions, however, may require you to put the vacuum cleaner in the back of the front hall closet or in an upstairs closet. Though many people keep their ironing board and iron in the broom closet, you may find that your bedroom closet where you keep your clothes is a more appropriate place for them. If you enjoy your bedroom, why not use this space as a pleasant place to iron?

MAKING THE MOST OF CLOTHING-CLOSET SPACE

*N*o one seems ever to have enough closet space. Although one client has an entire room for packing to go on trips, in addition to two spacious dressing rooms, most people will have to improvise and invent new ways to serve their needs with their available space.

Most closets are average sized, but by redesigning them, you can feel you have your own private dressing rooms.

Bedrooms can become more heavenly when you maximize the use of your closet space, allowing for more "lightness of being." Better to store as many clothes as possible in your closet than to have an extra chest of drawers taking up space and weighing down a room. If you have a shortage of built-in drawers in your bedroom closet, consider using colorful hat boxes stacked in the closet to hold stockings, socks, and underwear.

Take advantage of the ceiling height and consider having two rows of hanging clothes, one on top of the other. You will probably need a pole notched to hook the hangers purchased at a housewares store to retrieve the clothes hanging from the higher rod, but this minor inconvenience is well worth the extra space. Keep an attractive solid wooden footstool in every closet to reach the higher shelves, otherwise you will risk bringing the entire contents down on your head when you only want to retrieve a sweater. If you keep your hanging items on one side of your closet, you can use the opposite wall for shelves and a series of drawers with a recessed space to grip them so there's no need for protruding hardware.

Closet with double rods

A client wanted to turn her average-sized bedroom closet into a private haven. To achieve this feeling, mirror was installed down one whole side and along a ledge, giving the illusion of more space. By graduating the built-in drawers to allow the drawers you encounter as you first enter to be narrower than the drawers further in, they are not as bulky in the space. We had a carpenter build the units, but you can purchase them ready-made in different depths. As you enter the closet, on your right are hinged-door cubbies twelve inches deep for neatly stowing her makeup. The cabinetmaker installed adjustable Lucite shelves inside

each of the five cubbies so the client could see more of what's on the high shelves as well as to create a more open feeling. There are five hinged flush doors attached to the unit. Other than the five one-inch finger holes for the doors and the lines between each door, the units look like a white-lacquered wall. No hardware shows, leaving the space clean, simple, and useful.

The unit next to the cubbies is five inches deeper to create more room for silk blouses, underwear, and scarves. The difference in depth between the two units causes five inches of the second unit's side to show, so we mirrored that vertical strip, bringing in more light by reflecting all the light from the bedroom and creating the illusion of even more space. This deeper storage unit consists of sixteen identical drawers—seven and a half inches high by twelve and a half inches wide by seventeen inches deep. The right-hand sides of the drawers are bullnosed, flowing into the narrow five-inch strip of mirrored wall that accommodates the difference in depth between the connecting storage units. The left-hand side of the drawer storage unit has a bullnosed edge to make it symmetrical. Each drawer opens from the top with an indented groove for fingers to pull open the drawer. To the left of the second unit is a series of open shelves for stacking all shoes in clear plastic shoe boxes.

When all the cubby drawers and the adjoining storage unit and shelves for shoes are closed, all my client sees is the colorful clothes and the clear boxes storing her shoes. Above the shoe shelves, she stores purses. Above the drawers and cubbies, she keep sweaters and tailored shirts in hard, open plastic sweater boxes (the plastic covers they usually come back in from the dry cleaners are too slippery for stacking). The entire closet is only sixty-three inches deep and sixty inches wide, and every inch of space is useful, resembling a royal yacht. The main difference between the two storage units is the five-inch gap in depth. But the heights of the two whole units are the same and therefore line up with each other below the height of the ceiling.

The reason this tiny closet is so pleasing to the eye is its straightforward simplicity. When a master cabinetmaker created this custom closet, he suggested to my client that she keep it tidy by removing something old every time she introduces something new to the space. This way she

Closet with cubbies

Wicker planter

Wicker sewing basket

will never outgrow her available space and her clothes will all be those she wears and feels good in because they fit her body and suit her current style of dress.

While you may find colorful shoe boxes ideal for other storage, it is more convenient to keep shoes in clear plastic boxes stacked in the closet so you can find them easily as you get dressed. Organize them by color so you don't waste time searching for the appropriate pair. For men, I prefer simple open shelves for shoes. Shelves that project from the wall at a downward angle are too fussy.

If you are successful in maximizing your closet space so that most of your clothes fit inside, consider placing two wicker tables in the master bedroom in the place of the traditional his and hers wooden dressers that tend to burden the room. One client chose a two-tiered wicker table with a deep well for a top, probably once used as a planter on a New England porch. It is perfect for stacking books and magazines. She also has an old wicker basket on legs, with a lid and handle, an old piece with great charm probably originally used as a sewing basket table, for stowing odds and ends.

One client who was especially feminine asked me to shirr the walls of an entire room, leaving only two windows exposed, and to bring one wall forward twenty-four inches so that her entire wardrobe could be stored behind a concealed curtain track. She simply opens the curtain while dressing and hides everything when finished. When sitting in this blue-and-white-striped cotton-hung space, you have no feeling that you are in a dressing room.

If you have inadequate closet space, create your own. Some people use portable racks on wheels bought inexpensively at hardware stores. You can buy separate standing storage units, great for a kitchen or in a sitting room, to store a television or stereo. They can be made of wicker, rattan, or pine.

One client has a coat closet with a window so she can see pansies from the window box outside, adding vibrant life and color to the small space where she also keeps a light-catching collection of old English cobalt-blue poison bottles on the windowsill. She wrapped an uninspiring coatrack in grosgrain ribbon of reflex blue with tiny white dots suggesting a twinkling sky. The old wide floorboards, the beaded board walls, the antique Shaker rack on the wall for slickers, windbreakers, and hats, and all the gear of country life warm her heart. My client loves this

space so profoundly that she often keeps the door to the closet open so she can enjoy this charming scene as she relaxes in her study, watching the sunlight illuminate the blue bottles on the window ledge.

The Shakers originally installed a pegged rack high up along the walls of their dining rooms so they could hang their chairs on the pegs after meals to create space and make cleaning the floors easier. I love how you can adapt this practical and beautiful Shaker element to your house; its simple form can add so much delight to your own functional needs. This particular closet is large enough that my client can place a simple Windsor chair against one wall in case someone wants to sit while putting on Wellington boots. She placed a favorite hooked rug in front of the chair and a pine mirror above on the wall. The practical everyday stuff of life in this small room makes it no longer just a storage closet, but a warm, happy space.

Shaker pegged rack

CLEANING OUT THE CLOSET

I've seen people build on additions or even move into larger houses because they couldn't harness their gear, control their accumulation, or organize their stuff. If you feel you're at the end of your rope with clutter, don't jump to the conclusion that the only answer is additional space. Have the courage to reorganize your storage from scratch so it will be more accessible and suitable to your lifestyle and interests, increasing the pleasantness of your time at home.

When you clean out a closet, before you rush to put everything back in a more orderly fashion, contemplate the newly emptied space. Don't be discouraged by crumbling plaster, dirt, or sad beige walls. Until you confront chaos and what lies beyond, you won't be able to ruthlessly edit what you store, and you will *never* have enough storage space. A client felt liberated after confronting the front hall closet of her apart-

ment. She'd ignored the closet for twenty years, scared of the mass that had accumulated inside. She began by removing absolutely everything from the closet. (She had bought an inexpensive white collapsible coat rack ahead of time so she could hang items as she went along.) She was shocked by the number of coats, hats, scarves, boots, and tennis racquets pulled out of this single closet. She didn't even remember owning some items.

After my client cleared everything out of her front hall closet, she sanded and painted the walls brilliant white and the wooden floor spring green. Once the paint had dried, only the clothes and equipment that were being worn or used at the current time went back in. To avoid throwing random items on the upper shelf, she placed as much as she could in colorful hat boxes. The shelf was so high and deep that she decided she didn't want to keep anything there she might need on a regular basis. A glove could be missing for years. She bought a natural canvas set of hanging cubbies for scarves, gloves, and rubbers and keeps a supply of decorative shopping bags from museums—"art bags"—and hangs them on a long hook inside a closet door. It's quite uplifting to confront several favorite artists' work while coming and going. My client breathes more freely knowing the closet has gone on an effective diet, and she has vowed never to wait another twenty years before her next assessment.

One exasperated client labeled her linen closet impossible. It consisted of several thirty-inch-deep shelves, too deep to be organized. Anything that was in the back was lost in the thicket of terry-cloth and bed sheets. By ripping everything out and having a look at the pure space, she saw a solution. A series of one-inch bullnose-edged shelves were built in a U-shape on the sides and back of the closet. The two sides have twelve-inch-deep shelves and the back wall has fourteen-inch-deep shelves. Now she can see everything in the closet at a glance, keeping the bed sets together, making it easy to change sheets and towels. Because of the U-shaped shelves, there's room for a footstool so now she can utilize all the shelves and store blankets and quilts right up to the ceiling.

If you free yourself from what exists, and use your imagination to create something that will work for your particular needs, however peculiar or quirky, you will be able to work within the framework of your circumstances. The challenge is always to have your rooms as beau-

tiful as you can make them, and not have your storage needs impinge on the life force and harmony of your house. The more dynamic your life, the more interests and hobbies you have, the more "stuff" you accumulate and the more space you take up. Each individual has a different tolerance level for disorder, and the better your resolutions for closets and storage, the more cozy your home will feel. You can pretend you are a shipbuilder and learn to utilize every nook and cranny of space.

Remember, closets are small rooms, just as important as the rooms that are seen by guests. In Zen consciousness, small spaces are equal in significance to big spaces. What's seen and unseen are one. You experience your closets and storage every day, so why not put your flair into these areas? They needn't be boring or unremarkable. Think of them as secret treasure chests.

INDIVIDUAL STORING AREAS

Some storage considerations are not so straightforward. Where do you store suitcases? The basement and garage may be too damp, causing the luggage to mildew. Where do you store sports equipment? Do you have room in your clothes closet to hang out-of-season clothing on a high rod? Where do you store old but important financial information? As your children outgrow clothes and books that you want to save for future grandchildren, what is the best way to label and store these important, practical keepsakes? Now that you have organized your basic storage areas, you need to focus on your more specific needs. In the kitchen, the items you use most frequently should be easy to reach and convenient to the food preparation counter as well as the sink and dishwasher. If you have more than one set of dishes that you love to use, rotate the stacks from front to back in your cabinets for maximum pleasure.

What should you store on the top shelf of the linen closet where you need a step stool to reach? What do you want easily accessible (or out of reach) for children? Do you have open shelves in the breakfast area for children's art materials and books? What do you store in the front hall closet other than winter coats and scarves? One client keeps the scuba gear he uses only once a year in this prime space. When arrang-

ing your storage areas, concentrate on how often you use certain items and be honest with yourself. Ask yourself lots of questions. No one can tell you where to put your possessions, but you can rethink some of your storage habits to determine what doesn't make sense and can be reorganized in a more logical, intelligent, satisfying arrangement.

CREATIVE STORAGE

*P*utting your things in order can be a creative process. You can have fun figuring out the most convenient as well as practical solutions to storage. Remember that often it's not how much you have, but how well you arrange things that makes all the difference. Common sense and convenience are of primary importance in organizing your accumulated possessions so you have peace of mind about where everything is. But for those who love to feast their eyes on beautiful things, even the insides of closets and storage areas are opportunities for experiencing the beauty of order, while also being suitable to your purposes and needs. This is a tall order if you don't live alone and everyone in the family has a different set of passions and needs. One system is never right for everyone, but there are some general rules.

If you like all the things you store, or if they're intensely personal and meaningful, they can always be arranged in an attractive way so your closets and storage are aesthetically uplifting as well as sensible. A woman complained she couldn't bear the burden of unveiling her silver from the brown drawstring bags every time she wanted to use a piece. She decided to line her corner-cabinet shelves with tarnish-proof cloth and lay her silver on top, installing a draw curtain of the same material so she could see and retrieve it in an instant.

A client who is a lawyer stores legal documents in old leather suitcases in a stack under his desk. He has what he needs handy and in a safe place without letting office overtones take over his alternate workplace in the living room.

A client's pantry in her New England house is one of her favorite spaces. There is a window providing light and air, geraniums in a window box, counter space for arranging

flowers, a huge deep drawer for every home fix-it tool, and the shelves for hundreds of favorite containers, dishes, pitchers, and baskets. Because this is such a personal, lively space, she frequently leaves the door open so it can be enjoyed as she works in the kitchen.

Linen closets can serve their practical purpose and delight the eye at the same time when their colorful contents are exposed. The linen on the shelves of a client's dining room closet is such a sensuous visual feast that she often finds herself rearranging the stacks of napkins, place mats, and table cloths in order to see the beautiful cotton and linen. To further intrigue the eye, she ties ribbons around tablecloths and sets of napkins (the "set" of napkins may actually be a playful assortment of colors and patterns) before putting them away. This saves her time and work when she needs to set a pretty table, and it increases her personal comfort. No one sees the inside of this pretty closet but her, but its attractive organization contributes to her pleasure.

The laundry room is a no-nonsense space where practicality is an enormous priority. Racks inside cupboard doors don't make supplies accessible because the items are not always easy to reach. Instead, have white wire shelves and clear plastic bins on hand to house cleaning supplies, rags, items to be sewn and ironed, and a place to put dry cleaning and shirts to be laundered. The key is to have everything you need for doing laundry conveniently at hand. But there are opportunities for beauty in this space, too. Hang a colorful print or quilt on one wall to incorporate your style into the scheme as well.

As you de-thug your rooms, weeding out the excess and creating a greater sense of order through editing, pay attention to the appeal of your storage containers. Give all your storage units your signature flair. You can store your meaningful paraphernalia—and even important documents—in a variety of beautiful boxes for shelf and closet storage. Fabric- and paper-covered boxes help keep your things organized while enhancing a room's visual warmth. Paint brown cardboard boxes bright cheerful colors even if you keep them in the back corner of a closet. Housewares stores carry sturdy boxes in a variety of colors that are the same size as book cartons. The inside of a box should also be attractive enough to excite you once the lid is off. You can line any box with fabric or printed paper, or paint wild stripes for your own secret pleasure.

By arranging meaningful odds and ends attractively and storing them in pretty containers or boxes, you will feel more energized than bogged down by the personal affection you have for such a wide range of things. A client wanted to save all her pretty postcards, but she didn't know what to do with them. A convenient, fun, and attractive solution to storing those piles of unrelated but meaningful stuff are colorful, decorative storage boxes with brass label plaques. Whether you're filing away postcards or travel pictures, you can toss them in these boxes, label them, and they're safe until you have time on a rainy day to arrange them the way you wish.

Keep loose photographs in a favorite lacquered box. A friend keeps her family vacation pictures in an antique red- and black-lacquered woven basket with a lid lined in a decorative fabric. She leaves it out on a table in her library for anyone who wants to peek at its contents. She loves to walk into the room and hear laughter and stories connected to the memories behind the pictures.

Keep a decorative box on a table or counter surface for small items used every day, including car keys, loose change, stamps, tape, and scissors. By having an obvious place for these things, you will program yourself to return things to this spot automatically. On your dresser, des-

Decorative tins

ignate a decorative box for change. Hang a brass container by the front door where you store sunglasses, keys, and letters to be mailed. If you have several flags, stow them rolled up alongside the umbrellas in a holder near the front door. An antique letter box in the hall can hold a collection of hats. If scissors are stored with ribbons in a drawer or box, stamps in the stationery box, and matches in the candle drawer, you will find this handiness most agreeable.

Decorated tin boxes are wonderful for unromantic things you don't need to see but want close at hand, such as coupons, receipts, or personal, private items. There are always "dainties," things you don't want anyone else to see, that can be contained in an attractive tin or box.

You can leave a multitude of objects out in plain sight as long as they are grouped in a pleasing still life and are attractive to the eye. Use see-through containers to store items you are attached to and enjoy looking at. In a basement converted into a studio, clients' children paint the lids of pickle, salsa, and mustard jars outrageously bright primary colors and use them for storing colorful paper clips, Day-Glo elastic bands, and marbles. Why hide butter cookies in a tin or pottery canister when they're so pretty and fresh looking? Keep them in a glass cookie jar instead, where they will excite taste buds and warm hearts. Keep pens and colored pencils in brass cups or clear glasses.

When grouping containers or boxes of various sizes, repeat shape or design to lend order. You can store a wide range of memorabilia, files, and supplies by using the same type of box and labeling each one. You will create a cohesive appearance while taking care of a multitude of storage needs. You can fill dozens of different fabric-covered file boxes with unrelated objects, but because the boxes are placed together on a shelf, they seem to

Glass jars

be integrated and make sense. Storing miscellany in this fashion also provides flexibility, allowing you to take a single box from its place, explore its contents, and return it to it protected place. Value the attractiveness of the container, because it may end up in the living room or any space you enjoy in your house. The color of the box is a feature that contributes to and increases your comfort and should not be overlooked. Brown cardboard boxes strewn around a house make you feel unsettled, as though you are moving out.

Work-space storage can be colorful and fun. Don't use ugly metal file cabinets for paperwork; find decorative portable boxes. Attractive wicker ones come in letter and legal size, and you can use their lids for in/out boxes. You will find you have more energy for your work just from looking at the brightly colored Pendaflex folders hung in these boxes. Men can't wear pink or purple suits to the office, but they can benefit from the energy and cheer given off by bright colors at work. A client has a free-standing cabinet in her home office sprayed chartreuse with narrow drawers filled with pretty pictures and clippings she cuts out of magazines. She can sit next to an open drawer brimming with the colors and energy of gardens, fruit, and details of room interiors, and feel refreshed.

Your storage containers play a part in uplifting or dampening your spirit in your daily spaces. You and your family are the actors in the theater of your home, and it is important that you treat yourselves well as you file, store, and sort through your collected lives, so that no matter what you seek to store or retrieve, the experience is a private, pleasant one.

Wicker files

Chest of drawers

FURNITURE MADE FOR STORAGE PURPOSES

*F*urniture made for the purpose of storage can be practical and attractive, but beware of storing treasures in chests. You may love the look of old trunks and chests, but sifting through the piled contents inside can be a nuisance. One client keeps a file card, taped to the inside lids, listing what is inside each of her trunks so she doesn't waste time rummaging around.

Army trunks are ideal for storing children's memorabilia because they will not be regularly accessed; when you want to be sentimental and see what's inside, you can put the trunk in a sunny room and embark on a nostalgic journey. You can spray-paint an old army trunk in a child's favorite color, and write their name on the front in a contrasting color. When you need rubbers or a pair of gloves, trunks and chests are awkward to access. Pieces of wood furniture with solid tops and cabinets with drawers are far more practical for storing stacks of papers and other items than chests or trunks.

If you have a bench with a seat that lifts up to store scarves, mittens, and hats, it is best to avoid having it double as a coffee table. You will inevitably use the surface, making the storage below either inaccessible or inconvenient. A pine chest may make a fine small table, but retrieving a set of napkins from the inside becomes a hassle if you have to remove a vase of flowers, books, and glasses each time to lift the top. However, aromatic cedar trunks that guard against insects are great for protecting out-of-season clothes and can easily double as a table because chances are you open them only a few times a year.

While most purists don't have a chest of drawers or bureau in a public room, I believe the living room to be the ideal place for such a substantial piece of furniture because it carries the weight of a chest of drawers more attractively than the bedroom. A client's favorite antique fruitwood chest of drawers is located against the wall just as you enter her living room. It holds the table linens, convenient when she sets the farm table in the adjoining entrance hall for family dinners.

BE ZEN WITH YOUR CLOSETS AND STORAGE

*A*lways keep in mind the karma of what you keep in storage. These items should have dignity, and a storage space that is worthy of them. The more seriously you take the decoration of your house, the more care you will give to the details of your storage needs. By honoring all of the space in your house, including every closet and storage area, you will have excellent feng shui, and you will have more energy and promise of good fortune. Who knows if you could change

your fate and destiny by loving all of your spaces equally? Whatever happens, the energy you expend on your closets and storage will be worthwhile because it will bring positive energy into your home.

The transition from the living areas to the storage spaces in your house should be a seamless integration asserting one main point of view, decorated in compatible colors and style that speak to you and of you. Open your closets and cabinets and you will see the things that make up the whole of your life. By showing reverence for what is stored by how you store it, you will double your pleasure at home because everything you need is there, waiting to be put to use.

Hardware, Fixtures, Appliances, and Equipment

Well begun is half done.
—HORACE

THE JEWELRY OF A HOUSE

Hardware, often overlooked, is a significant part of the decoration of houses. Though its function is primarily practical, it is the jewelry of a house, affecting both the appearance and feeling of rooms.

Hardware comes in a wide variety of forms, designs, and materials. I urge you to study these details in your travels and exploration just as you do architecture. You may become as interested in and gratified by the shiny brass ornaments for doors, cabinets, and furniture as you are in ancient Greek arches and columns and Palladian windows. The more aware you are that hardware is an essential element in interior design, the more you'll pick up ideas and inspiration to use in your house. Everywhere you go, hardware—the hinges, faucets, knobs, backplates, key escutcheons, drawer pulls, and the fixed pieces on furniture legs called sabots—tell a story of the people and places you encounter.

THE HARDWARE IN YOUR HOME

*H*ow much do you know about hardware? Often in the rush to get a room pulled together, hardware decisions come last, but they really should be considered at the decoration planning stage. Some hardware is concealed, but the way a drawer slides open or a door swings closed makes an everyday difference, and any hinge affects the way the whole cabinet will look. Whatever you envision, the hardware you choose should complement your style.

Usually, the finer the room, the simpler and more refined the hardware. A common mistake is to use gaudy hardware to dress up an ordinary room. This tends to look like wearing rhinestones at the beach. A twelve-foot-tall raised-panel mahogany door with egg and dart carving looks noble and elegant with one-and-three-quarter- to two-inch brass saucer-shaped doorknobs. Look carefully and you will see some handcrafted beading around the edge of the backplate, but it will be small and subtle. Thomas Jefferson used small, simple brass knobs at Monticello and the University of Virginia. The one exception is the front door in a hall. By having a doorknob of a different, larger size, perhaps against a rectangular backplate, you inform a guest of the location of the main exit so they don't open a closet, bathroom, or side door in error.

What is the state of the hardware in your house? Take stock of your inventory in your notebook, looking at each individual piece, room by room. Examine carefully every door butt (hinge), knob, backplate, drawer pull, key escutcheon, and lock mechanism. One of the signs of refinement in a house is shiny hardware. This is the ideal, and if you like the warmth and glow of brass, your hardware will add a sense of elegance to the room. I prefer solid brass, even if it isn't always polished, to black iron or some other nonshiny metal.

Brass is always most beautiful freshly polished, so it should not be lacquered. Most people don't want to take the time to polish brass hardware even though the result is always worth the effort. You can order most fixtures and accessories lacquered, but when they come into contact with water, the lacquer quickly wears off, looking spotty or mottled. As a compromise, you may choose to have the hinges lacquered, but not the knobs.

What is the general state of the hardware in your home? Are you

pleased with the inventory? How do the doorknobs look and feel? Do the doors close easily and tightly? Does the door lock smoothly? What materials are the various pieces made of? Does the majority consist of brass, chrome, pewter, wrought iron, porcelain, or wood? Are some of the door hinges painted over? If so, and you're lucky enough to have butts of solid brass, I recommend restoring them to their original glory. It's a lot of work to remove the door, dip the hinges and nails in solution, and remove the paint, but it is worth it. Companies can do this for you if you don't have the patience.

DIFFERENT HARDWARE FOR DIFFERENT ROOMS

*H*ardware can be uniform throughout your house, or it can vary from room to room, depending on your philosophy and preferences. Some people prefer fancier hardware in the public rooms and something simpler for the bedrooms and baths. I tend to make a selection based on the overall lifestyle of the occupants and then use the same design throughout the house. A bathroom, kitchen, or child's room may vary, but a unified design throughout is generally appealing. This continuity promotes cohesiveness and speaks quietly to the integrity of the whole rather than the presumed importance of one space over another.

While size of hardware can vary, try to keep the style fairly consistent from room to room. Just as all your bedroom floors may be bleached wood, all your bedroom hardware can be solid brass in the same design. Don't spend more money on the hardware in the rooms where you entertain than in the spaces where you and your family spend most of your time. If a handsome high brass spigot and hot and cold handles for the sink in your laundry room help you to enjoy the space, then the investment is worth it.

For five generations, P. E. Guerin, Inc., has been making the finest artistic hardware in the world, shipping it internationally from their location on tiny Jane Street in Greenwich Village, New York. Virtually anything can be custom made and the quality is unsurpassed. When renovating their apartment, clients chose the finest brass hardware from

P. E. Guerin. Twenty years later, each knob and hinge looks as beautiful as the day it was installed.

CHOOSING HARDWARE THAT SUITS YOU

*T*here are thousands of different design possibilities for hardware pieces, and making a choice can be a dizzying experience. P. E. Guerin makes more than fifty thousand custom models. But once you find the voice of your personal style in a few pieces, you can quickly zero in on the hardware that's right for your house. If you are considering replacing your hardware with the finest in the world, hire an architect or interior designer as a consultant because they know the essential vocabulary and can translate your needs and desires to hardware experts.

In a girl's blue-and-white tiled bathroom, a client selected chrome. The silver color looks attractive with the cool blue and never has to be polished. Chrome is a chromium alloy plated over brass, so it is actually more expensive than brass. Another attractive, less expensive option ideal for bathrooms are white early-American porcelain knobs with chrome backplates. To add a touch of simple refinement, use chrome ball-tip finials at the end of each door butt (hinge). When you change hardware from brass to chrome in a space, be consistent, using chrome faucets for the tub and sink as well as having the flush valves of the toilet and sink plated to match. Some people mix gold and silver, but only do this if it is part of your design scheme, not accidental.

Ball hinge

HINGES OR BUTTS

A hinge joins a door or shutter to a stationary frame allowing it to turn or pivot. Before making any hinge selection for your rooms, do some comparison shopping. Make a template of the configuration of screws and the size of the hinges you need if yours are not standard. A ball, spiral, or some other simple classic detail on the

hinge is unnecessary but can be a very attractive embellishment when successfully selected as a finial.

One of the most classic hinges, used in most fine Georgian houses and always appropriate, is an olive-knuckle "H" hinge, larger in scale but similar in design to the standard "H" hinge you find on most residential doors. In any scale, this design, with the space between the olive knuckle and the vertical parts that make up the H, is always handsome.

Square-knuckle butts are a simple design that can add elegance to any space. Make sure the size and design of the butts will suit your taste as well as fit the doors. Obviously, you're not going to put a fine solid brass hinge on a cheap hollow-core door, nor would you put an ersatz metal-plated hinge and knob, coated to resemble brass, on an old raised-panel door.

My favorite hinge for bifold doors and shutters and cupboards is the piano hinge. This particular design has a pin, the center device of a hinge that allows the two parts to turn, that runs the entire length of the hinge. The whole hinge is fully exposed, a feature that is attractive and increases the sturdiness of the mechanism. The thickness of the wood and the width of the piano hinge should line up so the two joining wood parts are fully covered by the brass or chrome frames exposing the screws.

Spiral hinge

Standard "H" hinge

DOORKNOBS

*T*he most important element of a doorknob is how it feels in your hand. I have found that the brass oval doorknob is one of the best designs because its shape is so sensuous and inviting to grip and turn. I admit to an enormous weakness for solid brass hardware, and find my appreciation increases as I polish favorite knobs, touched regularly by loved ones over the years, making them much more than functional pieces.

Knobs that look like rocks and cut-glass knobs are fussy and out of place. Even though twisted steel hardware and other more complicated designs abound, consider your house's hardware as architecture and make it as classic as possible. Even in a stark contemporary house, you

Oval knob

Cut glass knob

Round knob

Melon knob

can't go wrong with round brass knobs. White porcelain knobs with brass or chrome backplates are always unpretentious and elegant.

Modern button-shaped disks, often called melon knobs look contrived. And, when selecting any knob, remember that the hand doesn't want to touch any hard edges, so choose simple round or oval designs with smooth surfaces. Avoid wobbly knobs because they induce the feeling that the doors are insubstantial. What's the door there for, if not to be solidly closed when necessary?

Try to narrow your doorknob choices down to two or three designs, sleep on it, and pick the simplest one that best suits your style. If you really like ornamentation, rather than selecting a swirl or melon knob, consider a rounded disk with concentric indentations and a button center, or a plain doorknob with reeding around the circumference as well as on the edge and backplate. Make sure the diameter of the knob, whatever its style, is between one and three quarters and two and a half inches. I prefer a two-and-three-eights-inch diameter.

Your self-restraint when choosing appropriate knobs for your house is invaluable to its authenticity. Just as a window with a beautiful view should have only the most simple curtains, your doors should carry only classic, elegant, unpretentious doorknobs.

LATCHES AND LEVERS

*T*here are alternatives to doorknobs, although I don't believe any are as satisfying or practical as classic solid brass knobs. One option is a latch—a fastening consisting of a movable bar that fits into a notch or slot. Latches are usually made of wrought iron, but they can also be made of brass. One client couldn't stand the old-fashioned wrought-iron thumb latches and hand combinations in her parents' Virginia farmhouse because she felt as though she were putting her fin-

Latch and lever

gers in a mouse trap every time she opened a door. Though they looked handsome and authentic, the appearance wasn't worth the nuisance.

Another alternative to the doorknob is is the lever—a projecting handle that opens or closes a door. The lever is going to be the code in public buildings because it is the easiest way to open a door. Levers are appropriate in formal rooms on French doors and can be extremely decorative. But in most other cases, I find doorknobs more appropriate because levers lack the fulfilling solidity of knobs. However, a plain lever is extremely functional for people who have hand problems that prevent them from twisting a standard round or oval knob. Levers come in all materials including porcelain.

Key plates

BACKPLATES, KEY PLATES, AND BOLTS

The backplate of a doorknob should be approximately the same size as the diameter of the knob itself. However, if the backplate is a vertical rectangle (the average length of a vertical backplate is seven inches), the width should be the same as the knob's. If the backplate does not fit the knob exactly, it is better for it to be smaller rather than larger than the knob. Just as a lampshade should never overpower a lamp, a doorknob should never overwhelm a door.

If the door has a keyhole, you can select a decorative key plate of the same design as the knob and backplate. If you don't keep the key in the door or if you prefer to cover the hole, add a keyhole cover. One obvious advantage of this is to keep children from peeking in their parents' bedroom. In your bedroom you can have round keyhole covers in exactly the same shape as the knobs to cover the locks in the closets when you're away. The thumb turn used to lock a bathroom door can also be the same design as the knob. Remember to repeat shapes for harmony.

The traditional brass rim lock, a rectangular box located behind the inside entrance doorknob often referred to as a bit key set, is suitable for old houses and can be custom made. This lock mechanism has an oversized brass key six inches long to lock the front door from the inside.

If you have a pair of doors, you may want a cremone or espagnolette bolt in the vertical shaft that locks into a closure at the top and bottom to keep the door securely closed. This mechanism that bolts one of the two doors in its place is decorative as well as functional. Clients chose espagnolette bolts for all the French doors throughout their eighteenth-century house in Paris. Horizontal bolts, providing more security, are practical for single doors and can also be decorative. They are usually placed twelve inches above the knob so you don't have to bend down to slide the bolt. If you are tall, install the bolt on the door.

CURTAIN RODS AND FINIALS

Finials

Decorative curtain rods and finials can add great style to a pair of simply tailored curtains in sumptuous, brightly colored fabric. As an appealing alternative to valances that can block natural light or drag a window down, curtain rods and finials can be extremely important to the overall appearance of a room. When you want something light catching, brass ball finials or even rock crystal balls are very charming. When appropriate, brass curtain rods can be attractive. In a paneled library, a three-inch-diameter brass rod with three-and-a-half-inch plain ball finials with curtain headings sewn on exposed brass rings looks wonderful against a tartan or dark-colored chintz. Tiebacks can be ormolu, an alloy resembling gold. The grander the architecture, the more refined the details of the curtain hardware should be, without being fussy. Lucite rods resembling crystal can look very handsome.

Lumberyards and housewares stores carry a wide range of rods and finials. If a rod is not hidden under a valance, it should not be too skinny. For most windows, a two-and-a-half-inch-diameter rod is most appropriate. If the curtains are simple, a decorative finial can be a good touch.

OUTLET COVERS AND SWITCH PLATES

While there is a huge selection of decorative duplex outlet covers and switch plates available, an electrical switch or socket

should never be embellished. You don't want to draw attention to these modern necessities. With no exceptions, try to have simple dime-store plates that blend in with the wall. If your room is paneled, hire a faux finish painter to simulate the paneling. If your room is wallpapered, have the paperhanger cover the plate to continue to pattern exactly, and ask him to cover several extra plates so you will have replacements if the original plates become soiled or ripped. To protect the plates from dirt, you can cover them with a thin clear piece of beveled glass. Just as the eye is bothered when a painting is a mere sixteenth of an inch off plumb, any switch plates or outlets that are not plumb on the vertical will cause you to feel seasick. The surest sign of careless workmanship is an outlet cover or switch plate installed off angle.

Measure with a twenty-five-foot tape rule (also referred to as a power tape) to be sure you establish a true vertical line, straight up and down. From the floor, measure to the bottom of the switch plate, then to its top. Next, measure to the nearest wall or doorframe. The two measurements, top and bottom, should be exact. In the event your wall or door trim is not straight, rely on your eye to make the judgment call—your eye can detect a sixteenth of an inch variation and is worth trusting.

HOOKS

*D*ecorative brass hooks for bathroom and closet doors can be both useful and attractive, but where there is a hook, there is usually something hanging on it, so take warning. When you count three bathrobes, a towel, and last week's pyjamas piled on one hook, you may wish for a pure unadorned door. In a coat closet, hanging a series of these old-fashioned brass hooks side by side is charming,

whether they're used to hang hats or a tote bag. Hooks say home. On the walls of your bedroom closet, have a series of hooks for purses, belts, ribbons, or sashes.

DOOR KNOCKERS

*I*f you have a door you find especially elegant, you may not want to busy the appearance with a knocker, especially if you already have a large horizontal brass letter slot. However, if you feel your door is too plain and could use some adornment, consider a simple brass knocker. Take your time in your selection, because the door knocker will be the first ornamentation besides the doorknob seen by anyone who enters. Look at the classic designs and choose one that feels right for your house or apartment. The only design guidelines are to have the door knocker be simple in its beauty, and for this you need to rely on your individual taste. Etching your family name or initials in the brass is an elegant finishing touch, though if there are two last names in your household I recommend keeping the knocker plain to prevent a busy or ambiguous look.

Door knockers

HARDWARE ON CABINETS
AND FURNITURE

*T*hink of the hardware on your furniture and cabinets as miniature versions of doorknobs. Understate whenever possible. Use the smallest knob or pull that can comfortably open a drawer. One small brass pull in the center of a small window is appropriate, whereas a larger window demands two to open and close without straining.

Cabinet knobs range in quarter-inch increments from one-half inch to one and three-quarters inches. Try them to determine whether the

depth or projection provides you with enough space to wrap your fingers next to the thumb around the back of the knob. Cabinet knobs come in the same designs as doorknobs, but because they are smaller, they can also be made of wood. Rectangular pulls can be installed vertically or horizontally.

The most widely used, least expensive cabinet hardware is the wire pull, available in sizes from two and a half to five inches. Whether in brass, chrome, Lucite, or colored plastic, this is the least pretentious, simplest example of cabinet hardware on the market. It's refreshingly clean in design. In a New York City apartment kitchen, the teak cabinets had solid brass ring pulls two and a half inches in diameter flush with the surface of the cabinet door. This hardware design, known as campaign hardware, where the pull is recessed into the wood so that the brass ring inside a frame is flush with the surface, has a unique honesty and subtlety to it.

Inevitably, knobs, pulls, latches, and bolts become loose with regular use, and chances are you'll end up with a missing piece. If you have a piece of furniture that is missing hardware, it will look sad, as though missing a button or tooth. If you are unable to locate the exact size, style, and finish you need, you can remove an existing handle, knob, sabot, or shoe and have it copied and the finish matched. But if you are going to that trouble, remove all the hardware on the piece and have it all polished and lacquered. Chances are your existing hardware has lost some of its original luster.

If you have tacky, fake Louis XV handles with curly ornamentation, consider replacing them with something simpler, unless the piece is period and in keeping with the hardware. In antique shops, examine the hardware on English and American furniture as well as Louis XV and XVI. Ask dealers lots of questions. Usually, if the hardware isn't original it isn't correct for the piece.

Observe the simplicity of the hardware on many fine eighteenth-century antiques. An Italian Directoire table with exquisite marquetry has one large drawer in the apron with no decorative hardware except for a keyhole with a metal key. There is some open work at the end of the key where the hand touches it, but it is the essence of understatement. A Louis XVI two-tier fruitwood end table has a round brass flat front pull one-half inch in diameter. The drawer of a French provincial table forms the entire apron, enabling you to pull the drawer out with

Round wire pull

Knob pull

Flush pull

Decorative pull

French Provincial table with drawer pull

your fingers without the aid of a decorative pull. A Louis XVI writing table has five drawers with key plates and a key for each drawer. The leaves on either side, also called slides, have half-inch round brass pulls. An Italian chest of drawers has four simple iron drawer pulls and key plates.

Hardware is a practical necessity as well as an opportunity to adorn your house with simple ornamentation. By carefully selecting simple, handsome, and elegant hardware for your doors, cabinets, curtains, chests of drawers, and other furniture, you will add integrity and beauty to your rooms.

FIXTURES AND THEIR ROLE IN INTERIOR DESIGN

*Y*ou can't install new hardware without considering the fixtures for the kitchen, bathrooms, laundry room, and bar area, including the fixtures on sinks, tubs, toilets, and bidets. The design and material of the towel bars and toilet paper holder can be similar to the doorknob, and should be compatible with the basin sets in the bathroom as well. By taking one design element and making it a theme throughout the bathroom, unity results. Repetition soothes. If you use white Plexiglas for towel rods, for example, you can use the same rod for the shower curtain. If you prefer clear Lucite towel rods, repeat that for the shower rod.

Standard sink fixtures

THE KITCHEN

*W*hen you consider how often your hands will touch the fixtures in your kitchen, it is important to figure out what works best for you. The sink can have levers, four-prong knobs, or a variety of other knobs for turning on and off the water. What feels best to

your hands? Keep in mind that turning water off and on when your hands are wet is easiest to do with a lever. Unless you have a four-pronged knob, your hands may continuously slip on a smooth, rounded surface.

Gooseneck spout

A gooseneck spout can be installed with a swivel mount allowing you to move the spout from one side of the sink to the other. The higher the spout, the more flexibility you have with tall vases and watering cans. You can find many gooseneck spouts seventeen inches high, whereas the average spout is four and a half to six inches high. The typical spout projects straight into a sink and curves down at the end. In every kitchen, the main sink area should be straightforward where function is emphasized over form. If you have a bar sink or a second, smaller sink you use for flower arranging or for cleaning fruit and vegetables, you may want it to have more decorative fixtures. For example, if you have a small round copper sink or hand-hammered nickel sink, a high gooseneck spout with ornamentation and decorative levers or handles and spout is appropriate and attractive.

THE BATHROOM: A PLACE FOR REJUVENATION

*T*he bathroom is one of the great rooms of the house, a place for enjoying a few moments of solitude and the time-honored healing powers of water. Try to avoid having the toilet directly opposite a door. Sometimes it can't be avoided. In most hotels, bathrooms awkwardly designed to the inch often result in the toilet being the focal point. In the sweetness of home, you should try to avoid that.

THE VIRTUE OF WHITE
BATHROOM FIXTURES

*S*tart with a simple, lustrous white backdrop—a white sink, tub, and toilet—and build your color from there. Every client who wanted to get some color into their child's bathroom regrets not heeding this advice. Soap scum and dandruff look awful in a dark-blue tub. Toothpaste, loose hair, and powder show at once in a colored sink. White is fresh and clean and pure, and expands space. Fresh vibrant colors in the tiles, towels, and linens can add warmth and charm. I ordered only one black sink in thirty-six years, a tiny oval for a black-lacquered powder room in Paris. I accentuated it with white embroidered hand towels, brass fixtures, and glass shelves holding a collection of old glass vase-shaped bottles.

Rarely am I drawn to decorated sinks, preferring to face a pure white bowl, but there are exceptions. A white sink with a simple blue Greek key border design can look handsome in an all blue-and-white powder room but is not suitable for everyday use. I feel this decoration falls into the category of gilding the lily; when something is well designed, in good scale and proportion, made of an honest material, it usually doesn't need extra embellishment. Fixtures should always be simple and appropriate. Save the money you would have spent on a hand-painted sink and purchase instead hand-painted glazed ceramic tiles for counter or wall decoration. What is more beautiful and Zen than white fixtures, pretty faucet sets, and lots of colorful towels in a room with running water?

SELECTING A SINK, TUB, AND TOILET

*W*hen your bathroom is thought of as a private sanctuary, from where you emerge a renewed person, attention to detail will make a huge difference to the ch'i in your home. Examine the sink. Do you prefer a round sink to an oval sink? Do you like a counter around a sink? Some sinks come self-rimmed so they drop in over the counter surface to hide the raw edges of the cutout in the same way a frame finishes the edges of a canvas painting. Others can be mounted so the

Self-rimmed sink

Mounted sink

counter is raised around the sink. If you have ample space, you can find beautiful large porcelain sink units with fat white matching legs. The virtue of not having a sink set into a cabinet is the space you gain visually. If you are renovating your bathroom, remember to look for pure space you can free up. Pipes can usually be relocated.

If you are renovating your bathroom, you may want to consider installing a Jacuzzi so you can have the stimulation of water jets massaging your muscles. Just as a king-sized bed takes up a lot of room in the bedroom, a whirlpool takes up extra space, but can be a worthwhile luxury for the tired and aching. One model called "classic" is seventy-two by thirty-six by twenty inches. If you have an old house, however, I recommend you stay with the old (American) Standard high rounded tubs on legs for integrity—and surprising comfort and joy.

Porcelain sink with legs

Sink and tub handles

The shape of your sink and tub will help you to select appropriate faucets and handles. Many of you have sinks, tubs, and showers with hardware you may want to replace to increase beauty and improve function. The four-pronged, old-fashioned spigot is especially appropriate for houses that have a traditional point of view. They are the most honest, least pretentious on the market. You can have porcelain buttons in the center of each one, indicating hot or cold, in English—H and C—or French— C and F, for chaude (hot) and froide (cold). Remember to keep the tap and handles

Pedestal sink

in scale to the sink or tub. In bathrooms with an old twenty-four-inch-deep tub on claw feet, old-fashioned brass faucet sets and white pedestal lavatories are ideal. If you're tall, you can raise the pedestal as much as five inches on a plinth or base so you're able to stand up straight when brushing your teeth. To install a pedestal, have a block of hardwood cut to the desired height and exactly the same size as the bottom of the pedestal and spray it with high-gloss white spray paint—two coats after you prime—and be sure it's completely sealed, including the bottom. If you are ordering a pedestal lavatory, spend enough time in the showroom to make certain you'll have ample room on its surface for your toiletries. You'll want to be able to spread them out when shaving or freshening up. Some have recessed areas for soap, but the soap soon gets soggy and slithers down into the sink. Better to get a model with enough flat surface to hold your things. You can always put a soap dish on a wall bracket. Hand-painted ceramic soap dishes are especially charming.

Examine the shapes of toilets carefully. They aren't attractive, but should be well designed for their function. Bring a bottle of water to the showroom and, without leaning down, pour the water into the toilet. If a lot splashes on the floor, the bowl of the toilet is too shallow and therefore not practical. The deeper the bowl, the less spray. To warm up the white, if you have natural wood in the bathroom, select a stained-wood toilet seat. One of the bathrooms in the Paris house was paneled in cypress, and we used a natural wood seat for the toilet. The tub, when placed wall to wall, exposes one long side that can be covered in wood as well if you choose not to have decorative tiles. By your keeping the fixtures straightforward, your bathroom will have a dignity that is unobtainable if the fixtures you choose are too fussy.

THE ROLE OF HOUSEHOLD APPLIANCES IN INTERIOR DECORATION

*T*he best way to make successful decisions for your house in the areas of hardware and fixtures is to expose yourself to a wide

variety before choosing what you like best. This holds true for household appliances as well. A kitchen should be set up so everything is in the right place to suit your needs, luring you in and inspiring you to create wonderful meals. I've redesigned a client's New York kitchen twice as the family's needs changed. When the children were young, one end of the kitchen was used to hold a banquette with a huge, rectangular, maple pedestal table where they ate meals together and where the children could do their homework and artwork. The washer and dryer were at the other end. The arrangement was cozy and practical. When one son went off to college, the stall shower in the small bathroom off the kitchen was replaced with a washer and dryer, transforming the space into a laundry room. Where the appliances used to be, there is now an antique pine table, chairs, and a round, copper bar sink. There is also a high counter with storage space where the banquette used to be, housing a dozen folding chairs, trays, soda, and other household supplies.

Even though you may think of appliances and fixtures as the permanent elements of your house, almost everything can be moved around, and you should always consider what arrangement you would enjoy most. E. M. Forster wrote that one must "connect" to one's space. Although you can relocate a sofa and move a chair more easily than you can move a stove, refrigerator, or sink, as you grow and become more aware of what pleases you, and are exposed to more designs, you will be able to reposition your appliances over the years. I've been in thousands of kitchens and the ones that are the most successful are those that accommodate the inhabitants' idiosyncracies.

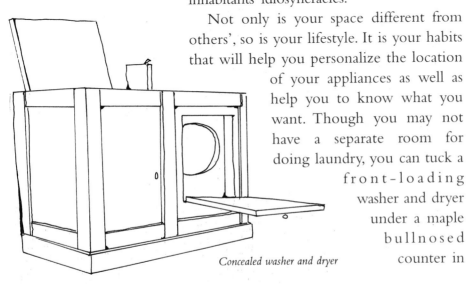

Not only is your space different from others', so is your lifestyle. It is your habits that will help you personalize the location of your appliances as well as help you to know what you want. Though you may not have a separate room for doing laundry, you can tuck a front-loading washer and dryer under a maple bullnosed counter in

Concealed washer and dryer

the kitchen, installing raised-panel doors to conceal them. And though you may not be able to rip out a sink, you can install a shiny, silvery-nickel gooseneck spout that swivels, turning the ordinary into something extraordinary.

The dishwasher must be next to the sink whenever possible. Remember to take into account whether you're right- or left-handed if you're installing a new one. Set up the coffee maker and coffee-bean grinder near a window so you can begin the day looking out at nature, the bird feeder, and fresh blooms.

CAMOUFLAGING APPLIANCES

*T*he major consideration for clients selecting appliances is how easily they'll be able to camouflage them, creating a warm, soft, cozy atmosphere in their kitchens, free of high-tech eyesores. The most successful kitchens I've designed all have white fixtures, brass faucets, cork or wood floors, maple or tile countertops, decorative-tiled back-splashes, and walls of hand-painted tiles. The cabinets are lit underneath, and glass cabinets display pretty china, dishes, and glasses. A round or oval bar sink is a glorious, affordable luxury, whether it is hand-hammered nickel, brass, or porcelain.

Don't buy colored appliances or fixtures. I assure you you'll tire of them within a few years. If you want the appliances to match the color of your cabinets, you can have them spray-painted. Just give a sample of the color to a company listed in the Yellow Pages under "Spraying and Finishing" and they will match it in a sturdy enamel spray. We had this done with our kitchen stove in our New York apartment, and the Brittany blue is a far better look than the original ugly quasi-copper tone. The Brittany blue has held up well over the ten years since we had it done. But I have no intention of doing the same with our new dish-washer and refrigerator because I prefer them white.

EQUIPMENT: HOUSING OUR TOYS

*Y*ou can't avoid having a lot of equipment in life today, but you can try to hide it rather than making it a focal point in your

rooms. Everybody has toys, but follow the advice you give your children and put them back in the toy chest when you're finished playing with them. I feel strongly about the textures of home, and having impersonal, inanimate, plastic, or stainless-steel equipment scattered about in every room shows lack of inner resources.

If you own one or more television sets, I urge you keep them out of the bedrooms and to keep them out of sight when no one is watching them. You don't have to disguise the equipment completely, but you don't want it to be a focal point, either. I have found that a quilt rack or a watercolor resting in front of the screen is an attractive shield to serve those who don't like to be distracted when having a moment of peace, surrounded by books.

Too many people keep television sets in their bedrooms. The bedroom is no place for technical equipment of any kind, with the possible exception of a radio or stereo and speakers. When a favorite shelter magazine featured a fax machine on a table at the foot of the bed in the master bedroom, I gasped in horror and disbelief. The noise alone could chill any romance. Who wants to be distracted by an incoming fax when they've turned in for the night? If you do keep a television, fax machine, computer, or any other equipment in your bedroom, I strongly recommend putting it in an old, charming armoire, behind closed doors when you are not using it. The decoration of a house is a process of refining, honing, and discovering ways to bring forth more beauty in all the areas of your daily private life. The bedroom especially should be one area in your life where you can retreat, where you won't be disturbed by news reports of violence, annoying advertisements, or your spouse watching "the game" or a shopping network.

THE JOY OF YOUR
HOME OFFICE

*M*any of you enjoy working at home and have full home offices carved out of available space. Whether you use the attic, basement, a former child's room, a maid's room, or a corner of your bedroom or living room, there is no reason to have a cold, beige and gray, sterile environment for your work. Because there is no easy way to "warm up" a computer, fax machine, copier, adding machine, and

answering machine, rather than trying to camouflage these necessities, take steps to counteract this cold equipment inherent to most home offices with warm touches.

If you have a home office in a separate room, treat it with the same care as your living room. If you spend time in this room every day, the atmosphere should be as uplifting and beautiful as that of any other space. You can place your copying machine on an antique table and the fax machine on another attractive table with a drawer for the paper. You can store office supplies in a pretty armoire or chest of drawers. By using lots of warm woods, you deflect the energy from inanimate technology to animate wood.

Metal file cabinets can be spray-painted to match the color of the room. By putting bullnosed oak tops on them, the coldness of the metal diminishes. Always keep a potted plant or fresh flowers in your space. Use large wicker baskets for wastepaper containers and display your favorite art, framed photographs, and desk accessories, including a silver letter holder, crystal paperweights, and an attractive address book. By treating yourself well in your work space at home, you'll forget you're "at the office."

If office equipment is exposed in a bedroom or living room, consider using a fabric-covered screen to hide it so your energy is focused on the beautiful and meaningful objects in the rest of the space, or cover them with a piece of favorite material when you aren't using them. Cameras and video cameras can be stowed in colorful canvas tote bags and placed in a closet when not in use.

Radios, stereos, and CD players are less than attractive showpieces. A decorative floral wooden screen designed to rest in front of a fireplace when it is not in use is an excellent choice for hiding the music equipment. Even though you enjoy the sound of music, try not to display the source. If you have a stereo in the living room, place it on an antique box or other attractive wooden piece of furniture in the far corner of the room, hidden from view by a large upholstered chair.

Your equipment may bring ease and comfort into your life, but it rarely pleases the eye. You should hide your business toys when they are not in use because they contradict the essence of the home as a private retreat, a peaceful place where you go for strength and renewal, where you reach out to loved ones with an abundance of affection.

CHAPTER 18

The Zen of Maintenance

It's spiritually renewing to re-create and freshen your space.
—A. B. STODDARD

MAINTAINING YOUR HOME
IS LOVING YOUR HOME

People's appetite for life is reflected in the spirit and freshness of their surroundings. Upholding, preserving, and sustaining a household speaks most of your love of home. When you love your house and all the things in it, the tending to and caring for, the maintenance of all the objects you've selected over many years is a treasury of loving gestures. When you touch, polish, dust, and arrange inanimate objects with your own hands, they become more alive to you, tightening and warming your connection to them.

Some of my favorite paintings depict scenes of domestic life where people are involved in household maintenance—a woman sewing with a child at her feet, a woman ironing, a woman draped in an apron. Mary Cassatt, the only American to be included in the French Impressionist movement, found pleasure in making her home a work of art through portraying domesticity in a divine light. In Edgar Degas's *Woman Ironing,* a woman is calmly, peacefully ironing a man's shirt. Nearby is a bowl of water she can dip into to moisten the blue-and-white cotton. To her left is a crisply ironed folded shirt and above her are colorful blouses, draped like banners and flags, catching the fresh breezes from the windows. She is there, but she is not there. She is in a state of serene meditation, accomplishing her work effortlessly. By not viewing her

work as a burden but as a way to express love, she radiates an abundance of energy. When you care for your house in this loving way, you, too, will feel an abundance rather than a drain on your body and spirit.

It's not what you do but how you feel about yourself in the work. Maintaining your home can be a dull routine and drudgery, or it can be joyful, uplifting, and satisfying. But unless you exert positive energy in caring for your rooms, you will be poisoning the atmosphere. It is up to you to become more Zen about maintenance and understand that everything you do in the home, including housework, can be a delightfully uplifting experience with lasting consequences.

Just as Emerson understood the value of gardening to a gardener, I strongly believe that one is happiest when actively participating in the fabric, texture, and nuance of daily life at home. Placing some flowers in a pitcher or basket, setting a pretty table, making an attractive bed, changing the towels and bath rugs, polishing the brass, waxing a wood floor, ironing bed pillows, and mending a broken dish are all activities where you can become so absorbed in the moment, you literally lose all sense of time. This is one of life's paradoxes: The more you focus on what you are doing the less self-conscious you become, and the more you expand your awareness. The English philosopher Dr. Samuel Johnson was partial to the benefits of puttering. The physical things you do around your house can become some of the most satisfying moments in a day. Washing, watering, cleaning, mending, sewing, polishing, and painting are moments of meditation and sensual joy. While you're lovingly maintaining your rooms, you're able to clarify your emotional house as well. You are exerting your energy productively, making you feel as good as if you had just gone for a brisk walk—or better. You get energy from exerting energy. After doing some laundry, scrubbing the kitchen floor, washing the window ledges, unloading the dishwasher, folding the wash, putting things away in the linen closet, and setting the table for lunch you feel you could do anything.

Maintenance keeps you literally in touch with the objects in your house, giving you opportunity to express your love and affection for your home and informing you about your passion for life. One of the greatest joys in life is to realize the pleasure you can experience from connecting to the possessions that grace your rooms as well as appreciating the space itself. To identify with your space, to feel that close connection, to love simply being in a room, to feel it is yours, to feel

grateful you have such beautiful things to care for, is a blessing. You would probably find it difficult to muster energy to wax and polish a piece of furniture that you didn't find beautiful. When you fix up and maintain the quality furniture and objects you buy over the years, you increase their beauty and value. You can even buy old quilts and linens and repair them to bring out their original charm and handwork.

You need to do your part to turn daily life into a joyful blessing. Maintenance takes time and can't be rushed if you are to achieve its full physical and spiritual effect. It may be necessary to spend three hours holding a piece of broken porcelain in a bowl of sand, tenderly trying to put the pieces back in their right place. I have a blue Shaker bucket made of wood slats, and one day the bottom fell out, leaving sticks of wood, the round bottom, and tin bands (meant to hold the wood slats in place) on the floor. Because a caring artist had created this bucket without a nail or glue, I felt compelled to put it back together myself. I sat at our round kitchen farm table in silence, afraid even soothing music would disturb my concentration. One slat at a time, and through trial and error, I recreated this bucket. One of the great benefits of maintaining what you have is being methodical, not skipping steps, resulting in a thorough job. Whenever you don't cut corners and do your best, you always feel good about yourself.

If someone else had seen the pile of debris on the floor, the blue wood might have ended up in the fire or garbage. Many people, in a rush to make their way, have become caught up in a "throwaway society" where technological progress is continuously making equipment obsolete. People who lived through any part of the Great Depression remember when nothing was ever discarded. A deeper appreciation and attachment to things existed at that time that is becoming more and more rare today. Through the loving care you give your possessions, you can revive that appreciation in your heart and home.

BALANCING MAINTENANCE
WITH RELAXATION

A house need not be a work trap. Too many women feel guilty reading during the day in the privacy of their house. The bigger

the life, the more there is to maintain. But there should always be a balance between the hours you spend cleaning and tidying up and those you spend enjoying the fruits of your labor by relaxing in the freshened-up space.

I usually balance my energy between sitting still, quietly reading and writing at my desk or in bed, and physically maintaining my rooms. Sometimes I can even combine maintenance and relaxation. While I'm drawing a bath, I can easily wash the bathroom floor and polish the mirrored walls. When on the telephone, I can sit in an antique wicker rocking chair in the bedroom and have a visual feast, taking in the beauty of the room, or I can iron. Ironing itself can be a form of meditation that soothes the nerves. You can become completely centered in the moment, smelling the sweet scent of freshly laundered cotton, the perfume of family life. You're able to appreciate the fine hand-stitching on a cocktail napkin or a baby pillow and the colors and patterns of place mats. After ironing a few scarves, pillowcases, and shirts you can emerge completely refreshed.

You may want to set a schedule for yourself to ensure a balance between maintenance and relaxation. I would probably never write a word if I were to begin my day running around my home, doing dishes, hanging laundry on the line, deadheading the geraniums, or cooking for a lunch party. Over the years, I have developed a habit of spending the early waking hours reading and writing, saving household upkeep activities for the afternoon.

It is important to draw a line between being obsessive about maintenance, and surrendering your house to dirt, dust, mold and, other accumulated grunge. How can you strike the right balance for your temperament and personality, where you are neat but not sterile, where you have rooms that feast your senses without worrying about the next time you have to clean? If you are on the casual side of the maintenance spectrum, how can you remain true to yourself without irritating your spouse or dragging down the feng shui of your rooms?

ESSENTIAL SUPPLIES

*N*othing is more frustrating than not having what you need on hand to do a professional maintenance job. As a house doctor

who has been making house calls since 1963, I have found that the best-run households have in place at least a loose system for maintenance. And through observation, asking questions and hands-on experience, I have discovered that there are a few essential items worthy of mention that will help you develop your own system. With a little extra effort, you can accomplish tasks in less time and with more pleasure. The undergirding of domestic bliss is making the overall process enjoyable.

Begin by having the basic tools and tips of the trade:

1. Wear long pants and a puttering apron with pockets to hold supplies. Keep a collection of aprons that you can put on more to feel homey than to stay clean as you go about "loving up" your rooms. Select an apron that suits your mood. Maybe you'll choose a mint-green-and-white seersucker apron or one with pastel flowers, or perhaps you prefer plain white or French bistro-blue-and-white checks.

2. Use only one hundred percent cotton rags. The best kind are the soft gauze rags sold in paint stores that are excellent for scrubbing, waxing, and polishing as well as painting. If you prefer to use your own, make sure they are pleasing to the eye. Who said rags had to be ugly or drab? I find the cloths I use to clean are as important as the clothes I wear, and once one becomes stained beyond recognition, out it goes. Some of my rags used to be my husband's pyjamas, patterned with colorful stripes that delight me as I work. One client uses her old Lanz flannel nightgowns for dust rags.

3. Use paper towels for brass and silver polishing, then buff with rags.

4. Buy a rubber mat for your knees.

5. As you make your way around a space, making it brim with life, carry a basket or caddie with a handle for all your cleaning supplies—cleaners with bleach, window sprays, waxes, metal polish, paper towels, pretty rags, a toothbrush (for stubborn corners), and a feather duster. Also, make sure you have a small bucket (for cleaning liquids, water, or paint) with a handle, sandpaper, steel wool, and white plastic garbage bags with yellow drawstrings.

6. Stock a tool box with the basics—hammer, assortment of screw drivers, pliers, picture wire, hooks, nails, screws, and brads.

7. Keep handy small jars of paint labeled for each room for touch-ups. Keep a can of white paint handy for spontaneous touch-up jobs. A little dab here, a windowsill there. Baseboards, doorframes, and corner spots can become chipped and dingy looking, needing a caring, gentle touch to bring them back to life. I find painting more fun than cleaning because it symbolizes a fresh start, but of course you have to first clean and often sand the surface. White paint as the backdrop for pure colors makes me smile. Try to use the same white for trim throughout the house so you can dance around and touch up easily. Don't forget to warn loved ones of wet paint.

8. Have a vacuum cleaner, dry mop, broom, dust pan and brush, floor waxer, iron, and ironing board.

9. Cover your ironing board with a favorite fabric to add fun to the activity. I use a fine hand-embroidered, scalloped remnant of a ripped sheet bought at a flea market to cover my European-sized board (smaller and less obtrusive than the standard one). I cut off the shredded, worn-out area, but because of the fine handworkmanship, the cotton was strengthened at the top, the turn-down section of the sheet. If you're accustomed to setting up the ironing board in the laundry room, try moving it to your bedroom or living room for an uplifting change of scenery. I find it a joy to iron in a room full of art and flowers.

CLEANING AND MAINTENANCE METHOD

When you gain the attitude that any energy you expend to make your house more enjoyable will give you positive energy and elevate your mood, you'll have fun in the process. Be a poet as you clean and maintain your home.

1. De-thug each area, throwing away old newspapers, magazines, and junk mail, and empty all wastebaskets. Bring in a tray and

remove everything from each table. Edit what you put back. Have a drawer or cabinet shelf where you can store your excess accumulation of objects when they are not on display.

2. Work in zones, and do everything but the floor in each area. Finish the room by vacuuming, cleaning, waxing, and polishing the floor.

3. Dust settles, so do the high work first: featherdust the walls, wash any woodwork, and scrub the window trims, ledges, and shutters if you have them.

4. After applying wax to the surfaces of furniture, polish the brass knobs and hardware to give the wax a few minutes to set. The wax protects the wood from any polish you may spill on it, so the polish can be erased when you rub the wax to a shine.

5. Use both hands for cleaning mirrors and windows and for rubbing furniture and floors. By using both hands, you will do a more even job and the karma will be good for your body as well as your house.

6. Certain materials should be hand washed—perhaps some delicate bed hangings, antique pillow shams, baby pillows, or other fragile fabrics. Try washing your white bed hangings in lemon-glycerin or almond soap—use your favorite. Once you spray-starch them and hang them back up on your bed posts, your bedroom will breathe new life.

7. Time yourself. When you become aware of all the little odds and ends you can do in a short time, you are encouraged to do things as you go along rather than putting them off so they become a chore hanging over you. Even if you're tired from a hard day at work, these few minutes of puttering, quietly walking around the house, doing what needs to be done, will calm you. You'll become enthusiastic to be home, and the few things you do to improve your home's appearance actually bring you energy because now you're able to do some things for yourself.

Maintenance falls into four categories—daily, weekly, monthly, and spring cleaning. Developing a system based on this framework will help you be more organized in the continuous upkeep of your house. When you work within this structure, be flexible and see what works best for you. Make sure you're in the right spirit to accomplish a task before you take it on. When you feel in the mood, you can go like the wind and feel exhilarated.

DAILY MAINTENANCE

No house is static. Keep your eyes open to assess what needs to be done on a daily basis. If you see a chip in the white wood trim, zap it with some paint. You have to stay alert to even the minor details because often it's the small things you do that make the biggest difference. Be brave. If you see something unattractive that disturbs your eye, attack it.

Making your bed should be a habit, and it brings immediate order to the bedroom. The bathroom sink and tub need to be wiped out each day, and the medicine-cabinet mirror should be wiped with glass cleaner and paper towel. Wiping a windowsill and countertop with a rag takes thirty seconds, and if you live in a city this is a wise habit to acquire.

A general rule of thumb in your daily cleaning escapade is that if you don't see dirt, then don't clean it. If the bathroom floor looks clean, it is clean. If it needs to be wiped, you can do it while the water is running for your bath because it only takes a few minutes. Water the plants that need it, and replace the water in any vases holding cut flowers.

On a daily basis, other than kitchen duties, making beds, and keeping bathrooms clean, there has to be de-thugging as a house rule or the accumulations of stuff will weigh you down. When you open your mail, always have a waste basket right next to you for unsolicited mail and catalogs you don't have the time to look through.

If you have small children and the abundance of toys, laundry, and meals that follow, having your daily maintenance rituals under control is essential so you don't become overwhelmed. I recommend doing a

load or two of laundry a day so it doesn't accumulate and the family doesn't run out of clothes or towels. Everyone's household is a different size and scale. But the daily maintenance should be minimal. Tailoring a system to your daily rhythms will keep your house in order. Run the dishwasher when it's full. The more flexible you are about the everyday things, the more fun you'll have. Whether you hang a picture or touch up some paint or scrub a dirty window or mend a broken plate, do what the spirit moves you to do. If you have the urge to clean out a kitchen drawer or polish the brass hardware, do what you think is appropriate at the time.

Once you feel your house has been renewed, burnished from the removal of dirt and dust, daily maintenance is little other than tidying up. The reward of having the house in order is a boost of energy and house love. Each caring gesture makes the interior glow, and the results are cumulative.

WEEKLY MAINTENANCE

*T*here is a lot you need to do on a weekly basis even if you don't have any children at home or pets who speed the accumulation of grunge. You should probably vacuum, sweep, and mop the kitchen floor, and dust the furniture. You can do one room every other night, or do the whole house with your partner over the weekend. Cleaning together gives you both more energy. Turn on some favorite music and go.

Every time you make a bed with a fresh set of sheets, tucking in the sides, plumping up the pillows, spreading a different quilt or blanket at the foot, you should be able to step back and feast your eyes on the simple beauty of what you have done. When you scoop up all the bath towels, hand towels, and washcloths in your bathroom, you can get excited about introducing a new color scheme for variety, complete with matching or contrasting glycerin soap and pitchers of fresh flowers. If you have dirty cotton throw rugs in your bathrooms and closets, turn them upside down or replace them with a clean rug in a new color. The surprise of yellow, mint-green, periwinkle-blue, and peppermint-pink will be refreshing.

MONTHLY MAINTENANCE

*P*olishing brass and silver makes a room truly shine. You can clean the inside of your windows every month with glass cleaner. Mirrors should be polished daily in bathrooms, but in other spaces, once a month is adequate. If your wood floors look scuffed, polishing them doesn't take long because they have a buildup of wax. The kitchen counters should be cleaned daily to avoid bacteria buildup, though if you have butcher-block counters, you will also need to sand them once a month or as needed, especially in spots showing oil.

Once a month you should give your counter surfaces thorough review. After removing everything from the counter surface, you'll see that, once again, your possessions have accumulated in excess. Be sure to edit, placing some objects in cabinets above or underneath to create counter space. There's something mysteriously uplifting about a clean, bare counter. It may not last long, but it's a fresh, new beginning.

SPRING CLEANING

*I*n the winter months we accumulate layers of excess, filling up our spaces. As we move toward the warmth of spring, shedding our winter cares and clutter, we transform our cocoons into light, airy gazebos. You can see a transformation unfold before your eyes, bringing you joy and spiritual satisfaction. The major de-thugging that is central to spring cleaning is one of the great pleasures of maintaining the home. Ask someone on a Monday how their weekend was, and if you hear energy in their voice, chances are you may learn about a major spring cleaning adventure.

When I embark on a extensive cleaning enterprise, I put on ballet slippers or sneakers, tie an apron around my waist, squirt on some cologne, put on some peppy music, and transport myself into a world of discovery and appreciation. I always begin to see things in a new way, with a fresh eye and heart, as I bring out items that had been put away for the cold season, whether it's a summery piece of clothing or a floral tablecloth.

Spring cleaning is a deep, thorough cleaning of every inch of space. It is essential in order to keep a house gleaming. Though its name refers

to traditional cleaning of houses after the winter hibernation once the warm spring air arrives, I have found it is a ritual that can take place annually or at the start of each season, or whenever you discover that the bright sun is highlighting the grunge and mess in your house rather than the beauty.

In large part, spring cleaning is the de-thugging of months or even years of accumulation of all the stuff of our lives. Every year adds more, requiring you eventually to put your rooms on a diet. You need to feel free to let go of some of the old and tired to make the atmosphere in your house refreshed and exciting. You may discover new uses for things of the past—a tarnished baby cup can be polished and used as a water cup in the bathroom, a pencil container on your desk can become an excellent container for field flowers picked on a morning walk.

After de-thugging, you have to attack the layers of grime and grit that have collected in all those hard to reach, often out of sight places—behind the refrigerator, in the corners of high shelves, in the back of closets, to name a few. Don't be surprised if you require bleach and boiling water.

Though you may prefer to wax your floor and furniture on a monthly basis, for most people this is probably an activity that occurs a few times a year. I recommend using a favorite lemon wax for your furniture and Butcher's paste wax for your wood floors. Spring cleaning also involves deep cleaning rugs, carpets, and upholstery. When you are finished, your home will have a new patina. You will realize that your house is more beautiful than ever before. The sheen imparted by age, use, and polish is incomparable and is extremely satisfying to the spirit.

Don't let yourself be intimidated by the energy required to do this Herculean job that is equivalent to an aerobics class, a tennis match, or more. Spring cleaning energizes your mind, body, and spirit. You emerge not exhausted but exhilarated, and the consequences last.

"LOVING UP" YOUR HOME WITH A SERIES OF GRACE NOTES

*A*nything you do to keep up your household is an act of love, not a chore, and it's a blessing to have a home where you can

create your own quiet beauty every day. If you view maintenance as a series of monotonous chores, think about it in a more Zen consciousness. Redirect your ch'i into an endless flow of appreciation for all your beautiful things, for a house you're blessed to uphold and use as a resource for inner strength. By doing so, you will lift your housework into a series of grace notes.

The Zen of maintenance is to get into the flow of beauty and love; to move or run freely as if a stream or brook; to abound in a smooth, meditative consciousness where you feel the rhythms of life and are in touch with the center of this energy, on your path, fully engaged, content, calm, and open.

A lot of fatigue and depression is the result of being in a constant state of anxiety where you have unrealistic expectations for yourself and become overwhelmed as a result. You must approach the maintenance of your home as an artist in the studio, entering into a state of flow in all your household activities so that chores become grace notes and housework becomes creative play. The process, the actual activity, is the fun. Your satisfactions will be far greater when you do the work yourself or with the help of your spouse or child. All effort brings immediate improvements, and you can take credit for a job well done, especially if you enjoyed the exercise and stimulation of meeting the challenge.

Try not to let efficiency become your top priority when you are engaged in home maintenance activities. Home is one place where you don't have to punch a clock and exhibit a high ratio of output to input. If it takes you twenty minutes to make a pretty bed, though you know you could do it in five, that is your business. If you enjoy arranging simple flower bouquets for your rooms, don't rush yourself. The time you spend with flowers can be a constant reminder of how beautiful and fleeting life is.

Thomas Jefferson and Claude Monet were not only talented in their professions, but they were also sensualists, improving the soul of their houses and gardens all the days of their lives. Though they performed the same maintenance rituals day after day, every moment was new, fresh, and splendid. When the nasturtiums are in flower in Claude Monet's garden at Giverny, you can witness their intense yellow and orange blooms descending to a path under an arbor in marching glory. You feel the efflorescence, the unfolding, culminating in full bloom underfoot. Monet created his gardens and tended to them for inspira-

tion in his painting, just as you can uplift your home by tending to its needs. Rather than fighting the abundance, participate in it. Put the same caring energy into maintaining your house as you put into keeping yourself healthy. Homes, as with children, flowers, and pets, need tending. Polishing a piece of brass is a caress, a kiss. Give a love pat to an antique table by waxing and polishing it. The wood, especially after being exposed to dry heat in winter, is starved for nourishment.

A STYLIST'S APPROACH

When you approach the maintenance of your rooms, pretend you're a photographer's stylist. You're hired to go into a specific space and, without altering the character or taste of the occupants, rearrange objects to create a more cohesive composition. Just as a skilled editor makes a writer's message come forth to the reader loud and clear without changing the author's voice, a good stylist can take a room and make you want to see it in a glossy picture magazine. The stylist doesn't want to change the tone of the space, but rather allow it to vibrate with enthusiasm and let its unique music be heard.

Just as an interior designer has to see beyond what is and envision what a room could become, as a stylist you need to determine what negative, visible things you can eliminate. Pay attention to a dangling brown electrical cord on a lamp. Make it disappear by taping it to the back of a table leg, or place a stack of boxes or baskets to hide it. Also question why a white lamp on a white surface in a white room has a brown cord.

Most stylists take what you have and edit out approximately fifty percent of the total. But some spaces handled that way become too empty to feel settled. It's all a question of proportion. Reevaluate your possessions and weed out unwanted items that no longer represent you well. Would loved ones recognize this space as yours? Does each table, every scene speak to you? Does it feel charming and comfortable?

By paying attention, you'll be able to continuously improve the resonance of your space. The polished brass clocks ticking and chiming is the heart of your rooms beating. Fresh flowers, gleaming mirrors and glass, shiny brass and silver, and lustrous wood recently buffed with a

soft, flannel cloth all add to this energy. When a room sparkles in this way, with a scent of lemon wax or beeswax in the air, there is a feeling of love, kindness, and joy.

I love the ritual of sanding the kitchen butcher-block counters to maintain their smoothness and divine pale tone. If there's an especially stubborn spot, I use a nail file. When they are clear, ready for meal preparation, I often run my hand over a counter and purr, satisfied by the nuance of the bleached color of the mellow maple wood.

BREATHING NEW LIFE
INTO YOUR HOME

*M*aintaining your possessions brings them alive. The better care you take of your things, the more time and energy you put into preserving them, the more tempted you will be to surround yourself with the quality furniture, objects, and fabric that make your surroundings so beautiful and personal. The collective authenticity of these fine objects, well-maintained, creates an atmosphere of luxury, elegance, and refinement that uplifts the house.

The Zen of maintenance teaches that merely keeping things up isn't enough. You can't go through life just maintaining your possessions. Become an artist and poet and call forth all the riches of life right in the heart of your own home. Living a beautiful life requires the whole flow of life to be enjoyable. After all, you're making these efforts for yourself, and you're the one who spends time at home enjoying the warm glow of a loving, loved household. You need to allow your spaces to grow in beauty and harmony as you mature and become more sensitive and aware. You can upgrade and improve your taste, removing everything that lacks spirit or produces negative energy, increasing your ch'i and bringing more joy to others. It is a gift of grace to be alive. To have a home where you're able to putter, do projects, arrange flowers, cook meals, set an attractive table, eat, sleep, and bathe is all you'll ever need to know about enlightenment. To feel joyful in your home each day is the highest form of happiness.

Just as a serpentine brick path can lead to a garden cottage, inviting you to meander, to take your time, to absorb the energy of the sun and

flowers, you cannot rush the maintenance of your house. A life well lived is centered in the celebration of each precious moment. Every modest, humble ritual, when experienced with a loving, caring spirit, supports and builds on this foundation. Each moment informs the next. By understanding that you are on your path, you will be improving, refining, changing, and elevating your taste as your eye and heart seek and find more beautiful sights and feelings. While you can always be maintaining, at the same time you can also be creating, expressing yourself, bringing forth all the ecstasy you feel inside.

The Zen of maintenance is ultimately the pure joy of being awake to all the opportunities you have every day of your life continuously to bring your home new vitality, grace, and beauty. Your greatest masterpiece is to elevate your vision so you can experience the art of living a beautiful life in the bosom of your private haven, moment by moment. This is essentially the artist's way, and you are invited to participate in the banquet.

Conclusion

Think of this book as a beginning, not an end. You will want to continue studying the decorative arts for the rest of your life, always guided by general principles of nature's beauty, light, harmony, and proportion.

Keep in mind you are composing your life, not merely furnishing and decorating a house with necessities. Your rooms are alive. Through your energy you transform the inanimate, manufactured, and hand-crafted possessions into animate objects of your affection, maintained rhythmically through nurturing and loving care.

Your house will inevitably make a statement. Always be true to your own aesthetic sensibility. The people who come into your house will know your taste and style whether you express an original style or not. It isn't the money you spend on the decoration of your house, but the attention you pay, the care you give, and the private passions expressed in your environment that makes your space uniquely yours.

From the architectural elements to the finishing touches, all the elements of interior design in your house will work together to make a fulfilling whole. You have the governing hand in the creation and decoration of your home. Through your attention to detail you will be embraced by your walls, not confined by them.

Use the best organic materials for their intrinsic integrity and enduring superiority. In order to bring your house to loving vitality you need to use materials that are real rather than fake whenever possible. There is no substitute for wood, marble, cotton, wool, and silk.

The decoration of your house is an ongoing process of discovery and

renewal. You never arrive at a finishing point, but are on a path that will continuously enrich you and bring more meaning—and pleasure—to your life. The decoration of houses is a lifelong course. Through reading, studying great architectural interiors, and going to museums and absorbing every piece of art and knowledge you can, you'll heighten your appreciation of beauty. Whether you experience the mysterious sense of exquisite wholeness in a cathedral, fabric store, friends' houses, or in the privacy of your own home, anywhere, everywhere, you can grow in sensitivity so that the most subtle details and nuances are revealed to you. You can enroll in courses, attend lectures, and participate in workshops, seminars, and symposiums. You can acquire knowledge from magazines, newspapers, and catalogs. There are no limits to the resources available to you in the world today.

The decoration of your house is not a preparation for future events, but is a way to live fully in the present moment, to truly appreciate your time at home. The more you give of yourself, the more of your spirit you put into your space, the more content you will feel within the walls that not only house your possessions, but your passions, your essence, your love. If you feel embraced by your four walls, you are making a statement about living well.

There's nothing more important to daily happiness than to find fulfillment in the privacy of your own home. The beauty you create will not only satisfy practical requirements that suit your lifestyle, but will touch your soul on a deeper, more expansive, mysterious level. By first adhering to the restraints of the classical tradition of architecture and interior design, you're then free to turn the physical structure into your personal haven of contentment. These fundamental classical elements have not changed in a hundred years, or indeed, for centuries.

There are houses everywhere, but a home is a sacred place, built over a lifetime with a loving heart, with common sense and your daily participation in all the forces that collectively create the harmonious sense of beauty. The more you put in, the more your home gives back.

Ultimately, not only do architecture and interior decoration become one in the home, but *you* are one with the space. The harmony you feel in your home is a reflection of the harmony you create all around you. If your home feels right to you, it is right for you.

You are the foremost interior decorator of your house. When you are well pleased, anyone who crosses the threshold of your front door will

be blessed because your pleasure will radiate in an atmosphere that charms, delights, and touches the lives of others.

In a world where technology plays an increasingly prominent role, by adhering to the immutable classical principles set out in this book, you have all you need to create heaven here, through the satisfying and sustaining decoration of your house.

Alexandra Stoddard

Alexandra Stoddard
New York City

Index

A Note About the Endpapers

Every moment of writing this book was a delight, but some of my happiest hours were spent selecting a rainbow of colors for the endpapers. The colors are separated by white bands so that each can be seen in the fullness of its intensity.

What colors do you love? What colors make you feel joyful, thoughtful, serene? Color—wavelengths of energy—has, from the beginning, been central to the lives of human beings. I hope these pages inspire you to begin your own voyage into the world of clear, fresh colors, filling your home and life with the hues that bring light, energy, beauty, and wonder to each day.